ROGER FRY

A BIOGRAPHY

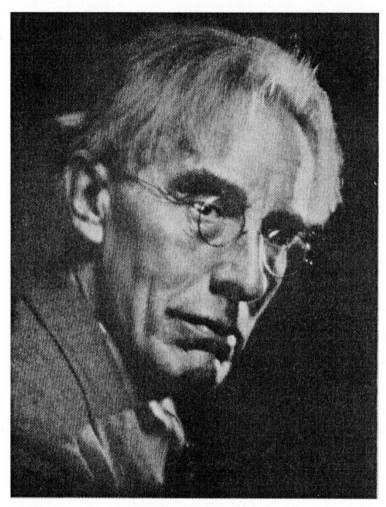

ROGER FRY ABOUT 1928

Virginia Woolf

ROGER FRY
A BIOGRAPHY

A Harvest/HBJ Book
Harcourt Brace Jovanovich, Publishers
San Diego New York London

Library of Congress Cataloging in Publication Data

Woolf, Virginia Stephen, 1882-1941.
Roger Fry : a biography.
(A Harvest book ; HB 338)
Includes index.
1. Fry, Roger Eliot, 1866-1934.
N7483.F79W66 1976 709'.2'4 [B] 75-34023
ISBN 0-15-678520-X

Printed in the United States of America

D E F G H I J

CONTENTS

LIST OF ILLUSTRATIONS

CHAPTER I

CHILDHOOD: SCHOOL

I

"I LIVED the first six years of my life in the small eighteenth-century house at No. 6 The Grove, Highgate. This garden is still for me the imagined background for almost any garden scene that I read of in books"—thus Roger Fry began a fragment of autobiography. We may pause for a moment on the threshold of that small house at Highgate to ask what we can learn about him before he became conscious both of the serpent which bent down "from the fork of a peculiarly withered and soot begrimed old apple tree", and of the "large red oriental poppies which by some blessed chance" grew in his "private and particular garden".

He was born on 14th December 1866, the second son of Edward Fry and of Mariabella, the daughter of Thomas Hodgkin. Both were Quakers. Behind Roger on his father's side were eight recorded generations of Frys, beginning with that Zephaniah, the first to become a Quaker, in whose house in Wiltshire George Fox held "a very blessed meeting, and quiet, though the officers had purposed to break it up, and were on their way in order thereunto. But before they got to it, word was brought them, that there was a house just broken up by thieves, and they were required to go back again with speed. . . ." That was in 1663, and from that time onwards the Frys held the Quaker faith and observed certain marked peculiarities both of opinion and of dress, for which, in the early days, they endured considerable persecution. The first of them, Zephaniah, was in prison

for three months for refusing to take the oath of allegiance. As time went on the persecution weakened; they had nothing worse to suffer than the "sneers and coldness of their own class"; but whatever they suffered they abode by their convictions consistently. The injunction "Swear not at all" meant that no oaths could be taken, and therefore many professions were shut to them. Some of the Frys added additional scruples of their own. Even the profession of medicine was distasteful to Joseph, the grandson of Zephaniah, because "he could not feel easy to accept payment for the water contained in the medicines he dispensed". Such scruples—"miserable questions of dress and address", as Edward Fry came to call them—tormented the weaker spirits and laid them open to ridicule. They vacillated between the two worlds. A coat-of-arms was first engraved and then scratched out; fine linen was ordered and then cut up; one John Eliot fretted himself into the conviction that he ought to outrage eighteenth-century convention by growing a beard. The arts as well as the professions were outside the pale. Not only was the theatre forbidden, but music and dancing; and though "drawing and water-colour painting were tolerated or encouraged", the encouragement was tepid, for, with some notable exceptions, even in the nineteenth century almost the only picture to be found in a Quaker household was an engraving of Penn's Treaty with the Indians—that detestable picture, as Roger Fry called it later.

Undoubtedly the Quaker society, as one of its members writes, was "very narrow in outlook and bounded in interests; very bourgeois as to its members". But the canalising of so much energy within such narrow limits bore remarkable fruit. The story of Joseph Fry is typical of the story of many of the Frys. Since, owing to his scruples, the medical profession was shut to him, "he took to business occupations, and established, or took part in establishing, five considerable businesses which probably proved far more remunerative than the profession which

he had renounced for conscience sake". Hence there came about a curious anomaly; the most unworldly of people were yet abundantly blessed with the world's goods. The tradesman who lived over his shop in Bristol or in Bartholomew Close was at the same time a country gentleman owning many acres in Cornwall or in Wiltshire. But he was a country gentleman òf a peculiar kind. He was a squire who refused to pay tithes; who refused to hunt or to shoot; who dressed differently from his neighbours, and, if he married, married a Quaker like himself. Thus the Frys and the Eliots, the Howards and the Hodgkins not only lived differently and spoke differently and dressed differently from other people, but these differences were enforced by innumerable inter-marriages. Any Quaker who married "outside the society" was disowned. For generation after generation therefore the sons of one Quaker family married the daughters of another. Mariabella Hodgkin, Roger Fry's mother, came of precisely the same physical and spiritual stock as her husband Edward Fry. She was descended from the Eliots who, like the Frys, had been Quakers since the seventeenth century. They too had eschewed public life and had accumulated considerable wealth, first as merchants at Falmouth "exporting pilchards and tin to Venice", and later in London, where they owned a large family mansion in Bartholomew Close. The Eliots married with the Howards, who were tinplate manufacturers and Quakers also. And it was through the marriage of Luke Howard, the son of Robert, the tinplate manufacturer of Old Street, with Mariabella Eliot that the only two names among all the names in the ample family chronicle in which their descendant Roger Fry showed any interest came into the family. His great-grandfather, Luke Howard (1772–1864), was a man of "brilliant but rather erratic genius" who, like so many of the Friends, being denied other outlet, turned his attention to science. He was the author of an essay "proposing a classification and nomenclature of the clouds" which

attracted the attention of Goethe, who not only wrote a poem on the subject but entered into communication with the author. Mariabella Hodgkin could remember her grandfather. He seemed, she writes, "always to be thinking of something very far away. . . . He . . . would stand for a long time at the window gazing at the sky with his dreamy placid look", and, like some of his descendants, he was "deft in the use of tools" and taught his grandchildren in his own workshop how to handle air pumps and electrical machines. Roger Fry left his copy of the family history uncut, but he admitted that he wished he knew more of this ingenious ancestor whose gift for setting other people's minds to work by speculations which were not "entirely confirmed by subsequent observation" suggests some affinity of temperament as well as of blood. The other name that took Roger Fry's fancy, though for different reasons, was his mother's—Mariabella. It was first given in the seventeenth century to the daughter of a Blake who married a Farnborough, whose daughter married a Briggins, whose daughter married an Eliot. It was a name with a certain mystery attached to it, for it was "evidently Italian or Spanish in its origin", and Roger Fry, who took no interest whatever in the Eliots and their possible connection with the Eliots of Port St Germans, or in the Westons and their possible but improbable descent from Lord Weston, Earl of Portland, liked to think that his ancestress, the first Mariabella, owed her name to some connection with the South. He hoped that the quiet and respectable blood of his innumerable Quaker forefathers was dashed with some more fiery strain. But it was only a hope. No scandal in the Eliot family had been recorded for more than two hundred years. His mother, Mariabella Hodgkin, the seventh to bear that name, was a pure-bred Quaker like the rest; and it was in the Friends' Meeting House at Lewes on a cloudless spring day in April 1859 that Edward Fry married her and brought her back to the small house in Highgate.

That house,[1] Edward Fry wrote, "looked over Miss Burdett-Coutts' garden of Holly Lodge beyond to the roofs of London . . . a little garden, with a copper beech in one corner, sloped down from the house to the trees of our great neighbour, and was very dear to us in those early days. It was a little plot

> Not wholly in the busy world nor quite
> Beyond it.

And murmurs from the great city below us often stole up the hill and reminded us of how near we were to the great heart of things." It was in that house that his nine children were born; and it was in that garden that his son Roger felt his first passion and suffered his first great disillusion.

This garden [Roger Fry wrote] is still for me the imagined background for almost any garden scene that I read of in books. The serpent still bends down to Eve from the fork of a peculiarly withered and soot begrimed old apple tree which stuck out of the lawn. And various other scenes of seduction seem to me to have taken place within its modest suburban precincts. But it was also the scene of two great emotional experiences, my first passion and my first great disillusion. My first passion was for a bushy plant of large red oriental poppies which by some blessed chance was actually within the limits of the square yard of bed which had been allotted to me as my private and particular garden. The plants I bought and glued into the ground with mud, made with a watering pot and garden mould—the seeds which I sowed never came up to my expectations, generally in fact refused to grow at all but the poppies were always better than my wildest dreams. Their red was always redder than any thing I could imagine when I looked away from them. I had a general passion for red which when I also developed a romantic attachment for locomotives led me to believe that I had once seen a "pure red engine". Anyhow the poppy plant was the object of a much more sincere worship than I was at all able to give to "gentle Jesus" and I almost think of a greater affection than I felt for anyone except my father. I remember

[1] No. 6 The Grove. Later Sir Edward took No. 5, next door.

on one occasion the plant was full of fat green flower buds with
little pieces of crumpled scarlet silk showing through the cracks
between the sepals. A few were already in flower. I conceived
that nothing in the world could be more exciting than to see
the flower suddenly burst its green case and unfold its immense
cup of red. I supposed this happened suddenly and that it only
required patience to be able to watch the event. One morning
I stood watching a promising bud for what seemed hours but
nothing happened and I got tired, so I ran indoors very hur-
riedly for fear of getting back too late and got a stool on which
I proceeded to keep watch for what seemed an eternity and
was I daresay half an hour. I was discovered ultimately by
an elder sister and duly laughed at by her and when the story
was known by all the grown-ups, for all passions even for red
poppies leave one open to ridicule.

The other event was more tragic. It was in fact the horrible
discovery that justice is not supreme, that innocence is no pro-
tection. It was again a summer morning and I was leaning
against my mother's knee as she sat on a low wicker chair and
instructed me in the rudiments of botany. In order to illustrate
some point she told me to fetch her one of the buds of my
adored poppy plant or at least that was what I understood her
to say. I had already been drilled to implicit obedience and
though it seemed to me an almost sacrilegious act I accom-
plished it. Apparently . . .

There the fragment stops. But the sequel is known—he
picked the poppy and was gravely reproved by his mother
for doing so. The disillusionment was great. For if he was
credulous and passionate, he was also "drilled to implicit
obedience"; and the person who had first exacted his
obedience and then punished him for it was his mother.
The shock of that confused experience was still tingling
fifty years later. It was akin to many of the same kind that
were to follow; but the fact that his "first great disillusion-
ment" was connected with his mother perhaps explains
the sharpness and the permanence of the impression. Lady
Fry exercised upon that very impressionable and sensitive,
yet also very logical and independent, boy an influence

that lasted long after she had ceased to teach him botany.
As her photographs show, she was a woman of great
personal impressiveness; handsome of feature, firm of lip,
vigorous of body. Tradition has it that she was a high-
spirited girl, fond of gaiety, and capable of attracting
admiration in spite of the Quaker sobriety of life and of
the Quaker dress which was still the common wear of the
Hodgkins in her youth. Late in life—she lived to be ninety-
seven—she made out a list of "Things that were not—:
Things that were: when I was a little child". It is an
instructive list. Among the things that were not, she
counted lucifer matches; hot-water bottles; night-lights;
Christmas trees; hoardings with posters; Japanese
anemones; spring mattresses; and gas for teeth extraction.
Among the things that were, she counted flint and steel;
rushlights; prunes and senna; clogs and pattens; beadles
and chariots; tippets and sleeves (in one); snuff-boxes and
Chartists. She drew no conclusion, and it is left for us to
infer that there were more denials than delights, more
austerities than luxuries in the life of the little Quaker girl.
An anecdote that she tells of her childhood bears out this
impression. "On this occasion [an illness at the age of four]
a kind Uncle brought me a box of lovely tea-things (I
have them still) and brought them up to me as I sat in my
crib. Though no doubt longing to have them, I resolutely
and firmly shut my eyes, and in spite of cajolements and
commands, refused to open them. My Uncle departed,
the tea-things were no doubt taken away and I was left
under the ban of displeasure. This was one of those secret
inhibitions which are part of childhood, and arise probably
from vehement shyness." And there were other inhibitions
that were peculiar to a Quaker childhood. To the end of
her life she remembered how her father had ordered the
tight sleeves that were fashionable to be cut from her dress
and large sleeves that were out of fashion to be inserted,
and how, as she walked along the road, the street boys had
jeered "Quack! Quack!" at her. Very shy and sensitive,

the effect of such an upbringing was permanent. Always she seemed to live between two worlds, and to belong to neither. Thus it was no wonder that when her second son was a child, her eyes remained firmly yet uneasily shut to many of the sights that were to him objects "of a much more sincere worship than I was at all able to give to 'gentle Jesus' "—red poppies, red engines, and green flower-buds with little pieces of scarlet silk showing through the cracks between the sepals. And yet he respected her; and was "drilled to implicit obedience".

The garden in which he received this first lesson in the rudiments of botany was surrounded by other gardens. Below it stretched Ken Wood, then belonging to Lord Mansfield; and Ken Wood merged in the heights of Hampstead. Highgate itself was a village; and though, as Sir Edward Fry said, the murmur of London stole up the hill, access to the great city was difficult. Only "an occasional omnibus" connected the two. The "villagers" were still isolated and exalted. They still considered themselves a race apart. When Roger was a child, the old hair-dresser who had cut Coleridge's hair was still cutting hair and recalling the poet's loquacity—"He *did* talk!" he would say, but was unable to say what the poet had talked about. Local societies naturally formed themselves. There was a chess society and a society for literary and scientific discussion. A reading society met "once in three weeks to read aloud selections from standard works. . . . Tea is handed round at 7, and sandwiches and fruit at 10 . . . and if any unfortunate lady, through ignorance or want of thought, put jellies or cream on her supper table she was sure to get a gentle rebuke for her lawlessness." Sometimes the society met at the Frys'; and the leading spirit—Charles Tomlinson, F.R.S.—an indefatigable and erudite gentleman whose published works range from *The Study of Common Salt* to translations from Dante and Goethe with volumes upon Chess, Pneumatics and Acoustics, and *Winter in the Arctic Regions* thrown in—would drop in of a

Sunday evening and listen to Sir Edward reading aloud
Paradise Lost or George Fox's *Journals* or one of Dean
Stanley's books to the children. The reading over, Mr
Tomlinson would talk delightfully, if incomprehensibly,
to the children. And then he would invite them to tea with
him. He would show them all the marvels of his "den".
The small room, as befitted the multiplicity of its owner's
interests, was crowded with fascinating objects. There was
an electrical machine; musical glasses; and Chladni's
clamp—an invention by which sand, when a violin was
played, formed itself into beautiful patterns. Roger's life-
long delight in scientific experiments must have been
stimulated. But science was part of the home atmosphere;
art was "kept in its place"; that is the Academy
would be dutifully visited; and a landscape, if it faith-
fully recorded the scene of a summer holiday, would be
dutifully bought. Thus it was through Charles Tomlin-
son perhaps that he first became aware of those aesthetic
problems that were later to become so familiar. As the
author of a *Cyclopaedia of Useful Arts* Mr Tomlinson had
access to certain factories, and he would take the little
Frys with him on visits to Price's Candle Factory, Powell's
Glass-making Works, and a diamond-cutting factory in
Clerkenwell. "And these factory visits", wrote Roger's
sister Agnes, "raised questions of a fresh sort; what made
good art and bad art, what ornament was justified, and
whether diamonds were not better used for machinery
than for necklaces. He was very strongly of opinion that
they were—a brooch, he told us, might be useful, but
lockets were an abomination to him." Roger's opinion, as
to what made good and bad art, was unfortunately not
recorded. It was again thanks to Mr Tomlinson, who was
on good terms with the head gardener, that they went
every spring for a walk in Lord Mansfield's strictly private
woods—that "earthly Paradise which we could see all the
year from our own garden, which we passed almost daily
in our walks, and which for one delightful morning in

May-time seemed to belong to us". So Agnes Fry described
Ken Wood; and Ken Wood, as appears from another frag-
ment of autobiography, had its place in Roger's memory
too. But his memory was not of walking in spring woods; it
was of winter skating.

One day in January 1929, he says, he was dozing when

suddenly I had a vivid picture of my father skating. It must
have been somewhere in the 70's about '74 I should guess and
the place was one of the ponds in Lord Mansfield's Park at
Kenwood which is now public property but was then very
private. Only when the ponds bore, the privileged families of
Highgate of which we were one were allowed in by ticket. It
was a beautiful place with beechwoods standing a little back
from the pond's edge and that winter all beflowered with long
needles of hoar frost which glittered rosy in the low winter
sunshine. And there was my father with a pair of skates which
was old-fashioned even for that date. Low wooden skates with
a long blade which curled up in an elegant horn in front, skates
exactly like those one sees in Dutch pictures. We half despised
them because they were old-fashioned, half revered them as be-
longing to my father. He was passionately fond of skating—it
was indeed the only thing approaching to a sport that he cared
for. He was passionately fond of it though he skated rather
badly at least it was an odd style or absence of style, the way
he scuttered along with legs and arms and long black coat tails
flying out at all angles and the inevitable top hat to crown it
all. He loved skating indeed so much that though he was a
Q.C. in big practice he sometimes managed an afternoon off
in the middle of the week so terrified was he of the frost giving
before Saturday. It was the only interruption he ever allowed
in the routine of his work. So there we were, my sisters and I
and Porty my elder brother six years my senior and a great
swell to us, in various stages of scrambling along on skates or
already gaining confidence. My father after two or three turns
of the pond would return to us and help us very cheerfully
giving a hand and a turn across the pond to those that were
sufficiently advanced, for he was always in high spirits when
there was skating and even more kind than usual, anyhow more

lively more talkative and less alarming. More and more alarm-
ing he was destined to become as we grew older and became
separate individuals and more unwilling to fit in to the rigid
scheme of Victorian domesticity. But on those days he was all
laughter and high spirits and there seemed no danger of sud-
denly finding oneself guilty of moral obliquity which at other
times seemed suddenly to be one's situation without knowing
exactly why or how it occurred, for the moral code was terribly
complicated and one didn't always foresee where it would catch
you tripping over some apparently indifferent and innocent
word or deed. And when it did my father's voice was of such
an awful gravity that one shrunk at once to helpless self-
condemnation and overpowering shame.

There was one dark or doubtful spot in the picture—the
skates. We were a large family and those who like myself came
in the middle had generally to make what they could of dis-
carded skates of the elders. These were made of blades of doubt-
ful steel set in wood with a small screw which went into the
heel of one's boot. These screws had always lost most of their
thread and used suddenly to come loose from one's feet in the
middle of an exciting race or when one was just beginning to
cut an eight. The worst of these imperfect skates was that in
the last resort they delivered you into the hands of the wretched
men who hired chairs and fitted on skates. Our relations with
these men were strained and painful.

First of all we were brought up to the absolute conviction
that all men not in regular employment and receipt of a fairly
high salary were morally reprehensible, that in fact the world
was so arranged that wealth and virtue almost exactly corre-
sponded, though every now and then we were allowed to de-
spise some parvenu whose mushroom fortune had grown so
quickly as to throw a dubious light on the theory itself. Such
indeed was the owner of the upstart Kenwood Castle which
thrust its gimcrack Gothic brickwork belvidere up into the
midst of our own private view from our garden and who seemed
actually to want to rival the splendours of Kenwood House
which Lord Mansfield filled with his hereditary and long estab-
lished dignity and actually allowed us to skate on his ponds.

This theory, then, of money being a coefficient of virtue

made the pond loafers with their big red noses and big red
neckerchiefs who stamped about blowing into their ugly hands
altogether foreign beings infinitely remote from us like some
other species, almost like the criminal species of man of which
we heard now and again.

It is impossible to exaggerate the want of simple humanity
in which we were brought up or to explain how that was closely
associated with the duty of philanthropy. To pay these poor
men who after all were trying to do a piece of work—to pay
them a decent tip was truckling to immorality because a casual
being immoral you were helping immorality. My elder brother
was quite particularly stern about this and many a painful scene
from which we retreated under a well-directed volley of abuse
resulted from our heroic attempts to live up to his principles.

There again the fragment ends. Obviously the man,
looking back at his past has added something to the im-
pression received by a child of seven, and, since it was
written for friends who took a humorous rather than a
reverential view of eminent Victorians, no doubt it owed
a little to the temper of the audience. Yet it is clear that
the child had received an impression that was very vivid,
and at the same time puzzling. He had felt the contrast
between the father who "scuttered along" with his coat-
tails flying "all laughter and high spirits" and the stern
man who could in a moment, in a voice of awful gravity,
reduce him to a sense of overpowering shame for some
moral obliquity of which, without knowing exactly why or
how, he had been guilty.

Indeed, judging from Sir Edward's own account of
himself in his own autobiography, these early impressions
were well founded. There were good reasons why he
should inspire his son with a mixture of devotion, fear and
bewilderment. He was a man of deep feelings and of many
conflicts. ". . . I often thought that in no human being had
the two contending elements of our nature—the baser
and the better—ever existed in stronger antithesis, or ever
fought more fiercely for the victory," he wrote: ". . . doubts

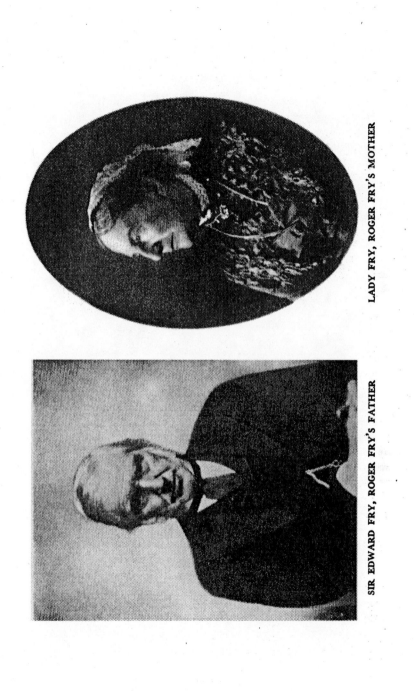

SIR EDWARD FRY, ROGER FRY'S FATHER

LADY FRY, ROGER FRY'S MOTHER

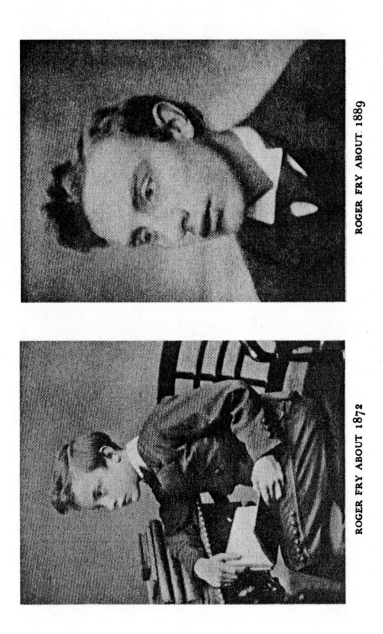

ROGER FRY ABOUT 1889

ROGER FRY ABOUT 1872

and difficulties about God and the other world: aspira-
tions often vague and purposeless, that were perforce un-
satisfied: fears for the future—of things both spiritual and
bodily: the mystery of the world: a sense that ordinary
life was full of triviality: a repulsion from the character
and habits of many people: regrets for things said and done
amiss, and especially for the outbursts of a temper that
was always somewhat masterful—all these and manifold
other things often gave me sad and painful thoughts"—it
was thus that he described his character as a young man.
Among the desires that were "perforce unsatisfied" was
the desire for the life of a scientist. His natural bent was
strongly scientific. As a boy at Bristol he spent his pocket-
money on the bodies of dead animals at the Zoological
Gardens which he dissected at home. His first published
work was on the *Osteology of the Active Gibbon*; his second,
On the Relation of the Edentata to the Reptiles. Bones and rocks,
plants and mosses were far more congenial to him than
the work of a clerk in a sugar-broker's office. The life
of a professor of science at one of the great universities
would have suited him to perfection. But as a Quaker both
Oxford and Cambridge were "practically shut" to him;
and he chose the law, for which he entertained "no pre-
dilection", because it gave him "a justification for asking
for College". The college—University College, London—
was not Oxford or Cambridge, but it was better than no
college at all. It was natural thus, that, though born and
bred a Quaker and remaining a Quaker all his life, he
was yet highly critical of the sect. He was one of the first
to protest against Quaker "peculiarities" and in his old
age he wrote that "miserable questions about dress and
address and the disputes about orthodoxy produced a
chasm in my feelings between myself and systematic
Quakerism which I have never got over". By temperament
he was shy and despondent, and "had very little interest in
the common run of humanity". But he had a vigorous and
critical intellect; was contemptuous of "anything morbid,

sentimental or effusive"; merciless to inaccuracy; and
so retentive of facts that in extreme old age—he scarcely
knew a day's illness till his last years and lived to be over
ninety—he could supply precise information "whether as to
the exact limits of the English Channel, the geographical
distribution of animals, or the spelling of a word". Such
gifts, though the law was not the profession of his choice,
naturally brought him to eminence. After a dreary time
of waiting, "seeing the current of briefs flow in the Square
below me", longing "for more society and love", longing
too for the country and sometimes catching a whiff of hay
and seeing above Lincoln's Inn the distant hills of Hamp-
stead, briefs came his way, and his practice steadily
increased. But the life of a successful lawyer never satisfied
him. Directly he became a Judge he told his clerk that he
would retire when he was entitled to a pension; and much
to the surprise and regret of his colleagues he kept his
word. In the prime of life, but too late to become a
serious scientist, he retired to the country to enjoy that
"union of simplicity of life with the benefits of cultivation"
that had always been his ideal. But like his ancestors he
was a country gentleman with a difference. He never
smoked; bowls and halma were the only games he tolerated;
and he had no skill with his hands. He read aloud to his
children, cultivated his garden, and served his country at
the Hague and on the Bench. His shelves were well stocked,
and the busts of great men ornamented the library; but
for works of art he had no feeling whatsoever. His only
recorded judgment of a picture was unfavourable because
"the beautiful lady [in the portrait] . . . had borne a
character not without reproach". Mosses, on the other
hand—the Hypnum, and the Tortulas and the Bryums
—gave him a satisfaction that human beings failed to
give. And if, as he said of himself, he lacked con-
fidence in his own powers and had "a certain rather
despairing way of looking at the future", there was no
lack of decision in the rulings he laid down either upon

the Bench or in his own house. The "scheme of Victorian domesticity" devised by him was rigid. The moral code might be "terribly complicated" to a small boy, but it was extremely definite. Even though he inspired his children, and his daughters in particular, with profound devotion, they "always realised that there were bounds not to be overpassed". Perhaps, could they have ignored those bounds, he would have welcomed it. Perhaps he regretted as much as his son did the "alarmingness" which, as they grew older and the son developed his own individuality, drove them further and further apart. Sir Edward at any rate was deeply conscious of his loneliness. He had had much happiness, he wrote in his old age, and many friends. "But in spite of all this, there is a sense of solitude —aloofness from my fellows, which has clung to me through life, and which in looking back has, I feel, coloured my intercourse with my fellow men as a whole. How few of those with whom I have associated have really understood me! One may think of me as a lawyer, another as a botanist, and another as this or that, and how few feel one's real self. . . . I was born alone; I must die alone; and in spite of all the sweet ties of home and love (for the abundance of which I thank God) I must in some sense live alone."

Naturally a child of seven could not enter into these solitudes; but he could, as Roger's memory of the winter's day on the pond at Ken Wood shows, feel the contrast between the father who, when he gave way for once to his passion for skating, was all laughter and high spirits; and the father whose large bright eyes suddenly clouded; and whose voice became one of awful severity as he accused him of sins which he could not understand. Moreover, there was another contrast which even as a child perturbed him. Whatever his father's moral convictions might be, they lived a highly comfortable life in the small house at Highgate. There were perpetual compromises with the world of respectability and convention. A carriage and pair

took his father to Lincoln's Inn. The rights of property were respected; class distinctions were upheld; and the pond loafers, with their red neckerchiefs, blowing into their ugly hands, were not to be pitied but blamed. There was, he felt, "a want of simple humanity" in their upbringing. He revered his parents, his father especially; but they frightened him; and there was much in their way of life that puzzled him.

Such impressions, however, though sharp enough to last a lifetime, and deep enough to cause much conflict, were of course momentary and exceptional. For the most part, there was nothing to perplex or to frighten. " The black hen is still sitting. Mr Carpenter's little girl came this morning to take the white kitten away. On Saturday Porty examined Mab and Kizzy and myself in Tables, Geography and Latin and he set Mab and Kizzy some sums while he examined me in French"—that is an average sample of daily life at Highgate in the 'seventies. The garden with its hot-houses and its gardener played a great part in Roger's day. He had his own garden, and a lily grew there which he drew in pencil for his grandfather in Lewes. He had his sisters to play with; and he ruled over them despotically and refused to let them borrow his toys. There was a wide connection of uncles, aunts and cousins, remembering birthdays and sending presents, often, for they were a highly scientific family, of a mineral or of a vegetable nature. He went up to bed not with a toy, but with a crystal that his grandmother gave him. "In return for the Epipactis," his cousin R. M. Fry writes, "would you like a specimen of the *Oxalis corniculata?*" And the boy of nine was always careful to use the proper scientific names in reply. His elder brother Portsmouth, already at school at Clifton, instructed him in other matters. "On the envelope is a picture of the hawkheaded God, I forget his name, and in his left hand he has the 'crux ansana' or symbol of generation, that is of life. He isn't exactly what you might call a handsome God but

perhaps he was very powerful and that is much more glorious. . . . I enclose another skeleton of a speech against the notion that the Greeks did the world more good than the Romans. . . . Grandpapa . . . again remarked on the thickness of my hand and said it was a good hand for work; his are so thin and shrivelled."[1]

Nor did his father when he was on Circuit forget to write to him. It is true that he moralised: "I am glad to hear that you are good. You feel happy when you are good and unhappy when you are naughty", but that did not prevent him from sending Roger the picture of a lion; and he picked a gentian and sent it him, and wished when he saw a squirrel in the Welsh woods that Roger at Highgate could have been with him and could have seen it too.

II

But a change in the garden at Highgate was at hand, and it was connected, as it happened, with a great family occasion—his father's appointment to the Bench. Roger Fry has described it himself:

I must have been between 10 and 11 years old when our schoolroom lessons were suddenly interrupted by a message from my mother that we were all to go downstairs to her. We ran down to the dining room filled with rather apprehensive curiosity. For lessons to be interrupted it must be grave, it might—it probably would be, a criminal case—so peculiar were the intricacies of the moral code—one might quite well have committed an act of whose enormity one was still unconscious. My mother was seated gravely with an inscrutable air—no it was not criminal—it was solemn but we were not in disgrace—how quickly and surely we had learned to read the hieroglyphics on a face on which so much depended! Solemn it was but not evidently altogether unpleasing. Then we were told that our father had been made a Judge. It was a great

[1] Portsmouth Fry, after a brilliant youth, contracted an illness which made him a lifelong invalid.

honour, we must feel proud of him—but he would not be so
well off as he had been—we must be prepared to sacrifice many
comforts and luxuries that we had hitherto enjoyed willingly
and gladly since the sacrifice would be due to his high station.
Also he would be knighted—he would be Sir Edward Fry—that
was a great honour but we must not be vain about it—though
we gathered we might indulge some secret satisfaction in
the far higher but more esoteric title of Mr Justice. We had
nothing particularly to say to all this, but we knew how to
murmur in a generally admiring and submissive way which
was all that the occasion required. We went away encouraging
one another to bear with Spartan fortitude those deprivations
with which we were menaced. As my father must have been
making something around £10,000 a year and as we lived in
a smallish suburban house of I guess £50 a year rental—as
moreover entertainment was confined to rare formal dinners
each of which wiped out the hospitality scores of months and
as my father had no vices and no expensive tastes I have no
doubt that even the miserable salary of £5,000 a year to which
he would be reduced more than covered our expenses—and
thank goodness it did for I should scarcely be here if my father
had not indulged in that grand Victorian vice of saving.

However we never noticed any serious change in our way
of life. The Sunday sirloin continued to appear; Sunday tea
still had its tea cakes and really it would have been difficult to
point to any luxuries that could be suppressed in our week day
menus. However when the summer came we found something
which we were called on to sacrifice. My father as junior
member of the Bench had to be Vacation Judge. So our yearly
visit to the seaside was impossible as he could not get to and
fro every day or at least it was thought impossible. My parents
rented a house near Leith Hill belonging to two old Miss
Wedgwoods. From here my father could drive to Abinger
Station and get to his Chambers in time for the day's work,
coming back in the late afternoon. The house was furnished
with a good deal more taste than our own and I suppose in
a dim as yet unconscious way I was sensitive to such things
for the memory of it remains as a peculiarly happy interlude
in my life. And besides that the garden was large and led

directly into a wooded valley which belonged to the house and of which we had the free run. So that our sacrifice to our father's honour cost us nothing and I believe we enjoyed those holidays much more than the usual holidays in some distressing seaside lodging house. My father had begun to be interested in me. I was old enough for him to talk to without too much condescension and we often went for long walks over Leith Hill and the neighbourhood. It was in 1877 and the Russo-Turkish War was in full blast, and I remember my father telling me that not only did he hope the Russians would win but he believed firmly that they would because God would not allow a Christian country to be defeated by a Mahommedan one. It was many years before the full enormity of such a statement from a man of my father's wide knowledge of history and science dawned on me. At the time it appeared perfectly natural and made me an ardent Russophil without having the slightest knowledge of the rights and wrongs of the quarrel. A month or two later when I found myself at Sunninghill preparatory school this conviction, which I was always ready to defend with rapidly improvised arguments, earned me a good deal of unpopularity for, for some reason, all right-minded people were on the other side. I fancy that the real issue for all even for my father was between Dizzy and Gladstone.

Fortunately during our delightful summer at Leith Hill I had no notion of the fate that was in store for me. So that when one day a clergyman Mr Sneyd-Kynnersley came to lunch I did not even wonder why this new acquaintance had turned up, although visitors were for the most part very scarce. After lunch he expressed a wish to see a particular view in the neighbourhood and I was told to show him the way. I suppose that he tried to draw me out during the walk, but I took very little notice of him or of anything he said believing in my incredible innocence of the world that he was just some stray acquaintance to whom my people wished to be polite. He left soon after and then I was called to a private interview with my parents and suddenly the bolt fell—would I like to go to a school with Mr Sneyd-Kynnersley? He was starting a new school at Ascot in a fine country house built by my uncle Alfred Waterhouse—this point was much dwelt upon as being

likely to make me feel more at home than in a house built by an
unrelated and unknown architect whereas I, who had so often
staid at my uncle's own country house, would be rejoiced to
find the same sacred pitch pine boarding everywhere the same
gothic windows with stained glass in the W.C. Mr Sneyd-
Kynnersley was very fond of boys and there were no punish-
ments. I had no desire whatever to go to school but I answered
in the manner that was expected of me that it would be very
nice to go to school with the strange clergyman.

And so sure enough in September I went, armed with a silver
watch which my father gave me, and a black leather bible
which my mother gave me, with many solemn warnings against
sin and the assurance that the Bible would always guide me
through the difficulties of life.

Now therefore Lady Fry began to receive the first of
many schoolboy letters which she kept neatly tied up in
little bundles. Many of them are stained with the juice of
wild flowers, and still contain withered buds that Roger
picked on his walks and sent home to his botanical parents.
From the record of paper-chases and school concerts (at
one Roger sang "The Tar's Farewell"), of cricket and
football matches, of sermons and visits from missionaries—
"We are going to keep a nigger at Bishop Steer's School.
It will cost I believe £60 per ann. . . . He seems to be
getting on well in most things but his character is only
fair"—it would seem that he was tolerably happy at
school, and was allowed not merely to have his own
garden, but to keep pets—among them two active and
adventurous snakes. As far as work went he was successful.
He was almost at once at the top of the school. And yet
there were certain sentences in the letters that might have
made his parents uneasy. Bullying there was of course. A
certain Harrison and a certain Ferguson "bully me as
much as they can, sometimes by teasing, and sometimes
by hitting me about . . . but their favourite dodge is to try
and keep me under water and upset me when we bathe".
But he got on well with the boys for the most part, and

liked the games and the work. The disquieting phrases concern the masters. Mr Sneyd-Kynnersley had assured the Frys that there were to be no punishments. Yet "there were two fellows flogged yesterday and there is going to be one flogged tomorrow. He was only playing with another boy at dinner." Again, "the moon-faced boy" had been flogged because he threw some water on to the wall. Again, "Last night Ferguson went to Kynnersley's room I don't know what for, but he was found out and I had to dress and go to the Head's room . . . Ferguson was so troublesome that Mr Holmes had to hold him down." As head of the school Roger had to be present at the floggings. He disliked it very much. "I intend to get leave not to bring the boys up to be whipped, as I don't like it" he told his mother; but the Head said that "it was the business of the captain of the school, but he hoped not to whip anyone". In spite of these very plain hints that Mr Sneyd-Kynnersley was not keeping his promise, his parents made no effective protest, and the letters continue their chronicle of treats and paper-chases and measles and chilblains and long walks botanising over Chobham Common as if on the whole life at Sunninghill House was quite a tolerable experience. Years later, however, Roger filled out in greater detail the expurgated version of school life that he had given his parents. It begins with a portrait of Mr Sneyd-Kynnersley himself:

Mr Sneyd-Kynnersley had aristocratic connections, his double name was made even more impressive by an elaborate coat of arms with two crests, one the Sneyd the other the Kynnersley, which appeared in all sorts of places about the house and was stamped in gold on the bindings of the prizes. He was a tall thin loose-limbed man with an aquiline nose and angular features. He was something of a dandy. The white tie and the black cloth were all that marked him as a clergyman—he eschewed the clerical collar and coat. But his great pride and glory was a pair of floating red Dundreary whiskers which waved on each side of his flaccid cheeks like bat's wings. How

much satisfaction they afforded him was evident from the way in which during lessons he constantly fondled them distractedly. He was as high church as was consistent with being very much the gentleman, almost a man of the world. But he spoke of respect for his cloth with unction and felt deeply the superiority which his priesthood conferred on him. He was decidedly vain. His intellectual attainments consisted almost entirely in having as an undergraduate at Cambridge belonged to a Dickens society which cultivated an extreme admiration for the great man, and tested each other's proficiency in the novels by examination papers, from which he would frequently quote to us. He read Dickens aloud to the whole school every evening before bed-time but I do not remember that we ever got beyond *Pickwick* and *Oliver Twist*. Dickens and Keble's *Christian Year* were I think the only books that he brought to my notice during the years I was under him. I doubt if he read anything else, certainly he read nothing which prevented him from being a bigoted and ignorant high church Tory.

He was however genuinely fond of boys and enjoyed their company. He was always organising expeditions—during a cold winter he took the upper form boys for long afternoons skating on the Basingstoke canal—in summer we went to Eton and always we were *treated* very lavishly with high teas and strawberries and cream. The school was I think a very expensive one but everything was done in good style and the food a good deal better than what I was accustomed to at home.

As the boys came mostly from rather aristocratic homes they were much easier to get on with than those which I met later at a Public school. They had not to the same extent the idea of good form were much more natural and ready to accept things. Altogether my time at Sunninghill House might have been more than tolerable if it had not been for one thing which poisoned my whole life there.

When my parents told me there were to be no punishments it was quite true that the masters never set lines or kept boys in, but as Mr Sneyd-Kynnersley explained to us with solemn gusto the first morning that we were all gathered together before him he reserved to himself the right to a good sound flogging with the birch rod. How my parents who were extremely

scrupulous about verbal inaccuracy reconciled it to their con-
sciences to omit this fact I never made out, but I cannot doubt
that they knew or else they would have expressed more surprise
than they did when later on I revealed the horrid fact to them.

Anyhow the birch rod was a serious matter to me, not that
I dreaded it particularly for myself because I was of such a
disgustingly law-abiding disposition that I was never likely to
incur it. But as I was from the first and all through either first
or second in the school I was bound *ex officio* to assist at the
executions and hold down the culprit. The ritual was very
precise and solemn—every Monday morning the whole school
assembled in Hall and every boy's report was read aloud.

After reading a bad report from a form master Mr Sneyd-
Kynnersley would stop and after a moment's awful silence say
"Harrison minor you will come up to my study afterwards".
And so afterwards the culprits were led up by the two top boys.
In the middle of the room was a large box draped in black
cloth and in austere tones the culprit was told to take down
his trousers and kneel before the block over which I and the
other head boy held him down. The swishing was given with
the master's full strength and it took only two or three strokes
for drops of blood to form everywhere and it continued for
15 or 20 strokes when the wretched boy's bottom was a mass
of blood. Generally of course the boys endured it with fortitude
but sometimes there were scenes of screaming, howling and
struggling which made me almost sick with disgust. Nor did
the horrors even stop there. There was a wild red-haired Irish
boy, himself rather a cruel brute, who whether deliberately or
as a result of the pain or whether he had diarrhoea, let fly.
The irate clergyman instead of stopping at once simply went
on with increased fury until the whole ceiling and walls of his
study were spattered with filth. I suppose he was afterwards
somewhat ashamed of this for he did not call in the servants
to clean up but spent hours doing it himself with the assistance
of a boy who was his special favourite.

I think this fact alone shows that he had an intense sadistic
pleasure in these floggings and that these feelings were even
excited by the wretched victim's performance or else he would
certainly have put it off till a more suitable occasion.

Monday morning thus was always a dreadful time for us. It nearly always resulted in one or two executions but sometimes no sufficient excuse could be found in the reports. Sunday in spite of its leisure and amusements was spoilt for me by the anticipation of next morning's session and I lay awake often praying feverishly, and nearly always futilely, that no one would get a swishing. But one was never sure not to be called on to assist. One night just as I was going to sleep the Head, as we called Mr Sneyd-Kynnersley, called me to come to his study. We slept in cubicles, sometimes three or four were arranged in a single large bedroom and the Head had overheard one boy say to another "What a bother, I forgot to pump-ship: I must get out of bed". This indecent talk merited of course a ferocious flogging and my night's rest was spoilt by the agitation it had put me into. I won't deny that my reaction to all this was morbid. I do not know what complications and repressions lay behind it but their connection with sex was suddenly revealed to me one day when I went back to my room after assisting at an execution . . . all ideas of sex had been deeply repressed in me in my unremembered past. I have the proof of that from the fact that I read through the whole of the Bible in the years of my preparatory school without the faintest enlightenment on the subject being borne in upon me even by the smuttiest parts of the Old Testament. Why, you will wonder, did I accomplish this peculiar feat? My mother had so firmly impressed on me the supreme virtue of the act of reading the Bible and of its incomparable prophylactic power that in the inevitable troubles and anxieties of school life I inevitably relied on its help. I managed by waking early to put in one or two chapters every morning before the dressing bell rang. It was a piece of pure fetishism, the longer the amount read the better the chances for the day. Under these circumstances I did not exercise my intelligence or imagination much upon what I read and indeed I had known nearly all of its histories from our Sunday Bible lessons long ago, but still I was not a stupid boy nor wanting in curiosity about some things and I find it hard to explain my total immunity from any understanding of sex.

But whatever the cause, my horror of these executions was

certainly morbid and it has given me all my life a morbid horror of all violence between men so that I can scarcely endure any simulation of it on the stage. . . .

You will no doubt long ago have come to the conclusion that Mr Sneyd-Kynnersley was at least an unconscious Sodomite but on looking back I feel fairly convinced that he was not and that his undoubted fondness for boys was due to his own arrested development. He was certainly very vain and his very meagre intellectual culture left him I suspect always with a feeling of slight humiliation among grown-up people. I attribute to that the care with which he got rid of any master of intelligence and supplied his place with imbeciles. It was natural therefore that he felt happiest among boys where he could more than hold his own and whose sense of humour was of his own elementary brand.

Such is his own account of what went on behind the façade of the letters from school. The effect, he thought, lasted all his life. Yet he seems to have borne Mr Sneyd-Kynnersley no ill-will. "I am very sorry for it," he wrote a few years later when his old schoolmaster died, "as although he never inspired me with much respect he was, I think, kindhearted on the whole." And Mr Sneyd-Kynnersley must have felt a certain affection for his old pupil; for when he died he left Roger Fry "a nice little copy of some of Arnold's sermons" in his will.

III

From Sunninghill and its shrivelled pine trees and dirty heather he went in 1881 to Clifton. The Head Master of Clifton, Canon Wilson, was a very different man from Mr Sneyd-Kynnersley. "One sees him standing there", an old Cliftonian wrote, "at the plain deal desk where Percival had taught before him, a tall gaunt figure with sweeping beard and shaggy eyebrows, like some Old Testament prophet. . . ." And the inner difference was no less marked than the outer. He was a man of the highest

academic distinction, a Senior Wrangler and a Fellow of
St John's, Cambridge. Far from following Mr Sneyd-
Kynnersley's habit of "getting rid of any master of intelli-
gence", the men he had for colleagues at Clifton were
"men of unusual ability and individuality"—men like
Wollaston and Irwin, Norman Moor and W. W. Asquith.
Clifton itself was "a new type of public School". In seven-
teen years it had realised in no small degree John Percival's
vision of a public school which "should be a nursery or
seed-plot for high-minded men, devoted to the highest
service of the country, a new Christian chivalry of patriotic
service". And Percival's ideal—an ideal "not only of
simplicity, seriousness, modesty and industry but of a
devotion to public service", was also the ideal to which
Canon Wilson was now devoting his immense ability and
enthusiasm. Clifton, then, was a very different place from
Sunninghill. There were no more floggings. The bullies,
Harrison and Ferguson, with their red bulbous noses and
small red-rimmed eyes, were replaced by quiet and con-
scientious boys, whose only fault, according to the evi-
dence of the letters home, was that they were too anxious
to uphold the public school convention of "good form".
No pet snakes were allowed in Roger's new study. His
messes—he tried unsuccessfully to make omelettes in a
machine of his own invention—were objected to by the
boy who shared this apartment. "One can hardly do any-
thing for fear of making it less gorgeous 'to anyone coming
in', as Wotherspon is always saying", Roger complained.
The community of six hundred boys was a highly organised
society compared with the rather childish company at
Sunninghill. Perhaps the newness of Clifton made it a
little self-conscious in its virtues; it had to assert the new
standards and to live up to them rather aggressively. The
machine was efficient, and Roger Fry seems to have been
completely ground down by the machinery. Dutifully and
rather perfunctorily he recorded how "a fellow of the name
of Reed had won the Short Penpole which came off on

Thursday in one of those freezing east winds"; how
"Clifton College has won the Ashburton Shield at Wimble-
don. . . . The Eight came back last night . . . were ac-
companied by the Gloucestershire Engineer volunteers of
which we form a company. . . . The Captain of the
Eight presented the shield to Wilson who made a speech
to which Colonel Plank, the Colonel of the Regiment,
replied. . . . The Eight were then chaired to their houses."
There were the usual games and examinations: "Oh that
there were no such things as exams. I am sure that they
are ruinous to education of the highest kind!" he exclaims,
and the usual epidemics of which he had more than his
fair share. Missionaries appealed for funds; and "a Mr
Johnson obtained £70 for a steamer on Lake Nyanza
by an earnest though incoherent and rambling address".
Occasionally a lecturer caught his attention. "A Mr
Upcott lectured on Greek Art and I noticed a curious
thing in the photos of the frieze of the Parthenon, namely
a rider riding apparently with his back to the horse's
head." Miss Jane Harrison also lectured upon Greek art
and he enjoyed her lecture very much. As for his school
work, though his classics and his English were only fair,
he did well enough to be among the first twenty fellows
in the House in 1882, and found "being in the Fifth very
much nicer than being a fag".

But his main interest lay in science; and his main
pleasure was in the Laboratory. That he "enjoyed
immensely". There he was allowed to carry out experi-
ments of his own. His letters home were largely filled with
accounts of these experiments in which his parents were
deeply interested—"one was to find out how fast bodies
fall by experiment; and another the specific gravity of
candle grease. . . . I got a block of ice from the fish-
mongers with which I illustrated regelation by cutting it in
half with a wire." He also painted modestly, economically.
With penny moist paints and twopenny chinese white and
penny brushes he decorated "two sweet little terra-cotta

plates" with pictures of flowers. Flowers picked on half-
holidays on the downs and scupulously given their long
Latin names fill a large part—a larger part than games—
in the weekly chronicle. At Portishead, where his father
in his boyhood had gone botanising, he found "*Litho-
spermum purpureo caeruleum.* I must tell you all about it, as
it is almost the only important thing that has happened
this week." Often "there is no news since I last wrote"
and the letter home has a blank page. Once, it is true,
there was a sensation: a boy called Browne who had been
"sent up for certain betting transactions" took "a large
knife out of his sleeve and stabbed the H.M. He appears
to have aimed at his heart but hit him in the right shoulder
only escaping an artery by an inch or two . . ."—a crime
which was partly attributed to the works of Miss Braddon
"in which he took a sort of horrid delight".

But that sensation apart, the terms seem to have dragged
along, heavily, respectably, monotonously. The weeks, the
days, even the seconds separating him from the holidays
are minutely counted and struck off. Whether the fault
lay with Roger himself or with the public school system,
it is strange how little the presence of men so remarkable
as Wollaston and Irwin and Norman Moor and the Head
Master himself penetrated his shell; how helplessly he
endured a routine which was breeding in him nevertheless
a "sullen revolt" against "the whole Public school system
. . . and all those Imperialistic and patriotic emotions
which it enshrined". The hygienic hideousness of the new
limestone buildings depressed him still further.

The shell was broken at last not by a master but by a
boy. One day in 1882 his study mate, "an exceedingly
prim and conventional schoolboy, the very personification
of good form", tried to express his amazement at a por-
tentous apparition which had been seen in the Lower
Fourth. "Words failed him to describe its strangeness—the
shock head of hair, the long twisted lank frame, the untidy
clothes, and above all a peculiarly crooked gait which

made it appear that McTaggart was engaged in polishing the limestone walls of Clifton College as he sidled along their surface." This description of the small boy who was afterwards to be the famous philosopher John Ellis McTaggart was received with "howls of laughter". Roger listened, but he did not join in the laughter. "I was already conscious of so deep a revolt against all school-boy standards that my heart warmed to the idea of any creatures who thus blatantly outraged them. Here, I thought, in one so marked out as a pariah, was a possible friend for me. I deliberately sought him out. . . . My intuition was more than justified; that ungainly body contained a spirit which became the one great consolation of my remaining years at school, and no Sunday evening walk for all that time was ever shared by anyone but him."

This, the first of many such "intuitions", was among the most fruitful. McTaggart's friendship was by far the most important event of Roger's life at Clifton. The influence lasted long after Clifton was over. But the nature of that influence was not plain then, and indeed it was of a peculiar kind. The discussions on those Sunday walks always centred, Roger said, "round Canon Wilson's Sunday afternoon sermon". But the centre itself was scrupulously respected. For "by the exercise of an extra-ordinary intellectual dexterity McTaggart never allowed me to suspect that he was already an atheist and a convinced materialist". The astonishingly precocious boy, who had "absorbed and accepted the whole of Herbert Spencer's philosophy" before he came to Clifton, must have perceived that his Quaker friend was by no means ripe for such revelations. The same disposition which made him argue that "being for a time an inmate of a Christian school he owed it a debt of loyalty which forbade any criticism of its tenets" led him also to respect his friend's traditions and conventions. Whatever Roger's latent revolt may have been, it was still deeply hidden.

He was outwardly pious and even priggish. He accepted the religious and political opinions of his family unthinkingly. He still asked his mother to pray for him, prayed devoutly himself, and "knows that God will help me". He exclaimed: "Is it not a pity about Bradlaugh being returned again by those wretched Northampton shoemakers?" and thinks "the explosion at Westminster" inexcusable in England "where the people have so large a share in the country's government". He still went as a matter of course with his family to Meeting on Sunday. Such opinions and pieties were not directly combated on those Sunday walks. Nevertheless, the discussions were speculative; the talk ranged over "every conceivable subject, from Rossetti's painting, the existence of which he revealed to me, to the superiority of a Republic over a Kingdom". Clearly, though McTaggart carefully avoided certain subjects, and was "delicately scrupulous never to let me feel my own inferiority", he was stimulating Roger Fry as none of the Clifton masters stimulated him. He was making him think for himself and suggesting the possibility of asking innumerable questions about things hitherto unquestionable.

Roger's parents were soon aware of this. There was something in that ungainly boy that roused their suspicions. He looked, a sister remembers, "with his ill-fixed head and his inordinate length of body, like a greatly elongated tadpole". His views were equally distasteful. "I am very sorry you were disappointed in McTaggart," Roger wrote to his mother after the visit, "though I do not feel so sure that you would be if you could see him alone as I do. He is whatever his views and manners may be one of the most thoughtful and conscientious boys I know, and one who struggles to have a good influence." Two or three years later, when they were both at Cambridge, Roger was still trying to lay his parents' suspicions; and the words are worth taking out of their place, not for what they reveal of McTaggart but for what they reveal of Roger Fry. Lady Fry had again

expressed anxiety about McTaggart's influence. Roger answered: "I suppose you have forgotten that I once told you of McTaggart's freethinking propensities as I thought I ought to, although I know he does not like them talked about nor is he anxious to talk on those subjects which relate to it. Indeed at Clifton I know he felt himself under a sort of obligation not to talk to fellows upon these subjects. I am very sorry if my friendship should be a cause of anxiety to you, as I feel he is a fellow of really fine character in many ways, and I know Wilson thought so too. I have often wished and prayed that he might be convinced of what we believe to be the truth, but I do not think that his want of Christianity ought to debar me from a friendship from which I believe that I have derived much good—though of course that friendship can never be of the very highest kind. I confess I do not feel that there is any danger to my own Christianity from this companionship, as I hope my Christianity is not so weak a structure as [not] to stand the proximity of doubt."

That letter was written from rooms which he shared with McTaggart at Cambridge in 1885. It serves to show that in spite of Sunday walks in which they speculated about everything under the sun, Roger must have been, as he admits, "portentously solemn and serious" at Clifton with no notion "of any but the most literal directness of approach"—a weedy boy, with a retreating chin and spectacles hiding the bright large eyes, who behaved decently, hid his latent antagonism under a deep surface of conformity, and attracted no particular attention from the masters who taught him. Nobody seems to have guessed that he had any particular gifts or tastes of his own. Canon Wilson, it is true, had "no special gift or appreciation of poetry, nor indeed of any of the arts". But Canon Wilson had at once recognised McTaggart's genius. He knew that McTaggart and "a friend" discussed his sermons on their Sunday walks. But though he valued McTaggart's opinion, and treated him as an equal

rather than as a pupil, Roger Fry was only McTaggart's friend. He seems to have made no impression upon the Head Master or upon any of the masters. His bent, if he had a bent, seemed to both purely scientific. It was taken for granted that he was to study science at the University; the only question was which University it was to be. Mr Jupp was in favour of Oxford. But for some reason the thought of Oxford roused Roger to express himself more outspokenly than was common with him then. "How long will it take for me to convince him [Mr Jupp] that I intend to go to Cambridge and that scholarships are not the only aims of one's life, or at all events of mine, though my getting one may be part of his aims and I expect it is", he wrote. Wilson himself was not only in favour of Cambridge but in favour of King's. "He says I shall not be swamped as I might be at Trinity, and that the set is he believes extremely nice."

So Cambridge it was to be, and in December 1884 he went up to try for a scholarship at King's. He found himself lodged in a queer little garret looking across at King's over the way. At once, in spite of the impending examination, his spirits rose and he began to enjoy himself enormously. The door opened and in came a gyp with an invitation from Mr Nixon to breakfast with him. "So I went rather in fear and trembling to his rooms." But Mr Nixon was not in the least formidable. He was a "very jovial and queer little man" who had only one hand, squinted and wore very extraordinary spectacles. And he was very kind and amusing and explained that he was a friend of Smith's. Then Roger went to his examination and feared that he had done very badly—"they set the life history of the Chara instead of the moss and unfortunately I could not do it". However, Mr Nixon asked him to come and have tea after Chapel, and other friends turned up, "so you will perceive that I am doing pretty well considering how few people I know". In spite of his foreboding he was successful. On 22nd December 1884 Lady Fry at

Failand received a telegram which she put with the other letters from school.

It simply said in telegraphist's English: "I have got the exhibition for two years they have only given this one for science". But it was an immensely important document. For it meant an end—an end to Sunninghill and its shrivelled pines and dirty heather and Monday morning floggings, and an end to Clifton and its good form, its Christian patriotism, and its servility to established institutions. From his private school he had learnt a horror of all violence, and from his public school a lifelong antagonism to all public schools and their ideals. He seldom spoke of those years, but when he did he spoke of them as the dullest, and, save for one friendship, as the most completely wasted of his life.

CHAPTER II

CAMBRIDGE

THE years at Cambridge—years that were to be so important to him that in after-life, he said, he dated everything from them—began cheerfully but prosaically. Nixon asked him to dinner; but the lodging-house keeper was a stingy brute who provided no slop pails. Also when asked to provide antimacassars to hide his "hideous green chairs", he refused, and demanded "twelve tallow candles apiece for his maid to use on dark mornings". George Prothero, the tutor, was appealed to; and these domestic matters arranged, Roger Fry at once began, with an ardour that seems miraculous after the perfunctory records of Clifton routine, to talk, to walk, to dine out and to row. "Every afternoon I am tubbed, *i.e.* instructed in the art of rowing", he told Sir Edward, and he showed such promise that Sir Edward took alarm, and hoped that he would not be called upon to cox the University boat. "I have met both senior classic and senior wrangler several times at coffee", Roger went on. "But I have met so many men lately that I cannot possibly describe them all."

Thus he was writing when his first term was only a week or two old. There is no reason to doubt his statement that "my life at present is anything but dull, but rather on the contrary over-full". He dined out, he said, almost every night, and found Cambridge dinner parties "where one plays games afterwards" very different from London parties and much more to his taste. He met the Cambridge characters. The great figure of O. B., "as Oscar Browning is commonly called", loomed up instantly, and he had the usual stories of the great man to repeat—how he had "invited 'the dear Prince' to dine and provided wine at

44

a guinea a bottle but 'the dear Prince' never came". He met the Darwins, the Marshalls, the Creightons—"Mrs Creighton very formidable but Creighton delightful"— and Edmund Gosse. He was elected a member of the Apennines, a literary society which met to discuss "the poets of Kings and the origins of Tennyson's Dora", and he read them a paper on Jane Austen. In short he had slipped at once into the full swim of Cambridge life and confessed that he had never enjoyed himself "away from home so much". "It is really so delightful to find so many nice friends and after school it is such a wonderful change. One is so free from the tyranny of one set who exacted homage from all others."

The ugly rooms with the unpleasant landlord were shared with McTaggart, and to that original friend others rapidly attached themselves. The names recur—Schiller, Wedd, Dickinson, Headlam, Ashbee, Mallet, Dal Young. He walks with them, boats with them, dines with them, and presumably argues late into the night with them. But at first they are names without faces—an absence of comment that was no doubt partly due to the coldness with which McTaggart had been received at Failand. But it was also obvious that he himself was overwhelmed by the multiplicity of new friends, new ideas, new sights. If he could have stopped as he ran about Cambridge— "I have no black gloves and I do not wear a hat", he told his mother—to single out which of the three came first, perhaps he would have chosen the third — the sights. It seemed as if his eyes always on the watch for beauty but hitherto often distracted by alien objects had opened fully at Cambridge to the astonishing loveliness of the visible world. After the shrivelled pine trees of Ascot and the limestone buildings of Clifton, the beauty of Cambridge was a perpetual surprise. The letters are full of exclamations and descriptions—"I have hardly seen anything more lovely than the view from King's Bridge looking down the river when the sunset glow

is still bright". He rowed up the river in a whiff with Lowes Dickinson to watch the sunset effects "and Dickinson ran into a bank of reed and was upset". He noticed the light on the flat fields and the willows changing colour and the river with the grey colleges behind it. He listened, too, sitting with Lowes Dickinson in Fellows Buildings, to the nightingales singing to one another all the evening. He borrowed a tricycle and began to explore the Fens. Blank pages of letters are often filled with drawings of arches and the windows of churches discovered in the little Cambridge villages. Gradually, his interest in the college boat faded away, and Sir Edward's fear that Roger would have to cox the University boat proved unfounded.

Soon the faces and the voices of his friends become more distinct to him. He refers to papers that he read himself or heard others read. There was one on William Blake; another on George Eliot; another on Lowell's *Biglow Papers*. After Dickinson's paper on Browning's *Christmas-Eve and Easter-Day*, "the discussion", he says, "turned on whether an universal desire for immortality was any proof of its truth". But he was reticent in what he reported of these arguments to his parents. They kept an anxious eye upon his morals, his health and his behaviour. "I shall of course observe your wishes entirely about smoking and such things", he had to promise. Some of his new literary tastes were not to their liking. He had to apologise for having left a copy of Rossetti's poems at home. His sisters had read it. "I am sorry," he apologised, "also that it is bad in parts. I did not read it nearly all through and did not come across any that were bad." It follows that Westcott's beautiful sermon receives more attention than Dickinson's speculations; and that when Edward Carpenter made his appearance in Cambridge he is described as "one of F. D. Maurice's curates once and has a great admiration for him".

Yet Edward Carpenter's visit to Cambridge created a great impression. He discussed the universe with the under-

graduates, made them read Walt Whitman, and turned Roger Fry's thoughts to democracy and the future of England. Later, with Lowes Dickinson he went to stay with Carpenter at Millthorpe. "I had rather expected", he wrote home, "that he might be a somewhat rampant and sensational Bohemian. But I am agreeably disappointed, for he seems a most delightful man and absolutely free from all affectation. The manner of life here is very curious and quite unlike anything I ever saw before, but I have not seen enough yet to form any opinion . . . he is quite one of the best men I have ever met, although he has given up so much for an ideal." Under this influence the political opinions that he had brought from home became more and more unsettled. He became interested in Ashbee's social guild, had a "Toynbeeast" to stay with him; and felt vaguely that a new era was dawning and that England was on the road to ruin. "Society seems to be sitting on the safety valve", he told Lady Fry; and when she expressed concern for the German Crown Prince's illness, said caustically: "I should be equally sorry for John Jones in similar circumstances, and doubtless far more sorry for most of the patients in the Cambridge hospital did I know the details". The riots in London (November 1887) made him "hope that it won't come to much because then one would have to make up one's mind what position to take up, which of all things is the most objectionable to me". And when Lady Fry expressed some uneasiness that his mind was not "made up", he replied: "I am sorry you were troubled because I said that I had not made up my mind about social questions. But then one has to consider such an enormous number of facts and it is so hard to get at them truly, and even given the facts it is so difficult to get into a sufficiently unbiassed frame of mind that I really think I may be excused if I say that I should like to wait a great deal longer before I commit myself practically to any one theory of the State. . . . I hope", he concluded, "that mere differences of opinion (which are after all only very

indirect indications of moral character and that is what
concerns us most) need not alter our feelings at all."

It became, as the terms went on, increasingly difficult to
describe his life at Cambridge to his parents. Letters from
London told him how they had been dining, as Sir Edward
wrote, with the Master of the Rolls to meet Sir Andrew
Clark and Lord Bowen—"Bowen", Sir Edward said,
"asked Clark: 'Is it true as I have heard that genius is a
kind of fungus?'—a remark which is I believe a little in
advance of any discovery yet"; and on the next night they
were entertaining the Literary Society at Highgate to read
and discuss More's *Utopia* and Bacon's *Atlantis*. In replying
to his parents, stress had to be laid upon scientific work—
"I am getting very swell at cutting sections with razors. . . .
I enclose with this a specimen of the true oxlip (*Primula
elatior* Jacq.) which may interest you"—upon the lectures
of Vines and his work with Michael Foster. He was work-
ing hard; he was showing brilliant promise as a scientist.

But it was not the work in lecture-rooms or in laboratories
that was most important to him. It was his talk with his
friends. Lowes Dickinson, the young Fellow of King's, had
quickly become the most important of those friends. All
one hot moonlit night they sat and talked "while a great
dome of pale light travelled round from West to East and
the cuckoo and the nightingale sang", and for a few hours
"we cared only for the now which is the same thing as
being eternal". His new friends were forcing him to take
stock of the vague religious and political beliefs which he
had brought with him from home and from Clifton. All
questions were discussed, not only Canon Wilson's Sunday
sermon; nor was there any need to circle round the centre.
His creed, he noted afterwards, had dropped from him
without any shock or pain so far as he was concerned. His
new friends were as respectful of the scientific spirit and
as scornful of the sentimental or the effusive as Sir Edward
himself. But they submitted not merely mosses and plants
to their scrutiny but politics, religion, philosophy. This

intense interest in abstract questions drew upon them a
certain amount of banter from outsiders. So one may infer
from a description given by Mr E. F. Benson of a certain
evening party in Oscar Browning's rooms. The host him-
self pedalled away at the obeophone; "Bobby and Dicky
and Tommy" strummed out a Schumann quintet; the
President of the Union played noughts-and-crosses with a
cricket blue, and in the midst of the racket Mr Benson
observed "a couple of members of the secret and thought-
ful society known as 'The Apostles' with white careworn
faces, nibbling biscuits and probably discussing the ethical
limits of Determinism".

The names are not given, but it is possible that one
of those thoughtful young men was Roger Fry himself.
For in May 1887 he confided to his mother: "I have just
been elected to a secret society (not dynamitic though it
sounds bad) commonly known as The Apostles—it is a
society for the discussion of things in general. It was
started by Tennyson and Hallam I think about 1820, and
has always considered itself very select. It consists of about
six members. McTaggart and Dickinson belong. It is
rather a priding thing, though I do not know whether I
shall like it much. It is an extremely secret society, so you
must not mention it much." Not long before he had been
elected, without being asked, to the Pitt Club, "which is
supposed to be a very swell thing, and for which there is
keen competition". But he refused, because he thought it
"not worth the very big subscription". He had no doubts
about joining the other society, even if he doubted whether
he would enjoy it. Soon the only doubt that remained was
whether he was worthy of the honour.

Since I last wrote [he continued a few days later] I have
been partially initiated into the society I mentioned before, *i.e.*
I have seen the records which are very interesting containing
as they do the names of all the members which includes nearly
everyone of distinction who was at Cambridge during the last
50 years. Tennyson I think I told you is still a member and

there are references to the society in "In Memoriam" which none but the duly initiated can understand. Thomson the late Master of Trinity, Baron Pollock, Lord Derby, Sir James Stephen, Clerk-Maxwell, Henry and Arthur Sidgwick and Hort are all (or have been) members, so that I feel much awed by thus becoming a member of so distinguished and secret a society—it has a wonderful secret ritual the full details of which I do not yet know but which is highly impressive. The most awful thing is that on June 22nd there is a grand dinner at Richmond at which Gerald Balfour is President and I (woe is me) as being the newest member am Vice-President and I have to make a speech. I suppose that theoretically it is very wrong of me to tell you all this but you must tell no one but father. I am afraid you will think all this rather absurd but I am rather delighted to have been elected though I know I am far below the average of members and was really chosen because they did not happen to know of anyone else so suitable. And now to turn to the awful Tripos. . . .

It was undoubtedly "a priding thing" to be elected a member of that very select, very famous and very secret society. No election to any other society ever meant so much to him. And "the most awful thing"—the speech at Richmond—was a success. They laughed at his jokes; Gerald Balfour paid him a compliment on his speech; and after dinner with eight others he rowed down the river to Putney, which was reached about two in the morning. So, it would seem, the Apostles were not quite so white and careworn as they looked to outsiders. Certainly they ate something more succulent than biscuits; nor were their discussions confined to the "ethical limits of Determinism". The meetings led to friendships and the friendships led to boating parties. Lowes Dickinson has described one of them:

We four [he wrote], that is McTaggart, Wedd, Fry and myself, used at this time to row down the Thames from Lechlade to Oxford at the close of the summer term and those few days were a wonderful blend of fun and sentiment. McTaggart

bubbled over all the time. He could not row, of course, but
we made him do so. "Time, Bow", said the cox and McTaggart
replied, "Space". He read aloud or quoted Dickens, whom he
knew almost by heart. The long stretches choked with rushes
and reeds above Oxford; Abingdon, where we could pass the
night and lie in the hay by the river; the wonderful wooded
reach between Pangbourne and Maple Durham; the Hill at
Streetley which we climbed at sunset; the locks with their
roaring water; teas in riverside gardens; a moonlight night at
Shipley; the splendid prospect of Windsor and ices in the
famous tuck shop; it all lingers still in my mind after forty
years, and the ghost of McTaggart rises up inspiring and en-
chanting it all, witty, absurd, sentimental, adorable.

It was a society of this kind then—the society of equals,
enjoying each other's foibles, criticising each other's
characters, and questioning everything with complete
freedom, that became the centre of Roger Fry's life at
Cambridge. The centre of that centre was the weekly
meeting when they read papers and, as Roger told his
mother, "discussed things in general". The records are
private; yet it is permissible, judging from the names of
the members and their future fame, to suppose that the
subject of Roger Fry's first paper, "Shall we Obey?" was
typical of the general run; and to infer that "things in
general" excluded some things in particular. It is difficult
to suppose that Baron Pollock, Lord Derby, Sir James
Stephen, Clerk-Maxwell and the Sidgwicks ever discussed
the music of Bach and Beethoven or the painting of Titian
and Velasquez. There is no evidence, apart from
McTaggart's early reference to Rossetti and from one
visit in his company to the Royal Academy, that the young
men who read so many books and discussed so many
problems ever looked at pictures or debated the theory
of aesthetics. Politics and philosophy were their chief
interests. Art was for them the art of literature; and litera-
ture was half prophecy. Shelley and Walt Whitman were
to be read for their message rather than for their music.

Perhaps then, when Mr Benson talks of the pallor of the Apostles, he hints at something eyeless, abstract and austere in their doctrines.

Often in later life Roger Fry was to deplore the extraordinary indifference of the English to the visual arts, and their determination to harness all art to moral problems. Among the undergraduates of his day, even the most thoughtful, the most speculative, this indifference seems to have been universal. His own interest in abstract argument was so keen that the deficiency scarcely made itself felt then. But as his letters show, even while they argued his eye was always active. He noticed the changing lights on the willows, the purple of the thunderstorm on the grey stone of the colleges, the sunset lights on the flat fields. Many half-sheets are filled with careful architectural drawings. He was sketching a great deal. At Cambridge indeed he began to paint in oils—his first picture was it seems a portrait of Lowes Dickinson. And pictures themselves were becoming more and more important. He bicycled over to Melbourne, where Miss Fordham showed him her "really very wonderful collection. She has five Turners, 2 Prouts, many old Cromes, Copley Fieldings, D. Cox's &c." When he stayed with Edward Carpenter he visited the Ruskin Museum at Walkley and noticed not only the minerals, though they are duly described, but also "copies of Carpaccio and Lippo and Botticelli, also a very fine Verrocchio". He began to add lectures upon art to his lectures upon science; he went to meetings of the Fine Arts Society in Sidney Colvin's rooms, and records how a scientific experiment that he was making was interrupted by "a huge discussion on the nature of art with an old King's man who is up".

Indeed, as the years at Cambridge went on, art was more and more frequently interrupting science. In November 1887 there was an important exhibition of pictures at Manchester. Roger Fry left Cambridge at 3.45 in the morning; reached the gallery at noon; looked at pictures

till eight in the evening; got back to Cambridge at 4.15 the next morning; slept for an hour on a friend's sofa and then went to a scientific lecture at nine.

It certainly was a somewhat fatiguing affair [he wrote], as of course one could not get much accommodation at the price. but the pictures were a sight worth all the trouble. I do not remember seeing so interesting a collection (bar the Nat. Gallery). I had got a catalogue beforehand and selected those pictures which I wanted to see so that I did not waste any time. I was as much delighted with some of Walker's things as almost anybodys, and Madox Brown another artist one rarely sees anything of was well represented. There are some lovely Prouts but some of Sir David Roberts' small architectural drawings delighted me as much as anything in the way of unfinished sketches. One or two of Uncle Alfred's [Waterhouse] were noticeable, the Pœstum (I think it is) and the doorway of Chartres. As you despise Burne Jones and Rossetti and I have a somewhat similar feeling for Edwin Long I fear it will not be much use my "enthusing" about the pictures I liked best. I was surprised to find how good some of Millais' earlier work is, making me still more deplore things like the "Dying Ornithologist" and the "North West Passage". I was very much delighted with Sir Frederick Leighton's "Daphnephoria". I do not know whether you ever saw it, an enormous picture of a Theban chorus of victory. Holman Hunt was very poorly represented, but A. W. Hunt's water colours were very magnificent and there were several that I had not seen before.

And there this first crude essay in art criticism stops, for, though it is only half-past eight, he is dropping asleep and must go to bed immediately.

The excursion to Manchester was made with friends, but they were not Apostles, a sign that when Roger Fry wished to gratify certain growing curiosities he had to seek company—and he had a great liking for company—outside the circle of that very select and famous society. But he had a gift for finding his way across country to the people he needed. At Clifton "an intuition" had made him

discover in McTaggart the one friend who made school life tolerable. So at Cambridge where the conditions were reversed—there were almost too many friends, too many interests, too many things to be done and enjoyed—he discovered the one man who could give him what he still lacked. The letters begin to refer to "Middleton". "I am getting to know more of Middleton which is very nice", he wrote in October 1886. "I go to him once or twice a week for a sort of informal lecture on art—he shows me photographs &c. It is exceedingly good of him. . . . He tells me about the development of Italian painting, illustrating it by photos."

John Henry Middleton had been elected to the Slade Professorship of Art at Cambridge in 1886. A romantic and rather mysterious career lay behind him. In youth the shock caused by the sudden death of a close friend at Oxford "had confined him to his room for five or six years". Afterwards he travelled widely and adventurously in Greece, America and Africa. In order to study the philosophy of Plato as taught in Fez he had disguised himself as a pilgrim, had entered the Great Mosque "which no unbeliever had previously succeeded in doing", and had been presented to the Sultan as one of the faithful. He had arrived in Cambridge with a tale of erudite works upon Greek and Roman archaeology to his credit; but he held very unconventional views as to the duties of a Slade professor. Dressed in "a thick dressing gown and skull cap looking like some Oriental magician", he was willing to talk informally about art to any undergraduate who chose to visit him. Mr E. F. Benson, who thus describes him, was one of the undergraduates who went to his rooms: " . . . he gave me no formal lectures," Mr Benson writes, "but encouraged me to bring my books to his room, and spend the morning there . . . now he would pull an intaglio ring off his finger . . . or take half a dozen Greek coins out of his waistcoat pocket and bid me decipher the thick decorative letters and tell me where they came from". As for the

Tripos that his pupil was expected to take, he never mentioned it. Roger Fry too found his way to the Slade professor. He too found him enthralling and stimulating as he wandered about the room talking unconventionally in his skull cap and dressing-gown. That room was full of "the most wonderful things . . . some very lovely Persian tiles which he got at Ispahan and Damascus, some beautiful early Flemish and Italian paintings and several original Rembrandt etchings, some of them very fine. . . . He is very delightful to talk to, though I fear", he added, "you [Lady Fry] would think him dangerously socialistic." Professor Middleton seems to have returned Roger Fry's liking. He guessed that though he was working for a science degree his real bent was not for science but for art. He encouraged him in that bent. One vacation he asked him to go with him to Bologna. But Roger Fry's parents were opposed to the visit. Their ostensible reason was that they doubted whether North Italy in the summer was "extremely healthy", as Professor Middleton asserted. But they may well have doubted whether a jaunt to Bologna to look at pictures with a Slade professor of socialistic tendencies was the best preparation for "the awful Tripos" that was impending. They were afraid that Roger was scattering his energies. How far, they may well have asked, was he fulfilling the wish that Sir Edward had expressed when he first went to Cambridge, "I wish you as you know to have a thorough education and not to be ignorant either of letters or science. At the same time I want you so far to specialise as not to turn out a jack of all trades and master of none"?

There were signs that Roger Fry was finding it increasingly difficult to specialise. Every week he was discussing "things in general" with the Apostles. And when one of the brethren, Lowes Dickinson, came to Failand he made no better impression than McTaggart had done: ". . . he was unobtrusive and untidy and forgot to bring his white tie. 'Have you any further luggage coming, Sir?' enquired

the footman." His mind was being unmade rather than
made up. All his friends were, as he called it, "uncon-
ventional". He was staying with Edward Carpenter who,
though once F. D. Maurice's curate, was certainly "very
unconventional" now. He also stayed with the Schillers at
Gersau—"the most unconventional family in all its arrange-
ments I ever saw". He stayed at Kirkby Lonsdale with the
Llewelyn Davies's. They too were unconventional; and
there he met Lady Carlisle, an unconventional countess who
preached temperance and socialism. He attended meetings
of the Psychical Research Society and visited haunted
houses in a vain pursuit of ghosts. Also he was helping to
start a new paper, *The Cambridge Fortnightly*, for which he
designed the cover—"a tremendous sun of culture rising
behind King's College Chapel". He was painting in oils,
and twice a week he was discussing art with a Slade pro-
fessor who wore a dressing-gown and cherished danger-
ously socialistic views. At a lunch party, too, there was
another meeting with Mr Bernard Shaw. The effect of
that meeting is described in a letter written to Mr Shaw
forty years later:

I remember that you dazzled me not only with such wit as
we had never heard but with your stupendous experience of
the coulisses of the social scene at which we were beginning to
peer timidly and with some anxiety. All my friends were al-
ready convinced that social service of some kind was the only
end worth pursuing in life. I alone cherished as a guilty secret
a profound scepticism about all political activity and even
about progress itself and had begun to think of art as somehow
my only possible job. I like to recall my feelings when that
afternoon you explained incidentally that you had "gone into"
the subject of art and there was nothing in it. It was all hocus
pocus. I was far too deeply impressed by you to formulate any
denial even in my own mind. I just shelved it for the time being.

In the midst of all these occupations, exposed to all
these different views, it is scarcely surprising that Roger
Fry himself admitted to some perplexity.

"It is perhaps no use retrospecting," he wrote home in December 1888, "but I can't help thinking that in 22 years one should be able to get through rather more than I have done. In fact I think one wants two lifetimes, one to find out what to do, and another to do it. As it is one acts always half in the dark and then for consistency's sake sticks to what one has done and so ruins one's power of impartial judgment." The family creed which had been so forcibly impressed upon him since childhood was no longer sufficient. "Life", he wrote, "does not any longer seem a simple problem to me. . . . I no longer feel that I must hedge myself from the evil of the world—that there are whole tracts of thought and action into which I must not go. I have said I will realise everything. Nothing shall seem to me so horrible but that I will try to understand why it exists." Just as his father had shaken himself free from Quaker peculiarities, so Roger in his turn was ridding himself of other restrictions. But his was a far more buoyant and self-confident temperament than his father's. Life at a great University, for which his father had longed in vain, had shown him a bewildering range of possibilities. Some of them were invisible to his friends. They, as he says, were convinced that social service of some kind was the only end worth pursuing. Of that he had come to be sceptical. Not only was he hiding from his friends as a guilty secret his doubts about political activity—he was hiding from his family another secret; that art, not science, was to be his job.

These doubts and secrets, the variety of his interests and occupations worried him. He wanted help and he wanted sympathy. In a letter to his mother he tried to break down the reserve which, as the years at Cambridge went on, had grown between them. "When those petty daily commonplaces of which our lives seem so much made up weigh upon me with the feeling of a dreary interminable life of getting up and dressing and eating and talking and going to bed and all without any object in the end, it is

sometimes delightful to realise that such things are all
shams and that at any moment the surface may dissolve
and the reality appear, whatever that reality may be. . . .
I do not know whether I am wise in writing a letter so
full of my own convictions which I can hardly expect to
be understood, but perhaps it is sometimes worth while to
show one's real self and not hide behind the make-belief
ideas which for the most part are all we show, and your
letter somehow encouraged me to make a confession."
Whatever else his new friends had taught him, they had
taught him to distinguish between the sham and the
reality, "whatever that reality may be". He was becoming
more and more conscious of the horror of hiding behind
"make-belief ideas". But it was very difficult to speak
openly to his parents. He could only assure them that
"the differences of opinion which I fear do and must arise
between us owing to our different points of view in no
wise affect our love for one another". As the time at
Cambridge drew to an end, he was concealing more, and
they were becoming increasingly uneasy.

The immediate question was a practical one. A friend's
letter summed it up. "What", he asked, "are you going
to be?" The "awful Tripos" provided what, to his parents
at least, seemed a decisive answer. Almost casually in the
postscript to a letter he told his mother that "the examiners
have honoured me by giving me a first; this is the more
kind on their part as I neither expected nor deserved one.
It was telegraphed to me at Norwich this morning by
Dickinson." The path was now open in all probability
to a Fellowship, and thus to the career that his father had
wished for himself and had planned for his son,—the career
of a distinguished man of science. But Roger hesitated. Did
he any longer want that career? Had he not come to feel
that painting was his "only possible job"? that art was his
only possible pursuit? When his father pressed him to decide,
he answered, "Please do not think me weak because I find
it hard to make up my mind about matters of great import-

ance to me, but it really is because I realise what infinite possibilities there are [more] than because I am apathetic or indifferent". He was going, he said, to consult Professor Middleton "on the subject of art as a profession". The result of the interview is given in a letter to Sir Edward:

Roger Fry to Sir Edward Fry

CAMBRIDGE,
Feb. 21, 1888

MY DEAR FATHER,

Middleton has been very kindly advising me about my prospects in life, and I will try and give you as clear an account as I can of what he thinks. I explained to him (thinking it an extremely important factor) how unpleasing an idea it was to you that I should take up art—he says he quite understands the feeling that to fail in art is much more complete a failure and leaves one a more useless encumbrance on the world than to fail in almost anything else—*e.g.* to be a 4th rate doctor in the colonies. . . . He advised me if I thought I felt strongly enough to ask you to let me try for about two years and by the end of that time he says that he thinks I shall be able to tell what my own capacities are and whether it will be worth my while going on. . . . In case I do do that, he says the best course would be for me to do at least the first year's drudgery at the cast and to do that up here at the Museum of Casts— spending some time on dissecting at the Laboratory. He kindly says that he would superintend my work and give me all the assistance he could and that I could get no better opportunities in London or Paris until I have had a year at casts.

He says that the idea of the possibility of landscape painting without figures is quite untenable—you must correct your drawing and colour on the figure as you see there more immediately where you go wrong. I then told him the objection you had to the nude—which he said was very natural tho' so far as his experience went it did not lead to bad results and was not so harmful as an ordinary theatre—he says however that there is no reason at all why one should draw from the female figure—on the contrary men have much better figures as a rule in England and are more useful to practise drawing on. . . .

I think I do feel strongly enough the desire for this, to ask you to let me try it. That is to say, if I do not do so I fear I may have an unpleasant feeling afterwards that I might have done something worth overcoming all obstacles to do if I had only had perseverance. I know what a great thing it is that I ask of you considering your views on the subject and what a disappointment it must be when you had hoped I should do something more congenial to your tastes. Still I do ask it because I think taking everything into consideration it is what I sincerely think I ought to do.

<div style="text-align:right">Your very loving son
ROGER FRY</div>

The result was a compromise and a strange one. For a few terms more he stayed on at Cambridge, dissecting in the Laboratory and painting the male nude under the direction of the Slade professor. Twice he sat for a Fellowship. But the first time his dissertation was purely scientific, and he took so little trouble with it that he failed. And the second time he tried to combine science and art—his dissertation was "On the Laws of Phenomenology and their Application to Greek Painting". That too was a compromise. It seemed, Mr Farnell reported, "to have been put together in haste", and again he failed.

The two failures mattered very little to him personally. "After all", he wrote to his father, "I have got more from Cambridge than a scientific education." For him that was true—he had got more from Cambridge than he could possibly explain. His mind had opened there; his eyes had opened there. It was at Cambridge that he had become aware of the "infinite possibilities" that life held. Now had become eternal as he sat talking to his friends in a Cambridge room while the moon rose and the nightingales sang. What Cambridge had given him could not be affected by any failure to win a fellowship. But to his father the failure was a bitter disappointment. It was not only that he had thrown away the career that seemed to Sir Edward the most desirable of all careers, a career too

in which he had shown brilliant promise. But he had thrown it away in order to become a painter. To Sir Edward pictures were little better than coloured photographs. And that the son, upon whom all his hopes centred —for his elder son was an invalid and his daughters, it is recorded, "had no claim to a career"—should have rejected a science for a pursuit that is trifling in itself and exposes those who follow it to grave moral risks, was a source of profound and lasting grief to him. If Roger Fry had no regrets for himself he felt his father's disappointment and his father's disapproval not only then but for many years to come.

LONDON: ITALY: PARIS

I

The little Queen Anne houses at Highgate, in whose gardens Roger Fry had felt his first great passion and his first great disillusion, had been given up in 1887 for a house in Bayswater. Sir Edward liked the house, because it was near Kensington Gardens and had a fine view down the Broad Walk. To Roger Fry when he came to live there, for the combination of art and science at Cambridge soon broke down, it was "peculiarly flamboyant and pretentious", and the years he spent there were, he said, "very uncomfortable". That was inevitable, for they were years of compromise on both sides. His parents still believed, or hoped, that he might give up his wish to be an artist and return to science. He still hoped that they might come to share his views and sympathise with them. They agreed, after consulting Briton Rivière and Herbert Marshall, that he should study painting under Francis Bate at Hammersmith, but they expected him to live at home. A room with a gas fire was allotted him at Palace Houses; all day he worked at Applegarth Studios with Francis Bate, and he came back to family life in the evening.

The compromise proved very difficult. He expressed his feelings openly in letters to Lowes Dickinson. "Oh Goldie . . . Incomparable Crock . . . My dear . . ." the letters begin, and they go on in a rapid unformed hand to talk of the books he is reading, the expeditions he is making, how Francis Bate is teaching him "more how to analyse your impressions than how to move your pencil—and this

seems to be the right end to begin"; how he is painting
from the nude and how the lady students very sensibly
"kick up a row" and insist upon painting from the nude in
the same room at the same time; how he shows his pictures
first to Briton Rivière and then to Herbert Marshall and
how each gives different advice. But the letters are also full
of complaints. He has to apologise for making them "a sort
of drain for my superabundant spleen". Again and again
he complains that the snow is falling at Failand; and the
fog is brooding over what he calls "the Bayswater bog",
and that both Failand and Bayswater reek with what he
calls "a Nomian atmosphere". "This Nomian atmosphere",
he wrote [March 1888], "is positively suffocating. . . .
When every member of a family has a moral sense that
makes them as rigid as iron and as tenacious as steel and
when they have got through this same moral sense a
feeling of the superlative necessity of doing everything in
common because of the family tie, you may imagine that
the friction is not slight." He went on to give an example of
this friction at work. "When a few minutes ago I made in
pure innocence the statement that I believed Elsie Venner
was founded on a psychological fact, I was immediately
challenged for my evidence, which was only of a very im-
perfect kind. This I at once admitted. 'Then you should
not spread inaccurate and dangerous views.' For quietness'
sake I admitted the enormity of my crime. 'It is but a poor
recompense to admit your folly, and I cannot but regret
that you should speak in that light way of it.' Silence on
my part. Now do you see why I am an Antinomian?" Yet
he could have been happy at home; he was highly
domestic; he was very fond of his sisters. In the same letter
he goes on, "All this is more or less made up for by my
younger sisters who are blessedly corrupt—poor things they
too will soon be ground down into presentable and eligible
young ladies—all acquiescence and smirk and giggle.
Damn—DAMN"—that forecast at least was not fulfilled.
 Home life was difficult, and London life was dull and

conventional after Cambridge. The family circle was legal and scientific, not artistic. When he dined out, he met a gentleman, a certain General, the type of many he was to meet in later years, who said, "What I demand in a picture is that it shall represent something to me which I can recognise at once, and if it doesn't do that I maintain it is a bad picture". Even with Lowes Dickinson he could not discuss painting. "But all this is technical rot to you", he broke off, after trying to explain Bate's methods as a teacher. When his Cambridge friends braved the rigours of family supper and went upstairs afterwards to sit in the room with a gas fire, they "plotted the destruction of society . . . unknown to the rest of the family". Their interests remained the old interests—Shelley, Walt Whitman, and social reform. They were all convinced that "social service of some kind was the only end worth pursuing". And in obedience to this creed Roger Fry tried also to make art the servant of society. He went to Toynbee Hall and gave lessons in drawing; but they were not successful. "I can't possibly tell them to look for hidden meanings in things . . . at least my tongue would visibly fill my cheek if I did." There was something in that compromise too that was disagreeable to him. He sampled the pleasures of London. He took train to Aldgate with a friend and tried to find adventures in the slums of Whitechapel and the Minories, "but we found nothing, much to *my* great relief for I didn't much like the idea of a row". The theatre was sampled too. One night he went to see Mrs Langtry act in *Antony and Cleopatra*. "Mrs Langtry really is very grand, quite worth going to see and acts really tolerably well, but anything more hopelessly absurd than the rest of the show it is hard to conceive. If you can imagine a number of respectable cheesemongers who have retired to Bedlam ranting and strutting about not invariably accompanied by the prescribed number of H's, you will have some idea of the ridiculousness of the whole thing." And one day on the top of an omnibus he again

met Mr Bernard Shaw. More illusions fell from him. Bernard Shaw "took occasion to explain to me what a colossal farce British Justice was. Up to then my respect for my father had led me to take his word for it that anything so pure as British justice had never been known on earth. Again I shelved it. . . ."

But he could not go on shelving it perpetually. The friction with his parents was increasing. They could not help "expressing disgust at my determination to go on drawing"; and he could not help asserting his determination to be an artist and nothing else. At last there was what he called "a general bust-up and explanation of my views with my people. . . . I think on the whole it is a very good thing. It removes the veil of reserve almost amounting to hypocrisy which I had long kept up so as not to hurt their feelings. You can understand knowing me as you do, how difficult I feel it to steer clear of priggish self-assertion on the one hand and dishonest compliance on the other, especially as I cannot quite make my usual motto of Don't care a damn apply to the opinion that my people have of me."

Obviously, he cared a great deal what his "people" thought of him. He was "fearfully sensitive to slight innuendoes". He had a profound admiration for his father. He had moreover little confidence in his own gift as a painter, and no reason to think that he could make his living as an artist. For many years to come he would be dependent upon his father, and Sir Edward would have the right to look for results and to criticise failures. But he could not go on vacillating between self-assertion and dishonest compliance. That was the compromise that family life forced upon him; and he was determined to end it. "I may be a bloody fool", he wrote, "but am at least as obstinate as a pig". So the compromise between the bed sitting room and the studio which had been "frightfully uphill work for both parties" broke down; and in the spring of 1891 he left home and went for his first visit to Italy.

II

He had crossed the Channel before—there had been childish holidays in Switzerland and undergraduate visits to the Schillers at Gersau. But this was his first visit to Italy, and he went with a friend of his own age, Pip Hughes, the son of Thomas Hughes. The change from Bayswater and Hammersmith, the change even from Cambridge, was immense. It was a change from fog and damp to clear colours and sharp outlines. It was a change from plaster casts in museums and photographs in friend's rooms to statues and buildings and the pictures themselves. It was a change from compromise and obedience to independence and certainty.

"Rome at last"—such are the first words of his first letter to Lowes Dickinson, dated 15th February 1891. A thick packet of letters, to Lowes Dickinson, to Basil Williams, to his family, is still in existence. They are traveller's letters; full of details about lost luggage and quarrels with railway officials, with long and laboured descriptions of pictures, buildings and landscapes. He was always a casual and a careless letter-writer; a letter-writer who did not, like the born letter-writer, change his tone according to his correspondents. But for all that, the letters still convey the hum and pressure, the excitement and the rapture of those first weeks in Italy. Perhaps some notion of what they meant to him can best be given by making a skipping summary of their packed pages.

Oh I wish I could send you some of the sunlight of this divine city of splashing fountains and sunburnt domes. . . . Yes, Italy is much better than I ever thought but it smells much worse. . . . We have a divine sort of balcony or rather roof top where our host grows vines and oranges . . . but the wife proceeded to have a kid the morning we came in . . . he therefore kicked up the devil of a fuss . . . and demanded the whole rent to be paid in advance. . . . I'm getting frightfully learned in Italian dishes . . . we have found a wonderfully

cheap Trattoria where we can dine splendidly for about 2
francs. . . . The Colosseum is a big ugly ruin very like a large
building contractors yard. . . . Sometimes I dislike being so
many hundreds of years old as one is in Rome and wish the
whole bloody place might be burnt down. . . . But it is Eternal
and I don't think anything can touch it. . . . Whatever I have
said against Rome . . . I won't say anything against Italy . . .
the country is perfectly lovely. . . . We took a two days' walk.
We went to Nemi [a pen-and-ink sketch of Nemi is inserted].
I doubt if you will understand this. If you don't, half shut
your eyes, and if you don't then, shut them quite. . . . Every
now and then we came on beds of purple crocus bursting up
through last years dead leaves. . . . We sat and drank wine
and watched the sun go down like a red hot ball into the blue
sea of the Campagna.

In the evenings the two young men argued :

We continue to discuss socialism and individualism, and of
course Pip has plenty of texts for his sermons in the treatment
we experience at the hands of officials. . . . I'm furious about
the officialism and bureaucracy of this damned government.
It seriously interferes with what good I might get from Rome
not to be able to make a note of a thing without rushing round
after a permesso. . . . I want to get some idea of the develop-
ment of early Christian art but can't without getting a separate
permesso. . . . I am often speechless with indignation.

But however he might abuse the Roman officials, the
Roman people enchanted him:

I've just been walking on our loggia under a vine trellis
through which the stars shine while in the street below . . .
some men are playing intoxicating and voluptuous dance music
which makes even me dance to it. . . . I think there is a great
deal of spontaneous music in the Italians. . . .

Then he began to go to the play:

Last night I went to hear *Antony and Cleopatra*. . . . Cleopatra
is done by the great Duse. . . . She is called the Italian Sarah

Bernhardt; she is really magnificent . . . she emphasised the witch or gipsy character rather than the grand queen and yet kept it full of dignity . . . it was incomparably finer than Mrs Langtry and the hair-dresser business.

But the greater part of every day was spent in seeing pictures. While Pip, who had no great liking for sight-seeing, sat in the loggia smoking toothpicks, "having a dislike for Government tobacco", Roger Fry, armed with a note-book, worked steadily, seriously and enthusiastically round the galleries.

My dear Goldie [he burst out], I've made a great discovery. Raphael is a great painter . . . one of the greatest. I never used to believe it, and I think I was right not to when I had only seen his English works—the fact is he is a fresco painter and not an oil painter. . . . I think the Venetians are the only Italians who knew what oil meant. Titian's Sacred and Pro-fane Love . . . is simply splendid . . . and so is Veronese's Rape of Europa. . . . But Raphael's Galatea! Isn't it divine? He seems to me in some way to have effected in some way the synthesis of Christianity and Paganism. . . . The Pantheon is the one really grand Roman building . . . I can't in the least explain the effect it produces—it is like the awe and reverence one feels in a great Gothic "fane" and yet it hasn't any mystery. . . . I've been to-day to see the Baths of Caracalla—they're no better than a railway station. . . . I've been to the Vatican sculpture and had the divinest antidote to Rome in Greek sculpture. I've noticed that the Greeks always have a wonder-ful treatment of the surface of the marble which leaves it almost soft to the touch instead of the polish the Romans sometimes put on. . . . I've got very keen on Etruscan things. . . . I think they will throw some light on Greek paintings because what is so interesting is the extraordinary way in which they accepted Greek art. But there is also much that is original in their art and I think I can trace all that I formerly thought the Romans had added to Greek art (namely something grotesque and picturesque) to an Etruscan origin—so much so that I think what the Italians of the Renaissance selected for their model was rather what was Etruscan in Roman art than anything

else. I daresay this is rather wild or else has been said before but at present I'm rather mad on them. . . .

So he spent the days indefatigably looking at pictures. And then he began to dine out.

I've begun [the letters go on] to get into Roman society . . . last night we had a most delicious dinner through a friend of Pip's people, Miss Cartwright. She asked Signor Costa, the great Italian Pre-Raphaelite, to take us all to a restaurant and give us a real Roman dinner. . . . We had frogs dressed in various ways and other strange and delightful Roman dishes. He brought his wife and daughter. . . . After dinner we walked about Rome. I fell quite in love with the daughter. . . . Also I have met Elihu Vedder a nice burly beefy sort of American with a stupendous opinion of himself. . . . I've also seen Mrs Stillman who is Rossetti and Burne-Jones personified. . . . I think a few years ago I would have thought her almost divine. Now I should like a little more blood.

And then he fell in with William Sharp, who excited him with stories of the Campagna—

one part South of Rome is absolutely wild—herds of wild buffaloes and wild horses without a soul living in it and yet once full of huge Etruscan cities. . . .

Finally the two young men made friends with a Contessa who showered invitations and introductions upon them, and altogether Roman society became so exciting that he was glad, he said, that he had not discovered its charms sooner, or he would have done even less work than he had done.

Yet he had worked hard enough, and not only at seeing pictures. He had been painting pictures too. He went out sketching by himself.

I'm doing a lovely thing near the Villa Madonna . . . a row of bare trees bright red in the afternoon sun and behind the Apennines and the blue sky and in front a pool and sheep and a shepherd. . . . The frogs in the pool drive me wild with their

incessant invitations to the female. . . . But there is a dear little
green lizard with whom I always have a talk as he sits by my
paint box and lets me brush his back which he afterwards licks.
The other inhabitant is a most wonderful shepherd boy who is
half savage. . . . He is ugly and dressed entirely in raw sheep
skins but what is interesting is that he always stands like the
shepherds in Greek vases in the most beautiful attitudes.

What with seeing pictures, painting them, making new
friends and dining with them, the weeks in Rome were
packed to the brim. He had seen "all the important pictures
and statues at least twice" as well as "a great many
churches". He had painted "six largish pictures, and many
little drawings and copies". And now, leaving Pip Hughes
in Rome, for though they got on very well Pip was
indolent—"he suffers from almost perpetual melancholy
relieved by occasional flashes of moody exhilaration" was
Roger's way of describing what was probably a natural
disinclination for several hours of picture-seeing daily—he
was off to Sicily alone.

Sicily begins with a quotation, "And torrents of green
rush down from the snows to be quenched in the purple
seas". It goes on with "Sicily is divine—to be there is to
live in a perpetual idyll". Syracuse, Palermo, Girgenti,
each with a note of exclamation, for each is the loveliest
place he had ever seen, follow. Temples and churches are
visited, ruins and mosaics are described. Good Friday
comes with its procession. Onlookers light their cigarettes
at the holy candles. The dead body of Christ is carried
past. And then a friend, Seaman, is met, who rushes him
through the sights "a good deal faster than I liked, but
perhaps it was as well to get a general view". Anyhow, this
is only a first taste of the wonderful land; next time Goldie
must come too. And the next letter from Cambridge is to
be addressed to the Villino Landau at Florence.

So, taking Amalfi and Sorrento and Paestum on the way,
walking much of the road on foot, and falling in with two
delightful American architects who played the flute and

discussed art endlessly, he reached Florence, and that incredibly cheap pension where one could live not merely in comfort but in luxury for six francs a day and enjoy many of the humours of a Jane Austen novel into the bargain. "Florence", he exclaimed, after a first walk by night to a hill-top from which the lights of the city showed bright among the olives and the cypress trees, "is splendid —in some ways the jolliest things I've had yet." And then work began—the usual round of all the galleries. There are references to Andrea del Sarto; to Masaccio; to the Lorenzo Library, and to the chapel of the Medici which "make me quite certain that Michelangelo was much the greatest architect that has lived since Greek times. It is a perfectly new effect, produced by the most subtle arrangement in proportion and expresses an idea at least as complete and intelligible as a sonata of Beethoven's which indeed it much resembles. . . . Botticelli's Primavera is as splendid as I had expected and renews all the delight I had when I first saw your photograph and which I feared I should never again get out of Pre-raphaelite painting. . ." Then by great good luck he met Daniel (Sir A. M. Daniel) and they "grind all day at pictures. . . . Daniel with his terrific energy and intellectual beefishness is making me do it much more scientifically than I should otherwise. . . . The pictures are extraordinary. . . . Ashbee is out here and has joined us. He occasionally gives us parts of a Wagner opera on the Piazza Signoria. . . . If only Cambridge could be transplanted to Florence I believe you [G. L. Dickinson] would produce a great work. Wedd would become an epic poet, and McTaggart would go up to heaven in a fiery metaphysic." So with music and argument and endless visits to the galleries, the days rushed by.

Then all of a sudden the gossip of the old maids in the pension became intolerable; the heat made him ill; he bought a great Panama straw hat and started off alone for a walking tour in Tuscany. The sun blazed; the country was

parched and wild. Sometimes he walked eighteen miles a
day through "the most absolute wilderness I ever saw . . .
everywhere mile after mile hill behind hill one desperate
wilderness of yellow sandy clay. . . . I assure you I nearly
gave up and lay down and prayed sometimes." But at
last "I got through to a lovely little village called Sinalunga
where I found a magnificent Sodoma. . . ." On he walked.
He stayed with peasants in a farmhouse and had "a
delightful feeling of being perfectly at home with them".
Adventures befell him. He was taken for a brigand in his
great straw hat; for some mysterious reason a man picked a
quarrel with him; a suspicious landlady refused to believe
that there could be such a name as Fry—it was too short
she asserted; he had to find an official and to produce his
passport, and even so he had to pay his night's lodging
in advance. Still, in spite of all rubs and hardships, "I can't
give you any idea of the gracious gentleness of manner of
these Tuscan peasants, nor of the Madonna-like beauty of
the women". And so, either on foot or by train, he visited
Volterra and Prato and San Gimignano and Pistoia and
Lucca; and made sketches and picked flowers and took
notes and looked at so many pictures, frescoes, baptisteries
and statues that at last he has to ask pardon both for
describing so much and for leaving so much undescribed.
At last, too, he exclaimed: "I am beginning to feel like a
boa-constrictor after a very big bull or whatever it is that
he constricts" and felt "half inclined to come home at
once and begin the process of digestion".

But still Venice remained. And Venice happily provided
a respite, for he had been walking too far and seeing too
much and was feeling mentally surfeited and physically
knocked up. In Venice he came to a halt. In Venice there
were cafés, or "little pubs" as he called them, where after
the day's sightseeing he could sit, and sample strange
dishes, and drink good wine. Such was always his natural
method of taking his ease when the sun had sunk and he
could see no more pictures. And at Venice in May 1891

he was supremely fortunate. For there he fell in with
John Addington Symonds, whose books, though he came
to dislike the style, had, so Roger Fry always said, the
root of the matter in them, and whose talk, he added,
was infinitely better than his books. With Symonds was
Horatio Brown, "*the* authority upon early Venetian
painting", "a solid unselfish pessimistic sort of man who
says very surprising things when he does speak". Both
Symonds and Brown were "awfully good" to him. They
asked him to dine with them almost every night "at a
little tiny pub where they are habitués and know all
the Venetians who frequent it". The atmosphere was
completely congenial. The pub was kept by a magnificent
Venetian who looked as if he "might have stepped out
of some great Vandyke portrait". Roger christened him
"il Senatore" and sketched his portrait while they talked
and drank. And while they talked, Roger marvelled at
the ease with which Symonds and Horatio Brown mixed
with "the people"—perhaps he was thinking of the pond
loafers at Highgate and their big red hands—and reflected,
"Somehow I think it would be easier to be friends with
'the people' here than in England. Class distinctions are
not really deeply implanted, and there is always a sub-
structure of latent culture; civilisation has had so long to
sink in and has penetrated the people so that they have all
sorts of fine and delicate perceptions even when they can't
read or write."

With Symonds and Brown he could talk to his heart's
content, and sometimes indeed rather to his mind's be-
wilderment.

Last night we stayed up till the small hours discussing the
preposterous paradox started by Symonds in real good faith,
namely that Botticelli was either a fool with a knack of drawing
who didn't understand the least what he was about or else a
puritan satirist who tried to bring the sensuosity of the Re-
naissance into contempt by his pot-bellied Venuses, &c. &c.
I tried to convince him but in vain; he is wrong and ought to

own it—the worst of it was that defending Botticelli is not at all what I am naturally keen on now but such a theory demanded criticism which alas, I was not very well able to give. Symonds ended by saying "Of course we are all very thankful to Botticelli for having inspired those pages of Walter Pater", and then he added with what I think was hardly good taste in one who is so obviously a rival, "That is the worst thing I've yet said about Botticelli".

Symonds perhaps saw in the young Cambridge art student someone who could still be very easily shocked and was worth shocking and so educating; for he continued the process at his own flat.

There one evening [Roger continued, to Basil Williams] we had the most extraordinary company I ever met. In the first place one Cope Whitehouse, an American who thinks he has discovered Lake Moeris and is going to fill it with water from the Nile. He was the most perfect type of schemer I ever met (Harry Richmond's father would give you some idea of him). . . . I never want to see a cleverer humbug and bogus company builder. With the next visitor the scene shifted from G. Meredith to Oscar Wilde for it [was] no one less than Lord Ronald Gower who one recognised at once as the original of Lord Henry in *Dorian Gray*. A middle-aged man with a splendidly finely featured aristocratic face not yet quite brutalised by debauchery, the most perfect manner, easy and affable, perhaps a little too indifferent. He talked very well about Greek sculpture and Giorgione and so on, but the conversation finally became weird and remarkable without ever being other than perfectly proper in its expression. The details of it I would rather tell you than write.

It was now Roger Fry's turn to be shocked; there was still a great deal of the Quaker in him that was liable to shock from the "surprising" things that were openly discussed. There was no "cast iron morality", nothing Nomian in the atmosphere that surrounded Symonds and Horatio Brown at Venice.

Symonds [he wrote admiringly] is the most pornographic person I ever saw but not in the least nasty . . . he has become most confidential to me over certain passages in his life. He is a curious creature—very dogmatic and overbearing in discussion, but with nice humane broad views of life.

But though he was still a little shocked—Quaker scruples still had an awkward way of asserting themselves—he felt nevertheless "absolutely at home here in Venice". As he sauntered along the Zattere at night after these conversations, "it had just the feeling of King's Backs to me without its associations" he remarked. Lowes Dickinson and Wedd and McTaggart unfortunately were missing; nevertheless, he found that he could talk perfectly openly with Symonds and Brown—"who is most Apostolic"—and not only about morals and philosophy, but about Veronese and Tintoretto and Tiepolo, whose pictures he had been seeing that morning. There was no fear that Symonds or Brown would complain, as his Cambridge friends complained, that he was "talking rot about technique". Technique was not rot to them; pictures were the most important things to them in the world. And then there added itself to the group at the little pub another figure who was to recur in other pubs and other places so frequently that no record of Roger Fry's life would be complete without mention of him—the traveller met by chance, the marvellous discovery. This time he was a nameless Swede— "a man of wonderful culture, who knows all English, French, and much Spanish and Italian literature and understands Italian art in a way I have hardly ever known anyone else do, but his special subject is Dutch literature in the 17th century . . . he gives one the notion of belonging to a bigger race than ours with a bigger future opening before it. . . . If he were a pedant, I wouldn't mind, but he is a man of the world with all his learning . . . and he is younger than I am." They made great friends; they roamed the streets at night talking

endlessly. All his life Roger Fry was meeting such people; and sometimes he struck up lasting friendships with them, and sometimes, as on this occasion, they remain nameless, and vanish into the May night.

To make the spring complete only one thing was wanting and that too came to pass. An English girl and her mother were staying at Venice. The girl was "fascinating"; the mother "very remarkable". Roger Fry fell deeply in love. To fall in love for the first time and in Venice in the spring must have been the most exciting of all those exciting new experiences. But his feelings must be guessed, for though he was on terms of perfect intimacy with Lowes Dickinson, falling in love was a topic that he did not find it easy to discuss with him. "Seriously I love you and understand you more than ever . . . and yet it's no use to blink the fact that it isn't the only kind of love I'm capable of although it may be better than any other; nor also that our love means something different to me to what it does to you—but I think you understand."

Thus it was that the Italian tour with its immense variety of exciting experiences — artistic, intellectual, emotional—came to an end.

<p style="text-align:center">III</p>

The process of digestion had now to begin. It was difficult; he had swallowed so much. He had seen enough in those few months to make him sure that compromise was impossible—his life's work was to lie not in laboratories, but among pictures. He had only taken a rapid glance at Raphael, Michael Angelo and the rest, but he guessed that the mass behind them was prodigious, and that it would need a lifetime to take its measure. But there was also the other desire—the desire to paint himself. There was the shepherd boy standing against a background of bright red trees with blue mountains behind him. The critic, to whom it came so naturally to form "wild theories" and

to analyse impressions, was always being urged by the artist to stop taking notes and to get out his canvas and paint. Yet although he had found that he could hold his own in argument with Symonds and Horatio Brown, he was very doubtful whether he could paint a picture that was fit to hang on a friend's wall, let alone among the works of real painters in a gallery. It was a doubt that troubled him and that was to go on troubling him. Further the love affair, that had begun so happily at Venice, came to an unhappy end in the winter that followed.

Naturally the few months that he spent in London with his family on his return were gloomy. "I am very sick about things in general just now and cannot manage to work properly", he wrote. After Italy, Bayswater was less tolerable than ever. The Quaker atmosphere, he said, made him "into a strange jelly-like mass with about as much consciousness as a chloroformed amoeba". And after Italy the atmosphere of Applegarth Studios, Hammersmith, with Francis Bate to instruct and Briton Rivière to advise was a little elementary. The solution seemed to be a second foreign tour, this time to France, to continue his education at the headquarters of art, the Académie Julian at Paris. He went there in 1892.

IV

According to Sir William Rothenstein, who had gone there a year or two before, Paris and Julian's studio— "that congeries of studios that was called the Académie Julian"—was enough to send young art students "accustomed to the orderliness of the Slade, and the aloofness of the students, wild with excitement". "Those first days in Paris", he writes, "seemed like Paradise after a London purgatory." Over the studio door was written the saying of Ingres, "Le dessein est la probité de l'art"; within, the rooms were crowded with students from all parts of the world. "Our easels were closely wedged together, the atmosphere was stifling, the noise at times deafening." So

Sir William begins his description of that exciting time, and he goes on to give a fascinating account of the friends he made; how they worked and discussed each other's work; how they dined at the Rat Mort and the Moulin Rouge; how the band struck up and La Goulue danced, and Rayon d'Or and Nini Pattes en l'air and Grille d'Égout displayed their charms; how Conder drew them; how one met and talked on equal terms with Lautrec and Anquetin and Édouard Dujardin.

All this and much more than all this, as a dozen memoirs testify, was going on when Roger Fry went to Paris. But he seems to have missed it. He was sharing rooms with Lowes Dickinson, and Lowes Dickinson, when he was taken to the Moulin Rouge, "or one of the dancing places", records that he was bored; and when "a very ugly old prostitute came up to me once, in some eating-place, and began fondling me", he "fairly ran away"—to continue writing his drama upon Mirabeau in the untidy attic which he shared with his friend. Roger Fry himself found Julian's "very mild after all the tremendous accounts I heard". Perhaps after Venice and Symonds and Horatio Brown, studio life with its song-singing and its merciless chaff and its frequent practical jokes, "some of them very cruel", seemed to him rather primitive. Whether because of his upbringing, or because of some innate Puritanism of his own, he never liked what he called "rampant Bohemianism". So, leaving Lowes Dickinson to write his play in their attic, he wandered about Paris by himself, gathering impressions of a mixed and miscellaneous kind. "What delights me in Paris", he wrote to Basil Williams (February 1892), "more than anything else is the sort of way in which the national sentiment has got itself expressed in the magnificent public buildings. . . . It is an organised vertebrate city, not an amoeba or fungus like London. . . . Then the pictures. Well the Luxembourg is a great disappointment—I scarcely can think it typical—there is so little that is really big—little

that is quite bad it is true, but a dull academic mediocrity pervades the place. Whistler's mother is quite among the first three, if not first of all, as I rather incline to think. Bastien-Lepage is a disappointment to me, nice and genuine observation of peasant life, but I don't like to have undigested facts thrown at my head in that way."

He sampled the opera too. "I have never got at Wagner before—it seems quaint to get ones first real thrill of Wagner in Paris, but so it was"—and the theatre. He dined out with Madame Darmesteter, and went to a state ball, "chez Carnot", at the Élysée. "Imagine me in the most gorgeous condition I could assume with a new opera hat wandering round the rooms at the Élysée—not knowing a soul and unknown. . . . It wasn't anything very extraordinary in any way except for the number of decorations under which fat little Frenchmen who looked as though they'd made their money in candles or soap staggered about. The women were nearly all rather ugly but the dresses were good." He was amused by the various samples of French life that came his way, but not excited, or much impressed. It is true that he made friends with "a young English artist, a friend of Oscar Wilde's, and one of the most conceited little *shits*—there's no other word for it—you can imagine but very clever and great fun", and through him heard talk of the symboliste poets; but the symboliste poets "seem to be a set of egregious asses in some ways and only to keep alive through vast orgies of mutual admiration and reciprocal incense-swinging". He went to the Chat Noir, "a café run by a sort of circle of artists where they give the most splendid shows"—but those shows seem only to have suggested aesthetic theories about an "ideal union of the three arts of drawing, music and poetry" upon which he meditated in solitude.

Altogether the months in Paris, though they had a wide circumference, seem to have lacked a centre. He was inquisitive and he was interested, but he found nothing in particular to fasten upon. He missed, to his lifelong regret,

seeing any picture by Cézanne. And Paris and French
painting, considering what both were to mean to him later,
made very little impression upon him at first sight. It
may have been that the first sight struck at him from an
odd angle. Modern painting had to strike through a
Quaker upbringing, through a scientific education;
through Cambridge and Cambridge talk of morals and
philosophy, and finally through an intensive study of the
old Italian Masters before it reached him. And there was
a further impediment; as a painter he was not in the least
precocious. Had he shown at Julian's a strong original
bent as a painter, he would have been a member of that
little artists' republic which, whatever the age or the state
of society, is always actively in being. His contemporaries
would have praised or abused his work. His elders would
have taken notice of him. He would have come to know
both painters and writers at first hand, not only through
the reports of others. As it was, he rambled about Paris
for himself and nobody took any particular interest in
him or in his work. Sir William Rothenstein sums up,
no doubt, the impression that he made upon his fellow
students at Julian's when he says that Roger Fry "was not
much of a figure draughtsman", and though "clearly very
intelligent", he seemed "somewhat shy and uneasy" as
if he had moved "chiefly in scientific and philosophical
circles". And to Roger Fry that famous studio seemed
"very mild".

Yet France was to mean more to Roger Fry than any
other country. It was to mean something different. Italy,
as the skipping summary of the letters is enough to show,
was a lovely land of brilliant light and clear outlines; it
was a place where one worked hard all day seeing Old
Masters; where one settled down at night in some little
pub to sample strange dishes and to argue with other
English travellers about art. But it was not a place with a
living art and a living civilization that one could share
with the Italians themselves. France was to be that

country. He was to spend his happiest days there, he was to find his greatest inspiration as a critic there. But he seems in 1892 to have had no premonition what France was to mean to him, and for perhaps the last time in his life he exclaimed on leaving Paris, "It'll be ripping to see London and its inhabitants again".

CHAPTER IV

CHELSEA : MARRIAGE

I

LONDON was Chelsea. He took a house in Beaufort Street which he shared with his friend R. C. Trevelyan. There was a studio in the back garden, and a great mulberry tree hung its branches over the garden wall. The house is still there, and Beaufort Street, whatever may have happened to the world since 1892, is practically unchanged. The years have given it neither dignity nor romance. The houses remain monotonously respectable and identical. But the river still runs at the end of the street, and Roger Fry, to whom London was a fungus, an amoeba, liked the river and the barges passing, and the silhouettes of factory chimneys and the yellow lights opening in the evening.

But though Beaufort Street remains unchanged and the river still runs, it is difficult to recapture the atmosphere of Chelsea in 1892. The peace was so profound. Politically, the most stirring question was the fate of the Home Rule Bill; in the world of poetry, it was the year of Tennyson's death; Sir Frederick Leighton was President of the Royal Academy; Millais was exhibiting "The Little Speedwells Darling Blue" at the Academy; some of Oscar Wilde's plays were being produced; and Roger Fry and his friends were immensely impressed by Ibsen. These are scattered landmarks that may recall as far as such things can the outlines of the world as it appeared to him. And it appeared to him of course from a certain angle, a sheltered angle, a favoured angle. Through his family, through his father, he had many connections with the active and eminent in the professional world; he had a tradition, a background, behind him.

For many reasons it seemed perfectly possible to settle down in Chelsea and to plan long years of work ahead. But another result of that profound peace was also obvious —it seemed necessary to revolt against it, to break it up. It was the stability of the world that impressed him; its security, its prosperity, its self-satisfaction. When he stayed at Failand, his father's country house near Bristol, he fumed with irritation. He could see no chance of any change in family life in his time. In the world of art the Royal Academy was his bugbear. It stood for everything that was dull, established and respectable. The New Gallery, the Grosvenor Gallery, the New English Art Club were all in opposition; he joined the opposition as a matter of course. When he set up on his own as a painter, he sent his first pictures to the New English Art Club. It was the centre, as he wrote later, "of the serious artistic life of the day". He had reasons of his own for criticising the New English Art Club and its aims; he thought, as he says in a letter at that time, that if he could ever paint a picture it would be "a better picture" than the pictures shown there—"My study of the Italian drawings has influenced my work in the direction of demanding more complete design in a picture". But he had no doubt that the artists who showed at the New English Art Club were the only artists worth considering in England. He took Lowes Dickinson to task for doubting it. "I wish you wouldn't say such things about the N.E.A.C.", he protested. "No doubt some of them are extravagant. Steer I'm sure isn't. He's much too genuine. . . ." So he sent his first pictures to the New English Art Club and was greatly disappointed when they were rejected.

But when he first set up house in Beaufort Street, perhaps Harris was more important to him than the New English Art Club. Harris certainly plays a far larger part in his letters than Mr Gladstone or the Home Rule Bill. Harris was the maid-of-all-work supplied by Lady Fry. Harris was a woman of sensibility. When left alone Harris

took rather more drink than was good for her; when remonstrated with, Harris's feelings were hurt, and when her feelings were hurt, Harris was incapable of cooking dinner. This was a serious matter, because Roger Fry was naturally hospitable. Now that he had a studio of his own, and not merely a room with a gas fire at the top of his parents' house, friends came crowding to see him. The old Cambridge friends came of course; Lowes Dickinson read aloud the play there that he had written in the untidy attic in Paris. But the old Cambridge circle was being considerably enlarged. Mr Bernard Shaw came, and talked delightfully, but refused to eat a delicious risotto cooked by Roger himself because "he detected a flavour of animal gravy in it". Family friends came—among them Mrs Crackanthorpe, who looked at his pictures and said: "I ought to write up large on my walls 'Do not take pains' "—a criticism with which he agreed; and then she carried off some of those too laboured canvases to show to Mr Ouless, R.A. And the argument, the everlasting argument, now that it was no longer necessary to plot the destruction of society in secret, raged fiercely in the studio at Beaufort Street. "When late one night Daniel [Sir A. M. Daniel] left", Mr R. C. Trevelyan writes, "Roger accompanied him the whole way down King's Road to Sloane Square Underground Station, and as the discussion was not yet finished, we all three walked the whole way back to Beaufort Street, and then back to Sloane Square again." The subject of the argument has disappeared. It may have been, according to the evidence of the letters, "on the methods of the old masters and whether they can be combined with truth to nature to which modern people have become accustomed"; or it may have been about the Old Masters and the failure of the Impressionists to absorb their meaning—a subject, according to Alfred Thornton, upon which Roger Fry at this time used to carry on vigorous arguments with Henry Tonks. Or again it was likely with R. C. Trevelyan as a house-mate that the

argument turned upon poetry. Through Robert Bridges, who had married a cousin, Roger had read some of Gerard Hopkins's poems in manuscript, and was at once convinced and must convince Bob Trevelyan that here was a great poet, a far greater poet than Tennyson. "I've got some manuscript poems by Gerald [sic] Hopkins which would make you tear your hair. Look at this: 'I caught this morning, morning's minion king' ", etc. From Tennyson to Gerard Hopkins—that may serve as a land-mark or as a mind mark, too.

Whatever the subject of those arguments, there is plenty of evidence that Roger Fry was, as R. C. Trevelyan writes, "a tireless and obstinate disputant"—on one side of the garden wall. But the garden wall had another side, and so too, it seems, had Roger Fry. On the other side of the garden wall lived Ricketts and Shannon, and the great mulberry tree, whose branches overhung the wall, brought about meetings. "Once every year," Mr Trevelyan writes, "when the mulberries were ripe, Ricketts sent us a courteous invitation to come to tea and eat our share of the mulberry vintage. The ceremony, though outwardly friendly enough, was apt to be rather formal and con-strained because Roger and Ricketts did not really like each other. Roger was still very much of a Quaker in temperament and tone of mind, though quite emanci-pated from Quaker puritanism, and he was inclined to be irritated by the somewhat irresponsible dogmatism of Ricketts's talk." But that irritation was concealed, it appears, and the "tireless and obstinate disputant" of the studio was silenced. He seemed to Sir William Rothen-stein, who met him on the Ricketts and Shannon side of the wall, to be "very much what he was when he first came to Paris—shy, rather afraid of life, painting in the manner of the early English water colour painters". And the discrepancy is interesting—it shows that there were two Roger Frys; one who had been trained at Cambridge to reason and was quite able to hold his own

in argument with McTaggart and Lowes Dickinson, and another who was still inclined to be shocked by what he called "rampant and flamboyant Bohemianism . . .", who was very diffident in the presence of painters, and who felt vaguely that if he could paint he would paint differently from the artists of his own generation.

There was a further characteristic that struck many people at that time and later. "He sat at Ricketts's feet", said Sir William Rothenstein. Mr Edgar Jepson, the novelist, uses the same words. "He sat at Selwyn Image's feet"—"a pleasant gushing young fellow," he called him, "and rather an ass. I never dreamt that he would grow up the Father of British Painting". Sitting at other people's feet was certainly a characteristic. Roger Fry had a great capacity all his life for laying himself open, trustfully, optimistically, completely to any new idea, new person, or new experience that came his way. But with it was combined another characteristic—when he had sat long enough at those feet to see where they led, he would get up and go off, sometimes in the opposite direction. This rare combination—the capacity to accept impressions implicitly and then submit them to the test of reason—made him the most stimulating of critics. But it was a gift that puzzled, and sometimes distressed his friends and colleagues. It led, as Alfred Thornton noticed, "to a certain restlessness and tendency to secede from societies to which he belonged and to found others, each to be abandoned in its turn". Roger Fry did not regret it; he was often to maintain that it is only by changing one's mind that one can avoid the prime danger of becoming either a fossil or a figurehead.

He seems, then, in those years at Beaufort Street to have sampled many groups but to have attached himself to none. He was always being driven by the range of his own interests and the activity of his mind to explore beyond the walls of the studio. The art of painting and its connection with the other arts was a subject that had already interested him when he was a student at Julian's. He went to a

AN EARLY PICTURE BY ROGER FRY

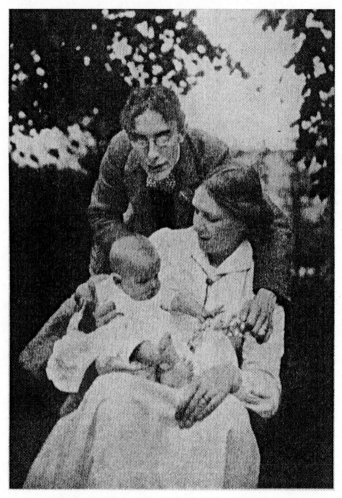

ROGER, HELEN, AND JULIAN FRY, ABOUT 1902

great many concerts, and he read a great deal of poetry. There would burst into the studio, to take one instance, "a man who has lived in Italy for eight years translating Dante into Spenserian verse" which he proceeded to shout by the canto. "But the really extraordinary thing is that it is quite good . . . a few little tips which I had second hand from Bridges" threw him into a wild state of excitement "and made him perspire all over his bald head." Then there was science. Science had been supplanted by painting; but it was dormant, not dead. Science was still the great bond between him and his father. He still discussed scientific problems with him, and would still gather some rare flower for Sir Edward to dissect on his cycling jaunts into the country. He continued to be interested in Psychical Research. Mrs Piper and her revelations were then exciting a good deal of discussion. He spent a week-end with Shadworth Hodgson and summed up the result of their arguments in a letter to his parents. "There does seem", he wrote to his mother, "some reason to think that there are spirits and that they exist in luminiferous aether. They all find it a much pleasanter place than this, but apparently they are still rather confused as to their whereabouts. . . . It is much the most rational and collected account I have heard." Then again medicine and its problems fascinated him. A new drug might always contain some magic property. His own colds and influenzas lent themselves to interesting theories and experiments. "Little tips" that he had discovered were always being handed on to his family. His charwoman had cured her husband of indigestion by putting isinglass in his tea— might it not be worth while for Lady Fry to try the same cure upon Sir Edward? . . . Undoubtedly, sitting at other people's feet, whether they were the feet of art experts or of psychical researchers or of old charwomen with a hoard of nostrums under their black bonnets, was a characteristic, endearing to some, in its innocency; irritating to others, the sign of something

fantastic, flighty, gushing, in his character. At any rate, it meant that his days were packed full of different things. In Beaufort Street, as at Cambridge, the old complaint recurs; life is too full of different possibilities and interests. "I sometimes think", he wrote, "that I shall have to get a disguise and give out that I've gone abroad so as not to hurt people's feelings by not spending all one's time rushing about."

All these different, sometimes conflicting, interests and activities may have interfered with that absorption in art, that isolation and concentration which, as he was often to remark, the great artists, like Cézanne, have found essential. To the critic, however, a richer, or a more varied diet, may be helpful. And circumstances were forcing him to become a critic. He was finding his allowance insufficient, and to write notes upon current art for the various weeklies was the obvious way of adding to it. There are frequent references to articles in the letters from Beaufort Street. Indeed, according to Sir William Rothenstein, he was already "an admirable writer". His writing never satisfied him; there was nothing plastic about it; pen and ink, were meagre tools compared with brush and paint. But his mind was stored with ideas and arguments, and editors were ready to accept notes and half columns, reviews of books and reviews of picture shows, if not more serious contributions. Pages torn from the *Athenaeum* and the *Pilot* began to accumulate and to be thrown into table drawers. In October 1893 there is reference to a more ambitious article upon Impressionism intended for the *Fortnightly*. He tried to explain that "painting is not mere representation of natural objects". But the *Fortnightly* refused it, and he turned to another method of making a living, and one that was more congenial to him.

"Berry wants to try me as an Extension lecturer upon art", he wrote in 1894. He had already some experience as a lecturer—he had lectured to the boys in his study at

Clifton with a block of ice in front of him; and he had
lectured staying down at Yattendon with his cousins, the
Bridges, when there was an explosion and the electric
machine went wrong. But this was his first attempt at
lecturing upon art, and though Berry said that his manner
"was not assured enough", it was a success. He went on
to give a course at Cambridge on Leonardo da Vinci.
Then Eastbourne applied for a course upon Italian art.
Brighton followed suit. Very soon he was saying, "It is
curious how my lecturing has caught on". He was even
complaining that though his lectures cost him very little
trouble compared with his painting, they were much
more successful. Lecturing was at any rate preferable to
writing, and more congenial to him. The audience stimu-
lated him, and the picture on the screen in front of him
helped him to overcome the difficulty of finding words;
he improvised. He had, too, natural gifts—a beautiful
speaking voice, and the power, whatever its origin, to
transmit emotion while transmitting facts. But he had to
develop a technique, and the practical difficulties were at
first very great. It was essential that his lectures should be
illustrated, and it was difficult in those days to come by
illustrations. He had to send to Italy for photographs and
to have them made into slides. Then there were long
journeys to remote places—often he went without dinner,
was nearly frozen in his third-class railway carriage by
the time he reached Dunfermline or Aberystwyth, and
then found that no arrangements had been made and he
had to set to work to rig up a screen, a light and a reading-
desk himself. But he liked his audiences, and even if they
wrote him papers too full of "gush about the fair city of
Florence and the slopes of the Apennines", he found
them eager to learn. He was always discovering, to his
great delight, someone in some out-of-the-way place who
"is really keen about art". He enjoyed, too, looking out of
the train window, for a new landscape was almost as
important to him as a new friend. Nor was he yet as

positive as he later became that Suffolk is the only county
in England worth looking at.

As a lecturer he was undoubtedly successful; but he was
not successful as a painter, and his painting mattered far
more to him than his lecturing. As a painter he complained
that he did not seem "to fit in anywhere". He was painting
in the manner of the early English water-colour painters
when his contemporaries were painting in the manner of
the Impressionists. When he succeeded in getting a picture
hung—a portrait of Mrs Widdrington—it seemed to him
"old-fashioned. . . . I fear it is not very original or up to
date—more like a reminiscence of Gainsborough than
anything." A fellow artist told him that he was "much too
Old Masterish—it seems quaint for me to be an old fogey,
but I see that it is a possible danger". Critics to whom he
showed his work took different views of it. "Steer has been
round and I think likes my work more than before, but
it is difficult to find out quite what he thinks. Powles has
also been round. . . ." And Powles of course said the very
opposite of Steer. For reasons which he gave later in his
"Retrospect" (*Vision and Design*), he found himself "out of
touch with his generation as a painter". And it followed
that he found it very difficult to show his pictures, let
alone to sell them. "I have had a great disappointment
over the N.E.A.C.", he wrote (November 1893), "which
chucked all but Mrs Schiller and skied that. I am very
sore about it, as I honestly think it is not a fair judgment
and am backed up in that view by Bate and others. . . ."
Again, "I sent two things to the New Gallery with the
usual result". Success, he wrote to his mother, "seems to
take a long time coming, but that chiefly troubles me in
so far as it concerns you". He did not like taking an
allowance from his father, who had many claims upon him,
and yet, though friends were very kind in commissioning
portraits—the Pearsall Smiths, the Palgraves and the
Bridges all gave him commissions, and he added to his
income by taking a pupil, a Frenchman who improved

his vocabulary—he was finding it very difficult to make both ends meet.

But he was right in saying that he felt his failure chiefly because it affected his parents. He had no doubt that he had found out "what to do"; he never regretted Cambridge or a scientific career. Particularly he was free to travel—indeed, his growing success as a lecturer made that great pleasure a necessity. He went to Antwerp and to Lille in order to see Rubens. There was another visit to Italy, partly in order to hunt up photographs for his lantern slides, partly in order to see pictures for a book on Bellini that was taking shape. "Daniel is talking so incessantly about the various ascriptions of pictures we have been to see that I am unable to concentrate", he wrote (to Basil Williams, 20th October 1894).

We work here at the galleries all day long and read Morelli all the evening, and I am really getting a grip on Italian art such as I have never had before and I hope my lectures will be the better for it though I don't see how in the least to convey what I have learnt in words. On the whole I am coming to the conclusion that the general level of painting in the 15th century was not very high. There was a batch of great men at the beginning, Masaccio, Piero della Francesca and Pisanello, and then no one first rate till Leonardo da Vinci. Also that on the whole the Florentines were a prosaic and rigidly scientific lot. I am trying very hard to see why Raphael is so great but he still leaves me cold and untouched.

And so to Prato and Pistoia and Parma and the works of Correggio. ". . . I am immensely excited by him. He seems to me almost the greatest painter of all the Italians. I know that I have felt that at random times of two or three others so you won't think much of it", he wrote home to his mother. Then it was necessary to go to Paris, to see the Salon and the work at the Louvre, "which seems to me finer every time I see it and to have more of importance especially in Italian art than our National Gallery". He was beginning to know France itself, not

merely Paris and the Louvre, but the villages, the rivers and the inns—France as it is known to the cyclist with a map in his pocket and an easel strapped to the back of his machine. There were expeditions at Easter and in the summer to little French villages—Sassetot-le-Mauconduit, Giverny, La Roche Guyon; visits to the English colony at Vétheuil, where he met Conder and admired the beautiful Miss Kinsellas; and there D. S. MacColl was staying too, and noted Roger Fry as "a modest youth worried because his painting would never look 'artistic' ". He missed seeing Monet, but he saw the poplars on the Ept with Alfred Thornton, who records "but despite the glamour of it all Fry was continually in doubt"—about the Impressionists, it seems; and once Jane Harrison was of the party, and they cycled together, and he delighted in her "ribald spirit" and her "really Apostolic mind" whilst her enthusiasm for "collecting idiotisms" helped him to a greater fluency in his own speech. Indeed, he fell in love not only with France but with the French language, and teased his friends by sprinkling both talks and letters unnecessarily with French words.

Back in Chelsea he filled up whatever crannies of time were left over after his articles were written, his lectures prepared and his pictures laboriously finished, with another activity. It came naturally to him to use his hands—they were broad, supple and sensitive. While he talked he was always doing something with his fingers. Now his friends gave him work. McTaggart asked him to design furniture for his rooms at Cambridge. Another friend, Bertie Crackanthorpe, the writer, asked him to decorate his house. Thus began his long connection with "little men in back streets", house painters and carpenters, with whom he began to grapple with practical problems—cost; material; design and construction. And then when he had surmounted these problems and the house was finished, Bertie Crackanthorpe must go and ruin the design—white walls and a black dado—by hanging up photographs. How to reconcile the carpenter and the client was a problem that

was to become familiar to him later. Meanwhile his father's words about being a jack-of-all-trades and master of none recurred to him, or, as he put it, "I sometimes feel tempted when I am in a cowardly mood to think that I've cut off a bigger chunk of life than I can chew. . . ."

Certainly there was no doubt that he had found out, and was daily finding out, what to do, but there is evidence that he was also finding out that he needed someone to do things with. His "fearful sensitiveness" to family friction is enough to show how much depended upon family sympathy. And now that the friction was lessened, the dependence showed itself. The general term "my people" is broken up significantly into the names of separate sisters. He was very anxious that they should share his freedom. With his sister Margery, in particular, he had a special sympathy. "I hear that Margery is coming to town at last. . . . If you really give up Rome, mightn't she and Agnes come and live here for the summer and study with Bate and me? They should have a room to themselves so that they need not see my visitors and friends, and I think it would be a great thing for both of them", he wrote to his father. The words hint at his conviction that his sisters must find family life and its "Nomian atmosphere" as suffocating as he did himself, but they also suggest, what was equally true, that he was, as he claimed, "highly domestic". To have a centre, to share a home, was a deep instinct. Perhaps it was an instinct of self-preservation. He needed someone to concentrate upon, to share things with, to curb his restlessness.

There were, needless to say, young women who were not sisters. One—"the heroine of a Meredith novel" he described her, "aristocratic, high-spirited"—had refused him. Another had treated him "cat and mouseically". He was very susceptible—"There are so many ways of love, aren't there?" he wrote once. Indeed his words to his mother about Correggio, when he felt him to be the greatest of all the Italians—"I have felt that at random times of two

or three others so you won't think much of it"—were true
in the emotional sphere also. Many young women found
themselves invested, in Roger Fry's eyes, not only with
transcendent beauty, but, what surprised them perhaps
more, with an infallible flair for the virtues of old Italian
masters. And among these fleeting attachments to young
and lovely faces there was a more serious relationship with
a lady who was neither young nor beautiful, but old
enough to be his mother. She it was who undertook to
educate him in the art of love, much as Symonds had
educated him in the art of painting. Endowed, he said,
"with enough fire to stock all the devils in Hell", she
stormed at his stupidity, laughed at his timidity and
ended by falling in love with him herself. He profited by the
lesson and was profoundly grateful to his teacher. Had she
not taught him what was far more important than the art
of dissecting the livers of drunken men or of discriminating
between a genuine Botticelli and a sham? So he thought
at least, and to the end of life pupil and mistress remained
the best of friends. Thus instructed he lost his Cambridge
callowness and learnt to distinguish between "the many
ways of love". And there was one relationship in the years
at Beaufort Street which from the first differed from any
other. One day, to use his own words, "the fated inevitable
thing" happened. "I fell completely in love in one after-
noon's talk", he wrote. "And it was so inevitable that I
thought she must see it too, but she didn't for nearly a year."

"She" was Helen Coombe. She was a year or two older
than he, an art student, living by herself, and exhibiting
too at the New English Art Club. "A delightful artist",
Sir Charles Holmes called her, and Roger Fry always
maintained that she had a far more instinctive and original
gift as a painter than he had. She, too, had broken away
from her family and its traditions. The impression she
made on him was strange, complex, unforgettable. She
had "wit and a strange touch of genius . . . and there
was beauty too, and a certain terror on my part at the

mysterious ungetatableness of her . . . but the terror,
though very definite . . . added a fearful delight". She was
the only person, he felt, with whom he could spend his life
in complete sympathy. But when, after a year's hesitation,
she felt as he did, and agreed to marry him, there were
obstacles. His parents, when asked their consent, objected,
naturally enough. It was not the marriage that they wished
for. She belonged neither to the Quaker world, nor to the
conventional world. She was an artist, and for artists they
felt a mixture of distrust and fear. Then there was her health
—a rumour had reached them that there were reasons for
anxiety. Roger Fry denied it. Then there was the old
Victorian respect for family—that he dismissed with a
laugh. "There is an Admiral somewhere in the offing", he
assured them. But there could be no answer to their final
objection—that she was penniless. And this was a serious
matter, which led to much discussion and roused much
of the old bitterness, as one quotation is enough to show.
"Don't think", he wrote, "I don't feel sufficiently the
humiliation of having to appeal to father's generosity—I
know that I am at his mercy and that if he chooses to cut
off my allowance the whole thing must be broken off.
We are neither of us very young or very rash. We both
know enough of the world to see the dangers and dis-
advantages of marriage. We were both averse to the idea
of it, I because of the possible interference with my work,
she because of her dread of losing her independence; and
yet we are both driven to it as the only solution."
 Marriage was "the only solution". Neither of them, it
is worth noting for the light it throws upon the conven-
tions of the time, contemplated any other; and at last the
objections were withdrawn. When the engagement was
announced he wrote to Lowes Dickinson: "I know that it
is momentous and irretrievable, and that it must make you
and Mrs Widdrington apprehensive, as it would me if I
hadn't that sort of fundamental instinct about the thing
which defies analysis. Of course I have to admit logically

that I can't prove anything. . . ." But he added, "I am afraid I am ridiculously happy". Proof of that, even if it was not logical proof, is given in many letters, too private, too outspoken, too sure that every word will be understood and their exaggeration discounted to be quoted. They are full of high spirits, full of laughter. There is an account of a visit to Cambridge—he was hanging a show of modern pictures; he laughs at himself "wheeling canvases in hand-carts through the astonished slums"; he pokes fun at the Cambridge attitude to art—"everyone here thinks it a queer sort of joke, this art business, and that a sensible chap must excuse himself for caring about it at all by a sort of shy laugh like a schoolgirl over an indecent book"; and he describes with fantastic exaggeration the rigours of family life at Failand on a Sunday morning. At last he has someone to laugh with him and, what, is equally important, to laugh at him. And then the laughter dies away, and he tries to put into writing "what I said to you yesterday when we walked up from Bourton in the twilight when the whole world was an accomplice in our transfiguration and the trees claimed a new familiarity and even the stars nodded mysteriously between the driving clouds. . . . Oh, I'm trying to say the unsayable." And what Roger Fry could not say that evening, in the twilight among the trees must be left unsaid by another.

They were married on 3rd December 1896. "The wedding was not so bad as it might have been", he told Lowes Dickinson. "And there was no sentiment or humbug about it. Everything most matter-of-fact and jolly in spite of some horribly well-dressed and gossiping Bath ladies. . . . You needn't be afraid that I don't want you. Can't you see the truth of your own quotation, that 'to divide is not to take away'?"

II

The honeymoon was spent, needless to say, abroad, and it was a time for both of them of "perfect happiness".

Happiness is a difficult emotion to convey in letters
written from a hotel bedroom with bags to be packed or
unpacked, with clothes and paint-boxes littering the floor,
and often "not a scrap of paper left to write upon". Yet
it was conveyed, and there it still is—a sense that every-
thing had fallen into place and all the odds and ends of
existence had come together to make a whole, a centre
of peace and satisfaction. The honeymoon was prolonged.
They loitered slowly through France, and then went on
to Tunis and Bizerta, where they stayed with the Vice-
Consul, Terence Bourke, "a jolly Irishman, a brother of
Lord Mayo", owing to whom Roger Fry, much to his
delight, "heard and saw more of Eastern life than one
could ordinarily through years of travel". A very long
letter to Lowes Dickinson gives a very full description of
what they heard and saw. One incident is perhaps worth
preserving. There was a service of the Isa Weir, a sect of the
Mahommedans. Would they like to see it? They said yes,
and were driven in a rickety mule carriage down to the
village. It was a wonderful pale-green moonlight night.
The village with its whitewashed domes and its mud walls
looked very mysterious. Strange figures wrapped in white
burnouses glided about. Then the service began. A holy
man "something like Edward Carpenter to look at", began
beating a tambourine, lifting it above his head and bring-
ing it down again in a kind of ecstasy. Others joined
in; for over two hours there was scarcely any stop in
the howlings and the jumpings; then the dancers were
seized with a wild passion, crushed glass in their teeth,
scraped their bare scalps with prickly pear leaves, and one
man plunged a sword into his belly. There was scarcely
any blood, Roger Fry noticed. "The only explanation
I can find of it is that it is some form of auto-suggestion
brought about by the music. . . . But I suppose the East
has always explored the subconscious self as thoroughly
as we have explored the ordinary consciousness." That
led him to ponder the difference between the Eastern

conception of life and the Western—"What is so extra-
ordinary about these people is that they have no idea of
movement. All the functions of life are regulated and
provided for—their religion prevents them from bothering
about a future life and so they actually live and enjoy
instead of preparing to enjoy as we do. . . . No one", he
reflected, "is disappointed by not getting what he hasn't
got because the idea of struggling and competition hardly
exists—everything is accepted as it is. They constater the
fact that they are poor or ill or wicked and there's an
end on't." Again, as at Venice with Symonds and Horatio
Brown, the atmosphere was sympathetic. It was a great
delight to find "a people who can't be vulgar or really
bad-mannered and who have complete *social* equality—in
fact a sheik talks on terms of absolute equality with the
man who serves his coffee at a few pence a day". Half a
page is given up to a sketch of the sheik, and that leads to
a description of a picture he is painting—a great classical
picture of the harbour at Carthage. And at Carthage
while he was painting his picture "Helen found a corner
of a capital sticking out of the earth and I grubbed it out
with a bit of potsherd and my nails. It was high up on a
bank of earth and took ages and nearly blinded both of us
but we were as excited as children digging in the sand and
finally got it out when it nearly crushed us under its
weight. It was a very ordinary Roman Ionic capital and
of course we could do nothing but leave it lying there,
but we felt we had made a great discovery."

The honeymoon was full of such discoveries. On they
went to Florence, to Naples and to Sicily. There is no
need to follow their progress in detail or to quote the rapid
notes of all they saw in full. The letters written, as usual,
post haste, on any sheet that came handy, on any surface
that happened to be flat, are crowded with descriptions,
with travellers' stories, all run together in one unbroken
flow of high spirits. Nothing went wrong—not even
a meeting with Sir Edward and Lady Fry in Sicily,

when there was a ridiculous scene with an eccentric
English woman who kept great dogs at large in her villa;
and the dogs set upon the party and Sir Edward "took up
an attitude something between Horatius Coccles and the
Vicar of Wakefield ready to die in defence of his family";
and "my mother carried on a sort of afternoon tea-party
conversation in the intervals of the dogs' remonstrances
and Mrs C. said shortly that it was a pity the dogs were
so nervous, poor things—she meant to get a really fierce
one soon. My mother horrified: 'Then I suppose you'll
keep him chained up?' Mrs C. indifferently: 'Oh no. We
shall keep him about the garden.' " Whatever happened,
savage dogs, trains missed, a handbag left on a café
table turned out to be a source of merriment and fun.
They read *Bouvard et Péchucet* together and laughed pro-
digiously; also the *Inferno*; they drank a bottle of wine to
celebrate the arrival of Goldie's letter, and Helen vowed
that she would dive into the sea next day and was made
to keep her vow. There were innumerable pictures to be
seen again with two pairs of eyes; there were pictures to
be painted and museums to be visited. "My museum
appetite", Roger wrote without exaggeration, "is a robust
one." Work and pleasure went happily hand in hand. In
blazing heat they visited Faenza and found it deserted;
the courtyards "all grown over with vine and honey-
suckle"; and noted the "beautiful simple-minded people
. . . with unconscious gestures like animals" as well as
the Donatellos. In blazing heat they reached Venice at
last. Symonds was dead now, but Horatio Brown was still
there and with him the old talks in the café were resumed.
Apparently, they discussed Symonds and his books; but
Roger Fry was no longer the ignorant art student sitting
at his master's feet. "I find Symonds", he told Lowes
Dickinson, "too much of an amateur in art. I like his
history better, but then I'm only an amateur in history."
Venice continued the train of thought begun in Bizerta
about life and the way to live it. "It makes me see

more clearly than ever that somehow beauty of life
as a whole (not the beauty of incidents and individuals
but the beauty of harmonious relations between people
and their surroundings) has somehow got reformed
and ballotted and steam-intellected out of the world."
Why should they submit to the unnatural conditions
forced upon them in England? Why not live in Venice, the
perfect life in perfect surroundings? "Now that we are here
of course we know that Venice is the one and only place
in the world that a mortal man can possibly think of
living in." The weather grew hotter and hotter, but they
delighted in the heat. They would get up at five in the
morning, hire a sulky little boy, and row out across the
lagoons in a sandolo. All day they loitered about, sketch-
ing, looking at pictures, talking with Horatio Brown in
the evening and bathing, until the heat at last grew too
much even for them. The flesh melted off their bones and
they fled across the Alps to the comparative coolness of
France. There they lingered week after week, and at last,
in the autumn of 1897, came home.

The letters to Lowes Dickinson and to R. C. Trevelyan,
are by no means models of composition. Commas drop
out, dashes insert themselves, sentences rush headlong
without beginning or end. And sometimes—"you see what
it is to be married—you can't keep a sheet of note paper
and its the last we've got to yourself"—Helen added a
page in the middle. But even Lowes Dickinson, who had
most reason to feel anxious about his friend's marriage,
could scarcely have doubted, as he read the many pages
that reached him from abroad, that Roger Fry had found
the wife who suited him, or that, whatever else life might
bring, the months of the honeymoon were the happiest
he had ever known.

III

The honeymoon over, the time had come to settle down.
A house had to be found; furniture extracted from the

warehouse, and the problem of making money enough to secure their independence to be solved. They were both of course to paint; Helen Fry had already some success as a decorator—Roger greatly admired a harpsichord that she was decorating for Arnold Dolmetsch; he was to paint, to lecture, to write articles, and if possible to come to grips with his book on Bellini. They were entering into negotiations with landlords, and proposing to R. C. Trevelyan that he should share rooms with them, when some slight illness, diagnosed by Roger Fry as rheumatism, made Helen Fry consult a doctor. He discovered symptoms of lung trouble and ordered them abroad at once.

Apart from the anxiety, the change was upsetting. The house had to be postponed, and engagements given up. Still, another visit to Italy was no great hardship, and Roger Fry was learning to carry on his work under all kinds of makeshift conditions. There were always pictures to see, and so long as he could improvise some sort of desk in his inn bedroom, he could fill yet another notebook with still more careful criticism. If it was fine, they could paint together, and in the evenings there was always a book to read—a learned German *kunstforscher*, a French novel, Dante, Baudelaire,—they read everything together; and their friends kept them supplied with plays and poems in manuscript. So the travels began again. Once more they went to Italy. There were one or two unpleasant incidents. Roger Fry was robbed of his pocket-book, containing what to them was the very important sum of ten pounds. On the anniversary of their wedding day they were almost suffocated by a faulty stove in the bedroom. But there were many pleasures. They made new friends from chance encounters, and old friends came out and stayed with them. Marriage, as Roger Fry had told Lowes Dickinson a day or two after his wedding, was not to mean an *égoïsme à deux*. And the theory was put into practice. Lowes Dickinson stayed with them in Rome. And once more they plunged into arguments about art, and Roger Fry was

again afraid that he had talked "too much rot about
technique". ". . . Indeed I was sorry all the time", he
wrote when Lowes Dickinson had gone back to Cambridge,
"that I was so immersed in pictures and so much in a
technical way that I got no time to get into your atmo-
sphere. I know you aren't complaining and you know I'm
not apologising for what was in the circs. inevitable, for a
place like Rome so bowls me over with its complexity and
the insistence of its purely sensuous presentations that I
can't get away from it. I can't think in the metaphysical
sense, not that you want me to talk metaphysics exactly.
But I mean that I can't get free enough from the im-
mediate to generalise. It's always been a little of an effort
to me. You and Jack [McTaggart] have always lugged me
panting though willing up your particular Parnassus and
—well, perhaps I've got a little bit out of it." But though
they diverged, Lowes Dickinson to climb the heights of the
metaphysical Parnassus, Roger Fry to explore the other,
the more sensuous and immediate, that was the inevitable
result of growing older. It was not the result of marriage.
Helen Fry did not interfere with her husband's friendships.
She was, Lowes Dickinson said, the wittiest woman he
had ever known, and, what was perhaps of more import-
ance, it seemed to him that she understood her husband
and gave him both the check and the stimulus that he
needed. To that, too, R. C. Trevelyan, who stayed with
them also, bears witness. And since his words throw light
from an outside angle upon a relationship that was of
intense importance to Roger Fry, they may be given.

She was certainly one of the most charming and intelligent
women I have ever known—I will not say intellectual, because
she was a little impatient of purely intellectual discussions and
ways of thinking—even in Roger. . . . Helen had none of
Roger's love of finding reasons for liking and disliking things.
. . . In a picture gallery, she knew at once what she liked and
went straight for it; and then Roger would try to make her
look at other pictures . . . to like works of art in the way in

which he himself liked them, and he would become quite sad when he failed. . . . She seemed to me to be very much devoted to Roger, and when she laughed at and teased him, as she sometimes did, it was never in a way that could hurt him. . . .

As for her appearance, she

may not have been really very beautiful; but she gave me the impression of being so. It is often so hard to distinguish charm and intelligence from beauty. Her movements were always graceful and unhurried and her way of talking too. She had a beautiful and expressive voice, and a quiet, humorous, often rather satirical smile. I think it was Roger who first put it into my mind that she was like the Spring in Botticelli's Primavera.

The old friendships it may be guessed were improved not spoilt now that they were shared with Roger's wife.

But happy as they were and hard as they worked, feeling sometimes, as Roger Fry said, overcome by the sight of so many masterpieces—"Italy makes one lose one's nerve—a malarious infection of humility creeps over one's soul"—a shadow little by little fell over them.

The illness which the doctor in London had diagnosed proved unimportant. But another anxiety, so vague at first that no reason could be found for it, took its place. Certain fears, whether reasonable or fantastic it was impossible to say, kept recurring. They moved from place to place in the attempt to escape from them. Roger Fry, it can only be said, did all that he could to help his wife; his patience and sympathy were indefatigable, his resourcefulness beyond belief. But her obsessions increased. And finally, when they came back to England in the spring, the blow fell. Madness declared itself. "I was a fool to be happy yesterday", he wrote to R. C. Trevelyan who was with him. "Last night she was worse. Nothing was omitted to make it horrible. We take her to-day to an asylum."

The agony that lay behind those words cannot be described but it cannot be exaggerated. To write of Roger

Fry as he was before his wife's illness is to write of some-
one who differed fundamentally from the man whom his
friends knew later. He was never again to know perfect
freedom from anxiety; the "beauty of life as a whole" was
shattered, and the centre upon which he depended was
shaken. The first shock was followed by the torture of
prolonged illness. Death, which then seemed to him the
most terrible possibility, was averted. But there were
harassing alternations of hope and despair. Sometimes he
was able to see her, again he was forbidden. Worst of all,
the doctors could give him no certainty as to the future
—the illness might be permanent, or again it might pass
as suddenly as it had come. He spent those terrible days
sometimes with friends—the Trevelyans, the Pearsall
Smiths, the Sickerts all did what they could for him—
sometimes alone. It was best, he found, to live as far as
he could in the country, and he found, as he was often to
find in the future, that the only way of facing the ruin of
private happiness was to work.

CHAPTER V

WORK

I

WORK was very necessary, if only to earn the money that was more than ever needed; and happily work was forthcoming. The *Athenaeum* made him at about this date their chief art critic; and the *Athenaeum* in those days devoted a generous space to art. They allowed their critic a column or two every week in which to express himself; and the public in those peaceful days, with time on its hands and a desire to cultivate itself, was willing apparently not only to be instructed about current pictures, but on technical matters—the use of tempera, for example, or the merits of Raphaelli's new colour sticks. They would suffer long disquisitions in very small print about Old Masters—whether a certain picture was from the brush of Bellini, or by one of his pupils. It was an opportunity of great value to Roger Fry, not only financially, but because it gave him a chance to clear his mind and to deliver himself of views that had been forming during these years of travel and intensive picture-seeing. He took advantage of it with extraordinary energy and independence. The mass of old newspaper cuttings is evidence of that, and if in time to come anyone should wish to trace Roger Fry's long and adventurous career as an art critic to its source, it is here in these columns of faded print. Even to the common seer, to coin a counterpart to Dr Johnson's Common Reader, to whom the names of Pesellino and Matteo da Siena mean nothing whatever, to whom English painting round about 1900 is an obscure tract of country and its figures shadowy enough, these old articles seem curiously alive, alert and on the spot.

Further, they are very amusing. This is the more remark-
able, because writing was often drudgery, and drudgery is
apt to leave its trace on the printed page. Nor was Roger
Fry a born writer. Compared with Symonds or Pater he
was an amateur, doing his best with a medium for which
he had no instinctive affection. For that very reason
perhaps he was saved some of their temptations. He was
not led away to write prose poems, or to make the picture
a text for a dissertation upon life. He wrote of pictures as
if they were pictures, and nothing else. But this itself led
to a difficulty. "When the critic holds the results of his
reaction to a work of art clearly in view he has next to
translate it into words." And there were no words. Often
in those early articles he makes shift with terms that
belong to the literary critic, or to the musical critic. He
often calls in Shakespeare to help him out with a quota-
tion, or Blake. Sometimes he gives up his attempt to express
his reaction; what he feels can only be expressed by music.
It was to take him many years and much drudgery before
he forged for himself a language that wound itself into the
heart of the sensation. And yet in spite of these difficulties,
perhaps because of them, it is plain even to the common
seer, even in these old articles, that here is someone writing
with a pressure of meaning behind him. He has a definite
idea of the critic's function. That is soon apparent:

> Mr Ricketts [he wrote in an early article] has tried to use
> the painful and laborious excavations of the Kunstforschern
> for the only purpose which in the end justified them, namely
> the more profound understanding of great imaginative crea-
> tions. This has to be done over and over again for each genera-
> tion. Pater did it to some extent for the last. Each successive
> performance of this work of appreciation and interpretation is
> based upon fuller knowledge and approaches nearer to com-
> pleteness and finality.

That was the fundamental idea that lay behind these scat-
tered notices, and it gives them their sequence, their serious-

ness. Though the notices may, and often must, deal with the
fugitive—Mr Walker's Twilight over Farringford Woods,
or Mr Patterson's Pink Roses,—each picture seems to
fall into its place, so that we feel we are taking part in a
planned and continued voyage of discovery. He makes his
statement positively, as if he had a weight of knowledge
behind him, nor is he afraid of speaking out—there is no
trimming or evasion. The voyage, too, is made on broad
lines—now we reach back to the early Italians, circle
round the French and Dutch, and reach the particular
picture laden with ideas gathered in other places. And the
excitement is great. However rapid many of the judgments,
however far they lead into unfamiliar regions, the theme
we are made to feel is of surpassing interest, the art of
painting is of the greatest importance. A few quotations
may serve to justify these claims, and, what is more im-
portant, will give some idea of the lie of the land and of
those bygone figures as they presented themselves to Roger
Fry when he went the round of the galleries as critic to the
Athenaeum about the year 1900.

In the first place, of course, the Royal Academy looms
up—the Academy was an important feature of the land-
scape. Roger Fry was by no means opposed to Academies.
They had a useful part to play. An Academy, he said,
might be "an effective organ of scholarly and academic
opinion". It might preserve "a tradition of sound crafts-
manship, a thing no more inherently impossible than a
tradition of good plumbing and of carpentering". And
Academicians in the past had done this—the tradition still
lingered among the older men. For the work of Etty and
Sant he had a great respect. And for the work of one living
Academician at least he expressed again and again the
highest admiration. Watts's portraits of Joachim, Garibaldi
and the Countess Somers he said "take rank with the
finest achievements of English art for all times". They
were enough to show that ". . . we are not altogether out
of sight and out of touch with that great and genuinely

academic tradition of British art. . . ." But the question
recurs again and again—"What does the Academy stand
for? What tradition does it uphold? What does it incul-
cate on its students?" And the reply also recurs—"The
Academy becomes every year a more and more colossal
joke played with inimitable gravity on a public which is
too much the creature of habit to show that it is no longer
taken in". He criticised the works of Academicians in some
detail and with considerable frankness. There was the
President himself, Sir Edward Poynter. "The president's
career", Roger Fry remarked, "shows how industry, and
decided specific talent, and strict attention to business,
combined with a certain fortunate commonness of feeling,
may lead to success; how gradually sentimentality may
take the place of imagination, and with what benefits
the change is attended." As for Mr Goodall, R.A., "one
rejoices that his geniality has never been warped by the
anxieties of thought or his complacency disturbed by
the ambition for imaginative creation". The Hon. John
Collier "is really outstripping the camera in his relentless
exposition of the obvious and the insignificant". Yet these
were the men who were officially at the head of British
Art, and in control of the endowments given by the State
for its encouragement. It was, he said, as if a theatre
endowed by the State for the production of classical drama
"pocketed its annual grant and proceeded to have
thousand-night runs of *Charley's Aunt*". In short, when he
contemplated the Royal Academy he was "often tempted
to think that as a nation we are incapable of the imagina-
tive life; and therefore fit for nothing but a harsh and un-
generous puritanism". The present condition of art in
England is chaotic.

Certain unacademic groups were, however, opposed to
this "vast formless resistent mass of commercial Philis-
tinism". Among them the most prominent was the New
English Art Club. The exhibitions held there were, as
he remarks again and again, the only exhibitions of serious

interest in London. There alone the critic had scope for
serious criticism. Again and again he singled out the works
of Steer, Conder, Sickert, Shannon and Rothenstein for
careful examination and praise. The praise was often
warm; but it was also critical, for reasons which he gives
at some length in an article upon the Exhibition held in
1902:

If we admit what is usually postulated of this society, that
the more serious and strenuous of the younger artists send their
work to its gallery, and that here, if anywhere, we should look
for some encouraging signs of regeneration in English painting,
the present exhibition can hardly induce an optimistic mood.
The very sincerity of these painters, the absence from their
work of the more glaring displays of vulgarity and senti-
mentality which distinguish the larger shows, bring into more
striking relief the poverty of their emotional and intellectual
condition. In saying this we do not mean any depreciation of
the individual artists. It is but their misfortune to have come
at a "dead point" in the revolution of our culture. But such a
point seems to have been reached. We are at a period which
is fiercely opposed to such a one as that of the early Pre-
Raphaelites, when fruitful and inspiring ideas were epidemic,
when the imaginations of even mediocre minds were stimu-
lated to attempt, and in some measure to achieve, things be-
yond the scope of their natural gifts. Now we have a good
display of talent—in the case of one or two men, of remarkable
gifts—and no sign of their finding a suitable investment for
them. If one were to judge by this exhibition alone one would
say that these artists seem paralysed by the fear of failure, that
they lack the ambition to attempt those difficult and dangerous
feats by which alone they could increase their resources and
exercise their powers by straining them to the utmost. Such a
landscape for instance as Mr Steer's Valley of the Severn (No.
120) shows what really great things he might produce if only
the conditions of contemporary thought favoured a more ad-
venturous spirit. . . . A lesser artist might be content with having
accomplished so much, but with Mr Steer we feel a sense of
disappointment that, having got so far, he does not push to

their utmost limits the possibilities of his idea. . . . If only
Mr Steer were to practise those powers of invention which in
past times have been accounted among the most important
parts of an artist's training he would be able to express with
far greater intensity his finely poetical feeling for landscape and
atmospheric effects. Doubtless it is vain to protest, for it is one
of the curious anomalies of the time that it is, as a rule, the
more capable artists who despise most the study of invention,
who are most influenced by a sophistical theory of aesthetics,
which denies them the full use of the pictorial convention. The
arbitrary rule that they have formulated is that they may leave
out anything they like in a given scene, but that they must
not introduce forms which do not happen to be there, how-
ever much these might increase the harmony or intensify the
idea.

These were some of the theories that he carried at
the back of his mind. But the theory had always to
be applied to the particular instance and that was not so
easy. The most famous of the artists who then exhibited
at the New English Art Club was J. S. Sargent. He
was being hailed both by the critics and by the public
as the greatest painter of his time. Roger Fry disagreed.
He condemned him instantly and unhesitatingly. "Mr
Sargent", he wrote in 1900, "is simply a précis writer
of appearances." Of his portrait of Lady Elcho, Mrs
Adeane and Mrs Tennant he wrote, "Since Sir T. Law-
rence's time no one has been able thus to seize the exact
cachet of fashionable life, or to render it in paint with a
smartness and piquancy which so exactly corresponds to
the social atmosphere itself. . . . He appears to harbour no
imaginations that he could not easily avow at the afternoon
tea-table he so brilliantly depicts." The portrait of Sir
Ian Hamilton made him exclaim, "I cannot see the man
for his likeness". And when he stood before Sargent's
portrait of the Duke of Portland he recorded his sensations
in the following order: "First the collie dog which the
Duke caresses has one lock of very white hair; secondly

the Duke's boots are so polished that they glitter; thirdly the Duke's collar is very large and very stiffly starched; fourthly the Duke was when he stood for his portrait sun-burnt. After that we might come to the Duke himself." But by the time he came to the Duke himself is so "deadened by the fizz and crackle of Mr Sargent's brush work that [he] can see nothing". Whatever other judges might say, Sargent was to him nothing but a brilliant journalist whose work had no artistic value and would have no more per-manent interest than the work of an expert photographer. Whether right or wrong, Roger Fry gave his opinion fear-lessly, for what it was worth.

But, happily, contemporary art round about 1900 was not exclusively British art. In 1906 the International Society held an Exhibition at the New Gallery. And there, it seems for the first time, Roger Fry caught a glimpse of Cézanne. As usual, he felt his way along the walls con-scientiously, noting first the sculpture. There was Rodin; there were two important works by M. Bartholomé; there was an excellent statuette by Mr Wells, and Mr Stirling Lee's portrait head was admirable as a treatment of marble, "though a little wanting in the sense of style". And then at last he came to the Bertheim collection in the North Room. There was a still life by Cézanne. In view of what he was to write later about that great master, this first glimpse may be given in full:

Here, indeed, certain aspects of the Impressionist School are seen as never before in London. There were, it is true, a few of M. Cézanne's works at the Durand Ruel exhibition in the Grafton Gallery, but nothing which gave so definite an idea of his peculiar genius as the Nature Morte (199) and the Paysage (205) in this gallery. From the Nature Morte one gathers that Cézanne goes back to Manet, developing one side of his art to the furthest limits. Manet himself had more than a little of the primitive about him, and in his early work, so far from diluting local colour by exaggerating its accidents, he tended to state it with a frankness and force that remind one

of the elder Breughel. His Tête de Femme (188) in this gallery
is an example of such a method, and Cézanne's Nature Morte
pushes it further. The white of the napkin and the delicious
grey of the pewter have as much the quality of positive and
intense local colour as the vivid green of the earthenware; and
the whole is treated with insistence on the decorative value of
these oppositions. Light and shade are subordinated entirely
to this aim. Where the pattern requires it, the shadows of white
are painted black, with total indifference to those laws of
appearance which the scientific theory of the Impressionistic
School has pronounced to be essential. In the "Paysage" we
find the same decorative intention; but with this goes a quite
extraordinary feeling for light. The sky and the reflections in
the pool are rendered as never before in landscape art, with
an absolute illusion of the planes of illumination. The sky
recedes miraculously behind the hill-side, answered by the in-
verted concavity of lighted air in the pool. And this is effected
without any chiaroscuro—merely by a perfect instinct for the
expressive quality of tone values. We confess to having been
hitherto sceptical about Cézanne's genius, but these two pieces
reveal a power which is entirely distinct and personal, and
though the artist's appeal is limited, and touches none of the
finer issues of the imaginative life, it is none the less complete.

One is reminded of a passage in his letters in which
he describes how on his honeymoon he had dug up
the head of a column in the sand at Carthage, with
a bit of potsherd and his nails. There for a moment
Cézanne is seen still half covered in the sand. But half
covered he still was and the critic had other matters to
attend to. His duties were not simply confined to going
round the galleries. The artist and the public had some-
how to be brought together. It was one of the critic's
duties to see that the artist was fairly treated by his pay-
master. And the artist, as Roger Fry was discovering, "is
intensely individualistic, and in proportion as he is an
artist, he finds it difficult to combine with his kind for any
ulterior purpose". It fell to the critic to mediate between

the two parties, and Roger Fry took the practical side of
his profession very seriously. He was in the first place a
fearless and outspoken critic of institutions. He attacked
the trustees of the Chantrey Bequest; he went at length
into the question of the administration of the National
Gallery. He pointed out that it is ruled by a body of
trustees "gentlemen of very various and in some cases of
quite empirical tastes . . ." so that the chances are that
"any work in which the characteristics of its own period
are strongly accentuated, any good work in short, will
arouse their vehement opposition". A body of trustees
will be bound to compromise. "Compromise which is the
deadly enemy of so absolute and definitely willed an
activity as art will rule all the nation's acquisitions." He
was of opinion that there should be one trustee with
absolute powers. And he was fertile and perhaps optimistic
in suggesting methods by which money could be raised
for the endowment of art. He suggested that "A tax of
one per cent. should be levied on all sales of works of
art, the tax to be levied by means of stamps, without
which the receipt will not be valid", a scheme, he said,
"so perfectly feasible, so simple and so likely to prove
efficient that one can hardly doubt that it will be put into
practice"—this was in January 1906.

Into these by-paths of the critic's duty he poured a
great deal of energy. But his main duty, so far as the
Athenaeum was concerned, was to keep his eye upon current
pictures, and to point out which tendencies were fruitful
and which barren. One more quotation will show how
keenly he scrutinised the present, and how eagerly he kept
his eye upon the future.

"We doubt", he wrote (19th November 1904), "if the
New English Art Club has ever had an exhibition to be
compared with this in importance . . . Mr Sargent, Mr
Steer, Mr Rothenstein, Mr John, Mr Orpen, to mention
only the best known artists, are all seen here at their
best." But he goes on to say that though they are at their

best, they belong to a group "whose traditions and methods
are already being succeeded by a new set of ideas. They
are no longer *le dernier cri*—that is given by a group of
whom Mr John is the most remarkable member."

The contrast between the two groups has been gradually
becoming apparent, and in the present show it is now clearly
perceptible, for the younger men are coming into the inherit-
ance of this power. The difference may be explained by their
approach to the thing seen. The older men are all more or less
impressionists, that is to say, they approach nature in order to
analyse it into the component parts not of the thing seen but
of the appearance. . . . But the younger men, really going back
to an earlier tradition, carry the analysis further, penetrating
through values to their causes in actual form and structure.
This they record, and then adding the particular and acci-
dental conditions of light and shade, and finally colour, regain
at last the general appearance. The older group, the impres-
sionists, are painters from first to last, and only draughtsmen
and chiaroscurists by accident; the younger men base all their
art upon draughtsmanship, and acquire the art of painting as
an afterthought. . . . We have no doubt that the younger men
in the group have got hold of the better method, a method
which allows of inexhaustible possibilities of expression and of
a deeper appeal to the emotions, and moreover that though it
may take them far longer to learn how to paint, they will
ultimately be able to paint much better, owing to their
methodical and deliberate attack. This year for the first time
Mr John gives promise of becoming a painter . . . at last he
has seen where the logic of his views as a draughtsman should
lead him. . . . Following out these stages he has arrived already
at a control of his medium which astonishes one by comparison
with the work of a year or two back. . . . One must go back to
Alfred Stevens or Etty or the youthful Watts to find its like.
. . . People will no doubt complain of his love of low life; just
as they complain of Rubens's fat blondes; but in the one case
as in the other they will have to bow to the mastery of power.
. . . In modern life a thousand accidents may intervene to
defraud an artist's talents of fruition, but if only fate and his

temperament are not adverse, we hardly dare confess how high
are the hopes of Mr John's future which his paintings have
led us to form. . . .

So the stream of comment and criticism runs on. It
had to deal with much that was trivial and much that
has proved ephemeral. A great many pictures of Farring-
ford in the Twilight, a great many bowls of pink roses
were painted forty years ago. Many of the theories here
sketched were worked out more fully in later years. Many
of the groups have changed their positions, and some of
the figures have changed their proportions. But whether his
judgment was right or wrong, it was an individual and
independent judgment. It went beneath the surface and
related the particular example to some general idea. Praise
and blame are both outspoken, yet they are always
directed towards the art, and not towards the artist. But
the quality which draws the reader past the ephemeral and
the accidental is one that is scarcely to be conveyed by
quotation. It is his power of making pictures real and art
important. Perorations about the function of art would
have been out of place in the *Athenaeum* even if the critic
himself had had a taste that way. But his belief conveys
itself, as such deep-seated convictions do, without the help
of set phrases, in his indignation, in his satire, in his under-
lying seriousness. Now and again it comes to the surface.
When Watts died, for example, he seized the opportunity
to do him honour because "he looked upon art as a neces-
sary and culminating function of civilised life—as indeed
the great refining and disinterested activity, without which
modern civilisation would become a luxurious barbarity".
Watts at least had always stood out against the view that
"art is only an amusement and luxury for the idle and
preferably the uneducated rich, that the artist is after all,
in Stevenson's phrase, a *fille de joie*". Whatever his own
deficiencies as a painter, this entitled him to an eternal
place of honour among the great "mob of commercial

philistines" who had reduced Victorian art in Roger Fry's opinion to a level of incredible baseness.

There is plenty of evidence then in these old articles that Roger Fry was qualifying himself to do that work of differentiation and interpretation which, he said, has to be done over and over again for each generation in order to bring about "a more profound understanding of great imaginative creations". They also show that he possessed the power of making the outsider, whose eyes are the least active of his senses, aware of something real and exciting on squares of coloured canvas. Further there is evidence that he was becoming capable of what he called "the painful and laborious excavations of the *kunstforscher*". He could state that a Fra Bartolommeo was really from the hand of Brescianino; or that "Lady Wantage's Adam and Eve is not we think by Bronzino, as stated, but by some Parmese artist, probably Mazzoloa Bedoli working under the influence of Parmegiano". But such feats of expertise were always to be subordinated to the critic's proper task and in themselves they were worthless. The critic, Roger Fry insists over and over again, must trust his sensibility, not his learning; he must lay himself open to all kinds of impressions and experiences; to science, to music, to poetry, and must never be afraid to revise a view which experience has altered. The muddle in which these old newspaper cuttings lie is perhaps symbolical—they are mixed up with passports, with hotel bills, with sketches and poems and innumerable notes taken in front of the picture itself. But there was another reason why it was impossible for Roger Fry to be content with the triumphs of a specialist. It is contained not in an article but in a letter. "I'm grinding away at my writing", he told R. C. Trevelyan in 1898, "but it's difficult to make the jump from Helen who seems all-important to the date of Bissoli's death for which I don't care just now a tuppenny damn."

II

Gradually Helen Fry recovered. By the beginning of 1899 he was able to bring her back to a small house that he had taken near Dorking. The relief was enormous. Happiness returned with a bound. "It is really so wonderful to be with Helen again and at last in a home of our own that I can hardly believe it is real", he wrote to his mother. Their plans for the future, the rooms in Berners Street, the artist's life where each was to work independently had to be abandoned. Great care was necessary; often he had to be doctor and nurse; and there was always anxiety in the background. Still, "The month down here", he wrote to R. C. Trevelyan, the friend who had helped him through the worst, "has been as happy as any we have either of us spent". And the letter goes on to say that Helen was laughing at him as he wrote it—"laughing at my pretensions as a lecturer".

The cultivated classes were beginning to take him very seriously, perhaps too seriously, as a lecturer. He was lecturing not only in the provinces but at Leighton House and the Albert Hall; at Cambridge he delivered a course of lectures on Venetian painting a syllabus of which remains. But a home of his own meant as usual visits from friends—Logan Pearsall Smith, the Berensons, Desmond MacCarthy—those are some of the names that recur in the old letters. They came; they dined; they talked. Faint echoes can still be overheard; Stephen Phillips's new play, *Paolo and Francesca*, was discussed—was it a masterpiece or a fake? Roger Fry had no doubt. "It was exactly", he declared, "what the English like, there's no harm in it, and no real poetry to shock and disturb them, and the consequence is that the critics are all tumbling over each other in their hurry to say that Sophocles and Dante aren't in it." He was reviewing books. A pile of books "as high as the tower of Babel and as intelligible I expect" stood on his table. Among them, however, was *Letters to John Chinaman*,

by Lowes Dickinson. He was enthusiastic: ". . . really", he wrote to the author, "I am amazed at the beauty of it. It seems to me the only eloquent prose I've seen for ages or that so far as I know anyone but you can produce, and the added chapters are the best of all. In some ways I think it's the biggest thing you've done yet—at all events you've let yourself go in bigger and freer flights. The last few years and all their disillusionment have made me think that eloquence and even rhetoric is not done with yet. The reasonable people can't afford to let their view be shown merely on its reasonable merits but must speak in the emotional language that the unreasonable understand. But what a people the Americans are," the letter goes on, for there was another book on his table, "I'm just reviewing a book on the great epochs of Art history by one Hopkins of Yale—the most amazing farrago of loose tit-bits of information all muddled up in his stupid colourless brain and tumbled out anyhow. . . . But for all this and for many other ills there is consolation in Max Beerbohm's show of caricatures. They are perfectly amazing. There is a series of John Bull . . . but it's no use describing them— they are really superb and a delightful revenge for much Pan-Anglo-Saxondom."

The usual plans and projects sprang up. A colony was to be founded, either in Italy or in Surrey, where life could be lived as a whole without interference from Pan-Anglo-Saxondom. That great project broke down, but there were lesser enterprises to be carried out; a book to be written by R. C. Trevelyan and illustrated by Roger Fry; the craft of printing must be investigated, and printers instructed how to print wood blocks; new magazines—the *Burlington,* the *Independent*—were being founded and were, as usual, to be better than any that had appeared before. "Bertie's article (*A Free Man's Worship*) I think very fine indeed, but I don't quite think resignation is a logical result of the attitude. I think indignation however fatuous would be more justified. Anyhow

his attitude is too exalted for me. I cling to a cowardly
'hope'."

His friends the writers were doing brilliant work. With
his own work, now that he was able to settle down to it,
he was by no means satisfied. "I loathe art criticism more
and more", to take one phrase from many to the same
effect, "and long to create." But the doubt remained,
could he create? Painting gave him the keenest pleasure;
but when the pictures were shown the critics were de-
pressing. From time to time he held exhibitions—with
Neville Lytton at the Alpine Club; alone at the Carfax and
at other galleries. All the critics, he complained, said the
same thing; what the critic of the *Westminster Gazette* said
may therefore be taken as an average sample. "Too
strong a critical faculty and too wide an acquaintance
with precedent are apt to act as a danger upon spon-
taneity. Sometimes we may suspect Mr Fry of thinking
too much of his models and trusting too little to his
instinct"—that was the usual verdict. His reputation as
a critic stood in the way of his reputation as a painter.
It gave him a label which the public read before it looked
at his work. And perhaps there was a grain of truth in
it. "Fry's pictures looked too much pondered", Alfred
Thornton wrote, "and I suggested once that he let
himself go and allow his sub-conscious mind some
freedom. His reply was that if he did 'the damned thing
would only produce a pastiche'." How far must the artist
surrender to the damned thing? And did Roger Fry with
his puritan upbringing and his Cambridge training repress
the damned thing too severely? The psychologist may note
that he had "given up day-dreaming when he was a boy
of sixteen". Again, when he found that a mood of
"egotistic exaltation" forced itself upon him when he was
listening to music, he gave up going to concerts. Perhaps
the subconscious mind resented this incessant inspection
and took its revenge. Or perhaps, as he claimed towards
the end of his life, the art which is produced consciously

and intellectually has its own quality, and it is a lasting one. At any rate, he painted indefatigably, pictures that were out of touch with his generation, with a queer mixture of obstinate belief in his own gift and of extreme diffidence. The critics were tepid; and he had no commercial success whatever. The usual fate of exhibitions held about 1900 is summed up in the account he gave of one of them: "My show has been a rather modified success. Rather poor notices in the press." Sixteen pictures had been sold, and he had made one hundred and six pounds. Criticism and odd jobs of expertise were forced upon him against his will.

But criticism with all its drawbacks meant seeing pictures, and seeing pictures meant foreign travel. Directly his wife was well enough they were off abroad. "I assure you", he wrote to his father, who had doubted the necessity of these journeys, "I don't waste my time. . . . It's solid hard work all the time." There he certainly spoke the truth. When he was in his sixties, he would spend six hours a day every day for two months going round the Berlin galleries—"and I am a quick worker". Picture-seeing when he was in his thirties, "filling up gaps" in his knowledge in the galleries of Berlin and Dresden, in Amsterdam and Madrid, must have been still more formidable. By way of proof, he was enraged when the Berlin galleries shut "at the absurd hour of three" in order that the officials might have "mittagsessen or something". If the public galleries were shut there were always private collections to be seen. Note-book after note-book was filled. Seeing pictures was the foundation of his work. "You see", he wrote to his father, "whatever success I have had has been the result of my Italian studies, not only in lecturing and writing, but in painting. It is there that I find the real source of all my ideas and there I must go often to get them. Even from a purely worldly point of view it would be very foolish to rest on my oars as it were and not keep constantly in touch with the latest ideas and constantly refreshed by new

investigations of the Italian painters." So they went, not
only to Italy, but to Germany, to Spain and to Holland.

To the end of his life he would never write a book or
deliver a lecture without seeing the pictures themselves,
whether a fresh sight confirmed his opinions or upset
them. And to his friends at home those journeys meant
that each letter contained a shower of comments upon the
pictures seen. He compared this year's sight with last year's
sight; was amazed by this, disappointed by that; revised
an old judgment, struck the track of a new one, improvised
a theory and pressed it to the limits. To quote these com-
ments in full would fill many volumes, and to select from
them so as to show his snailhorn sensibility trembling this
way and that would require the skill of a trained hand.
But one extract may be made, not for its critical interest
but because it shows Roger Fry sitting in a café and doing
what he always did when he had seen a picture—discussing
it with somebody else and comparing notes. "Helen", he
wrote, "won't come round to Correggio and she don't like
the Sistine Madonna. . . ." The words bring back to those
who went picture-seeing with Roger Fry in later years the
pause with which he would receive an opinion contrary
to his own. And then, after the first shock, and the sur-
prise, his eyes would light up—there might be something
in it. The remark would be taken, and explored, given
the benefit of every possible doubt, and returned to its
author, perhaps exploded, but certainly illuminated. To
have another pair of eyes to see with, another brain to
argue with, was a very necessary process in making up his
mind. And his wife's instinct, he always maintained, rightly
or wrongly, was much better than his own knowledge.
"Women", he wrote in an article at this time, "seldom
learn. . . . But if they have good taste, they rarely
sophisticate it . . . they have an instinct, a certainty and
rapidity of judgment which not even the most gifted men
can emulate." This opinion, he goes on to say, is based
"not on chivalrous grounds but from experience". There

can be no doubt that it was his wife who gave him that experience, or that whatever views she might hold upon Correggio and the Sistine Madonna would be carefully considered by her husband. But the letter continues: "In spite of all Helen's attempts to undermine my beliefs I'm almost annoyed to find that I really do always like the great artists. It would be cheering to say with conviction that Raphael was not so good as Fiorenzo di Lorenzo, but I can't." That too was always behind his delight in the expression of direct sensation—something stable, and serious, a standard to which all speculations must be referred.

So they went on seeing pictures in Berlin, Dresden, Amsterdam, Madrid, and at last, with the usual regrets at returning to the land of the Philistines, came home. England among its many drawbacks of convention and climate always meant work—the work of writing and of lecturing, which had to take precedence of painting. He had to make money, and he had to take whatever work offered itself. It came from many quarters and it took him during these years (1900–1906) in many different directions. Now he was lecturing in Glasgow; now painting a Band of Hope banner in Guildford; now helping to build a friend's house and overseeing workmen; now he was "just back from a wild journey to the Highlands, whither I went to report on two portraits in the house of a Highland laird. . . . Next week I must go to Paris, Brussels and Ghent." The words show that his reputation as an expert was growing. He had no great respect for expertise; often enough he said sarcastic things of those who can only like a picture or trust themselves to buy it if assured by an expert that it is "genuine". But it was fortunate for his purse that such people existed and some of the tasks they set him gave scope for his ingenuity and skill with his hands. "I've restored various old masters with a power of imitating various styles which is I suppose a proof that I haven't one of my own—but it's vastly intriguing work and brings in some of the increasingly necessary money." It was exciting to

clean a picture that its owner thought worthless and to find "a very good Florentine Madonna and Child underneath". His visits to Paris and Italy were often on matters of business—flying visits that sometimes led to exciting incidents—one for example that reads something like a sketch for a story by Henry James. At Vienna there was an impoverished nobleman who, forced to part with his family collection, sent for Roger Fry to verify some of the ascriptions. Together they went round the gallery of reputed masterpieces. At each Roger Fry's heart sank—it was a fake. Each time he had to declare that the Van Dyck or the Raphael or whatever it was called was worthless. And each time the Count remained unmoved. Finally Roger Fry saw unmistakable signs of a well-known forger's hand and named him. The Count started with surprise. It was true—the man in question had been a friend of the family. The Count himself had always had his doubts. In fact he had always thought the collection a very poor one. And he was so delighted that his taste was confirmed and so impressed by the insight of the expert that, in spite of the fact that the verdict robbed him of a fortune, he was in the best of spirits and so won Roger Fry's heart "by the perfect simplicity and candour of all his transactions with me . . . that I gave him a very good dinner and we parted excellent friends".

Then again there was an experience of the very opposite kind—the discovery in a Venetian palace of two large pictures which the experts rated very low and Roger Fry was positive were in fact by Jacopo Bellini. They were for sale at a ridiculous price if he was right. But suppose he was wrong? He risked it, and wired home for the money. Very generously Sir Edward advanced it; the pictures were bought, packed and sent to London. There "Sidney Colvin fully endorsed all my views about them and considers them as the unique survivals of the great works that Jacopo Bellini did for the Venice Scuolo. But he thinks that the present authorities of the National Gallery will

not seriously look at them and he says no one of the
Trustees will understand their historical value." Eventu-
ally a sale, though not to the National Gallery, justified
his boldness, and his reputation was increased.

What with flying visits to the Continent, what with paint-
ing and writing at home his hands were full enough; but
he could never resist embarking upon any enterprise that
seemed promising. Perhaps the Quaker blood in him was
responsible for the ardour with which he threw himself
into such crusades. The cause was different but the zeal
was the same. And perhaps from some old Eliot or Fry
who in bygone days had made a fortune by chocolate-
making or shipping he had inherited not only a strong
interest in practical affairs but considerable though un-
trained business ability. Demands were frequently made
upon it. There was the *Burlington Magazine*—in the autumn
of 1903 it was *in extremis*. It had been run on insufficient
capital "and with absolutely no business method". It could
not be left to perish; it must be revived and given wider
scope. "I believe the only thing to save it is this . . ." he
wrote to Charles Holmes. There followed not only an
urgent appeal to Mr Holmes to take the editorship, but the
most strenuous efforts on Roger Fry's part to secure the
capital. "On this errand we tramped about London
together", Mr (afterwards Sir Charles) Holmes wrote.
"Fry . . . was simply magnificent. No rebuff could shake
his determination to carry the matter through. . . ."
Friends were appealed to; millionaires approached. Some-
how the money was found; somehow the magazine was
started afresh.

The quiet painter's life was always being interrupted by
demands from the other world, the practical and active
world where trains start punctually and business men are
waiting to keep appointments. Nevertheless, he managed
during those years to publish two books—the *Bellini* (1899)
and his edition of *The Discourses of Reynolds* (1905). A first
book is apt to lay a load upon a writer's vivacity, and this

first book seems, to the ordinary reader at least, less vigorous and less characteristic than the articles that were dashed off simultaneously. It is a little elaborate and literary, as if he were still in thrall to the literary associations of pictures, and had not found his own way to his own words. It was successful however—on the strength of it he was made art critic of the *Pilot*. But in the *Reynolds* he speaks with his own voice. His voice had only to provide an introduction and notes, but it is clear that he found in Sir Joshua not only a great critic—he gave, he said, "the truest account of the function of an art critic that has ever been framed"—but a critic after his own heart. Sir Joshua too was a painter as well as a critic. He too had to fight against "the demands made upon art by the untrained appetites of the public". He too believed passionately in the importance of art; he too was disinterested and praised the work of contemporaries. In writing of him, Roger Fry praised the qualities he most admired and most wished himself to possess. Indeed, in the last year of his life he wrote, "Looking back on my own work, my highest ambition would be to be able to claim that I have striven to carry on his [Reynolds's] work in his spirit by bringing it into line with the artistic situation of our own day". Both books, like many of Roger Fry's books, increased his reputation, but when the first edition was sold out, there was not enough demand to cause them to be reprinted.

But he was a cool and dispassionate parent of books. He cared very little what was said of them compared with what was said of his painting. And another and more absorbing form of paternity came to him during those years. The doctors no longer forbade the natural wish that both Helen and Roger felt for children; and their first child, a son, Julian, was born in March 1901. It was a very anxious time, but everything went well. "He looks very jolly curled up asleep in Helen's arms", he wrote when the baby was born, and though momentarily

crippled—he had been thrown riding "with that hippo-
maniac Goldie"—he was sitting with his wife, sketch-book
in hand, preparing to make "innumerable bambini
drawings". Another child, a daughter, Pamela, was born
in 1902. For a time it seemed that the centre was safe
again, that a happy life with wife and children was
assured. "I can never tell you", he wrote to his mother,
"what enchantment and happiness Helen has brought
me." As for the children, "they are really a pure joy to
us", he wrote; and the letters become full of childish
stories. Their games, their gifts, their doings—all this fills
pages in the letters to Failand. He was an enthusiastic but
perhaps a puzzling father. He was determined that his
children should not suffer what he had suffered. There was
to be no moral censure from their parents; no lack of simple
humanity in their upbringing; no floggings when Julian
went to school. He was not alarming as his own father had
been; but his sympathies sometimes seemed perverse—he
could not understand how any boy could like school; he
was delighted by any sign of rebellion. And perhaps to
reverse the ordinary standards is in its way as alarming as
to accept them. Fortunately, however, the nursery came
before school, and in the nursery there were toys—he
made a water-wheel from a piece of tin and a hollow
parsley stalk; he made a sailing boat—"the first that ever
really sailed"; and these, his son writes, "have always been
bright stars in my memory and have had associations of
joy above all others". And his daughter of course was given
paints and brushes as soon as she could use them, and her
childish scribbles were kept by her father, for they suggested
"what an astonishing natural gift for art" children have
before teaching has ruined them. Then, as they grew older,
there were expeditions—"bicycling from Oxford through
the Windrush valley to Fairford, walking from Guildford
to Canterbury . . . rowing down the Thames from Oxford
to Maidenhead, with anecdotes of Goldie and of Wedd
thrown in. . . . The rare occasions when Roger was able to

be with us, or better still to go out with us were very ex-
citing", his son wrote of those childish days. But inevitably
those occasions were rare. There was very little time to
spare, however carefully he contrived "to fit things in".
With two children in the nursery it was difficult to travel
with his wife in the old way. A cycling tour in France had
to take the place of the old rambling journeys through
France to Italy and back again to France. The expenses
of family life—"I am suffering from suppressed doctors'
bills which are coming out like the measles", he com-
plained—meant that he was hard pressed to make both
ends meet. But for a time happiness returned, the domestic
happiness that he had always wanted. There were, he
told Lowes Dickinson, two kinds of happiness, one of
"tantalising ecstasy", the other of "comfortable reci-
procity". It was this last that he preferred: ". . . there's
something infinitely satisfying in the mere mass of affection
two people accumulate between them in a number of years
of quite close intimacy—but then boredom must never
have to be suppressed—with us I feel that it has never
begun to occur, but then I'm a lucky one in this at all
events and I think I'd rather be fortunate so than have all
the other sorts of success".

That letter was written from London—they had moved
to Hampstead (22 Willow Road) in 1903. But the happi-
ness described there was not to last. "It seems", he wrote
to his mother, "as if one never could get free from constant
anxiety, as though peace and security always eluded us."
During those years at Hampstead Helen Fry's health was
constantly threatened, and with the children to consider
a new load of responsibility fell upon him. Whatever plan
the doctors could suggest, he followed out with a devotion
that amazed them. He carried on his own work under diffi-
culties that need no description, always hoping that his
wife's health would be restored, always undaunted when
once more that hope was shattered. At one time he was
tempted to leave England for good, but he had his living

to make, and for that London was essential. "The break is too difficult", he wrote when a scheme for settling in Italy had to be abandoned. "And I must grind on in the old mill."

<center>III</center>

It was becoming more than ever necessary to find some employment less precarious than journalism upon which he could depend for an income. "I hope that some post like a Slade professorship may fall to my share ultimately", he wrote in 1902. And in 1904 the Slade Professorship at Cambridge was vacant. He collected the necessary testimonials, and was very sanguine, he told his father, about his chances of success. Many people in the art world, according to those old testimonials, thought that he was "peculiarly fitted for the post". He appeared to George Prothero, for instance, "to possess an *ensemble* of qualifications for the duties of a professor of Fine Art which it would be difficult to surpass". He was, the various witnesses testify, frank and independent; original yet learned; he had a mental and physical energy which were rare; he was an expert and experienced lecturer; and the tendency to over-severity which, in the opinion of Walter Armstrong, was a "debatable point" in his criticism, became a virtue in a professor. In short, there seemed to be considerable agreement among experts that "no critic and historian of Art in England is better fitted for the post than you are". But he failed, and it was a bitter disappointment. "It is a very serious blow to my hopes", he wrote to his father (June 1904), "and I find but little consolation in the indignation that the appointment has aroused in Cambridge. I gather that the King expressed a wish for Waldstein's election, and that Poynter showed a very determined antagonism to me." The articles in the *Athenaeum*, he might have reflected, had done nothing to ingratiate him with the President of the Royal Academy. And he minded the failure also because of its effects upon his parents. He had

disappointed them again. "I feel", he wrote to his mother, "that my want of worldly success has caused you more and more anxiety, and that you have felt that it must be my fault. So no doubt in a sense it is, that is that if I were a different kind of person with different ideals, I might have succeeded more conspicuously. . . ." It seemed, he said, "an endless uphill fight" and he needed all the encouragement and sympathy that she could give him. Since he had failed at Cambridge, it was necessary to look elsewhere.

Among the collectors who had employed him to buy for them was the most famous and the wealthiest of them all—Pierpont Morgan. He had not only a great collection of his own, but he was one of the trustees of the Metropolitan Museum at New York. He had already sent Roger Fry to Liverpool to report upon a picture for the New York Gallery, and Roger Fry had already recorded his first impressions of the millionaire. They were mixed. He described him as "the most repulsively ugly man", "with a great strawberry nose" who behaved "like a crowned head"; but there was no doubt that he was "a very remarkable and powerful man". Suddenly, while he was still suffering from the disappointment about the Slade, and considering another possibility—that he should become the head of the British School at Rome—the Metropolitan Museum cabled to ask him to sail at once to New York. It was Christmas, and he had to take the next boat, but he decided to go. "I can't tell you what it is precisely that the Americans want of me," he wrote to Lady Fry, "but there is no doubt that certain very influential people there are getting disgusted at the way they are being cheated by the London dealers and I think they have pitched on me as a person who might give advice on pictures over here. . . . The chief persons behind all this are the Trustees of the Metropolitan Museum of New York which has more funds at its disposal than any other gallery in the world, so that I hardly think I could

hesitate about going, much though I dislike rushing off just now."

This first visit to America was short and crowded with conflicting impressions. He found himself at once much more of a celebrity in New York than in London. Cultivated Americans, he found, had read his *Athenaeum* articles and had been impressed by them. He was fêted in the most imposing way. The scale of the eating and drinking and speech-making amazed him. He was present at a great banquet of which the toast list remains, illustrated in pencil with portrait heads of some of his fellow guests. He stayed with Pierpont Morgan and was astonished by the luxury of millionaires. He travelled in the great man's private car tacked on to the end of a private express. It was snowing, and a log fire was lit in the car, which was "fitted up like a private house in the grandest style". It appeared that they wanted him to become Director of the Metropolitan Museum under Sir Purdon Clarke. The decision was difficult. "There is no doubt", he wrote to his mother, "that with the immense wealth here and the growing enthusiasm for pictures I should have a very big position, or at least the possibility of making one. I needn't say that I am tempted to accept. It seems so much better to have a free field for one's activities and real scope for one's knowledge than to be for ever browbeaten and snubbed as I am at home. But it's very difficult to think of making one's home over here for some years and of course it would mean that." It would also mean that he was much in contact with Pierpont Morgan, who was "all powerful" at the Museum. And Pierpont Morgan, seen at close quarters, was not altogether prepossessing. "I don't think he wants anything but flattery", he wrote home. "He is quite indifferent as to the real value of things. All he wants experts for is to give him a sense of his own wonderful sagacity. I shall never be able to dance to that tune, so that it is more than doubtful if after all America will come to anything. I must be quite inde-

pendent in my judgements and behaviour and if Morgan
is too great for that we had better part company. . . . The
man is so swollen with pride and a sense of his own power
that it never occurs to him that other people have any
rights." The difficulty of submitting to Morgan and the
difficulty of transporting his family to America decided
him finally to refuse. He told Morgan "quite politely" and
Morgan was "very furious". If proof is needed of the
curious power that Roger Fry possessed of charming
millionaires even while he enraged them, it is to be found
in the fact that he persuaded Morgan in spite of his fury
to subscribe a thousand pounds to the *Burlington Magazine*.
He also arranged that though he would not accept the
post in New York he would act as buyer to the Museum
in Europe. It was a compromise that allowed him to live
in England, and there was always the chance that some
appointment in England would be given him.

In fact, no sooner had he come back to England than
the possibility presented itself. The post of Director of the
National Gallery was vacant, and Roger Fry heard on
good authority that the choice "lies between Sir Charles
Holroyd and myself". It was the one post, since post he
must have, that would have suited him. Again he was
sanguine—he was even so bold as to think not only that
he would be made Director but he would make a good
Director. Sir Charles Holmes gives an amusing account of
Roger Fry's experiences when he offered himself as candi-
date for the office. "The Prime Minister, Mr Balfour," he
writes, "a professed lover of the arts, did absolutely
nothing for them that I can remember, and through this
critical year of 1905 left the National Gallery without a
director. Claude Phillips was getting old and had made
enemies, as active scholars in those days were bound to.
Fry, in consequence, became the fancied candidate, and
gave me an illuminating account of his interview in
Whitehall. After explaining what he had done in the
world of art to a high official, who appeared to understand

and to care very little about the matter, he was finally asked, rather testily, 'Yes, but isn't there *anyone* whose name we know, who could tell us something about you?' Fry was nonplussed. At last he timidly ventured, 'Perhaps my father, Sir Edward Fry. . . .' 'What!' interrupted the other. 'Are you a son of Sir Edward Fry? Why didn't you say so at once? That will be all right.' " But in spite of Sir Edward Fry's great distinction as a lawyer, the appointment was delayed. It was delayed until the trustees of the Metropolitan Museum had revised their original offer and had made one that allowed him to spend most of the year in England. His circumstances being what they were, he was forced to accept it. No sooner had he done so, and was on the point of sailing for America, than Campbell-Bannerman wired to say "that he was anxious I should be appointed to the National Gallery". The compliment, Roger Fry said, was gratifying; but it had come too late. "So Holroyd's appointment to the National Gallery followed in due course", says Sir Charles Holmes, and Roger Fry left for America.

The incident created some little stir at the time. There were references to it in the newspapers. Roger Fry, it seems, was criticised for giving his services to America instead of waiting until his native land had decided whether or not it wanted him. In London the gossips ran about giving advice and proffering help. The post was still open; he had only to break with America and it would be given him. Helen Fry recorded some of these suggestions with caustic comments of her own in letters that reached her husband when he landed in New York. His friends in England were rueful even while they congratulated him. "I wish you were going to buy pictures for us here", wrote Arthur Clutton-Brock. "We want someone to do it very badly indeed." And McTaggart wrote: "I have been busily employed in addressing congratulations on your appointment—not to you, not to New York, but to myself —the one person, you will observe, in this universe who

always scores. It is not well for people to differ from me. They always come to a bad end. I have always thought that the wicked will be damned by sending them to heaven and letting them be intensely bored there. Even so it is happening to you on this earth. Who, my ethereal Roger, is Pan-Britannic now?

"But, sincerely, while I am awfully glad you have got a post which is worthy of you, I wish it was for England that you were collecting pictures. Still, it is America, and it's not Germany."

There is no doubt that Roger Fry too wished it was for England and not for America that he was to collect pictures. He would have liked to direct the National Gallery; he had no reason to feel sure that he would suit the Metropolitan Museum. And for a time the English post remained open and tentative offers were made to him. But he had given his word to the Americans and neither he nor his wife thought it possible to go back upon it.

AMERICA

I

By the terms of his agreement with the trustees, his visits to America were to be short; he was to spend two or three months yearly in New York. What he saw of America therefore was very limited, and his impressions naturally were full of sharp contrasts, now favourable, now unfavourable, laid side by side but never summed up. He begins: ". . . wonderful as the first view of New York is it seems a fierce and cruel place, monstrous and inhuman, so that in spite of the voyage [which had been detestable] one scarcely wants to land". When he landed he had no time to prowl about the streets with a sketch-book, as he liked to prowl about the streets of new towns, letting the character of the place sink in. He had at once to focus his attention upon the Museum, which was, he said, "in a state of chaos". But as soon as he found his feet he began clearly to enjoy the stimulus and excitement of New York. He was asked out everywhere. For the moment at least he found that he was "quite the rage". It was a new experience, and, in spite of the strain "of being on parade with fresh people constantly", one that he enjoyed. He was sociable; he enjoyed talking—even after-dinner speaking amused him. And it was remarkable, after the apathy, the browbeating and the snubbing of the English, to find that New York "is wildly excited at what I'm doing and going to do. . . ." His days filled themselves completely. "I get up at 8.0, down town to see pictures at 9.0, then to the Museum till 5.0, then calls, then dining out at a fresh house every night and then bed." The dinner parties led

to friendships: soon "the Americans" became separate
individuals, with some of whom he formed lasting relation-
ships. "Yes," he wrote to Lowes Dickinson, "it's mighty
queer but I meet more and more nice people—European-
ised and sensitized and they are all very keen to help the
new ideas at the Museum. . . . My two trials are the
American artists who keep asking me to say that theirs is
the greatest art the world has ever seen, and the Million-
aires—the latter fortunately nearly all away just now. The
in-between people are all right even when rich, and a few
quite delightful. I've got as an assistant one of the most
charming creatures I've ever met, a young and unsuccess-
ful but quite good artist called Burroughes, a man who
has never bothered about anything but just gone his own
way—with no money and no reputation but with peace
in his heart." There was also a ruined French aristocrat, a
Mons. de Beauvoir "who knows everything, has the most
perfect taste and manners of the Ancien Régime. Instead
of being my rival, and he was already installed as arbiter
elegantiarum when I came, he has done all he can to
befriend me and been in fact all that one doesn't expect
from a cher confrère." This gentleman, unlike Roger Fry,
was an anglophile, so much so "that he goes close to the
subway exits parceque c'est la même odeur que celle du
Tuppeny Tube". "Like all other Europeanised people
here we make signals of distress to one another in this
weltering waste of the American people. It is strange what
an invariable bond of sympathy this instinctive hatred of
America as it exists to-day is—tho' many believe in the
future. I suppose I do, as I'm investing so much in it. . . ."
 In spite of this instinctive hatred of the weltering waste,
he felt that America offered him a great opportunity. He
was sure that he could "do a lot for [Burroughes] and for
the other young who here just as much as in England,
perhaps more, are crushed by the regular commercial
organisations—the Academies and societies. One of them,
a young Jew, is really first-rate and quite unrecognised."

To help the young and unrecognised in their fight against commercial organisations was as much his duty as his work at the Museum. And he hoped too that he could do much for the Museum. "I am allowed so far", he continued to Lowes Dickinson, "to do what I want, and have bought heaps of pictures. I have got them at ridiculously low prices and quite fine things. Lotto, Goya, Guardi, Murillo, Bugiardini and so on, and am getting ready a great gallery, a sort of Salon Carré, where all the real things will be seen in the hopes that it may throw a lurid light on the nameless horrors of modern art which fill the remainder."

He worked very hard, and, so long as he could do what he wanted, he enjoyed his work very much. But as he foretold, it required "great tact to navigate one's way". And tact, a virtue that he never held in high esteem, if by tact was meant flattering the susceptibilities of officials, was not always at his command. Difficulties soon arose about his tenure of office. He had stipulated that his visits were to be for three months yearly; he soon found that the trustees expected him to return in the spring. "It's too disgusting. I think there'll be a big flare-up and perhaps I shall get notice", he wrote home. The difficulty was arranged; Morgan for the moment was in high good-humour and upheld him against the other trustees; and an agreement was come to. "It gives me power with the Director and Assistant Director to withdraw pictures—to restore them—to repaint galleries and it establishes the idea of serious as opposed to frivolous art", he told his wife. His hopes were high. He had plenty of scope for his abundant energy; he had been able to buy more pictures than he had expected—more, he was sure, than he could have bought for the National Gallery in the course of many years. He did not regret that he had closed with the American offer, in spite of the fact that overtures were still made him from home.

But the real difficulty he soon found was not with the

Director nor with the trustees. It was with the President of
the Metropolitan Museum, with Pierpont Morgan himself.
Mr Morgan, according to his biographer,[1] wished to be as
great a power in the world of art as in the world of
finance. And he saw little difference between them. He
was "a cheque-book collector. . . . He bought in batches.
. . . He did not believe in giving the dealer a large profit.
In the midst of a dicker he would turn his terrific eyes full
upon his visitor and exclaim: 'I have heard enough. I'll
take this at the price you paid plus fifteen per cent. How
much did you pay?' " By such methods he was "set upon
making the Metropolitan Museum the finest institution of
its sort in the world". And he was also set upon owning
the finest private collection in the world. He expected
Roger Fry to help him to achieve both these aims.
Naturally, this led to much conflict between them. The
great man's vanity was prodigious and his ignorance was
colossal. Sometimes he was ready to take advice; some-
times it infuriated him. And besides advice he required
flattery. He liked to look upon himself "as a modern
counterpart of a gorgeous Renaissance Prince" and
needed support in that romantic conception. Both as
Curator of the Paintings at the Museum and as private
adviser Roger Fry had much to do with him, and the more
he saw of him the more difficult he found it "to dance
to his tune". Helen Fry had several times to warn him that
tact was necessary, and to encourage him to persevere
when difficulties seemed insurmountable. "Helen", he
wrote, "never doubts that one *can* do things." And for a
time all went well.

The work at the Gallery was absorbing in itself, and it
enabled him when he came home to drop his journalism
and to write articles on less ephemeral subjects for the
Burlington, the *Independent* and other magazines. His re-
putation as a critic was growing—he was becoming, Sir
William Rothenstein wrote, "the only English critic with

[1] *The Life of J. Pierpont Morgan*, by John Kennedy Winkler.

a European reputation". But there was now a difference—
he was no longer merely a critic; he was a critic with money
to spend. It was one of his duties to buy pictures in
Europe for the Metropolitan Museum; and as master of
an American purse he was a very important person in the
world of picture-dealers. That world he discovered was a
very strange one. Sir William happened to be in his com-
pany when he was considering the purchase of a Renoir for
the Metropolitan Museum. It was strange, he writes, that
"the once shy and retiring Fry should be swimming in
such dangerous waters". On this occasion "A fashionably
dressed and attractive-looking lady showed us over the
collection. While Fry was occupied the lady joined me.
What taste and knowledge Monsieur showed . . . perhaps
Monsieur was married. . . . No doubt Monsieur found life
expensive and so forth. I wondered at her interest in a
stranger, before I realised that since Fry consulted me
about various pictures, she thought my influence was of
importance, and was hinting at a bribe!" Such hints and
blandishments were of course given much more frequently
and persuasively to the Curator himself. ". . . I have had
some tremendous revelations of the way things are done
and of how difficult it is to stand out against the system of
secret commissions which honeycomb the whole business",
Roger Fry told his mother. His stories of the sharks who
haunt those dangerous waters, and of the baits and bland-
ishments which they dangled in front of him, were many
and amusing. One letter may be quoted to show how he
dealt with one of these gentry in particular:

 22 WILLOW ROAD,
 HAMPSTEAD,
 July 22, 1905
SIR,
 You are entirely mistaken as to my position. I am the in-
dependent art critic of the Athenaeum and not a dealer nor
am I in the habit of doing the kind of business which you
suggest is best done after lunch. I could not under any circum-
stances have interested myself in the *sale* of your picture. The

tone of your letter is such that any further communications I
may see fit to have with you will take place through my
solicitors.

<div align="center">Yours faithfully,</div>

<div align="right">R. E. FRY</div>

But if his possession of an American purse had its dangers
and brought about tremendous revelations, America was
giving him the greatest opportunity that he had yet had.
There was far more enthusiasm for art in America, he
found, than in England, and the interest that was taken in
his work at the Museum astonished him. Complaints indeed
were made that he was too active; that he had cleaned a
Rubens too thoroughly, and that he had paid too much
for a Renoir. But his reputation was very high. He gave a
series of lectures that were "quite a huge success"; and he
found that "any number of people" were ready to pay him
twenty guineas for an opinion. His popularity as a social
figure waned of course; he found, rather to his relief,
when he returned, that he had been "moved out of the
lion's cage into the smaller carnivora". But he went out
a good deal and American society continued to puzzle
him. The contrasts were so violent. "I meet pretty often
men of the finest culture and the frankest openness and
genuineness"—men like Mark Twain for example, whom
he sat next at dinner and found "a really fine generous and
liberal minded gentleman, altogether one of the fine men"
—"but", he continued, "the contrasts are amazing. . . . I
sometimes wonder whether this society isn't drifting back
to sheer barbarism. . . . The trouble is that no one really
knows anything or has any true standard. They are as
credulous as they are suspicious and are wanting in any
intellectual ballast so that fashion and passing emotions
drift them anywhither" (to Sir E. Fry, March 1906). The
Quaker in him, if his hatred of pretence and ostentation
is to be attributed to that ancestral presence, was
shocked. "The injustices I hear of are almost incredible,
but that I have good authority. Everyone feels that this

state of things can't last and that the good people must
come forward again." And then again he met many of
"the good people"—Europeanised Americans as he called
them, William James, whom he admired greatly; "the
wonderful and eccentric Mrs Gardner who has made the
most remarkable collection of modern times and is alto-
gether a woman of extraordinary force of character"; and
Russell Loines, with whom he paddled in a canoe in New
Jersey. These were people who would have been remark-
able anywhere. On the other hand, America itself even in
the Fall when "the trees are all one solid mass of colour,
golden brown, deep claret, and most wonderful of all a
pale rosy mauve like the colour of some chrysanthemums",
did not attract him greatly. It was too like England and
not enough like itself. "One expects a new continent to be
more original", he complained. He vacillated from warm
admiration to bewilderment and denunciation.

But general reflections upon America were always
being interrupted by doubts as to his own position. That
was becoming more and more precarious. It was partly
his own fault—he could not conceal his opinions. "The
one criticism of myself that comes back to me in round-
about ways is that I have not yet learned not to say what
I think", he wrote home. "But I'm not in a hurry to
mend it." He said what he thought, even when it was the
opposite of what the President thought. And the President
was omnipotent. To Roger Fry's amazement, no one
dared withstand him. Therefore, "one never knows what
turn things at the Museum may take". But the best
account of this peculiar relationship is given in a description
that Roger Fry wrote many years later of a journey
that he made with Pierpont Morgan in 1907. There was
an exhibition at Perugia, and Morgan summoned his
adviser to consider possible purchases for the Museum.

I was asleep at the Grand Hotel at Perugia one morning in
May 1907 when a knock at the door woke me and the Cameri-

era entered with a card. The Count Torelli urgently requested
a short interview. I sent word I would be down soon, dressed
and went into an empty room on the ground floor where the
Count, young, dandified and weakly sympathetic, greeted me
with anxious effusiveness. What did he want? I knew the
answer beforehand,—family heirlooms to be offered to Pierpont
Morgan still sleeping upstairs in the arms of the elderly and
well preserved Mrs Douglas. What were they? Chinese pictures
rather recently imported and an immense eighteenth-century
carpet spread all over the floor. The poor Count had rushed
from Rome to Perugia to catch some of the golden shower and
there they were displayed. Would I do what I could? The
family fortunes depended on his success. He would be eternally
even perhaps practically grateful if only I would intercede
successfully with il Morgan. I could hold out very little hope
but said I would see what could be done.

Before I could get away from him there jumped out from a
dark corner of the room a little Levantine or Maltese gibbering
in broken English and broken Italian. He had in his hands a
large 17th-century crucifix which he handed me with feverish
gestures. It was not a remarkable work of art and [I] was be-
ginning the usual process of getting out when he whipped out
a stiletto from the shaft of the cross. This was the clou of the
piece and I knew my Morgan well enough to guess how likely
he was to be taken by it. "Shows what the fellows did in those
days! Stick a man while he was praying! Yes very interesting."
For a crude historical imagination was the only flaw in his
otherwise perfect insensibility.

Once more I tried to get to my petit déjeuner but once
more I was stopped, but this time by an elderly lady very re-
fined with the timid dignity of an old Italian provincial aristo-
crat. She and her sister lived in a Castello some ten miles away
in the hills and had a wonderful service of Majolica. Wouldn't
it be possible for il Morgan to visit them? Well, there was some
possibility. I would do what I could and let her know. No need
for that. She and her sister never left the ground. Any time
would do. That made the chances all the more favourable and
I could almost promise a visit. After petit déjeuner I went on
to Morgan's suite of rooms. He was up and ready to start while

Mrs Douglas was putting the final touches to her stately and enamelled appearance. The courier entered. He was il Cavaliere Luigi Poretta, a lank hungry Italian cadger, a servile and insinuating bully who had lived on his wits and somehow managed to get a title. He was ignorant, incapable and intriguing and the title was the only quality to recommend him for the post of courier to Pierpont Morgan. He announced in tones of greasy servility that the Fiat motor was waiting. The party descended and passed through the hall, eyed with awe-struck admiration by the expectant Italian counts, the Levantine Jews and all the other human flotsam that was drawn into the whirlpool of Morgan's wealth. They indeed but most of all the Italians looked at Morgan with something like worship. His wealth affected them not merely as something from which they might hope for doles but as something glorious and romantic in itself. Their passion was so great as to be almost disinterested. The mere thought that one man had so much wealth seemed to them ennobling and uplifting and incredibly more romantic than royalty itself. I forgot one other member of the party, little shrivelled white haired old Miss Burns, Mrs Douglas' chaperone. She was entirely unnoticeable and the only evidence of her presence was that at proper intervals and whenever it seemed appropriate she uttered little shrill mouse-like squeaks of admiration at pictures, scenery, or Mr Morgan's remarks.

It was a beautiful day and we were spinning along the road to Assisi. For a wonder Mr Morgan was in a good humour, he didn't know how bored he was going to be with the frescoes at Assisi where moreover there was nothing one could buy. He was so pleased with himself that he joked about one of his gloves having a rent in it. "Can't afford to buy another pair haw haw." Faint screams of delight from Miss Burns and a slight relaxation of the grimly well preserved features of the maîtresse en titre. There was even something like conversation which Morgan pulled round to Raphael a sign of good humour because it allowed him to make the inevitable remark "What fools those National Gallery people were to let me lend 'em my Raphael—made their Ansidei thing look pretty queer". (The said Raphael was a much repainted altarpiece which had

been left for fifty years in the S.K. Museum because no one would buy it and no one wanted to look at it.)

The motor spun along driven by a horribly skilful but reckless Italian chauffeur who had his ideas of how an ultra-royal and Morganatic car should be driven, namely to cause as much terror to the inhabitants as possible. Oxen dragging loads of hay plunged wildly into ditches and up the opposite bank, fowls, dogs and children rushed screaming away and everyone realised that Morgan was a real millionaire. So we spun along until a particularly deep canniveau gave the car such a jerk that Morgan was projected violently up to the ceiling and his hat crushed down over his eyes. (He wore a kind of truncated top-hat.) Then there was an apoplectic splutter of rage, the Cavaliere was called from the front seat, the driver warned, and the car driven less impressively. Assisi was a failure. Mr Morgan was displeased with the condition of the frescoes, Miss Burns let off a few screams but stopped when she saw it wasn't approved. Mrs Douglas would like to have improved her mind by pumping me on the history of the church and Giotto but we were hurried away since neither Morgan nor the Cavaliere were enjoying themselves.

On the way back I persuaded Morgan to go round by the old ladies' Castello and see the Majolica service. It was a lovely place up in the hills and Morgan was always pleased by the idea of buying family heirlooms from the family itself, the object seemed to convey with it some of the distinction of impoverished nobility. He was none the less rude to the poor trembling old ladies but he agreed to buy the service. I think he imagined that he gave more when he bought from the family than when he bought from the dealer. But this was not so. It is true he bargained less but then no private person except Clive Bell ever had the gumption to stick on to the proper price a quarter as much as the Jew and Levantine dealer did. I forget what the ladies got but I fear whatever it was the Cavaliere got 6/7 of it. That was what he considered the proper perquisite for having arrived in the same motor car as Morgan.

Such was our triumphal progress through Italy. At Siena the whole of the wooden floor of the Cathedral was taken up

that il Morgan might see the mosaics. The Queen of Italy had visited Siena a little before and had asked in vain for this. I must say the Cavaliere was ingenious. He got all the smaller galleries and libraries which are ordinarily open to the public shut up and then opened to Morgan as a special favour. At San Gimignano though we visited the town without warning we were instantly recognised and the royal book was brought out by the Mayor to be signed by the more than Royal millionaire. At Ancona we drove to the harbour through the square while everyone was listening to the military band. In a second the band was deserted and the whole population followed our carriage to the harbour where we embarked on Morgan's yacht. As the launch put out a salute was fired and answered from the yacht. We lay off the town all night and till late in the evening the choral society of Ancona serenaded us in boats. They shocked Morgan very much by asking for money and they were rudely refused. It was not so much that he minded parting with money as that the request was a blow to the cherished illusion that everything was done out of pure admiration for his personality, just for his beaux yeux. I always wondered that his mistresses in New York got such substantial subsidies as they did. To man it is impossible but to Jews Armenians and women . . .

There the fragment ends. Morgan returned to New York "with a million dollars worth of the lovely spoils of his voyage", writes his biographer. "Wood carvings, historic ceilings, treasures from the trappings of ancient palaces . . . lay in yet unopened cases at the Metropolitan Museum of Art." And Roger Fry, having done his duty by the millionaire, returned home to his wife and children.

But he came back to anxiety, not to rest; he could no longer share these humours with his wife. During his absences Helen Fry was frequently ill, and the doctors were beginning to hint that her recovery was impossible. Once more he was faced with all the problems that her illness brought with it. He fought them with splendid courage; he won spaces of great happiness; but the menace

was always there, increasing the strain of his work, taking
away any pleasure that he might have had in his success.
When about this time some show of his pictures was un-
expectedly successful he wrote, "it comes at a time when I
have lost my ambition in that direction and indeed in all
directions". With his sister's help he made provisional
arrangements for his wife and children, and went back to
the problems that awaited him in America. They were
familiar enough, and the words of one of the trustees, Mr
Johnson of Philadelphia, may be taken as a sufficient descrip-
tion of them. "The trouble is", he wrote, "that everybody
is under the coercion of Mr M's dominating will. No one
does, or dares, resist it. . . . The one-man power in public
institutions is a good one; but where it is exercised as in the
case of the M[useum], it is worse than Turkish rule. . . . I
do think", he continued, "it would be wiser for you, until
some arrangement by way of complete substitution opens,
to run upon the modified engagement although at a very
considerable cost of just irritation." Whatever "the modi-
fied engagement" may have been, Roger Fry did his best to
comply with it. He was feeling "grumpy and dissatisfied",
he said, but "I must not throw up in mere disgust a
position that does give us some much needed money",
to renounce a post which with all its drawbacks was still
"the greatest opportunity I have ever had", was a step
to be deferred as long as possible. The break was
only put off; given the President's temper and his own
inability to dance to that tune it was inevitable. On 14th
February 1910 he wrote to his father: "The blow I ex-
pected has fallen. Morgan could not forgive me for trying
to get that picture for the Museum,[1] and Choate has proved
a broken reed. . . . It is useless to make any fuss about it.
I could get no satisfaction from these people and they have
behaved vilely." "A vile deed," he called his dismissal in
a letter to Sir Charles Holmes, "villainously done with
every kind of hypocritical slaver." It is immaterial whether,

[1] Pierpont Morgan wished to keep it for his own collection.

as Sir Charles says, he "received his congé" or took it.
The breach was final and for the moment he could not
help regretting the National Gallery. Yet, as Sir Charles
pointed out, the conditions in England were as unsatis-
factory as in America. In America, he says—and his
words throw some light upon Roger Fry's difficulties at
the Museum—"Fry . . . was . . . meeting with serious
difficulties from Trustees as anxious to retain good pic-
tures for themselves as ours apparently were to see them
sold, of course for the highest obtainable price, to other
countries." The policy that then ruled the National
Gallery—"the strangling of National Gallery initiative"—
would have been as distasteful to Roger Fry in one way
as the tyranny of Pierpont Morgan in another. Many years
later, when he realised the difficulties under which Sir
Charles Holmes laboured under the English trustees, he
exclaimed: "How glad I am that the Americans prevented
me from having that post which once seemed to me the
height of my ambition!" But that was in 1927. In 1910 he
was left without any post whatsoever.

 The end of his work in America coincided with a far
more terrible conclusion. When, three years before, Sir
George Savage had told him that in his opinion Helen
Fry's illness was hopeless, he had refused to believe him.
He had gone from doctor to doctor; he had tried every
method that held out the least chance of success. It is a
splendid record of courage, patience and devotion. In the
hope that his wife could still live with him he had built
a house from his own design near Guildford. In 1910 the
house was ready, and he brought her there. But the illness
increased, and in that year he was forced, for the children's
sake, to give up the battle. It had lasted, with intervals
of rare happiness, since 1898. "You have certainly fought
hard to help your wife, and shown a devotion I have never
seen equalled", Dr Head wrote to him in November 1910.
"Unfortunately the disease has beaten us."

 What that defeat meant to one so sanguine, and so

dependent upon private happiness, is only to be guessed at, and only from his own words. To his mother he wrote:

It is terrible to have to write happiness out of one's life after I had had it so intensely and for such a short time. . . . I suppose we learn more from suffering than from happiness. But it's a strange world where we are made to want it so much and have so little chance of getting it.

He also wrote:

. . . with all the terrible trouble that these years have brought . . . I do feel a kind of pious gratitude for it all.

And to Lowes Dickinson:

I think I could get used to the dullness and greyness of life without love if it weren't for the constant sense of her suffering. This thing seems to be as diabolically contrived to give prolonged torture as anything could be. If she could only die! . . .

When Helen had first fallen ill, the thought of death had been intolerable. The years that followed had made death desirable. But he wrote:

I do believe almost mystically in tout comprendre est tout pardonner. The understanding is generally too impossibly difficult, but when one does understand it's always a pitiful rather than a hateful sight one stumbles on.

His emotions were broken and contradictory. He did not attempt to take up any attitude. He had to find his way, to piece things together, as best he could. "I've given up even regretting the callus that had to form to let me go through with things. Now and then it gives, and I could cry for the utter pity and wastefulness of things, but life is too urgent", he told Lowes Dickinson. He had no creed. The old phrases meant nothing to him. He dreaded most, he said, "shutting myself up in the imprisonment of egotism." The understanding of life, like the understanding of art, must be attempted by following

its lead according to his own discovery of the pattern. He laid himself open to all experience with a certain recklessness, because so many of the things that men care for, as he said later, were now meaningless. The centre which would have given them meaning was gone. From this experience sprang both his profound tolerance and also his intolerance—his instant response to whatever he found genuine, his resentment of what seemed to him false. So much perhaps may be read into his fragmentary and broken words without risking the scorn with which he blew away stock phrases. At the back of all that he accepted and rejected after his wife left him lay the fact of that experience—he had suffered and was to go on suffering, something that was, he said, "far worse than death".[1]

[1] Helen Fry died in the Retreat at York in 1937. After her death the cause of her illness was found to be an incurable thickening of the bone of the skull.

CHAPTER VII

THE POST-IMPRESSIONISTS

I

To a stranger meeting him then for the first time (1910) he looked much older than his age. He was only forty-four, but he gave the impression of a man with a great weight of experience behind him. He looked worn and seasoned, ascetic yet tough. And there was his reputation, of course, to confuse a first impression—his reputation as a lecturer and as an art critic. He did not live up to his reputation, if one expected a man who lectured upon the Old Masters at Leighton House to be pale, academic, aesthetic-looking. On the contrary, he was brown and animated. Nor was he altogether a man of the world, or a painter—there was nothing Bohemian about him. It was difficult at first sight to find his pigeon-hole. And another impression floated over the first glimpse of Roger Fry in the flesh—a glimpse caught a year or two before on a lawn at Cambridge. The trees were in leaf, and through the green light by the side of the summer river came two figures, both tall, both for some reason memorable and distinguished. Who were they? "Roger Fry and his wife." And they disappeared.

He talked that spring day in a room looking out over the trees of a London square, in a deep voice like a harmonious growl,—"his and Forbes Robertson's were the only voices one could listen to for their own sakes" says Bernard Shaw—and he laughed spontaneously, thoroughly, with the whole of him. It was easy to make him laugh. Yet he was grave—"alarming", to use his own word of his father. He too could be formidable. Behind his glasses,

149

beneath bushy black eyebrows, he had very luminous
eyes with a curious power of observation in them as if,
while he talked, he looked, and considered what he saw.
Half-consciously he would stretch out a hand and begin
to alter the flowers in a vase, or pick up a bit of china,
turn it round and put it down again. That look, that
momentary detachment, was so instinctive that it made no
break in what he was saying, yet it gave a sense of some-
thing held in reserve—things played over the surface and
were referred to some hidden centre. There was something
stable underneath his mobility. Mobile he was. He was just
off—was it to Paris or to Poland? He had to catch a train.
He seemed used to catching trains whether to Poland or
to Paris. It was only for a week or so, and then he would
be back. Out came a little engagement book. The pages
were turned rapidly. He murmured in his deep voice
through a long list of engagements, and at last chose a
day and noted it. But the particular Sunday he chose for
a first visit to Durbins was somehow muddled. There was
no cab; there was no Roger Fry. The name Durbins con-
veyed nothing to any porter. And much to his contrition
—but the blame must be laid on the "cussed nature of
human affairs"—he inflicted upon his would-be guests
the horrors, about which no one could be more eloquent
than he, of Sunday lunch at an English inn.

It was to Poland, not to Paris, that he was starting that
spring evening in 1910. A letter to his mother fixes the
date—24th April 1910. "I am very busy", he wrote,
"just now. I have to go to Poland to buy for Mr Frick a
very important picture. The whole business came upon
me very suddenly, and I have, I hope, transacted the
affair satisfactorily. The owner is a rather stupid country
gentleman who insists on selling the picture in his château,
that's why I have to go and get it, as I must see it before
buying. The picture costs £60,000 so it is an important
affair. . . . It's tiresome and rather hateful work but I
couldn't refuse to do it. . . . At all events I ought to get

handsomely paid for it, and indeed it comes at a critical time for I am just at the end of my resources and have been feeling very anxious of late as to how I can possibly meet expenses."

He had plenty of work on hand that spring—a ceiling to paint for Sir Andrew Noble, the Mantegnas to restore at Hampton Court; but it was spasmodic and miscellaneous, and he hoped again, though he was no longer sanguine, for some appointment that might canalise his energies and provide the income that was more than ever necessary. Once more the Slade professorship, this time at Oxford, was vacant. And again men of reputation in the art world asserted his fitness for the post. "I, for my part," wrote Salomon Reinach, Conservateur des Musées Nationaux, "would consider Mr Roger Fry as capable of exerting the most beneficent influence on young students; they would learn from him to use their eyes not only for reading, but for seeing works of art; he would teach them to appreciate *quality* which makes the difference between handiwork and art"—but the electors thought differently; the post went elsewhere, and Roger Fry's energies were made no use of, officially, to teach the young to use their eyes.

Perhaps it was as well in view of another journey that he made later that summer. It was only to Paris to see pictures—he had done that often enough. But on this occasion he went not to buy pictures for a millionaire or for a Museum but in order to choose pictures on his own responsibility for an exhibition that he had been asked to arrange at the Grafton Gallery in the autumn. "I've perhaps foolishly been the instigator of an Exhibition of modern French art at the Grafton Gallery this winter," he told his mother, "and though I am not responsible and have no post in regard to it I'm bound to do a great deal of advising and supervising." The words are casual enough; they give little notion of the interest that this particular exhibition was exciting in him or of the importance that

it was to assume. Ever since 1906, as a letter to his wife explains, he had been becoming more and more absorbed in the work of Cézanne in particular and in modern French painting in general. Now at the invitation of the directors of the Grafton Gallery he had a chance to bring together a representative exhibition of those pictures in London. For reasons that he has given himself, and are too familiar to need repetition, the exhibition seemed to him of the highest importance. But what was remarkable was that he made it seem equally important to other people. His excitement transmitted itself. Everybody must see what he saw in those pictures—must share his sense of revelation.

There they stood upon chairs—the pictures that were to be shown at the Grafton Gallery—bold, bright, impudent almost, in contrast with the Watts portrait of a beautiful Victorian lady that hung on the wall behind them. And there was Roger Fry, gazing at them, plunging his eyes into them as if he were a humming-bird hawk-moth hanging over a flower, quivering yet still. And then drawing a deep breath of satisfaction, he would turn to whoever it might be, eager for sympathy. Were you puzzled? But why? And he would explain that it was quite easy to make the transition from Watts to Picasso; there was no break, only a continuation. They were only pushing things a little further. He demonstrated; he persuaded; he argued. The argument rose and soared. It vanished into the clouds. Then back it swooped to the picture. And not only to the picture—to the stuffs, to the pots, to the hats. He seemed never to come into a room that autumn without carrying some new trophy in his hands. There were cotton goods from Manchester, made to suit the taste of the negroes. The cotton goods made the chintz curtains look faded and old-fashioned like the Watts portrait. There were hats, enormous hats, boldly decorated and thickly plaited to withstand a tropical sun and delight the untutored taste of negresses. And what magnificent taste the untutored negress had! Under his

influence, his pressure, his excitement, pictures, hats, cotton goods, all were connected. Everyone argued. Anyone's sensation—his cook's, his housemaid's—was worth having. Learning did not matter; it was the reality that was all-important. So he talked in that gay crowded room, absorbed in what he was saying, quite unconscious of the impression he was making; fantastic yet reasonable, gentle yet fanatically obstinate, intolerant yet absolutely open-minded, and burning with the conviction that something very important was happening.

It was in November 1910 that the first exhibition of Post-Impressionist pictures—the name was struck out in talk with a journalist who wanted some convenient label, and the title, to be accurate, was "Manet and the Post-Impressionists"—was opened at the Grafton Galleries. Desmond MacCarthy, snatched from a sick-bed, revived with a bottle of champagne and assured that his real job in life was art criticism, had written an introduction. It reads to-day mildly enough. It has even an apologetic air: ". . . there is no denying", he remarked, "that the work of the Post-Impressionists is sufficiently disconcerting. It may even appear ridiculous to those who do not recall the fact that a good rocking-horse has often more of the true horse about it than an instantaneous photograph of a Derby winner." Several people of distinction, "though not responsible for the choice of the pictures", allowed their names to appear on the Committee, and the opening was conventionally distinguished. Then the hubbub arose.

It is difficult in 1939, when a great hospital is benefiting from a centenary exhibition of Cézanne's works, and the gallery is daily crowded with devout and submissive worshippers, to realise what violent emotions those pictures excited less than thirty years ago. The pictures are the same; it is the public that has changed. But there can be no doubt about the fact. The public in 1910 was thrown into paroxysms of rage and laughter. They went from Cézanne to Gauguin and from Gauguin to Van Gogh,

they went from Picasso to Signac, and from Derain to Friesz, and they were infuriated. The pictures were a joke, and a joke at their expense. One great lady asked to have her name removed from the Committee. One gentleman, according to Desmond MacCarthy, laughed so loud at Cézanne's portrait of his wife that "he had to be taken out and walked up and down in the fresh air for five minutes. Fine ladies went into silvery trills of artificial laughter". The secretary had to provide a book in which the public wrote down their complaints. Never less than four hundred people visited the gallery daily. And they expressed their opinions not only to the secretary but in letters to the director himself. The pictures were outrageous, anarchistic and childish. They were an insult to the British public and the man who was responsible for the insult was either a fool, an impostor or a knave. Caricatures of a gentleman whose mouth was very wide open and whose hair was very untidy appeared in the papers. Parents sent him childish scribbles which they asserted were far superior to the works of Cézanne. The storm of abuse, Mr MacCarthy says, positively alarmed him.

The critics themselves were naturally more measured and temperate in their strictures, but they were dubious. Only one of the London critics, Sir Charles Holmes, according to Mr MacCarthy, came out on the side of the Post-Impressionists. The most influential and authoritative of them, the critic of *The Times*, wrote as follows:

It is to be feared that when [Roger Fry] lends his authority to an exhibition of this kind, and gives it to be understood that he regards the work of Gauguin and Matisse as the last word in art, other writers of less sincerity will follow suit and try to persuade people that the Post-Impressionists are fine fellows, and that their art is the thing to be admired. They will even declare all who do not agree with them to be reactionaries of the worst type.

It is lawful to anticipate these critics, and to declare our belief that this art is in itself a flagrant example of reaction.

It professes to simplify, and to gain simplicity it throws away all that the long-developed skill of past artists had acquired and perpetuated. It begins all over again—and stops where a child would stop. . . . Really primitive art is attractive because it is unconscious; but this is deliberate—it is the rejection of all that civilisation has done, the good with the bad. . . . It is the old story of the days of Théophile Gautier—the aim of the artist should be "Épater le bourgeois" and by no means to please him! Such an aim is most completely realised by the painter Henri Matisse, from whose hand we have a landscape, a portrait, and a statue. We might have had more, but it is understood that nearly all his works belong to one rich family in Paris, who, we suppose, are so enamoured of them that they will not lend. Three are enough to enable us to judge the depth of the fall, in these strange productions, we will not say from the men of long ago, but from three idols of yesterday—from Claude Monet, from Manet, and from Rodin.

Finally *The Times* critic concluded by appealing to the verdict of Time—"le seul classificateur impeccable", which he assumed, somewhat rashly, would be given in his favour.

Among the artists themselves there was a great division of opinion. The elder artists, to judge from a letter written by Eric Gill to Sir William Rothenstein, were uneasy. "You are missing an awful excitement just now being provided for us in London," Eric Gill wrote to William Rothenstein in India, "to wit, the exhibition of Post-Impressionists now at the Grafton Galleries. All the critics are tearing one another's eyes out over it, and the sheep and the goats are inextricably mixed up. The show", he continued, "quite obviously represents a reaction and transition, and so if, like Fry, you are a factor in that reaction and transition, then you like the show. If, like MacColl and Robert Ross, you are too inseparably connected with the things reacted against and the generation from which it is a transition, then you don't like it. If, on the other hand, you are like me and John, McEvoy and

Epstein, then, feeling yourself beyond the reaction and beyond the transition, you have a right to feel superior to Mr Henri Matisse (who is typical of the show—though Gauguin makes the biggest splash and Van Gogh the maddest) and you can say you don't like it. But have you seen Mr Matisse's sculpture? . . ." To which Sir William Rothenstein adds, "Yes, I had seen Matisse's sculpture in his studio in Paris. I could not pretend to like it." Nor did Mr Ricketts make any bones about his contempt for the pictures. "Why talk of the sincerity of all this rubbish?" he asked. And he proposed, ironically, to start a national subscription "to get Plymouth and Curzon painted by Matisse and Picasso"; and detected definite signs of insanity in the painters. Here he was supported by eminent doctors. Dr Hyslop lectured on the exhibition in Roger Fry's presence. He gave his opinion before an audience of artists and craftsmen that the pictures were the work of madmen. His conclusions were accepted with enthusiastic applause and Mr Selwyn Image expressed his agreement with Dr Hyslop in an appreciative little speech. Privately, Professor Tonks circulated caricatures in which Roger Fry, with his mouth very wide open and his hair flying wildly, proclaimed the religion of Cézannah, with Clive Bell in attendance as St Paul. And in his diary Wilfrid Blunt gave expression to the feelings of those who were not painters or critics but patrons and lovers of art:

15th Nov.—To the Grafton Gallery to look at what are called the Post-Impressionist pictures sent over from Paris. The exhibition is either an extremely bad joke or a swindle. I am inclined to think the latter, for there is no trace of humour in it. Still less is there a trace of sense or skill or taste, good or bad, or art or cleverness. Nothing but that gross puerility which scrawls indecencies on the walls of a privy. The drawing is on the level of that of an untaught child of seven or eight years old, the sense of colour that of a tea-tray painter, the method that of a schoolboy who wipes his fingers on a slate after spit-

ting on them. . . . Apart from the frames, the whole collection should not be worth £5, and then only for the pleasure of making a bonfire of them. Yet two or three of our art critics have pronounced in their favour. Roger Fry, a critic of taste, has written an introduction to the catalogue, and Desmond MacCarthy acts as secretary to the show. . . . They are the works of idleness and impotent stupidity, a pornographic show.

The "awful excitement", then, that the Post-Impressionist Exhibition aroused in 1910 seems to have been genuine. The works of Cézanne, Matisse, Picasso, Van Gogh and Gauguin possessed what now seems an astonishing power to enrage the public, the critics and the artists of established reputation. Roger Fry was to analyse that excitement and his own reactions to it ten years later in the article called "Retrospect" (*Vision and Design*). At the time he was both amazed and amused. He was surprised at the interest that the pictures excited in a public normally indifferent to pictures. "There has been nothing like this outbreak of militant Philistinism since Whistler's day", he wrote to his mother. How had he contrived to spring this mine of emotion in that very phlegmatic body? He was amused to find that his own reputation—the dim portrait that the public had drawn of him as a man of taste and learning—was replaced by a crude caricature of a man who, as the critics implied, probably from base motives, either to advertise himself, to make money, or from mere freakishness, had thrown overboard his culture and deserted his standards. But his childish lesson that "all passions even for red poppies leave one open to ridicule" stood him in good stead. Desmond MacCarthy records that in the midst of the uproar Roger Fry "remained strangely calm and 'did not give a single damn' ". The pictures themselves, and all that they meant, were of absorbing interest to him, and much of the annoyance that he was causing his respectable colleagues passed over him unnoticed. He never realised, it is safe to say, how from this time onward he obsessed

the mind of Professor Tonks, so that that gentleman could scarcely bear to hear his name mentioned and felt at his death that it was for English art "as if a Mussolini, a Hitler, or a Stalin had passed away". Professor Tonks did not obsess Roger Fry. He and other of his colleagues tended to recede into the background, and were rather to be pitied than abused for remaining in their little eddy of suburban life instead of risking themselves in the main stream of European art.

But there was one element in all this hubbub that roused Roger Fry to anger. That was the attitude of the cultivated classes—the attitude expressed by Wilfrid Blunt in his diary. For so many years he had helped to educate the taste of that public. They had attended his lectures upon the Old Masters so devoutly, and had accepted so respectfully his views upon Raphael, Titian, Botticelli and the rest. Now, when he asked them to look also at the work of living artists whom he admired, they turned upon him and denounced him. It seemed to him that the cultivated classes were of the same kidney as Pierpont Morgan. They cared only for what could be labelled and classified "genuine". Their interest in his lectures had been a pose; art was to them merely a social asset. "I found among the cultured," to quote his own words, "who had hitherto been my most eager listeners, the most inveterate and exasperated enemies of the new movement. . . . These people felt instinctively that their special culture was one of their social assets. That to be able to speak glibly of Tang and Ming, of Amico di Sandro and Baldovinetti, gave them a social standing and a distinctive cachet." They had not the excuse that their sales were hurt, or their pupils corrupted. They were not "inseparably connected", like the professors, "with the things reacted against". They should have been disinterested and dispassionate. And yet it was they who attacked the new movement most virulently, and from being their urbane and respected guide, Roger Fry had become "either incredibly flippant, or, for

the more charitable explanation was usually adopted, slightly insane".

Time, twenty-nine years at least, of that judge whom the critic of *The Times* called, perhaps too confidently, "le seule classificateur impeccable", has vindicated Roger Fry, if money is any test. Shares in Cézanne have risen immeasurably since 1910. That family, who, according to the same authority, accumulated works by Matisse must to-day be envied even by millionaires. And opinion too is on his side. It would need to-day as much moral courage to denounce Cézanne, Picasso, Seurat, Van Gogh and Gauguin as it needed then to defend them. But such figures and such opinions were not available in 1910, and Roger Fry was left to uphold his own beliefs under a shower of abuse and ridicule.

But the exhibition had other results that were far more important. Roger Fry may have sacrificed his reputation with the cultivated; but he had made it with the young. "Fry thenceforth", as Sir William Rothenstein writes, "became the central figure round whom the more advanced of the young English painters grouped themselves." That position was no sinecure, but, if it allowed room for the central figure to move on, it was the one of all others that Roger Fry would have chosen. So long as the young trusted him, he cared nothing for the enmity of officials. What mattered was that the young English artists were as enthusiastic about the works of Cézanne, Matisse and Picasso as he was. The first Post-Impressionist Exhibition, as many of them have testified, was to them a revelation; it was to affect their work profoundly. And to explain and to expound the meaning of the new movement, to help the young English painters to leave the little backwater of provincial art and to take their place in the main stream, became from this time one of Roger Fry's main preoccupations. In his own words: "I began to discuss the problems of aesthetics that the contemplation of these works forced upon us". He discussed them in all their

aspects with the learned and with the ignorant, in lecture-halls, in drawing-rooms, in studios, in railway trains. And he wrote—often in an omnibus or in the corner of a third-class railway carriage. His writing gained a new vigour and depth. He became the most read and the most ad-mired, if also the most abused, of all living art critics.

But anyone who had followed his criticism from the time when he laid about him so vigorously in the *Athenaeum*, or had wondered why it was that he was out of touch with his generation as a painter, knew that the importance of the Post-Impressionist movement lay in the fact that it was a continuation and not a break. He had always, as his criticism of the New English Art Club shows (he had resigned his place on the Jury of the New English Art Club in 1908), been dissatisfied with the Impressionist school. He had asserted in 1902 that we are "at a dead point in the revolutions of our culture". One would say, he went on, "that these artists seem paralysed by the fear of failure, and they lack the ambition to attempt those difficult and dangerous feats by which alone they could increase their resources and exercise their powers by straining them to the utmost". He had lighted with eagerness upon the work of some of the younger artists, like Augustus John, who "by going back to an earlier tradition, carry the analysis further, penetrating through values to the causes in actual form and structure". Here, in the work of the French artists, he found the very quali-ties that he had been looking for. To the British public the French painters were ignorant if not insane; even Professor Tonks could write, "If you want to know more of the follies of men, go to the Lefevre Galleries and see the Cézannes". To Roger Fry, on the other hand, it was obvious that they were masters of their art; he could see "how closely they followed tradition, and how great a familiarity with the Italian primitives was displayed in their work". The excitement, then, that these pictures gave him was the excitement of finding that what he had dimly

hoped for and half foreseen as a possible development was actually in being. The statue that had lain half hidden in the sand was now revealed. He had feared that the art of painting was circling purposelessly among frivolities and was at a dead end. Now he was convinced that it was alive, and that a great age was at hand. He laid himself open with all his sensibility—that sensibility in which, as he said, one's housemaid "by a mere haphazard gift of providence" might surpass one—to register the sensations that Cézanne, Picasso, Matisse and the rest produced in him. But he went on, as his maid could not, to analyse those sensations with an erudition that years of "seeing pictures" had made considerable, and with an honesty and acuteness that his training among the philosophers had made habitual. The results are to be read in the very rich and profound investigations which fill such books as *Vision and Design, Transformations*, and the masterly essays upon Cézanne and French Art.

But the Post-Impressionist Exhibition interested him not merely as a critic but as a creator. It freed him from some obstacle that had stood in his way as a painter. Now, after long years of groping and fumbling, he was able at last to begin to paint as he wished. It came to him as a painter at the right psychological moment. Such moments of vision, when a new force breaks in, and the gropings of the past suddenly seem to have meaning, are probably familiar to most artists. But most artists leave them unexplained. It would need a critic endowed with his own interpretative genius to single out and sum up all the elements in that long process which at last seemed to bear fruit. Unfortunately, though he traced many such spiritual journeys, he never traced his own. And even such a critic would have to admit that the origin of these moments of vision lies too deep for analysis. A red poppy, a mother's reproof, a Quaker upbringing, sorrows, loves, humiliations —they too have their part in moments of vision. But the moment had come. "I feel", he wrote, "that I have an

altogether new sense of confidence and determination which I shall stick to as long as it will last" (to D. S. MacColl, February 1912).

And he felt that confidence, that determination not only as a painter. All his doubts and difficulties, he said, seemed to have left him. He had found himself at last—he could deal with life, he could deal with people. It is easy to find reasons, whether they are the right or the sufficient reasons, for the change. There was the relief from the long strain of his wife's illness—the relief that comes naturally and healthily when a struggle has ended and defeat has been faced. There was the new friendship with Vanessa Bell, who, as a painter belonging to the younger generation, had all the ardour of the young for the new movements and the new pictures and urged him away from the past and on to the future. There was her painting and her studio and the younger generation arguing with him and laughing at him, but accepting him as one of themselves. All this brought about a change that showed itself even in his face, so that a friend meeting him in the street exclaimed, "What's happened to you? You look ten years younger." He repeated that saying, and added that, strange as it was, at last, at the age of forty-four he found himself where most people find themselves twenty years earlier—at the beginning of life, not in the middle, and nowhere within sight of the end.

II

The exhibition shut, and the hubbub calmed down. But the excitement remained. It had left a trail behind it. He had made new friends as well as new enemies. He was being asked to dine, to lecture, to address this or that art society in the provinces or at the universities. Everybody was writing to him, either to express their views or to ask him to explain his own. His hall table—to recall some impressions of a visit to Durbins that did not fail—was littered

with letters. They were still abusing him—"It is odd that people should think that because they don't like a thing it was done specially to insult them, but such seems to be the usual reaction on such occasions". But the letters could wait. Family life was in full swing. His sister Joan was not merely "keeping house" for him—she was creating a home, a safe and happy home, for the children who had long lacked one. A small boy was shooting arrows in the garden; a little girl was dabbling her brush in a jar of discoloured water. The house on the outskirts of Guildford, with its lofty rooms, was airy and spacious—"I hate Elizabethan rooms with their low ceilings in spite of their prettiness, and I love the interiors of the baroque palaces of Italy". He had designed the house himself, and he was proud of its proportions and of its labour-saving devices. His work-room upstairs was crowded with tools of various kinds; it was littered, yet orderly. Sheaves of photographs lay flat on shelves. There were paintings and carvings, Italian cabinets and Chippendale chairs, blue Persian plates, delicately glazed, and rough yellow peasant pottery bought for farthings at fairs. Every sort of style and object seemed to be mixed, but harmoniously. It was a stored, but not a congested, house, a place to live in, not a museum. Certainly it was not luxurious—"It was characteristic of my purse that I could not afford to keep up a gentleman's establishment, and of my taste that I could not endure to". A pleasing freedom seemed to prevail. There was time—time to look at the garden, with the flowers nodding over the pool; time for a walk to see a view he liked, though the country was only Surrey. He half apologised for the country, spotted as it was with "gentlemanly residences". "My own house is neighboured by houses of the most gentlemanly picturesqueness, houses from which tiny gables with window slits jut out at any unexpected angle." The path he took over the downs avoided those gentlemanly residences, but his talk did not altogether avoid the inhabitants of those houses—

their snobbery, their obtuseness, their complacency, and their complete indifference to any kind of art. That still amazed him. Yet his indignation dissolved in a kind of humorous pity. How much they missed—how little they allowed themselves to enjoy life. It was the English passion for morality, he supposed, and also the English climate. The light, he pointed out, was full of vapour. Nothing was clear. There was no structure in the hills, no meaning in the lines of the landscape; all was smug, pretty and small. Of course the English were incurably literary. They liked the associations of things, not things in themselves. They were wrapt in a cocoon of unreality. But again of course the young were all right—he had great hopes of the young. And the uneducated, whose taste had not been perverted by public schools and universities, had, he was convinced, an astonishing natural instinct— witness his housemaid, who had seen the point of Cézanne instantly. He was full of hope for the future, even for himself, late though it was, and much as he had groped and wandered and lost his way.

And so, deriding the village churchyard, its owls, its epitaphs and its ivy, and all those associations which appealed to the impure taste of the incurably literary, he led his way back to the house that the neighbours thought an eyesore, with its large rooms, its great windows, and the bands of red brick across the front. There were many things to be seen there: old Italian pictures, children's drawings, carvings, pots and books—French books, in particular, tattered and coverless, which led to an attack upon English fiction. Why, he demanded, was there no English novelist who took his art seriously? Why were they all engrossed in childish problems of photographic representation? And then, before he went to busy himself in the kitchen, out came the picture that he had been painting that morning. He held it out with a strange mixture of anxiety and humility for inspection. Could he possibly mind what was thought of it? It was plain that he did

DURBINS

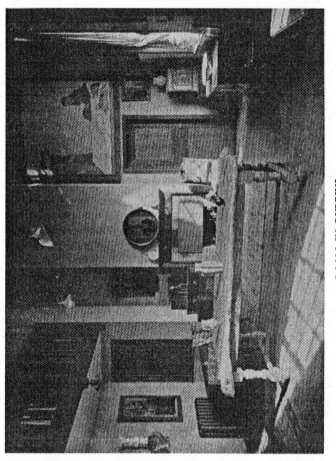

ROOM IN DURBINS

mind. He gazed at his own work, intently, in silence, and then said how at last he was getting at something— something that he had never been able to get at before.

III

The tasks that fell upon him now that he had become "the father of British painting", the leader of the rebels, increased daily. Anyone with a scheme on foot, or an idea that only needed money in order to achieve wonders, came to him for advice and help. He was busy that spring helping to start "a vast institution for keeping photographs of all manner of products of human activity, from temples to towel horses". A hundred thousand pounds had to be collected. He was full of optimism and energy. Then, rather to his surprise, he was offered the Directorship not of the National Gallery, but of the Tate. Financially, the offer was not tempting; the salary was £350 rising to £500; it meant too that he would have to give up all his other work. He refused it. "I really think", he wrote, "I can do more outside, so I must give up the idea of official life and titles and honours which I very willingly do, so long as I can manage to get along as regards money. I once wanted these things, but now I feel quite indifferent to them."

The Post-Impressionist Exhibition had made it clear not only that his work lay outside, but that there was a great deal to be done, and that the young English artists looked to him to do it. The Directors of the Grafton Galleries had made him an offer that seemed to him of much greater importance than the Directorship of the Tate. They offered him the control of their galleries for the autumn months. This gave him an opportunity— though the risk was great—that must be seized. He could use it to bring together, as he hoped, all the different schools of English painting, and to show them side by side with the French. If it succeeded, it might become an

annual institution; it might unite groups; destroy coteries, and bring the English into touch with European art. Though "frantically busy" he put his views before the older artists and asked them to help him by lending their work. By this time he knew the difficulty of getting artists to combine. Had he not written years before, "the artist is intensely individualistic, and in proportion as he is an artist, he finds it difficult to combine with his kind for any ulterior purpose"? But perhaps he was not aware what a change had come over his reputation, since he proclaimed his faith in Cézanne, or how difficult it had become for the older artists to work with him, let alone under his direction. Some letters to Sir William Rothenstein show both what his aims were, and what difficulties he had to encounter.

The offer of the Grafton Gallery, he wrote to Sir William, means "a real acquisition of power for the younger and more vigorous artists. We can give them a chance they have never had before of being well seen, but if it is to succeed I must rely on the loyalty to the cause of those like yourself who have a more established name. I had hoped to make the scope very wide—to have a kind of general secession show and approached Steer and Tonks. They were unwilling to be seen with the younger men—said literally 'let them wait till they can get into the New English Art Club'. But I don't want them to wait. Well, there remain John, Epstein and yourself. John has promised to send . . . I don't like Exhibitions any more than you do, but until we have got back to a more perfect way of life altogether they remain the only possible medium of communication. I have to ask all these people who send to trust me to do their work justice—well from you I hoped that would not create a difficulty. I have no axe to grind except to make the show a success on the best lines but I am not, I think, narrow-minded where real art is concerned." When he wrote that letter he was about to start on a holiday, the first he had had for many years, to Constantinople. From Constantinople he wrote again:

HOTEL BRISTOL,
CONSTANTINOPLE,
April 13, 1911

MY DEAR ROTHENSTEIN,

I have just got your letter. I am sorry there should have been misunderstandings but I don't think anything I have said or written ought to have given rise to them. I did explain to you as fully as I could in the time that I hoped for your co-operation in a show of contemporary English art at the Grafton. I thought that you knew me well enough to know that such a show would be in general character sympathetic to you and that in particular your work would receive a hearty welcome. . . .

Now let me try to explain at greater length what I hoped to do. Originally I thought that the Grafton might be used for a general secession exhibition of all non-academy art of any importance including members of the NEAC. I approached Steer and Tonks with this idea and found them unwilling to join. I then thought it might still be possible to make up an Exhibition from the works of younger artists together with yourself, John, Epstein, W. Sickert. Only I saw that with this we could not fill the Grafton so I conceived the idea of having the Exhibition divided 2 rooms to this English group and 2 rooms to the works of the younger Russian artists which I thought ought to be better known in England; I thought that this would be of great interest to English artists. . . .

It is still an unfortunate necessity that artists sh. exhibit and be seen and discussed in order to live and paint, and my ambition is to give the younger and more progressive men more opportunity than heretofore. On the other hand, in order to do this I must make the exhibitions pay their way on the average. . . . The conditions make it inevitable that I sh. appeal to the various artists to trust me with large powers since I have the actual control and responsibility on behalf of the Grafton Galleries. Now you know me well enough to know that I am not unlikely to listen to advice from you and that I should give every consideration to any suggestions which you or John or McEvoy might make and I sh. be delighted if you would co-operate; at the same time I could hardly go to other groups of younger artists who are quite willing to trust me personally and

say to them that their work must come before such a committee as you suggest for judgment, nor can I possibly get rid of my responsibility to the Grafton Galleries. . . .

Now you see I really want you to join in this and I believe it would be not only to the advantage of English art that you should join but ultimately to the good of yr. position. Unless those who care for what is vital in art agree to co-operate loyally commercialism will always trample us under foot. Just now there seems to me an occasion for a real effort at such co-operation and it wd. be a great and lasting regret to me if we did not have you with us.

<div style="text-align: right">Yours very sincerely,
ROGER FRY</div>

Sir William Rothenstein in his Memoirs has given the reasons which made it impossible for him to co-operate: ". . . I still felt the New English Art Club to be the body with which I had most sympathy. Further, remembering Carr's and Hallé's ways at the New Gallery, I did not feel inclined to work under Fry's dictatorship. . . ." Mr Steer and Professor Tonks also were "disinclined to move". Indeed, since to Professor Tonks Roger Fry was the counterpart of Hitler and Mussolini, there was nothing to be surprised at in that; and even if that comparison was still to be made, "it was not pleasant", as his biographer says, to the Professor "to know that New English Art, after having been *hors concours* for so long as 'the advanced thing', was now relegated to the academic category". Also "one has a suspicion that Tonks felt that there was something in Fry's ideas". That, too, must have been irksome. But it is unnecessary to enquire further into the various motives which made it impossible for the older artists to co-operate with Roger Fry. He was greatly disappointed, and also he was surprised—it is a proof perhaps of the credulity that was so often observed in him—that what seemed to him "a perfectly simple and sincere offer" should not be met in the spirit in which it was made. But though after this he drifted apart from many of the

artists mentioned, there was no bitterness on his side at least. His attitude was summed up in the words "poor dear" or "dear old" which attached themselves regretfully, humorously, to certain distinguished names, so that it was a surprise, many years later, to find that Henry Tonks was still alive, and natural enough to suppose that since he was alive, he must be, perhaps the President of the Royal Academy, and certainly a baronet. But for Henry Tonks personally Roger Fry had nothing but affection; and Henry Tonks seeing Roger Fry mount a chair at a dinner in order to explain to Lord Lascelles "something about a triptych", was charmed. "Fry", he wrote, "is really a very charming man; I have seen more of him lately, and now speak to, and lecture him freely."

But in 1911 difficulties were made; difficulties, however, though they might surprise, always roused in him a spirit of indomitable energy. "No rebuff", as Sir Charles Holmes had noted, "could shake his determination to carry the matter through." He was determined, in spite of the rebuffs, in spite of the drudgery—the above letter is only one instance of the labours he undertook—to carry the exhibition through, even if the older artists held aloof. He was convinced that here was a chance both for what was vital in art and for the younger artists. And his mind was teeming with plans for the second Post-Impressionist Exhibition during his holiday in Constantinople.

IV

It was the first holiday that he had taken for many years—if that can be called a holiday which includes the writing of long letters filled with minute details. He was seeing a new country for the first time in company with friends—the Clive Bells—who were to mean much to him; he was "filling up gaps" in his knowledge of Byzantine art, and there were all the aesthetic problems roused by the Post-Impressionist pictures and the practical problems

roused by the forthcoming show to be discussed. All this
went to the making of a perfect holiday. Unfortunately,
at Broussa one of the party—Vanessa Bell—fell ill, and the
emergency brought out a side of Roger Fry, which though
it could be guessed—did he not seem even at first sight a
man with great experience behind him?—needed illness
to bring it to the surface. He took control of the situation—
it was difficult and complicated. There were few facilities
for serious illness in a ramshackle Turkish inn; the pro-
prietors were suspicious, the doctor unqualified and there
were no nurses. But Roger Fry was in his element. He
fetched and carried; ordered and conciliated; was absorbed
but never flustered. All his curious medical lore came into
use. He had a doctor's interest in drugs and their pro-
perties. But unlike most doctors he was imaginative and
adventurous. The human body and its oddities fascinated
him. And his acute sympathy with suffering made him
extraordinarily quick to anticipate and suggest. Bed, food
and litter had all to be improvised from the most inappro-
priate materials—he had full scope for his ingenuity; he
ventured into the kitchen, and returned triumphant with
a new dish or two. Directly the immediate problem was
solved he dismissed it; and turned instantly to the next thing
on hand. It might be his painting—he had set up an easel in
the courtyard where a tree or a fountain had suggested a
subject. He was absorbed in that problem. But he was not
absorbed to the extent of forgetting the presence of someone
reading a book. What book was it? What sort of merit had
it? A tentacle seemed to float out that attached itself to
whatever was going on in his neighbourhood. He ques-
tioned; he pondered; at the same time he was washing in
his sky with what seemed extraordinary dexterity. He was
also noting the attitude of a peasant carrying a pot on her
head, and taking stock, with a quick shrewd glance, of the
English family who had arrived the night before and
would have to be persuaded to renounce their rights to
the shady corner of the garden where he had rigged up a

tent for the invalid. They were the sort—he could tell that
at a glance—who proved troublesome.

And then, his duties in the sick-room done, there was
just time for a drive. He was enthusiastic about the land-
scape. There was a magnificence about the Turkish hills
that gave him immense satisfaction. They were not
romantic. The light was real light, not pea-soup dissolved
in vapour. One could see the structure of the hills. Then he
stopped the driver. Where could he buy pots like those the
women used for water? And handkerchiefs like those they
wore on their heads? Talking partly French, partly
Turkish which he had picked up from a conversation
book, he persuaded the driver to take him to the native
quarter. Soon he was standing with his hat on the back of
his head gesticulating, laughing, the centre of a group of
excited peasants. Pots were bought and coloured handker-
chiefs, and he pointed out how the bold crude pattern was
based on some half-forgotten tradition—Russian, or Greek,
or Chinese? Whatever it was it proved that the tradition
was alive and that the peasants of Broussa put the educated
English to shame.

Soon therefore his room at the hotel was littered with
stuffs and pots and silks, mixed with chessmen, medicine
bottles and paint-boxes. Thanks largely to his skill, the
invalid recovered. And though the Orient Express was
crowded, and a truculent Colonel, whom Roger Fry sized
up correctly at first sight, refused to give up his corner
seat—had he not said that he would?—he contrived some-
how to convey an invalid who could not stand and a
freight of fragile china successfully across Europe. He
himself was attacked by sciatica, but as the train rattled
through the uplands of Serbia he stretched his leg upon
an improvised leg-rest, took a book from his pocket and
read it aloud.

The book that he was reading was by Frances Cornford.
He liked it very much. "I think this shows", he wrote to
his mother, "that she is a genuine, though no doubt not a

great poet. She has felt things for herself, and managed to
say them. It is strange that this should be so rare, because
when it's done, it seems so simple, as though anyone could
do it." The Post-Impressionist movement, as the casual
words show, was by no means confined to painting. He
read books by the light of it too. It put him on the track of
new ideas everywhere. Like a water-diviner, he seemed to
have tapped some hidden spring sunk beneath the in-
crustations that had blocked it. The twig turned vigorously
and unexpectedly in streets, in galleries, and also in front
of the bookcase. There it was — this reality, the thing
that the artist had managed to say, now in Frances Corn-
ford, now in Wordsworth, now in *Marie Clare*, a novel by
Marguerite Audoux in which, if memory serves, the writer
has contrived to express the emotions of a peasant at the
sight of a wolf without using a single adjective. But it was
not where it was expected to be. He laid sacrilegious hands
upon the classics. He found glaring examples in Shake-
speare, in Shelley, of the writer's vice of distorting reality,
of importing impure associations, of contaminating the
stream with adjectives and metaphors. Literature was
suffering from a plethora of old clothes. Cézanne and
Picasso had shown the way; writers should fling representa-
tion to the winds and follow suit. But he never found time
to work out his theory of the influence of Post-Impres-
sionism upon literature, and his attempts to found a broad-
sheet, profusely illustrated, to be sold for one penny at all
the bookstalls, in which the two arts should work out the
new theories side by side, failed—the money difficulty
floored even him. And he went on to turn his attention to
another undertaking that came more naturally within his
scope.

 This was to find work, not as painters but as decorators,
for the young English artists who had been drawn together
by the Post-Impressionist Exhibition. It was bad for young
artists to be forced to depend upon private patrons who,
as the exhibition had convinced him, looked upon art

"chiefly as a symbol of social distinction". He wanted to
see the walls of railway stations and restaurants covered
with pictures of ordinary life that ordinary people could
enjoy. As soon as he was back in England therefore he
persuaded the authorities of the Borough Polytechnic to
let him decorate the walls of the students' dining-room.
He got the artists to design cartoons; he got the Com-
mittee to accept their designs; and in the autumn of 1911
the students of the Borough Polytechnic were given pic-
tures, not of saints or of madonnas, but of the pleasures of
London to look at as they ate their meals. Duncan Grant,
Frederic Etchells, Bernard Adeney, Albert Rutherston,
Max Gill and Roger Fry himself made designs representing
Swimmers and Footballers, Punch and Judy, Paddlers in
the Serpentine, Animals at the Zoo, and other familiar
London scenes. The pictures have, it is said, now been
destroyed; but Roger Fry threw a great deal of energy
into the work of organisation that as usual fell chiefly
upon him, and he was delighted with the results.
"My work at the Borough Polytechnic", he wrote that
autumn, "has been a great success. They had a great
debate upon it the other night which I was asked to open.
It was a very amusing occasion, with much freedom of
speech, but on the whole they seemed to be converted to
my view."

No record of the speech remains, but "the view" he
expressed may be gathered from the essay called "Art
and Socialism" which he wrote in 1912. In that essay,
published later in *Vision and Design*, which begins with the
words "I am not a socialist", he investigated the position
of the artist in the modern State, and tried to discover
how the ideal State might make the best use of his powers.
Only one phrase need be taken from that reasoned and
subtle argument—"the greatest art has always been com-
munal, the expression—in highly individualised ways no
doubt—of common aspirations and ideals". Attitudes had
always to be revised, the fixed pose was always suspect, but

though he would not call himself either a socialist or a
democrat, he had views about the relation of art to society,
and the pictures on the walls of the Polytechnic were an
attempt to put those views into practice. One has to
"accept modern conditions and to make the best of them".
He accepted those conditions down in Southwark, and if
the public did not come forward, as he hoped, with com-
missions on a larger scale, it was an experiment that
interested him greatly. If he was disillusioned about the
love of art among the cultivated, he was sanguine about
the love of art among the untaught. Indeed, it was more
likely to be found, he had come to think, in Southwark
than in Grafton Street.

Meanwhile, there were his own pictures. Underneath all
these theories, fertilising them, there was his own "petite
sensation". That somehow had been freed from impedi-
ments. He was hard at work all that winter painting.
Pictures accumulated. They "threaten to choke my room
entirely", he wrote. There they were, among the peasant
pots and the Broussa handkerchiefs, those new pictures;
upon one a cheque with five pounds still legible upon it
was pasted; upon another the figure of Christ stood upon
his head. The painters, without caring a rap for their
reputations as men of learning and culture, were trying
to penetrate beneath appearance to reality. And Roger
Fry was carrying on any number of supplementary adven-
tures. He was maintaining that a hat suitable for a negress
under a tropical sun was fit headgear for Lady Ottoline
Morrell in Bond Street; he had discovered a new cure for
sciatica, and he was arguing some abstruse point about
representation and the aesthetic emotion while all the
time the picture grew rapidly beneath his brush.

He was going to hold a one-man show of his pictures in
January. He wrote of it with the usual doubts: "I fear it
may be rather a rash speculation. But I hope that it may
cover expenses and distribute a few of my works which
at present threaten to choke my room entirely. Perhaps

it would be simpler to give them away without more ado. . . ." But he attached great importance to that exhibition, for he was convinced that he was painting better than he had ever painted before. The pictures were shown at the Alpine Club in January 1912. They roused a good deal of attention. He was laughed at of course. The Post-Impressionist label had succeeded the Old English Water Colour label. It was astonishing, the old press cuttings said, to find that the cultivated and erudite Mr Fry had thrown overboard all his learning and all his science. But he was obviously sincere, and though the frames were of deal, and he had painted them himself, and though a pot of tulips if stood upon a table must have toppled over, the pictures were worth looking at. The press was kindly enough. But as the following letter shows, he was hurt when a critic for whom he had a great respect, Mr D. S. MacColl, expressed doubts about his "conversion"

To D. S. MacColl

DURBINS,
Feb. 3rd, 1912

Of course I don't like your article, partly no doubt because one doesn't like to be called a pasticheur. There's enough ground of truth for it to be very plausible and to be the most unpleasant thing I could have said of me, but as far as I can judge of my work impartially—and I try for my own sake to do so—I don't think it's true. I've always been searching for a style to express my petite sensation in. One of my earliest oil paintings was essentially Post-Impressionist but was so derided at the time—I never showed it publicly—that I gave in to what I thought were wiser counsels and my next rebellion against the dreary naturalism of our youth lay in the direction of archaism. I know that was no good, knew it at the time, but saw no other outlet for what I wanted which was a much more deliberate and closer unity of texture than any of my contemporaries tried for.

Now as to my sudden conversion. I don't think it's a point of any importance but you don't state the facts correctly. So

long ago as March 1908 I wrote a long letter to the *Burlington Mag.* to protest against Holmes's contemptuous tone with regard to Cézanne and Gauguin and what I said there seems to me, on re-reading it, to show that my first reaction to Cézanne and Gauguin was exactly what it still is.

The step from critical and intellectual assent to practise obviously takes some time but I think those—and there were one or two critics—who saw more of Matisse than of Guido Reni in my ceiling were right. In fact I thought the Guido Reni idea was a mere joke of Ross's and could not be taken seriously at all. Still, that work had been commissioned and designed more than a year before I began to paint it and obviously I couldn't with fairness change the whole thing to something quite other than I had covenanted to do.

All this may seem very trivial personality only I like to put it on record.

If indeed I have had a petite sensation which struggled now and then towards expression, why on earth didn't you ever give it a helping hand by showing where and when it showed itself and pushing one in that direction? I should have been very grateful in old days.

Now, whether rightly or wrongly, I feel that I have got a way out of it and have an altogether new sense of confidence and determination which I shall stick to as long as it will last.

There is an asperity—a personal tone—in the letter that shows that what was said of his painting affected him differently from anything that was said of his writing. "You can create", he once wrote to Lowes Dickinson, "and can influence others and impose your own creations on them and that is surely the greatest position to be got out of life." After "long years of toil and uncertainty" he felt that he too was able to create and any doubt of that new capacity hurt him acutely. Under certain circumstances, as the letter shows, he might have become an artist with a grievance. But the circumstances were not favourable. For he had to leave his own problems as an artist, and to deal with the practical problems that faced him in Grafton Street.

V

The second Post-Impressionist Exhibition was opened
on 5th October 1912. "The scope of the present Exhibi-
tion", to quote the introduction to the catalogue, "differs
somewhat from that of two years ago. Then the main ob-
ject was to show the work of the 'Old Masters' of the new
movement, to which the somewhat negative label of Post-
Impressionism was attached for the sake of convenience.
Now the idea has been to show it in its contemporary
development not only in France, its native place, but in
England where it is of very recent growth, and in Russia
where it has liberated and revived the old native tradi-
tion." This time, though English artists of established
reputation had refused to co-operate, works by young
English artists—Spencer, Grant, Gill, Etchells and Miss
Etchells, Vanessa Bell, Adeney, Wyndham Lewis, and
Gore—were included. And once more in his introduction
to his own section—the French—Roger Fry did his best to
anticipate objections and to explain the idea that lay
behind the movement. "It was not surprising", he wrote,
"that a public which had come to admire above every-
thing in a picture the skill with which an artist produced
illusion should have resented an art in which such skill
was completely subordinated to the direct expression of
feeling. Accusations of clumsiness and incapacity were
freely made, even against so singularly accomplished an
artist as Cézanne. Such darts, however, fall wide of the
mark, since it is not the object of these artists to exhibit
their skill or proclaim their knowledge, but only to
attempt to express by pictorial and plastic form certain
spiritual experiences; and in conveying these ostentation
of skill is likely to be even more fatal than downright
incapacity. . . . Now these artists", he went on, "do not
seek to give what can, after all, be but a pale reflex of
actual appearance, but to arouse the conviction of a new
and definite reality. They do not seek to imitate form,

but to create form, not to imitate life, but to find an equivalent for life. By that I mean that they wish to make images which by the clearness of their logical structure, and by their closely-knit unity of texture, shall appeal to our disinterested and contemplative imagination with something of the same vividness as the things of actual life appeal to our practical activities. In fact they aim not at illusion but at reality."

Once more the public exposed themselves to the shock of reality, and once more they were considerably enraged. This time perhaps the shock was less considerable—the novelty had worn off; certainly Roger Fry himself had lost some of his illusions. But the business side of the enterprise was enough to engross his energies. The first exhibition had not done quite so well, financially, as had been expected. Therefore it was of the greatest importance, if as he hoped the exhibition was to be held annually, that the present show should succeed. Much depended upon his own aptitude for business. And he was not a trained business man. He sometimes thought, he said, that he had "a great business instinct somewhat smothered in great superficial incompetence". "In fact", writes Leonard Woolf, who took Desmond MacCarthy's place as secretary, "he was a very curious mixture. In many ways he conducted business in an extremely un-businesslike way, and this occasionally led to disastrous results. For instance, he would make agreements with people without recording them in writing. Although extraordinarily good and ingenious about the details of business, he was inclined to be carried away by his en-thusiasm for a scheme and brush aside as unimportant all the details upon which success or failure depended." Hence there were many scenes, in the basement beneath the gallery where business was transacted, that were both "hectic and comic". Many of the Russian pictures failed to arrive upon the opening day. The rates of commission had been left unspecified and Roger Fry was naturally held

responsible when they were found to be higher than the artists had anticipated. And when accused by artists and business men of mismanaging their different interests, he was not conciliatory. "He was completely disinterested", Leonard Woolf writes, "in the large sense of the word, *i.e.* his ultimate motives were not his own interests, but some idea. But in planning and carrying out the actual steps and business necessary for attaining his disinterested object, he would be both dictatorial and ruthless." Plain business men who were not used to skipping details in order to follow ideas were puzzled; and they protested. But the plain business men were not only puzzled; they were often coerced. In order to achieve his end, Roger Fry brought to play upon them three different qualities, not usually exercised in business dealings. "First", his secretary writes, "there was the immense charm which everyone felt as soon as they began to talk to him. Then there was his incredible persuasiveness. In a personal business interview these two assets were usually sufficient. But if they were not, there then appeared a third line of defence which often, I think, surprised people. Roger had an extraordinarily strong will and immense persistence. If he had made up his mind on a practical business question, he nearly always got his way and in the pursuit of his object he would display what can only be called ruthlessness. Intellectually, he was the most open-minded person I have ever met, but he was not open-minded in practical affairs. That is why people who 'got across' him in business often genuinely misunderstood his motives."

But difficulties with business men in the basement were not the only difficulties that he had to solve. All sorts of people were daily passing in front of the pictures in the galleries above. They were being exposed to the shock of reality and were registering many unexpected emotions. Directly Roger Fry showed his face in the gallery they would seize upon him; they would demand explanations;

they would express their delight or their disgust. And then, his secretary observed, "His handling of people was masterly —it did not matter who they were". Often they were very angry—then he would "skilfully and courteously manage to squash them". Often, on the other hand, they would show unexpected intelligence. Then he would take them round the gallery and "deliver an extraordinarily interesting lecture". And among the daily press of unknown people there would appear now and then an old friend— Arnold Bennett for instance, or Henry James. Them he would take down to the basement where, among the packing cases and the brown paper, tea would be provided. Seated on a little hard chair, Henry James would express "in convoluted sentences the disturbed hesitations which Matisse and Picasso aroused in him, and Roger Fry, exquisitely, with something of the old-world courtesy which James carried about with him", would do his best to convey to the great novelist what he meant by saying that Cézanne and Flaubert were, in a manner of speaking, after the same thing.

But that was not the end of his day's work. When the galleries were shut to the public he would open them again to bring people together—people from many different worlds, ladies of fashion, painters, poets, musicians, business men. The new movement was not to be restricted to the art of painting only. Some of the young French poets were invited to read aloud from their work. He lectured both upon poetry and upon painting himself. He arranged concerts. The fashionable and the aesthetic rubbed shoulders at those parties. Post-Impressionism had become, he noted, all the rage. Whether that meant that people really enjoyed Cézanne or merely thought that it was the right thing to say so, he was doubtful. His enthusiasm was always corrected by a douche of caustic common sense. His exquisite urbanity concealed a certain scepticism. Lady So-and-so was charming; she was ecstatic; but did she really cherish a disinterested delight

in Cézanne himself, or was he merely a new fashion to be
worn this summer and thrown away the next? He often
dwelt in the articles he wrote then upon snobbism and its
symptoms—"the tendency to believe in the value of right
opinion—to think that by knowing whom one ought to
admire . . . one achieves aesthetic salvation". But his own
faith was more deeply grounded than ever, and whatever
his share in the movement had been, there could be no
doubt when the second Post-Impressionist exhibition shut
on the last day of 1912, that the two exhibitions had made
an immense impression both upon the artist and upon
the public.

CHAPTER VIII

THE OMEGA

I

MANY of the things that Roger Fry had thought impossible in 1892 seemed to him possible in 1913. The stability which he had found so oppressive as a young man was breaking up. The Post-Impressionist Exhibition was only one sign of the change that was coming over the world. What did that change amount to? He threw out a theory, characteristically, in a note to Goldie Dickinson (1913). What was happening in England, he said, was much what had happened in Rome in the sixth century. They were "in a hopeless muddle" then, he said: "the old stupid Roman attitude (dully materialistic and fatuous like that of modern popular art) still persisting, and yet this new ferment working. . . . And the new thing in the sixth century", he went on, "wasn't a religious thing . . . it was just a new excitement—about what? That's where the difficulty is—to see what it was, which crystallised art into the spirituality of the Middle Ages and S. Francis. Anyhow its life and Roman art was dead. We're so like that now somehow—all the people in this new movement are alive and whatever they do has life and that's new. How long will it last—will it fizzle out like the pre-Raphaelites or have we got hold of something permanent?"

The change was in himself too. The shy and studious youth, with his faculty for sitting at other people's feet and absorbing other people's ideas, had become "dictatorial and ruthless", the leader of rebels, the father of modern British painting. Perhaps it was growth, not change, a natural development that sprang from his conviction that

182

one must lay oneself open to new ideas, and to new passions even if they expose one to ridicule. Certainly the new ferment worked in him. He was gay, hopeful and immensely active. The new movement was suggesting fresh developments of the old aesthetic problems. As he explained in a letter to G. L. Dickinson (1913):

I'm continuing my aesthetic theories and I have been attacking poetry to understand painting. I want to find out what the function of content is, and am developing a theory which you will hate very much, viz. that it is merely directive of form and that all the essential aesthetic quality has to do with pure form. It's horribly difficult to analyse out of all the complex feelings just this one peculiar feeling, but I think that in proportion as poetry becomes more intense the content is entirely remade by the form and has no separate value at all. You see the sense of poetry is analogous to the things represented in painting. I admit that there is also a queer hybrid art of sense and illustration, but it can only arouse particular and definitely conditioned emotions, whereas the emotions of music and pure painting and poetry when it approaches purity are really free abstract and universal. Do you see at all and do you hate it? The odd thing is that apparently it is dangerous for the artist to know about this.

He worked out these theories at dinners, at debates, even at week-ends. "A. J. Balfour and Lord Morley are both here," he wrote to his mother from Lord Curzon's country house in December 1912, "so we have some delightful discussions. As I hoped, Balfour tumbled at once to my ideas about Post-Impressionism, tho' he has not liked the pictures hitherto . . . but he sees how logical the theory is. Lord C. denounces it as pure humbug. So we have heated but very agreeable arguments. Balfour is charming as I always suspected he would be. Lord M. is getting old. He is old for his age, and I should think never had anything of Balfour's intellectual agility." Lord Morley, it is to be inferred, did not "tumble to" his ideas about Post-Impressionism. But a surprising number of people passed

that test, as it was put to them by Roger Fry. He was ready to exempt a great many individuals from the common curse of Philistinism which brooded over the British Isles. He made many converts and friends. There was nothing he liked better than those heated but very agreeable arguments. At last, he felt, after the hypocrisy of the Victorian age, of which he had many anecdotes drawn from his own past, a time was at hand when a real society was possible. It was to be a society of people of moderate means, a society based upon the old Cambridge ideal of truth and free speaking, but alive, as Cambridge had never been, to the importance of the arts. It was possible in France; why not in England? No art could flourish without such a background. The young English artist tended to become illiterate, narrow-minded and self-centred with disastrous effects upon his work, failing any society where, among the amenities of civilisation, ideas were discussed in common and he was accepted as an equal. He was always hoping that he had discovered some such centre. Naturally, he was often disillusioned. The hostess whose passion for Cézanne had seemed to him absolutely disinterested was suddenly discovered to be a mere lion-hunter; the old Quaker in him would be roused, and henceforth she would be relegated to the lowest depths of the human hierarchy. But hope always revived—the very next night he sat next somebody who could talk, who could provide an atmosphere. And the centre of civilisation would be removed once more to her dwelling.

But if he was convinced in 1913 that there was a new excitement — something was happening — he was never blind to facts. There was always the Adversary. The Adversary, a compound of schoolboy bully, Pierpont Morgan, the pseudo-artist and the British public, had been too long and too solidly established in the centre of his mindscape to let him indulge in dreams of an easy Utopia. If you wanted a better world, you had to fight for it. And he fought—he waged endless newspaper battles for the

Post-Impressionists; or indeed for any other cause that needed a champion. In 1912, to take one instance, Regent Street was being pulled down. *The Times* leader expressed a hope that the new buildings would "sacrifice to art" Roger Fry at once protested.

The writer adjures us to make sacrifices for art, as though that were not the very root of all our aesthetic disasters. We all sacrifice to art, from the lodging-house keeper who fills her house with incredible ornaments to the millionaire who buys Old Masters that he does not like. It is the art that comes from such motives which is so deadening to all artistic impulse and effort. Nowhere is this dreary aesthetic "snobbism" more devastating than in architecture. We make buildings for our need, and then, sacrificing our pockets to art, cover them with a mass of purely nonsensical forms which we hope may turn them into fine architecture. . . . Let Messrs Swan and Edgar and the rest be as vigorous in their demands for plate glass as ever they like, and then let a really good engineer solve them their problem. . . . Thus we may get something really satisfactory instead of another piece of polite archaeological humbug. Fortunately there is already one building in London which reveals what may be done by honest methods—I mean the Kodak building in Kingsway. . . . This admirable shop puts all its neighbours to shame by sheer reasonableness and good sense, for it has what they lack—essential dignity of style.

Again, there was an exhibition at Burlington House of the works of Sir Lawrence Alma-Tadema. The Royal Academicians had been denouncing Cézanne. This then was the kind of art they admired. Roger Fry was indignant. He devoted an article in the *Nation* to the exhibition. He began by saying that "Sir Lawrence's products are typical of the purely commercial ideals of the age in which he grew up". He went on to say that "he had undoubtedly conveyed the information that the people of that interesting and remote period" (the Roman Empire) had "their furniture, clothes, even their splendid marble villas made of highly scented soap", and added that while

no one grudged "so honest and capable a commercialist his fortune", artists must protest "against the remissness and indifference of the governing classes who instead of enforcing the Adulterated Foods Act . . . stamp it all over with the Government stamp, indicating that it is guaranteed to be the best dairy-made butter". "How long", he concluded, "will it take to disinfect the Order of Merit of Tadema's scented soap?" This was the signal for an astonishing outburst. Perhaps, since times have changed and Alma-Tadema's marble is no longer as solid as it seemed, a few phrases are worth resurrecting. Sir Philip Burne-Jones began the attack. "Fortunately at this date", he wrote, "the work of Alma-Tadema needs no sort of defence. It rests in the security of a practically unanimous European reputation." But since Mr Fry had attacked it, and expressed no contrition when called to order, lovers of art must protest. But what reason for surprise was there? Mr Walter James demanded. It was the "third consecutive year in which Mr Fry has performed a war dance over the recently interred remains of a Royal Academician". (The other corpses were apparently those of Mr E. A. Abbey, R.A., and Mr John M. Swan, R.A.) But of course, they were all agreed, the man who could champion the works of the Post-Impressionists was capable of anything. Yet even he must realise that "his malignant sneers at a great artist only just dead did no good but great harm" to his advertisement of Post-Impressionism. That Post-Impressionism "as at present known will have any real effect upon true art I think nobody believes", was the opinion of Mr Richard H. Herford. And Sir William Richmond summed up: "Mr Fry's position as a student of art, of connoisseurship and criticism is not strong enough to stand up against many more such suicidal egoisms"; and he "must not be surprised if he is boycotted by decent society". To all of which Roger Fry could only reply that there were two standards of art and that they differed, and suggest that "the

State should either endow both, or, better still, allow
complete free trade in art, and refuse all subventions and
all honours to artists"—a conclusion that was naturally
unpalatable to Royal Academicians. And then the "Roger
Fry rabble", as Professor Tonks called them, among
them Lytton Strachey and Clive Bell, joined in, and the
battle raged merrily.

The venom and the vigour of those old feuds proved
that the Post-Impressionist movement had some sting in
it. Roger Fry was delighted. He would quote Sir William's
boycott with great appreciation. "The poor things lose
their heads altogether", was his private comment in a
letter. But the vigour of the movement was being proved
much more seriously and effectively by the young artists
themselves. They were absorbing the new ideas; they were
besieging Roger Fry for advice and criticism; they were
asking him to organise exhibitions. He was convinced that
the young English artists were extraordinarily gifted. If
they were given the opportunity, they could use it. But
that was the problem. How in England, with an Academy
that was enraged by Cézanne and delighted by Alma-
Tadema, could they hope to make a living? It was always
possible, perhaps useful, to go on denouncing the indiffer-
ence of the governing classes in the columns of the *Nation*,
to prove over and over again that the State only rewarded
"the honest and capable commercialist". Every week almost
he could find some fresh instance "of the complete indiffer-
ence of contemporary officials to spiritual things". But some-
thing practical had to be done, even if his experiment at
the Borough Polytechnic had shown him the difficulty.

Many ideas occurred to him. Some are expressed in the
article "Art and Socialism" from which quotation has
already been made. He shows there how the artist has
nothing to hope from the plutocrat; nothing to hope from
the aristocrat; and nothing to hope "from the gentlemen
who administer . . . the public funds". Frankly, he says,
"one scarcely knows if things would be worse if Bumble or

the Royal Academy were to become the patrons of art".
So he conceives that in the great State, the State of the
future, things might be so arranged that "all our pictures
would be made by amateurs". The painter would earn his
living "by some craft in which his artistic powers would
be constantly occupied, though at a lower tension and in a
humbler way". "There are", he goes on, "innumerable
crafts, even besides those that are definitely artistic,
which, if pursued for short hours . . . would leave a man
free to pursue other callings in his leisure." And with his
love of the concrete, in order to put some of these ideas to
the test of fact, he wrote certain paragraphs of this article
in a railway station restaurant. He described what he
actually saw in front of him. It was, as he said, "a painful
catalogue". The window was half filled with stained glass;
the stained glass was covered by a lace curtain; the lace
curtain was covered with patterns; the walls were covered
with lincrusta walton; the tables were covered with ornate
cotton cloths—in short, every object that his eye rested
upon was covered with an "eczematous eruption". And
"not one of these things has been made because the
makers enjoyed the making; not one has been bought
because its contemplation would give any one pleasure".
Display was the end and explanation of it all. And horrible
toil was involved in that display. The article ends with a
vision of what might be possible in the future: "Ultimately,
of course, when art had been purified of its present un-
reality by a prolonged contact with the crafts, society
would gain a new confidence in its collective artistic
judgment, and might even boldly assume the responsi-
bility which at present it knows that it is unable to face.
It might choose its poets and painters and philosophers
and deep investigators, and make of such men and women
a new kind of kings."

Ultimately that may be the case; but in 1910 it was a
vision in the far future. In 1913, art depended upon "quite
small and humble people . . . people with a few hundreds a

year", upon people like himself. It was they who must trans-
form the vision into fact. It was their business to destroy
the railway restaurant and all that it symbolised and put
something else in its place. A plan was sketched in talk.
A company was to be formed; a workshop was to be
started. The young artists were to make chairs and tables,
carpets and pots that people liked to look at; that they
liked to make. Thus they were to earn a living; thus they
would be free to paint pictures, as poets wrote poetry, for
pleasure not for money. Thus they would assert the free-
dom of art "from all trammels and tyrannies". And the
great danger which had seduced so many fine talents—the
danger of becoming a "pseudo-artist", the prostitute "who
professed to sell beauty as the prostitute professed to sell
love", would be removed. He knew by this time the
drudgery and the difficulty of putting such schemes into
execution. He had first-hand knowledge both of artists and
of business men and of the abuse that is the reward of one
who tries to bring them together. But—"all the people in
this new movement are alive and whatever they do has
life". There were the young artists and they looked upon
him as their leader. The moment had come, he believed;
that was proved by a show of Post-Impressionist pictures at
Leicester. People flocked to look at the pictures. "I can't
understand the enthusiasm", he wrote. "I went and
lectured there. The gallery packed, crowds standing all
the time and an extraordinary interest. It's really very odd
and sometimes frightens me." The artists and the public
seemed to be coming together. All that was wanted to
make the union fruitful was a connecting link. As it
happened a legacy had been left him; for the first time
he had a little capital of his own to play with. He decided
to make the venture himself, to float a company, and to
start a workshop. Once more he went about explaining,
expounding, persuading. "I've got £1500 and am going
ahead", he wrote to G. L. Dickinson. "Already an archi-
tect has given me an order and to-day a big firm of cotton

printers has written to ask if I can supply designs and
so far I haven't published a word so it looks as though
I had hit on the psychological moment. . . . God knows",
he added, "why I work so hard. I don't. It's a stupid plan
but I suppose I dimly think the thing's worth doing tho' I
couldn't prove it to my own satisfaction." In July 1913
the Omega workshops in Fitzroy Square were opened.

<p style="text-align:center">II</p>

The Square remains, one of the few Bloomsbury squares
that are still untouched and dignified, with its classical
pillars, its frieze and the great urn in the middle, though
the roar of the Tottenham Court Road sounds not far
away. The house in which Roger Fry set up his work-
shop is there to-day—a house with a past of its own, a
Georgian past, a Victorian past. A lady remembered it in
her childhood; the Pre-Raphaelites, she said, had con-
gregated there, and either Rossetti's legs had appeared
through the ceiling or the floor had given way and the
dinner-table had crashed through into the cesspool
beneath—which, she could not remember. It had a past,
anyhow. But now the Georgian and the Victorian ghosts
were routed. Two Post-Impressionist Titans were mounted
over the doorway; and inside everything was bustle and
confusion. There were bright chintzes designed by the
young artists; there were painted tables and painted
chairs; and there was Roger Fry himself escorting now
Lady So-and-so, now a business man from Birmingham,
round the rooms and doing his best to persuade them to
buy. But before that stage was reached a great deal of
business had to be transacted. The work was very heavy
and it fell mainly upon him. "I have to think out all
between the design and the finished product and how to
sell it—also how to pay the artists, and it's almost more
than I can manage", he wrote to G. L. Dickinson. Another
letter gives further details:

I've hardly known which way to turn since I've been back for the number of things to do and people to see. Most of all I've had to work at the Omega workshops which is now fully started. It needs a tremendous lot of work to organise it properly. The artists are delightful people but ever so unpractical. When I think of how practical the French artists are I almost wish these weren't the delightful vague impossible Englishmen that they are. But I think I can manage them and it's very exciting. Our stuffs are being printed and the French firm that's doing them is full of enthusiasm and are altering all their processes to get rid of the mechanical and return to older simpler methods. Already a big American firm wants to buy some with the right to use them as wallpapers which I don't mean to let them have. The main difficulty is the fact that everyone is going to copy and exploit our ideas and it'll need great business skill to prevent it. Altogether the situation is exciting and rather alarming. I've *got* to make it pay or goodness knows what'll become of me, let alone the group of artists who are already dependent on it. God knows how they lived before they got their 30/- a week from my workshop.

It was as he said "very exciting". The public was eager to buy; and the artists were eager to work. He was surprised by the excellence of their work. "The artists have a tremendous lot of invention and a new feeling for colour and proportion that astonish me", he told Lowes Dickinson. "My fearful problem is to harness the forces I've got and to get the best out of them practically and it's the deuce to do." The truth of that last statement was soon to be proved. The Omega had been opened in July; in October four artists, three of whom were employed by the Omega, issued a circular addressed to possible patrons which began:

<div align="right">1 BRECKNOCK STUDIOS,
BRECKNOCK ROAD, N.</div>

DEAR SIR,
 Understanding that you are interested in the Omega Workshops, we beg to lay before you the following discreditable facts.

They detailed them. The first charge was that "The Direction of the Omega Workshops secured the decoration of the Post-Impressionist room at the Ideal Home Exhibition by a shabby trick, and at the expense of one of their members—Mr Wyndham Lewis, and an outside artist—Mr Spencer Gore". The second charge was that the Direction of the Omega had suppressed "information in order to prevent a member from exhibiting in a Show of Pictures *not* organised by the Direction of the Omega". But the circular did not confine itself to these alleged facts; it went on to express opinions of a highly damaging nature about the Omega Workshops and their Director. One passage ran as follows:

As to its tendencies in Art, they alone would be sufficient to make it very difficult for any vigorous art-instinct to long remain under that roof. The Idol is still Prettiness, with its mid-Victorian languish of the neck, and its skin of "greenery-yallery", despite the Post-What-Not fashionableness of its draperies. This family party of strayed and dissenting Aesthetes, however, were compelled to call in as much modern talent as they could find, to do the rough and masculine work without which they knew their efforts would not rise above the level of a pleasant tea-party, or command more attention.

The reiterated assurances of generosity of dealing and care for art, cleverly used to stimulate outside interest, have then, we think, been conspicuously absent from the interior working of the Omega Workshops. This enterprise seemed to promise, in the opportunities afforded it by support from the most intellectual quarters, emancipation from the middleman-shark. But a new form of fish in the troubled waters of Art has been revealed in the meantime, the Pecksniff-shark, a timid but voracious journalistic monster, unscrupulous, smooth-tongued and, owing chiefly to its weakness, mischievous.

No longer willing to form part of this unfortunate institution, we the undersigned have given up our work there:

FREDERICK ETCHELLS WYNDHAM LEWIS
C. J. HAMILTON E. WADSWORTH

This document was sent to Roger Fry, who was abroad.
He was not, apparently, greatly surprised; once more he
remained "strangely calm", as the following letter shows:

Many thanks for your letter [he wrote to Duncan Grant]
and all the bother that you have gone through in fighting my
battles. I think you've got to the bottom of the question. . . .
I quite agree with you about Etchells. I always thought he
would act on rather romantic impulses. The only thing is that
I personally find it a little hard to think that he could turn
them so completely against me after having been so very friendly
and without ever listening to me. But I really want to help him
and I quite expect that when he's seen the thing in a more
reasonable way we shall be able to.

I've not heard a word about the Ideal Home. Has it been a
success and has there been any decent press on it? This place is
magnificent and we work quite hard. I don't know whether
to any purpose. I'm afraid all I've done so far is to "take
views" of the various objects of interest. I try to turn my back
on the mediaeval castle and the distant town of Avignon, but
the beastly things will get into my composition somehow or
another.

However I have come definitely to the conclusion that the
painting of pictures is too difficult a job for human beings. It's
evident from the history of art that you sink such an amount
of talent and taste and thought and feeling in producing some-
thing completely tiresome wherefore I rejoice in the Omega
because it is not beyond the wit of man to make a decent plate
or a decent stuff.

Doucet sends you his amitiés. He's just gone to bed very
tired after a game of billiards.

 Yours ever,

 ROGER FRY

The circular, however, had been sent to the press; and
some of his friends urged Roger Fry to bring an action for
libel. The Omega might be damaged, they pointed out, if
such charges were left unanswered. But Roger Fry refused
to take any steps. No legal verdict, as he observed, would

clear his character or vindicate the Omega. Publishing correspondence would only advertise the gentlemen, who, he sometimes suspected, rather enjoyed advertisement. He was quite content to abide by the verdict of time—*le seule classificateur impeccable*, as *The Times* critic had observed in another connection. But the young artists themselves anticipated the verdict of time. They gave him then and there the most practical and emphatic proofs of their confidence. They were quite ready to go on working for him; and, what was perhaps more remarkable, he was quite ready to go on working for them. The storm in a tea-cup blew over; though he noted bubbles from time to time—"The Lewis group have got hold of the *New Age* critic and he's written an amusing thing wh. I send you —please send it back. . . . The Lewis group do nothing even now [March 1914] but abuse me. Brezska who sees them says he's never seen such a display of vindictive jealousy among artists" (to Duncan Grant).

But he had much more important matters to attend to than storms in tea-cups. The "fearful problem" presented by the Omega was very real. It showed signs of immediately becoming a great success. Orders were coming in. The public was amused and interested. The papers devoted a great deal of space to the new venture. Interviewers were sent to Fitzroy Square, and one of them has recorded his impressions of the Omega in those early days. Mr Fry, he says, took him round and he asked Mr Fry to explain his intentions. "It is time", said Mr Fry, "that the spirit of fun was introduced into furniture and into fabrics. We have suffered too long from the dull and the stupidly serious." He took up a wool work cushion. "What do you think that represents?" said Mr Fry. "A landscape?" the interviewer hazarded. Mr Fry laughed. "It is a cat lying on a cabbage playing with a butterfly", he said. "It was a mid-Victorian idea," he explained, "but it was not treated in a mid-Victorian manner. The coloured designs are as full of colour and rhythm as the others were full of dullness

and stiffness." The interviewer looked and at last saw the butterfly though he failed to see the cat. Then Mr Fry showed him a chair. He said it was "a conversational chair", a witty chair; he could imagine Mr Max Beerbohm sitting on it. Its legs were bright-blue and yellow, and brilliant bands of intense blue and green were worked round a black seat. Certainly it was much more amusing than an ordinary chair. Then there was a design for a wall decoration; a landscape with a purple sky, bright moon and blue mountains. "If people get tired of one land-scape", said Mr Fry, "they can easily have another. It can be done in a very short time." Then he brought out a screen upon which there was a picture of a circus. The interviewer was puzzled by the long waists, bulging necks and short legs of the figures. "But how much wit there is in those figures", said Mr Fry. "Art is significant deformity." The interviewer was interested. Upstairs they went to the great white work-room, where one artist was at work upon a ceiling, another was painting what appeared to be "a very large raccoon with very flexible joints" for the walls of a nursery. Then down again to the show-room where the journalist was made to look at chintzes, cushions, lamp-shades, garden tables and also "a radiantly coloured dress of gossamery silk" designed by a French artist. Mr Fry was tackling the subject of women's dress. Upon this one the artist had designed "a mass of large foliage and a pastoral scene, and maidens dancing under the moon, while a philosopher and a peasant stood by". It was very beautiful, the interviewer agreed, but would English women ever have the courage to wear it? "Oh," said Mr Fry, "people have to be educated. . . ." So at last the interviewer took himself off, prophesying that posterity would hold the Omega in honour because "it had brought beauty and careful workmanship into the common things of life" and in high good temper for whatever else might be said, the Omega, or Mr Fry, had "certainly stimulated one's intellect and one's curiosity".

Another visitor was Arnold Bennett. "I went up to the Omega workshops by appointment to see Roger Fry. Arrived as arranged at 2.30. I was told he was out. Then that he was at his studio, down Fitzroy Street. I went there and rang. He opened the door. 'Come and have lunch', he said. 'I've had lunch; it's 2.30', I said. 'How strange!' he said. 'I thought it was only 1.15.' Then as he went up-stairs he cried out to a girl above: 'Blank (her Christian name), it's 2.30' as a great item of news. Fry expounded his theories. He said there was no original industrial art in England till he started, *i.e.* untraditional. He said lots of goodish things and was very persuasive and reasonable. Then he took me to the show-rooms in Fitzroy Square, and I bought a few little things. . . . I began to get more and more pleased with the stuff, and then I left with two parcels."

Roger Fry had to say a great many goodish things and to be very persuasive and reasonable before people left with parcels under their arms. But the show-room side of the business was a very minor branch of his work at the Omega. He had also to deal with business men. As Arnold Bennett also records, he met with very serious opposition in that quarter. English firms, he said, "roared with laughter at his suggestion that they should do business together". When he produced his designs they would not take them. "One firm quoted an impossible price when he asked them to make rugs to his design at his own risk." But though they roared with laughter, the business men were, as he had foretold, quick to see how the designs could be copied and made agreeable to the public taste. Emasculated versions of the original Omega ideas appeared in the furniture shops and were more acceptable to the ordinary person than the original. Further, the original besides being original had to be practical. Chairs had to stand upon their legs; dyes must not fade, stuffs must not shrink. Sometimes there were failures. Cracks appeared. Legs came off. Varnish ran. He had to placate angry customers and to find new methods.

He had to hunt out carpenters and upholsterers, little men in back streets who could be trusted to carry out designs and to make serviceable objects. He had to keep an eye upon estimates and accounts. Altogether there were "almost endless small worries about details". And then when the day's work was over, "I have to be bagman", he told G. L. Dickinson. "I go out into smart society and advertise my schemes. . . . You can guess if I'm busy."

Lowes Dickinson, it may be presumed, had no need to guess. And sometimes the endless small worries that fell to Roger Fry's lot made him doubt if he "could stick it out". But again the excitement was great. Not only was the thing itself worth doing, but it opened a new world that appealed to his insatiable curiosity. He visited factories; he interviewed the makers of stuffs and carpets and wallpapers and furniture; he tried to understand the problems which confront manufacturers. And when he had found out how things are made there was the excitement of trying to make them himself. It seemed a natural division of labour—while his brain spun theories his hands busied themselves with solid objects. He went down to Poole and took lessons in potting. Soon a row of handmade pots stood on the studio floor. "It is fearfully exciting . . . when the stuff begins to come up between your fingers", he wrote.

As his readers may remember, he had a habit, when he had found the word he wanted, of working that word, perhaps too hard. This spring the word was "exciting". Everything was "exciting". He went for a holiday to Italy. He revised his views upon Piero della Francesca. "Incomparably beyond all the men of the High Renaissance", he commented. "He's an almost pure artist with scarcely any dramatic content, or indeed anything that can be taken out of its own form." He discovered new country to the north of Rome that was "very exciting". Even England that summer—Bird's Custard Island as he called it— though there were "gloomy inky black shadows round the

trees and no clear-cut shapes or bright colours"—how could any artist possibly work there?—was "very exciting". Above all the Omega was flourishing. Orders were pouring in. Brezska had sold several drawings. Lady (Ian) Hamilton had given a commission for stained-glass windows and a mosaic floor. The French and the German manufacturers were placing orders. He was able to pay his young artists their thirty shillings a week.

But the excitement was not confined to the Omega. Smart society yielded some very good friends to the bagman. There were parties; there were plays; there were operas and exhibitions. London was full of new enterprises. He went to see the Russian dancers, and they, of course suggested all kind of fresh possibilities, and new combinations of music, dancing and decoration. He went to the Opera with Arthur Balfour. It was *Ariadne*, by Strauss, and he was enthusiastic. "I do think seriously he's incomparably better than Wagner, more of a pure musician. . . . It's still not the music I want, but I think it clears the way for it." The way seemed cleared in many directions at the moment. He had fallen very much in love— that was the most exciting thing of all. With complete openness, for the Quakers had taught him to be as honest about love as, indirectly, they had shown him the evils of suppressing it, he shared his excitement about that too. The most incongruous places—the Tottenham Court Road, for instance, on a rainy night—were lit up as he talked of this new hope in his life and of all that it meant to him.

So that exciting summer wore on. The garden at Guildford was ablaze with flowers as he sat writing to Lowes Dickinson—"It's a mass of blue anchusas and red poppies and yellow and pink water lilies and Julian and Pamela are playing about with an old donkey they've hired". He was reading Goldie's articles in the *Manchester Guardian*. "My dear, they're splendid. You know you do write better than anyone. It's always alive and humorous and unexpected and so beautifully passive to reality. They've given

me enormous pleasure." All sorts of people were coming down—Princess Lichnowsky, Lady Ottoline Morrell, G. L. Dickinson, a Chinese poet, a French poet, business men, young artists. He was working harder than he had ever worked before, and with more hope. Many of the things that he had worked for seemed to be coming within reach. Civilisation, a desire for the things of the spirit, seemed to be taking hold not merely of a small group, but to be breaking through among the poor, among the rich. As for himself, though he knew that he often seemed "self-sufficient and headstrong", though he was "conscious of a great indifference to most of the things men work for", though "success seems such a tiny thing compared with what I have lost", he was happier than he had been since his wife's illness. "We are at last", he summed it up, "becoming a little civilised." And then of course the war came.

CHAPTER IX

THE WAR YEARS

I

THAT a break must be made in every life when August
1914 is reached seems inevitable. But the fracture differs,
according to what is broken, and Roger Fry was a man
who lived many lives, the active, the contemplative, the
public and the private. The war affected them all—it
was, he said, "like living in a bad dream". And the first
shock was terrible. He had come to believe that a more
civilised period in human life was beginning; now that
hope seemed ended. "I hoped never to live to see this mad
destruction of all that really counts in life. We were just
beginning to be a little civilised and now it's all to begin
over again. . . . Oh if only France would keep out and leave
Slavs and Teutons to their infernal race hatreds! But we
are all entrapped in the net of a heartless bureaucracy"—
such are two exclamations in August 1914.

But there were reasons why the shock affected him dif-
ferently from some of his friends. He was not surprised,
once the first shock was over, as G. L. Dickinson was sur-
prised. "I suppose the difference is that I've known since
Helen that the world was made for the worst conceivable
horrors and Goldie somehow has thought it wld. stop
somewhere", he wrote to Vanessa Bell. "The war seems
to knock the bottom out of his universe in a quite peculiar
way. I was really glad when a knock came at the door
at 10 o'clock and a thirsty and supperless Desmond
[MacCarthy] appeared. So we were able to talk of all sorts
of things. . . ." And there was another difference between
him and some of his friends. He had not to change his

work; he had only to work the harder. The problem of the
Omega—how to pay his artists their thirty shillings a week
—was more of a problem than ever. The same letter goes
on to say therefore that he is "plugging away at his tables".
And again he had not to reconsider his beliefs or to re-
construct his life. He had been waging his own war against
the adversary for many years now, and his life, as he said,
had been full of bad dreams. The adversary was now more
formidable; the bad dreams were not fitful but continuous.
Thus the war was not so much a break as an intensification
of many old struggles.

But the effect of the war upon the many lives that he
lived simultaneously is best shown perhaps by piecing to-
gether his own day-to-day comments as he scribbled them
down in letters to his friends. They were hurried letters—
the pen was a very poor substitute for talk. And the pen in
the studio in Fitzroy Street was often lost. It was an untidy
room. He cooked there, slept there, painted there and
wrote there. There was always a picture on the easel, and
on the table an arrangement of flowers or of fruit, of eggs
or of onions—some still life that the charwoman was ad-
monished on a placard "Do not touch". It was there that
he was living in the first months of the war.

"The Omega still struggles on," the letters begin in the
autumn of 1914, "but it doesn't anything like pay ex-
penses." He is interrupted by a visit from Mr —— of the
British Museum, an expert on pottery. Mr —— says that
"the Omega pottery is far better than any modern pottery
he has seen. He praised the turquoise in particular . . .
though the peculiar beauty of the colour is, I think, more
due to some mistake in the firing than to calculation."
Then he is off to Poole, to practise throwing, glazing and
painting on china. He is making a dinner set. The lodgings
are squalid; the cast-iron mantelpiece has a design of
classical ladies' heads upon it; he must find some way of
deleting them; clay perhaps will do it; but he is out work-
ing at the pottery from dawn till dark. At Durbins he has

a family of refugees who have "nearly wrecked the house-
hold". And he realises that "the war isn't going to be over
th s winter. A kind of deadness through the prolongation
of the horror" is coming over him. "Oh the boredom of
war—the ways of killing men are so monotonous compared
with the ways of living." His old suspicions of British
hypocrisy are revived. "I can't say just now the whole
truth [about the bombardment of Reims Cathedral], which
is that no bombardment can do anything like the damage
that the last restoration did." But France, the centre of
civilisation, must be supported. He is full of admiration
too for the English soldiers. "I had a talk with Sir Ian
Hamilton, who is commanding the forces in England. He
is the really fine type of soldier who never allows such
feelings as hatred of the enemy to get the better of them."
And so the letters pass to his private life: "Why I am
happy, why I am unhappy" is the title of one pencilled
page.

 1915. . . . Interest in the Omega revives. People are dis-
covering that they must have houses and furnish them.
Customers begin to return. "Had there been no war we
should have been doing a very good trade by now, judging
from the greater appreciation and liking we get for our
work." But the war is coming closer. Doucet (one of the
Omega artists) is at the front. A friend to whom he was
much attached had lost her son, her daughter-in-law and
their six children, in the *Lusitania*. He must see her—he
must do what he can to comfort her. He is off in April to
work with his sisters in organising the Quaker relief fund
in France. He attempts to see Doucet. Without a pass, and
with a letter from the German Ambassadress in his pocket,
he ventures into the front line, is arrested as a spy, and
only saved by the intervention of the head of the Friends'
Mission. But he saw Doucet, who was killed a week or
two later. Then he went on to stay with the Simon Bussys
at Roquebrune. There he painted. "I see that all my
efforts in England will sooner or later be likely to fail

through the war, and that I must aim at painting as my
serious occupation." Back in England he finds the Omega
languishing. Can it be revived by "doing hats and dresses
as being things which people must have quand même"?
No sooner is that scheme set on foot than air raids begin.
One day that autumn "I found everyone at the Omega in
a state of panic". The suffragist lady who rented the top
flat "typed all through the raid without looking out of the
window, and was much disappointed to find that she had
missed seeing the Zeppelin over the Square". But the con-
cierge gave notice and he must find another—"raid proof
if possible". In November he held a show of some of his
pictures. Much to his surprise it is successful. "30 or 40
people come daily. But of course I don't sell." And "most
of the critics are very cross with me", though Sir Claude
Phillips is enthusiastic, "chiefly because he found a moral,
unintended by me, in the Kaiser picture". Meanwhile, the
newspapers are becoming more and more disgusting. "The
tyranny of the Northcliffe press is intolerable. . . . If only
Asquith had hung him [Northcliffe] at the beginning of
the war as an undesirable native how much better off we
should be." And the Germans evidently "are going to
stick at nothing. It only shows to what length of inhumanity
devotion to one's country leads one, for I don't believe they
are naturally inhuman." Privately, unhappiness is much
greater than happiness. He is suffering acutely. He has a
feeling "that the whole centre and meaning of my life"
has been destroyed.

1916. . . . The war is closing in. It is pressing upon non-
combatants. The servant difficulty is acute. At Durbins he
is camping out alone; the children are at school; the house
is too big for him; he has an ineffective old Scotchwoman
"who can talk but can't cook". He does the washing-up
himself. On the other hand, the Omega surprisingly flour-
ishes. "The Bank balance has risen from £27 to £130 after
paying a quarter's rent." Norway and Sweden are be-
ginning to buy. California is "clamouring for our pottery".

And he has been commissioned to decorate a room in Berkeley Square, for which he is making a "large circular rug and tables in inlaid wood". Public affairs, however, are going from bad to worse. "The persecution of the C.O.'s seems to be getting more and more horrible." He is taking up the cudgels on their behalf. A sharp correspondence with Lord Curzon and Mrs Asquith leads to the comment: "It is terrible, isn't it, that we have lost all the liberties that we set out to fight for. I think England will become unendurable." One Conscientious Objector anyhow is employed by the Omega. And he is writing testimonials for friends. "I have known Mr R. C. Trevelyan for twenty-five years. I can state most emphatically that he is a man of serious and genuine convictions and of strong principles. . . ." The children are a comfort. At Easter he bicycles about Oxfordshire with Pamela: "Pam is delightful to travel with. She loves loafing about towns and looking at shops as much as I do", and Julian at Bedales "delighted me by going to bed when I lectured". There was a rapid journey with Madame Vandervelde to Paris; visits to Ministers; visits to the "little artists' rabbit warren behind the Gare Montparnasse". The painters are all discussing Seurat. "You know . . . how I'd gradually come to think he was the great man we'd overlooked. . . . The new Matisses are magnificent, more solid and more concentrated than ever. Picasso a little derouté for the moment but doing some splendid things all the same." Then England again; and work at the pottery at Poole. More and more of the work was falling on him; the Omega artists were being called up. At Poole he had to work "13 hours one day" and "didn't finish till it was dark on Saturday, working on alone in the empty factory. . . . At the last moment I found I'd forgotten to put handles on [Madame Vandervelde's] dishes and there was no time to prepare them and let them get stiff as one ought. So I had to invent a handle which could be made instantly out of a ribbon of clay. . . . Miss Sand's umbrella stand was a

terrible job. It sagged and bulged and threatened utter collapse but I managed at last to punch and squeeze and cajole it into shape." And then he has to give his mind to a bedstead: "I'm afraid the varnish has rather a bad effect on the tempera red lead. It seemed to run and clot in places in a way I've never seen. But it isn't serious unless you look close." He is always being sent for to the workshop to talk to possible clients. Among them was W. B. Yeats. They argued. "I had a huge discussion on aesthetics with him. . . . I impressed him so much that . . . he actually bought linen and carpets—rather a triumph for my dialectics." But he was feeling "very seedy". Something seemed wrong inside. A new doctor advised a new diet— potatoes and rice. The wear and tear of the war was beginning to rub sore places on the surface of some old friendships. McTaggart was becoming more and more reactionary. Lowes Dickinson, whose political views were sympathetic, "has no sympathy or understanding for art so that we never talk of it, and my work is just a subject for jokes with him". His temper was short. A deputation from the Arts and Crafts Society provokes an outburst. "Three sour and melancholy elderly hypocrites full of sham modesty and noble sentiments" came to the Omega to choose exhibits for a show at Burlington House. "They represent to perfection the hideous muddle-headed sentimentality of the English—wanting to mix in elevated moral feeling with everything." And in spite of their moral feelings they "wanted to put me in a sort of dark cupboard and I got really angry . . ." and the show as a whole " is such incredibly lunatic humbug and genteel nonsense as you could hardly believe possible". But he found relief in the picture he was painting—a copy of Buffalmacco. "The more I study it the more I am amazed at it. It seems to me to be just the next step that I'm aiming at. It goes one further than Seurat." And he was reading Stendhal with enthusiasm. But he was "horribly lonely" that winter. The "old Scotch witch" had been replaced by a slavey

"bred in genteel houses and with only one conception of housework—that there must be a tray under everything". So he was developing bit by bit a habit of solitude and was struggling as best he might to find some means by which "out of the wreck of all that seemed safe and central" something might yet be preserved. But he was bitter; irritable, and at times "the struggle seems hopeless".

In 1917 there were more air raids. That meant fresh difficulties with the staff at Fitzroy Square. Also the supply of coal was failing. "Some days you can get 6d. worth of briquettes, other days not even that." The pipes froze; he mounted the roof at Durbins with a pail of boiling water but failed to thaw them. Water rushed over the walls; the bath remained cold. In spite of air raids and frost the Omega must be made to form a centre. A play by Lowes Dickinson was acted there. He used it too to show pictures. One show was of children's drawings. He had met Marian Richardson, "a school mistress in the Black country". "She'd been up in town", he says, "to try and get a post in London and brought her class drawings. She'd been refused without a word, and I didn't wonder when I saw what she'd been at. . . . She has invented methods of making the children put down their own visualisations —drawing with eyes shut &c. I assure you they're simply marvellous. Many of them are a kind of cross between early miniatures and Seurat but all are absolutely individual and original. Everyone who's seen them is amazed. John was in and said quite truly it makes one feel horribly jealous. . . . Anyhow here's an inexhaustible supply of real primitive art and real vision which the government suppresses at a cost of hundreds of thousands of pounds. If the world weren't the most crazily topsy-turvy place one would never believe it possible." In the showroom he started a "sort of evening club. . . . It meets once a week and is a great success. We hope to get all the more interesting people in London to come. We hadn't enough chairs and didn't want to buy them so we made great pillows of sack-

ing filled with straw and put them round the room against the wall. [A sketch.] . . . Yeats and Arnold Bennett came last night." Arnold Bennett records that he came on "Friday March 2nd 1917". "After dining alone at the Reform I went up to Roger Fry's newly-constituted Omega Club in Fitzroy Square. Only about 2 chairs. The remainder of the seats are flattish canvas bags cast on floor near walls, and specially made for this. An exhibition of kids' drawings round the walls. Crowd, including Madame Vandervelde, Lytton Strachey, the other Strachey, Yeats, Borenius &c. They all seemed very intelligent." But there was no comfort to be found in the public world: ". . . it seems as though nothing would break the evil spell and as though we should drift on forever into an utter decline of civilisation. I dined with the Hamiltons a night or two ago and found what seemed intelligent military opinion entirely sceptical, as I had long been, about any chance of decision on the Western front. . . . Really the white man's burden isn't the poor blacks but his own incredible idealistic folly." He was painting—a copy of S. Francis by Cimabue, revising his misconceptions of that artist, and making discoveries. ". . . When one begins to study the forms in detail one finds just the kind of purposeful distortion and pulling of planes that you get in El Greco and Cézanne and the same kind of sequence in the contours." He was trying his hand at portraits too—"It's odd how I get likeness without character", he reflected; and Viola Tree failed to come—". . . sitters are the devil and there's nothing so unsettles one as waiting for one who doesn't come". As to his own drawing he reflected, "I'm beginning to find out about my drawing . . . the way that is to unhitch the mind. You've no idea what a difficult thing that is for a creature like me that's always on the spot." Was that why the unhinged, the insane always came to him? His "incorrigible sanity" seemed to attract them. An account follows of advice asked and given. The Omega, which refused to die or to live,

was becoming a heavy burden. A whole day was frittered
away doing "horrid little things" at the workshop; among
others choosing a lining for a bedspread with a "disagree-
able smart lady" who talked with the fashionable drawl.
"If I could only see my way to get quit of it altogether I
would", he groaned.

Then spring came. He lunched with Madame Vander-
velde, and met Elgar and Bernard Shaw. "Elgar", Mr
Shaw records, "talked music so voluminously that Roger
had nothing to do but eat his lunch in silence. At last . . .
Roger . . . began in his beautiful voice . . . 'After all, there
is only one art: all the arts are the same'. I heard no more;
for my attention was taken by a growl from the other side
of the table. It was Elgar, with his fangs bared and all
his hackles bristling, in an appalling rage. 'Music', he
spluttered, 'is written on the skies for you to note down.
And you compare that to a DAMNED imitation.' There was
nothing for Roger to do but either seize the decanter and
split Elgar's head with it, or else take it like an angel with
perfect dignity. Which latter he did." And with Madame
Vandervelde he went to Dulwich. "The Poussins [in
Dulwich Gallery] are gorgeous. My word, what a com-
poser. Also the finest Rubens in the world, and a Guido
Reni which I found myself admiring seriously." He half
thought of taking an old house with a magnolia tree in the
garden and of retiring to Dulwich for life. But there was
Durbins—he had no servants; but friends still came down.
"Gertler came for the week end and we had endless talks on
art. Gertler is really passionately an artist—a most rare and
refreshing thing. . . . The fact is, artists are a different race.
. . . He went wild over my photos and reproductions."
Goldie Dickinson came; Clive Bell came: "We had a very
good time together. . . . He's amazing in the quantity and
flow of his mind, and the quality gets better I think." The
gardener had been called up. The weeds were rampant. He
took on the job of weeding himself. "I quite understand
Maynard's [Keynes's] passion for weeding. When once it

gets hold of you it's irresistible. . . . I've learnt to scythe properly at last. . . . And now I must finish planting the cauliflowers." In London there were more raids. One sent him to sit in the basement of Heal's shop, where he was hanging pictures—"an absurd and boring proceeding". Another raid he watched from his window in Fitzroy Street. "It was like a game being played high up with purest blue sky and dazzling light." During the full moon he made Durbins into a refuge for some of his friend's children. "It's rather a business, and I'm so seedy I hardly know how to make all the arrangements." Internal pains had not yielded to his diet of rice and potatoes, and he was trying yet another doctor. "I begin to feel I should like someone to look after me instead of always looking after the innumerable helpless ones," he admits.

So autumn came, and he tried to finish his pictures for a show in the midst of other distractions. "It's been a fearful rush, ending yesterday afternoon with me painting in my bedroom (for light) and . . . and . . . and . . . all trying to talk to me at once about their separate affairs." The show of flower pictures was a success. But it was difficult to feel elated by success. The cold was horrible. Again the pipes froze; again hot water was poured from pails; and "Julian dragged me off to a pond three miles away through a bitter North wind to skate . . . and I enjoyed it very much when I had once started". He visited his parents at Failand. He was amazed by his father's vitality. "My father has just worked out with me a most admirable letter on the Pope's peace proposals which I hope will come out and may do good. He's splendid about the war. It's very odd which side people come out on."

So 1917 came to an end; and he noted how the struggle to keep going was almost intolerable; both publicly and privately. He spoke of the "sadness and numbness of my life". Happiness had left him, he felt; and he was training himself to live "only on outside fringes".

January 1918 begins with a pencil draught of a poem.

"Accidia" it is called. "Accidia", he explains, "is the sin of gloominess." The gloomy, he says, are the sinners who do not enjoy life, whom Dante punishes by "eternal fog and blackness and I think mud". Accidia was a great sin; it must be fought. But it was hard; for the cold was bitter; and food was getting scarce. The gift of a rabbit was very welcome. But again, to his surprise, the Omega improved. Sales increased "and I am the only person who can be called upon to do designs". Odd jobs multiplied. He was helping to produce a play by Zangwill. "I've spent the whole day at the theatre seeing about the dress rehearsal of Zangwill's play. My scene is really a great success." He met Diaghileff and "have hopes that later on he may give us some decorations to do for a new ballet". Also "I had an amusing time on Sunday with the Empire builder [Sir James Currie]. . . . I spent Sunday afternoon composing an inscription for his and Kitchener's busts at Khartoum—an odd job for me, but it was amusing trying to turn the usual official humbug into something real." He was also trying his hand at translating the *Lysistrata* for Madame Donnay. "I've never imagined such indecency possible on the stage. It would be fun if they could really do it, but of course no one could now. What civilised people the Greeks were! . . ."

But his health was worse. He was constantly suffering severe internal pain which the doctors failed to diagnose. He went to a new doctor. "He wanted me to have had jaundice very much but I couldn't oblige him. He's given me a new treatment with all manner of strange and potent drugs which makes me very giddy. In fact I've been rather bad of late." He even contemplated taking a week's rest, "sitting out if it's fine enough and lying down after every meal". But rest was impossible; the pains increased and so in despair "I've had recourse to a much advertised quack remedy. . . . I hardly like to say it but I can't help thinking it's doing me good."

Public affairs seemed worse than ever. "Oh the un-

fathomable beastliness of our newspapers!" Once there
seemed a chance of peace; but "these beastly intriguing
politicians will really bring the whole thing to a smash".
His father, whose views on the war he found unexpectedly
sympathetic, began to fail. He "can hardly speak loud
enough to be heard and can't move a muscle". But the
Fry constitution is indomitable. There was no immediate
danger. Friends were his great consolation. That summer
he made a new one—André Gide. He brought him down
to Guildford. "He's a real event in my life at a time when
events are very rare. I feel almost as tho' I'd always known
him. That I haven't is evident from the fact that I never
suspected him of being a musician, but when I showed
him my virginals he sat down and played all the old
Italian things I have as no one ever played them before
and exactly as I have always dreamt that they should be
played. He's almost too ridiculously my counterpart in
taste and feeling. It's like finding a twin. I exaggerate of
course. We should differ on a hundred things and he's
much more gifted than I am but still it's a strange like-
ness in the point of view. . . . But we mostly talk poetry and
I've got from him immense quantities of books to read
which will keep me going for ages". Heine, Tchekov,
Lord Dunsany, Colette, Havelock Ellis, Romain Rolland,
Schreiner (*Sea Parasitism*), Tristan Bernard; Durkheim;
Schlumberger; Pierre Weber; Paul Fort; Levy Bruhl—
those are some of the names jotted down in a note-book;
in addition to the usual learned works by French and
German Art Experts. He was reading too Harris's *Life of
Oscar Wilde*—"an amazing book and frightfully tragic.
Also confirms all my beliefs of the impossibility of art in
England. I don't think any other civilisation is so recalci-
trant to art. However you'll say I'm back in my obsession.
But I wish you would read it and see what happened then
and would happen again if ever the British public could
get its teeth into an artist."
So the summer of 1918 wore on; peace seemed further

away than ever; he took stock of his resources against the winter. He had saved one cwt. of coal from last year. He had replaced the slavey with her trays by a married couple —"The Shepherd and the Shepherdess" he called them. They were a delightful pair. But travel was becoming impossible. There were no porters and no taxis. A page is filled with a sketch of himself heavily burdened leading a procession of small boys carrying the family luggage from the station to Durbins. The Omega flourished, then flagged. It would not die, and it would not live. He could scarcely face another year of that struggle, he felt. "I really think the Omega will have to shut up. It's too discouraging now. I'm having to pay all the time and I can't keep it up." Then in October, while he was paying a visit to Failand, his father died. "It was infinitely quicker and better than I had feared", he wrote. It was the end of a long relationship. They had had much in common, and many differences. His father and mother had shared his failures but they had not shared his success. He had not realised perhaps how much his own unhappiness had saddened his father's life. And now it was over. There were many reasons that autumn, both public and private, to make him write more despondently than ever before. He said how he had failed to achieve "the kind of intimate companionship that my domestic nature longs for"; how "I've missed marriage which was what I wanted, and there's no means of getting a substitute"; how "after all these years of pain spent to try to save something from the wreck" all seemed wasted.

And then at last, as the autumn wore on, the cloud lifted. "Isn't Prince Max's speech splendid?" he exclaimed. It was almost impossible to believe that peace was at hand. At last the Armistice was signed. "Isn't the relief immense?" he wrote. "But how much there is to do now. . . . I feel it's the beginning not the end."

II

The war years then, as these scattered and incongruous fragments show, broke into many of the lives that Roger Fry lived simultaneously. It was no longer possible to believe that the world generally was becoming more civilised. The war had killed, or was about to kill, his own private venture, the Omega. It had destroyed the hope of an annual exhibition in which English painters were to muster their forces at the Grafton Galleries. And private happiness, though this lay beyond the reach of any war, had once again eluded him. He had no centre of private security in which to shelter from the public catastrophe. But civilisation, art, personal relationships, though they might be damaged, were not to be destroyed by any war, unless indeed one gave up one's belief in them. And that was impossible. He fought his old battles on their behalf, as the letters show, with many different weapons. They were humble and practical battles for the most part—with business firms, with public men, with private customers. He cooked; he washed up; he made pots; designed rugs and tables; showed visitors round the Omega; found work for Conscientious Objectors; fought on their behalf with politicians; did what he could to pay his artists their thirty shillings a week; and in one way or another he tried his best to make the Omega, though chairs were lacking, a centre in which some kind of civilised society might find a lodging.

But he fought the bad dream most effectively with his brain. "My intellectual life", he wrote at the end of the war, "is perhaps keener than ever." Throughout the war he went on writing articles, writing letters to the papers on behalf of this cause or that, and lecturing all over the country. Very little mention is made in his letters of his criticism. "I've been doing an article for the *Burlington*. . . . I had just time to scribble a few notes for my lecture in the train . . ."—that activity is dismissed

casually enough, as if it could be taken for granted. But there is one paper—*Art and Life*—read to the Fabians during the war, which helps to explain how it was that he survived the war, and not with his intellect merely. He there makes "a violently foreshortened survey of the history of art", and concludes that "the usual assumption of a direct and decisive connection between art and life is by no means correct". Art and life are two rhythms, he says—the word "rhythm" was henceforth to occur frequently in his writing—"and in the main the two rhythms are distinct, and as often as not play against each other. . . . What this survey suggests to me is that if we consider this special spiritual activity of art we find it no doubt open at times to influences from life, but in the main self-contained. . . . I admit of course that it is always conditioned more or less by economic changes, but these are rather conditions of its existence at all than directive influences. I also admit that under certain conditions the rhythms of life and of art may coincide with great effect on both; but in the main the two rhythms are distinct, and as often as not play against each other."

This suggests, what the letters also confirm, that there were two rhythms in his own life. There was the hurried and distracted life; but there was also the still life. With callers coming, the telephone ringing, and fashionable ladies asking advice about their bedspreads, he went back to the studio at Fitzroy Street to contemplate Giotto, to look at a picture by Buffalmacco, and to remark "That's the next step I'm aiming at". If he survived the war, it was perhaps that he kept the two rhythms in being simultaneously. But, it is tempting to ask, were they distinct? It seems as if the aesthetic theory were brought to bear upon the problems of private life. Detachment, as he insisted over and over again, is the supreme necessity for the artist. Was it not equally necessary if the private life were to continue? That rhythm could only grow and expand if it were detached from the deformation which is possession.

To live fully, to live gaily, to live without falling into the great sin of Accidia which is punished by fog, darkness and mud, could only be done by asking nothing for oneself. It was difficult to put that teaching into practice. Yet in his private life he had during those difficult years forced himself to learn that lesson. "It was a kind of death to me", he wrote of that long struggle, "and it is a pale and disembodied ghost that's survived. . . ." But it was no pale and disembodied ghost who opened the door if one knocked at it in December 1918 as Desmond MacCarthy had knocked at it in August 1914. He was huddled in an overcoat over the stove, writing. He was worn; he looked older; his cheeks were more cavernous; his face more lined than before. But he was as eager as ever to talk "about all sorts of things", and the room was if possible still more untidy. Mrs Filmer had obeyed the command on the placard "Do not touch". Mrs Filmer had not touched. Rows of dusty medicine bottles stood on the mantelpiece; frying pans were mixed with palettes; some plates held salad, others scrapings of congealed paint. The floor was strewn with papers. There were the pots he was making, there were samples of stuffs and designs for the Omega. But on the table, protected by its placard, was the still life—those symbols of detachment, those tokens of a spiritual reality immune from destruction, the immortal apples, the eternal eggs. He was delighted to stop work and to begin talking. But directly the friend was gone, the article would be finished, and directly the light dawned upon that very untidy room he would be at work upon his picture. Whatever the theory, whatever the connection between the rhythms of life and of art, there could be no doubt about the sensation—he had survived the war.

CHAPTER X

VISION AND DESIGN

I

IT was the beginning not the end, he wrote to his mother
when the Armistice was signed. But in order that there
might be a beginning, there had also to be an end. And it
was difficult to make that end. The Omega too had survived
the war, but in a badly crippled condition. A fresh spurt
of business came, of course, with the peace; but then three
of the staff went down with influenza; the auditors com-
plained of unbusinesslike book-keeping, and Roger Fry
had to pay certain debts out of his own pocket. At last,
when it came to selling two chairs for four pounds "after
being abject for a whole afternoon", the struggle seemed
no longer worth the effort. By March 1919 he determined
to make an end of it; and in June of that year he presided
over a sale of goods at the Omega workshops.

Rather bitterly Roger Fry watched the public buying
linens and pots at half price which they had refused to
buy at the full price. They might so easily have turned
failure into success. Even now, could he have found the
right manager, or carried on himself for a little longer, the
business might have struck roots and flourished. It was
on the brink of success when he dropped it. "Nobody
knows", one of the press gossips remarked, "why he is
giving up the Omega place. . . . Everyone wants a Roger
Fry house . . . perhaps he can't live with his own wall-
papers. . . . Lady Fry, his mother, dislikes his frantic
colour schemes, and the family in general will be tempted
to say 'I told you so' when he puts up the shutters. But I
admire him", the gossip concluded, "for all that. He looks

good—he looks like one of the early Italian saints he writes about."

Unwittingly the gossip had put his finger upon one of the sore places that this failure had left behind it. Many people would be tempted to say "I told you so" when he put up the shutters. It was not the first time that Roger Fry had failed, and this failure, unlike the others, left unpleasant consequences behind it. He had lost the money that his friends had invested, as well as his own. Also "drenched by Post-Impressionism and immersed in his Omega business", Roger Fry, as Sir Charles Holmes records, "now seemed by general consent to be out of the running" for directorships and appointments. Once more he was without a settled source of income. And when he came to survey his work later he was by no means sure that he had done anything to make the railway restaurant less eczematous, though there was a notable change, superficially, in the shop windows. The English, it seemed to him, always attack an original idea; then debase it; and when they have rendered it harmless, proceed to swallow it whole. "Twenty years ago", he wrote in *The Listener*, "I organised the Omega workshops with a view to creating just that kind of art applied to the needs of everyday life which Mr Barton so eloquently recommends. Twenty years ago the little group of artists which ran that workshop were experimenting with cubist designs and were endeavouring by the austere simplicity of their designs for furniture, and the geometrical quality of their patterns, to give expression to that new feeling for orderliness, clarity and adaptation to use which Mr Barton extols. Unfortunately we were too far ahead of our times, and people who now buy degraded and meaningless imitations of what we did twenty years ago feel that they are on the crest of the wave of a new movement." Snobbism was ineradicable. The failure of the Omega and incidents connected with it no doubt did something to confirm him in his conviction that art "in this vile country" is hopeless.

He wrote bitterly and with reason. But perhaps he was too pessimistic. Perhaps Mr Thornton was right when he said that though "the value of the venture at the Omega workshops is not yet [1938] fully appreciated, yet much that is vital in present-day designs derives from this source". Perhaps without the Omega to lead the way drawing-room suites and dining-room suites would have been still more degraded and meaningless than they now are; the riot of patterns in tea-shops and restaurants would have pullulated still more profusely. But whatever disillusionment the Omega brought him, it had not shaken his belief in the movement, or in the young English artists and their capacities. He could reflect that he had given them work when they were most in need of work; and he had carried out experiments that interested him greatly. If he had made enemies—"but you must admit", he wrote, "that I've chosen my enemies well"—he had made new friends and given the old still more reason to say with the journalist "I admire him for all that". Who but Roger Fry could have undertaken such a task single-handed, or have carried it within an inch of success, or have remained after all his difficulties and disillusionments not only undaunted but full of fresh projects for the future?

So the Omega workshops closed down. The shades of the Post-Impressionists have gone to join the other shades; no trace of them is now to be seen in Fitzroy Square. The giant ladies have been dismounted from the doorway and the rooms have other occupants. But some of the things he made still remain—a painted table; a witty chair; a dinner service; a bowl or two of that turquoise blue that the man from the British Museum so much admired. And if by chance one of those broad deep plates is broken, or an accident befalls a blue dish, all the shops in London may be searched in vain for its fellow.

II

The relief when the Omega was wound up, and he was quit of that incessant strain and struggle, was very great. He was free; and the first use he made of his freedom was to take a holiday. First he went with his daughter to the English lakes, but the English lakes were not to his liking. "There's very little temptation to paint here. It's all so deucedly scenic", he wrote. Nor was he moved by the poetic associations of the country. The cottages of the Lake poets left him cold, but at least he was vouchsafed a vision of William Wordsworth. "I have very little doubt that I have seen William Wordsworth. I found him in the form of a very old sheep lying under a tree. I sat down close to him and did a drawing. He never moved but looked over my shoulder and coughed occasionally."

With this tribute to his native land he crossed the Channel. He felt, he said, like an exile returning to his own country. At first he was disappointed; he found France "to all intents and purposes back in the middle ages". The bureaucrats were all-powerful; soon they would be unable to keep the railways running; there was a tobacco famine; and he was reduced to a starvation diet of six cigarettes a day. But Paris was still the centre of civilisation. If there were strikes and bureaucrats and politicians there were also artists. He met Derain and Vildrac. Talk about pictures began again. "He [Derain] complains that every technique is so terribly easy. He seems to want to find some material that will resist his facility. He talked a great deal of getting rid of the quality of painting. I think I know what he means. He wants the vision to be communicated directly so that one is quite unconscious of the medium through which it is given." He bought a picture by Derain. He visited Picasso; and was amazed by his work. "It's astonishing stuff. Rather what I hoped might be coming. Vast pink nudes in boxes. Almost monochrome pinkish red flesh and pure grey fonds which enclose it.

They're larger than life and vast in all directions and tremendously modelled on academic lines almost. They're most impressive almost overwhelming things. I said 'Mais vous commencez une nouvelle école, l'école des invendables', for one can't conceive who on earth could ever find a place for these monsters. He was very much pleased, and it is rather splendid of him . . . he goes and does things which disconcert everyone. . . . He's always chucking his reputations. It's curious how near all his late work is in its aims to things Fr. Bartolommeo and Raphael worked out."

Then of course he spent long days in the Louvre. "I spend most of my time over the Poussins in the Louvre and am trying to hammer out some notions very vague at present about the different kinds of fullness and emptiness of picture space. Poussin fascinates me more than ever. His composition seems to me more full of new and un-analysable discoveries than anyone. I want to find what principle there is that governs the relations of a convex volume to the space it occupies or fills pictorially. Do you understand? I don't yet, but I've got the glimmer of something which I can't grasp. . . ." (To Vanessa Bell.)

From Paris he went south to Avignon, and the further south he went, the happier he became. His eyes absorbed colours and forms as if they had been starved all these years in England. ". . . It's too exciting to see this Southern colouring again", he wrote to Vanessa Bell. "Every bit of old wall, every tiled roof seems as though it were exactly right, and only needed to be painted." Although it was October, there were masses of wild flowers in the fields, "the most lovely daisies, our kind, only huge with bright pink flowers and heaps of candy-tuft". He painted all day long. Up at seven, he was out by eight; and there in the open air he painted, until the mistral blew his canvas down and he had to seek refuge in an "incredibly dirty inn" kept by Spaniards. He found

them surly at first; then as usual he made friends with them. Helped by the village carpenter he devised a special easel, warranted to resist the mistral; and when even this capsized, he took up his lodging in the kitchen. That kitchen may serve as the setting for innumerable scenes in Roger Fry's pilgrimage. It was the common sitting-room of the place. He had only to sit there, sketch-book in hand, and someone turned up who fell into the very pose he wanted for a big composition he was working at. At night they turned on "an awfully loud mechanical piano called euphemistically the viola", which ground out three tunes incessantly; the young men and women danced the farandole very beautifully, and he sat entranced, talk-ing, drinking, sketching. Compare this with the Tottenham Court Road on a Saturday night! . . . but he was too busy and too happy to dwell upon his old obsessions, the Philis-tines, the British public and Bird's Custard Island. He bicycled on to Les Baux.

There an adventure befell him. Les Baux itself was "too theatrical to be much good for painting", and he was about to move on. But by chance he fell into talk at a restaurant with a very beautiful young man and woman. The man was an artist, who had run off with the beautiful lady and they were hiding at Les Baux until some formali-ties, "divorce of his wife or what not", could be completed. They persuaded him to stay, and with them he went to an entertainment at which "a Breton cabotin" declaimed patriotic poetry. Roger Fry was outraged; and the village schoolmistress, whose name he discovered was Marie Mauron, observing his indignation, insisted that the peasants should sing some of their Provençal songs. The peasants sang; and Roger Fry was enthusiastic. In letter after letter to his friends in London he described those perfect autumn days at Les Baux. "I can't give you any idea of how delightful these people are", he wrote. "First of all there's no idea of any class distinction—the peasants behave to one exactly as equals, and then they all seem to

be artists in a way—*i.e.* they all know these poems which
are quite modern and sing them beautifully." He made
friends with the singers, and through them he met the
poets themselves. The greatest poet of all was "an old
peasant who lived in one room of a tiny cottage. He was
just preparing his supper which was stewed apples and we
helped him to light the fire and cook the apples and all
the time he talked about poetry and intoned his favourite
poems. He is the great authority on the Provençal language.
He has translated Homer into Provençal and is now doing
Dante. . . . He was immensely distinguished and had the
most charming manners and was quite conscious of being a
great artist. . . ." There follows a description of the wedding
of the beautiful young man and the beautiful young
woman, and how at the feast afterwards he made friends
with another poet—"a most amusing character, no one
knows his real name, but he is called 'le sauvage' because
of his peculiar habits. He lives quite alone and has a passion
for all kinds of wild animals and plants, but above all for
spiders which he collects and keeps in his room which is
entirely tapissé with spiders webs. He has written a charm-
ing poem in French to his spiders. . . . The odd thing is
that he is also very well read in French literature and
criticised things with perfect taste. He never wears a hat
because one day the mistral blew his hat away and he
swore it should never happen again. I'm afraid all this",
the letter ends, "sounds very dull, because I can't give you
the curious delight of finding that one can spend an even-
ing with these peasants with much greater ease and happi-
ness than let us say with . . . [a well-known literary man].
The fact is they really are our sort of people with our ideas
of what's worth while and our absence of all notions of
arrivisme."

He had the same sense of ease and well-being that had
come to him years ago in Venice with Symonds and
Horatio Brown and the gondoliers. He found again, even
more completely with the Omega and the Tottenham

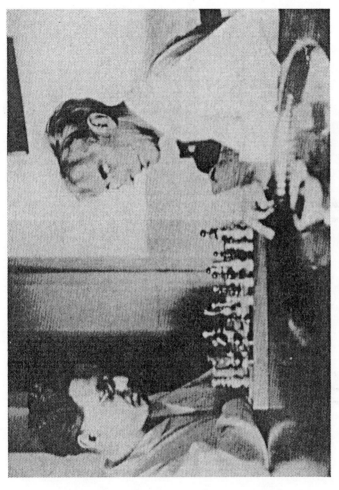

CHARLES MAURON AND ROGER FRY, ABOUT 1927

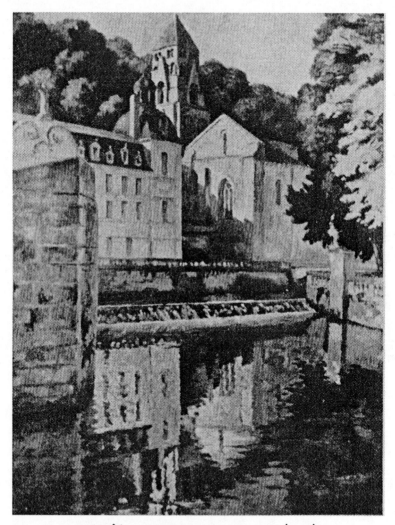

BRANTÔME, A PICTURE BY ROGER FRY (1923)

Court Road to point the contrast, the atmosphere that suited him—the atmosphere in which people developed their own idiosyncrasies whether for spiders or for poetry, where differences of birth and education had ceased to exist, and the "great artist" living in one room and stewing his apples merged naturally in his surroundings— "for they all seem to be artists in their way". And again, as if things repeat themselves, there was the unknown traveller met by chance. This time she was Marie Mauron, and the chance meeting was to lead to two of the most valued friendships of his life. With the Maurons he was to share a mas at St Rémy, and with Charles Mauron he was to carry on the most fruitful of his aesthetic arguments. The meeting at Les Baux ranked high among Roger Fry's adventures.

From Les Baux he moved on to Martigues, cycling with his easel strapped to the carrier. He preferred travelling alone, he confessed, for then he could give his whole mind to the landscape. It is difficult to exaggerate the importance of the landscape in his life. He analysed it in all its vagaries and its moods, its asperities and its charms, as if it were a human being. The atmosphere of the country affected him almost as much as the human atmosphere, to which he was, as he said, "horribly sensitive". "Aren't atmospheres", he wrote, "the reallest things there are?" Les Baux he found too theatrical; Martigues had certain merits but was too like Venice; and so he moved on to Aix, "the holy place" he called it, the home of Cézanne. To his critical eye it was too dramatic. "The illumination is so tremendously definite here that a small change of angle alters the tones a great deal. It hasn't the sharp sculpture of the country round Avignon." After Les Baux and the life there with the peasant poets the bourgeois atmosphere —he was lodging in a respectable hotel—was unendurable. He could no longer tolerate the conventions of his own class. He looked round and discovered a carriers' inn, where though it was noisy, for the carts on the cobbles

woke him at dawn, the company was entirely to his liking. He made friends with the local antiquity dealer, and persuaded him to put some of his pictures in the shop window. "At once there was a buzz of excitement. It reminded me of Vasari—one old connoisseur bringing another and then the artists coming and asking 'Où sont les tableaux du peintre Anglais?' " Compare that with the dull supercilious indifference of the English! "There is more interest in art here than in the whole of London!" he exclaimed.

Cézanne even persuaded him to go sight-seeing. He made a pilgrimage in the holy place to the holy shrine. He went over the great man's house, penetrated to the attics and persuaded the gardener to let him wander over the garden. But the gardener had never even heard of Cézanne, and when Roger Fry tried to get the shopkeepers of Aix to talk about him, they could only remember an old man who was rather cracked. Roger Fry was a little downcast. "It all seemed to me very queer and uncanny that Cézanne came and went and left no trace in the little bourgeois life of the place." He gave up the pursuit of associations and turned to his own canvas. Colours and shapes after the frozen war years when he had no one to talk to about art, and everyone talked politics, became absorbing. He slipped back—he was writing to Vanessa Bell—into the fascination of painters' shop. "I consume more terra verte than anything. . . . I use hardly even a touch of cadmium or rose madder." The words murmur on as they murmured on hour after hour in the studio. And the problems of his own work came once more to the fore. "Why is it that I, who am a good critic, am so helpless in front of my own work?—is everyone? I alternate between fits of thinking—now this time I've done something, and sheer disgust." Perhaps he was letting himself become "too terribly subordinated to the thing seen. . . . I don't think I'm au dessus de mon sujet as Poussin said one should be—and I think he was right . . . but I think all the same that a period of subjection to the thing seen fills one with a lot

of new possibilities of forms and colours which one may use later more freely. But perhaps I'm only persuading myself because I do get so excited by what I see every day. . . ." Once more his favourite word was "excited". Mont Sainte-Victoire inspired it again and again. It dominated him; it absorbed him. He sat in the valley with his legs wrapped in a copy of the local newspaper painting the mountain. He tried to describe it—"the most beautiful mountain I have ever seen . . . all white with blue shadows and pink rocks . . . and green tufts of dwarf oak and then the river-bed filled with all kinds of pale brown red orange and grey bushes". Words as usual refused to do his bidding. A pen-and-ink sketch follows. But nothing he could say in a letter could give any idea of the beauty of the place, or of the harmony and satisfaction of the life there. Vanessa Bell must come there. She must transplant her family. He found a house. He counted the rooms; he planned alterations; he described the garden, the olive trees and the river. No doubt there was some school in the neighbourhood where children could be far better taught than in England. Was it not madness to live there?

But at last in the autumn he came back to Dalmeny Avenue.

III

The end of the Omega had brought about another change. The house at Guildford was too large now, and with his sister Margery's help he discovered another in London. It was "in the wilds of Camden Town with a fine view of Holloway Jail"; and there in 1919 they set up house together. House-moving was an arduous occupation in the early days of peace; the price of linoleum, he groaned, was exorbitant; firm after firm refused to move his furniture; but at last two meat vans hired at Smithfield arrived at Durbins, and under his supervision porters who reeked of blood but were charming characters nevertheless removed the Chinese statues, the Italian cabinets, the negro

masks and all the pots and plates that had made the big rooms at Durbins glow with so many different colours in so many different styles, in safety to Holloway.

The house in Camden Town (7 Dalmeny Avenue) was, he lamented, "in a horribly good condition". The previous owner had decorated it with only too Victorian a thoroughness. Fortunately, he had learnt how to obliterate classical ladies' heads in his lodgings at Poole; the Victorian wallpaper was dabbed out with a stencil; and there in the garden—for there was a "beautifully designed garden which stretches away for ever"—by the side of a fountain presided over by a Chinese deity under the austere gaze of the tower of Holloway Jail he sat writing an article for the *Athenaeum*. It was on Victorian furniture. "I think it's the best I've ever done," he wrote, "though written with great toil and labour."

A mass of such articles had accumulated. They were torn out and tossed away without any respect for order or subject. For twenty years he had been lecturing and writing upon art, but save for the Bellini and the edition of Reynolds's *Discourses* he had published no book. It was owing to his sister's "gentle but persistent pressure" that he now began the work of collecting a volume from these old and repulsive deposits. "My notion", he wrote, "of making a book is dumping old articles into a basket and shaking them up." With his sister to supply pressure, and the "devoted and patient labour" of Mr R. R. Tatlock to help in the task, the book that he called *Vision and Design* was finally collected. It was made up of old articles —a difficult and unattractive form. The articles treat of many subjects—of architecture, of society, of the Ottoman and the Whatnot. And inevitably the book suffers from the chops and changes and repetitions that are unavoidable when many short pieces are strung together. But why is it that the book attracts the common seer—the ordinary non-visual human being to whom pictures are far more inaccessible than books or music? Its appeal to the expert

is plain enough. There is the masterly essay upon aesthetics to absorb him. And for the practising painter there are the essays upon Cézanne and the French Post-Impressionists and Claude. But why is it that Roger Fry's criticism has for the common seer something of the enthralment of a novel, something of the excitement of a detective story while it is strictly about the art of painting and nothing else?

To this old problem it is only possible to hazard one such reader's answer, as it forms in turning the pages once more. It is perhaps, in the first place, that Roger Fry makes painting different from the other arts. It is not literature; it is not biography; it is not music. It is the art of painting that he is writing about. And he does not make the approaches easy. It is an art of supreme difficulty. "Good painting", he quotes Michael Angelo's saying, "is a music and a melody which intellect only can appreciate and that with great difficulty." So curiosity is stimulated. And then sensation is roused. For he assumes that we all have sensations; all that is necessary is to let ourselves trust to them. How, without any of Ruskin's or Pater's skill in words he rouses sensation; how he brings colour on to the page, and not only colour but forms and their relations; how without anecdote or prose poetry he wakes the eye to qualities that it has never seen before, are problems for the literary critic to solve at leisure. Undoubtedly he wakes the eye; and then begins what is in its way as exciting as the analysis by a master novelist of the human passions—the analysis of our sensations. It is as if a great magnifying-glass were laid over the picture. He elucidates, he defines. And as the colours emerge and the structure, learning begins easily and unconsciously to release its stores. He recalls other pictures—one in Rome, another in Pekin; he is reminded of a negro mask, or bethinks him of a Matisse or a Picasso seen the other day in Paris. So the tradition, the submerged but underlying connection, is revealed. And then from the collision of many converging

ideas a theory forms. It may be helpful. For if we allow sensations to accumulate unchecked they lose their sharpness; to test them by reason strengthens and enriches. But fascinating as theories are—"I have an itch for explaining my own sensations"—they too must be controlled or they will form a crust which blocks the way for further experience. Theories must always be brought into touch with facts. The collision may prove fatal to these delicate and intricate constructions. It does not matter. The risk must be run. Running risks indeed is not the least part of the excitement of reading Roger Fry. At any moment he will have to confess, when faced with the discoveries of his eye, that he has been wrong, and so must change his mind. More sensations are examined, not ours—ours are long ago exhausted; but his. His well up, refreshed it may be by the theory which he has made but thrown aside. He seems to have an inexhaustible capacity for sensation; until at last, whether we see the picture itself, or only what he sees, there is nothing for it but to drop the book and take the next omnibus to the National Gallery, there to gratify the desire for seeing that has been so miraculously stimulated.

But besides the power to stimulate, he has also another gift which does not always accompany it,—the power to suggest. Even when the chase is at its hottest sayings like "There is great danger in a strong personal rhythm . . . unless [the artist] constantly strains it by the effort to make it take in new and refractory material it becomes stereotyped", or a remark—"You cannot imitate the final results of mastery without going through the preliminaries" —break off heavy with meaning. They go behind the picture; they bring into being a rich background which we explore half-consciously while we read. That is why, when we read him, we never feel shut off alone in a studio; morality and conduct, even if they are called by other names, are present; eating and drinking and lovemaking hum and murmur on the other side of the page.

And pervading all is the character of the critic himself, with its strange mixture of scrupulous sincerity and fervent belief. He will reason to the last moment, and when that limit is reached he will admit honestly: "I feel unable at present to get beyond this vague adumbration". But if reason must stop short, beyond reason lies reality — if nothing will make him doff his reason, nothing will make him lose his faith. The aesthetic emotion seems to him of supreme importance. But why?—he cannot say. "One can only say that those who experience it feel it to have a peculiar quality of 'reality', which makes it a matter of infinite importance in their lives. Any attempt I might make to explain this would probably land me in the depths of mysticism. On the edge of that gulf I stop." But if he stops it is in the attitude of one who looks forward. We are always left with the sense of something to come.

This attempt to explain the fascination of Roger Fry's criticism may serve to show that others besides the practising painter felt his spell. He started so many hares that all kinds of people joined in the chase. Among them one of the most distinguished was the Poet Laureate, Robert Bridges. Unfortunately, the Poet Laureate's letter has been lost; but its drift can be gathered from Roger Fry's reply:

DALMENY AVENUE, *Jan. 23rd*, 24

. . . I am delighted to have your criticisms of my book, though whether I fully grasp them or can meet them is more doubtful. First of all my attempts at aesthetic (and they are confessedly only attempts and suggestions) are much more empirical and less philosophical than your criticisms. I very early became convinced that our emotions before works of art were of many kinds and that we failed as a rule to distinguish the nature of the mixture and I set to work by introspection to discover what the different elements of these compound emotions might be and to try to get at the most constant unchanging and therefore I suppose fundamental emotion. I found that this "constant" had to do always with the contemplation of

form (of course colour is in this sense part of artistic form). It also seemed to me that the emotions resulting from the contemplation of form were more universal (less particularised and coloured by the individual history), more profound and more significant spiritually than any of the emotions which had to do with life (the immense effect of music is noteworthy in this respect though of course music may be merely a physiological stimulus). I therefore assume that the contemplation of form is a peculiarly important spiritual exercise (your "spiritual mirth"). My analyses of form-lines, sequences, rhythms, &c. are merely aids for the uninitiated to attain to the contemplation of form—they do not *explain*.

But agreeing that aesthetic apprehension is a pre-eminently spiritual function does not imply for me any connection with morals. In the first place the contemplation of Truth is likewise a spiritual function but is I judge entirely *a*-moral. Indeed I should be inclined to deny to morals (proper) any spiritual quality—they are rather the mechanism of civil life—the rules by which life in groups can be rendered tolerable and are therefore only concerned *directly* with behaviours. I shd. admit that the feelings we have to our kind are of a spiritual nature (love being a function of spiritual health and hate of spiritual disease) and that those feelings may issue in good or bad behaviour. But in so far as they do not issue but remain "states of mind" they are spiritually good or bad but not morally. But in any case it must, I think, be admitted that there are spiritual functions that are not moral.

As to sex. It like the endocrine glands may be a predisposing cause, a stimulus (like Mozart's smell of rotten apples), but surely is no part of the aesthetic apprehension. I find that in proportion as a work of art is great it is forced to discard all appeal to sex. Only bad art can be successfully pornographic. It may have been the *point de départ*, it is no longer visible when the work of art has arrived. Of course those people who are insensitive to the artist's real intention may go off on even the slightest hint of a more accessible appeal. As for instance a man reading a great poem which he did not understand might occupy his mind with the *double entendre* of words it contained. I can imagine that to some people Velasquez's Venus might

excite sexual feeling; to any one who understands the picture
such an idea is utterly impossible, it is too remote from the
artist's meaning to be even suggested. As regards painting I
think you are quite wrong in thinking that the preoccupation
with the female nude is a result of sexual feeling. It is simply
that the plasticity of the female figure is peculiarly adapted to
pictorial design; much more so, on account of its greater sim-
plicity, than the male—though of course the plasticity of the
human figure in general is peculiarly stimulating to the pictorial
sense—perhaps not more so than that of a tiger but it is the
most stimulating of easily accessible natural phenomena.

There—if I've answered you at cross purposes it is because of
the great brevity of your exposition. One day we must talk it
over at length.

<p style="text-align:center">IV</p>

The letter to the Poet Laureate is enough perhaps to
show that the argument, always growing in vigour and
variety, had survived the war. And no doubt the keenness
of his intellectual life, which, he said, had increased during
the war, helped him to bridge the difficult transition from
war to peace. But that keenness made him also acutely
aware of the difficulties that lay ahead. "My God", he ex-
claimed, "what a world the reaction is going to bring—
a return to the Middle Ages without the naïveté and the
beauty of the Middle Ages." He noted signs of that re-
action in the early 'twenties with apprehension and horror.
"The question for Europe is no longer to struggle for
power, but simply to safeguard what is left of civilisation
by helping each other as much as possible. If Germany
succumbs there will be no hope for Europe, and to con-
tinue to prevent it from re-establishing itself is so mad
that one can't understand it." Again, "Of all the religions
that have afflicted man (and they are the most terrible
afflictions) Nationalism seems to me the most monstrous
and the most cruel". He was neither blind nor deaf to
what was happening in the world of politics, even if he

had to coin a name—"I'm an individualistic anarchist"
was his attempt in 1925—to sum up his own political
position. All his sympathies of course were with Lowes
Dickinson in his fight to establish a League of Nations.
Through Lowes Dickinson's persuasion he attended one
of the many conferences of intellectuals that were then
being held in Paris. But conferences seemed to him to
result in outbursts of moral indignation; and moral
indignation was a mere "gaspillage de l'esprit". His own
fight lay elsewhere; and a long series of letters to Charles
and Marie Mauron, written during the early 'twenties,
shows how clearly Roger Fry realised the necessity of
fighting if, as he said, "it"—civilisation in one word—was
to begin again.

"The herd" is the phrase that dominates the letters at
this time—the herd with "its immense suggestibility more
than ever at the mercy of unscrupulous politicians". The
herd has taken the place of the adversary; the herd is the
adversary, swollen immensely in size and increased in
brute power. The herd on the one side, the individual on
the other—hatred of one, belief in the other—that is the
rhythm, to use his favourite word, that vibrates beneath
the surface. A vast mass of emotional unreason seemed to
him to be threatening not only England—that was to be
expected; but France also. France, he lamented, had lost
that "objectivity which has been the glory of its great
thinkers". And this emotionalism, this irrationality could
only be fought by science. We must try to understand our
instincts, to analyse our emotions. That was a doctrine
that he preached and practised. He extended his reading.
He read Wilfred Trotter's *Instincts of the Herd* with im-
mense interest. He pressed it upon all his friends. He read
the Behaviourists; he read the psychologists. "Il nous faut
surtout de la psychologie vraie. Il nous faut comprendre
cet animal entêté, violent, idéaliste qui se laisse mener par
les mots creux." He poured out the theories that all this
reading suggested in argument and in letters. Two quota-

tions from letters to the Maurons will be enough to show
the drift of the ideas that swarmed in his brain.[1]

March 2nd 1920

Le bon Duhamel hurle dans *La Nouvelle Revue* contre la
science—il prêche un soulèvement moral, la bonté, &c. Je
trouve cela tres dangereux et au fond réactionnaire. L'homme
ne peut s'élever moralement par la bonne volonté pas plus
qu'il ne s'élève dans l'art par sa propre force. Rien ne change
en l'homme que les mœurs . . . et la science seulement peut
changer les mœurs on nous montrant les moyens d'arriver à
tel ou tel but . . .

And again in the same year:

. . . Je crains au dessus de tout l'impatience de l'homme—qui
cherche des raccourcis qui l'amènent dans les culs-de-sac. La
seule route qui ne l'a jamais égaré c'est la science et la science
demande les plus grandes vertus pour l'homme . . . une
humilité à toute épreuve et une complète désintérressement—
c'est pour cela que c'est toujours mal vu par le commun des
hommes qui ne l'acceptent que pour ses côtés utiles ou plutôt
(voir la guerre) néfastes. Pour moi je crois que l'intelligence
humaine n'a jamais rien construit de si beau, de si impres-
sionant que la théorie de la matière depuis la découverte du
radium. Je la comprends à peine mais juste assez pour en voir
l'immensité et l'audace.

But though the scientific method seemed to him more
and more the only method that could reduce the human
tumult to order, there was always art. In painting, in
music, in literature lay the enduring reality. And though
in the 'twenties he noted with dismay the return to mysti-
cism in religion, and the return to nationalism in politics,
by one of those paradoxes that were for ever upsetting the
theorist he was forced by the evidence of his own eyes to
believe that, far from perishing, art was more vigorous
than ever.

[1] In these passages and those that follow Roger Fry's French has been
allowed to stand as he wrote it.

Moi qui détestait l'art moderne dans ma jeunesse, qui m'absorbait entièrement dans les vieux maîtres Italiens—je vois maintenant une véritable Renaissance—nous vivons dans une époque extraordinaire pour l'art. Je suis sûr que je ne me trompe pas . . . à Paris j'ai trouvé un artiste jusqu'alors presqu' inconnu pour moi, Rouault, qui est sûrement un des grands génies de tous les temps. Je ne peu comparer ses dessins qu'à l'art Tang des Chinois dont il nous reste seulement quelques spécimens. Non, je n'ai pas de patience avec les gens qui décrient notre époque—nous avons developpé aussi cette immense système de faux art—l'art officiel et pompier—l'art véritable devient toujours de plus en plus une chose esotérique et cachée comme un secte hérétique—ou plus encore comme la science au moyen âge.

So he wrote with all the old enthusiasm to Madame Mauron.

The question that he had asked Lowes Dickinson before the war, whether the new ferment, the new movement, was lasting or would it "fizzle out like the Pre-Raphaelites", was answered. There were, it seemed to him, more "honest artists" in England than ever, in spite of the emotional turbulence that the reaction was stirring on the surface. On the other hand, the adversary was stronger than ever. In England, he wrote in 1920, "the artist is almost without resources". So while theories multiplied, and with the help of science and with the help of psychology he tried to fortify the individual against the herd, he had also to help the individual in his private fight—to pay his rent, to sell his pictures. "I seem", he said, "for some reason to be the only person available." In his double capacity as artist and man of business he was indispensable. So the letter which has been dealing with the evils of mysticism, and the evils of nationalism, with behaviourism and psychology, breaks off in the middle of a quotation from Alain, from Bertrand Russell, from Flaubert, to exclaim, "I have a million calls upon me. . . ." He is due at a hanging committee. He is trying to organise a new group. A and B and C are all pestering him with letters. A is the

Secretary of a provincial art gallery. "He wants me to go down and lecture. And as they seem really keen . . ." B is a young artist who wants to start a picture gallery with a lending library of pictures attached. It is an admirable idea; but money is needed. Every artist seems to think that Roger Fry can extract money from stones. Then there is C. He has real talent but "is in a frightful muddle about his private affairs". He has, the letter laments, three children already, and another is on the way. "Oh dear, why are these delightful people so unpractical?" he breaks off with a groan.

Each of these letters of the alphabet—and that alphabet had twenty-six letters at least—was an individual—a man or a woman who was trying to put up a fight for the spiritual life against the dominion of the herd. Therefore each had a claim upon him. For "What a rarity the individual is! . . . More and more I understand nothing of humanity in the mass and *au fond* I only believe in the value of some individuals. . . . I know that I have no right to detach myself so completely from the fate of my kind, but I have never been able to believe in political values." More and more he interested himself in the individual. The individual might be an old tramp who had stolen a watch and was found by Roger Fry sitting on a bench in the Temple Gardens. Roger Fry sat down beside him. "Oh la conversation exquise que j'ai eue l'autre jour avec un vieux mendiant criminel! Il faut que je raconte ça." The old tramp told him how he had stolen the watch, and how he had gone to prison, and the account ends with the exclamation, "Mais comme ces gens sont sympathiques et moralement supérieurs aux bourgeois!" These were the people who must be helped if civilisation were to continue. And so, though "the jealousies and suspicions of artists make it almost impossible to help them", he was off, as the abrupt ending of many letters testifies, to sit on committees, to hang pictures, to organise exhibitions, to beg money and to persuade the rich to buy.

He was also off to lecture. For by lecturing not only did he make a living and support his family, but he did something to encourage the individual to enjoy the rarest of his gifts, the disinterested life, the life of the spirit—"I use spiritual", he wrote with his usual care to make his meaning plain, "to mean all those human faculties and activities which are over and above our mere existence as living organisms". Instead therefore of nursing his bronchitis over the fire, he would pack his bag in the chill of January and February and be off to Dunfermline, to Birmingham, to Oxford, to lecture upon art. And that his audience was grateful is proved by some simple and anonymous lines in the local newspaper :

> Beauty awoke: you heard her stripling call;
> Enthroned her where some vulgar upstart sat.
> *Beauty is truth, truth beauty. That is all*
> *We know on earth.* . . . You helped us to know that.

v

Then of course there was always his own painting. The studio at Dalmeny Avenue, a very pleasant room looking out over the garden and under Margery Fry's supervision comparatively tidy, was full of his pictures—too full unfortunately. Nobody bought them, he complained. He held a show of his work in 1920, and it was a complete failure. Only five sketches were sold and he was bitterly disappointed. "I will never show again", he wrote to Madame Mauron. "I will go on painting, and when the canvases are dry, I will roll them up." This failure he explained partly by the crass indifference of the British public to art, and partly by the fact that the emotionalism left over from the war was rushing both public and painters "pall-mall into romanticism under the guidance of the sur-realists". Even in France, the country of civilisation, the pseudo-artist, the arriviste, was for the moment rampant. A letter to Helen Anrep (1925) gives an amusing account of a dinner-party

in Paris where he met one of the apostles of the new mysti-
cism and, rather maliciously, drew him out. "Mon dieu,
the arrivism, the mercantilism, of the art world here! It
has fallen very low and it seems to me all the young are
given over to the determination to arrive and attract atten-
tion. . . . After dinner I got alone with —— and pumped
him about the ideas of les jeunes. I was shamelessly open-
minded and sympathetic and out it all came. 'We spent
our youth at the war—that has made us more serious than
the old—we can only accept life at all on condition of find-
ing God. To find God we must reduce all to a desert and
then we may see him. . . . I accept life. . . . I can make
money by dealing and I get drunk only because I know
the emptiness of all except God. We seek to dislocate every-
thing, to stir up trouble everywhere for trouble's sake and
because it leads to the desert where God is &c. &c. . . .'—
the new mysticism, you see it all. . . ."

The new mysticism which despised science and also
Flaubert ("Flaubert," said the young man, "je ne lui prête
plus d'attention que je donne à ma concierge") was highly
antipathetic to Roger Fry. While sur-realism and romanti-
cism swept the surface, he felt more and more "left alone
on the deserted island of orthodox classicism". The mean-
ing of that phrase so far as his own work as a painter was
concerned is given in a letter to Vanessa Bell; and since it
represents a considered opinion of his painting it may
be quoted:

I am coming to have quite a good conceit of myself. At least
I think I get more power every year and that's all one need
worry about. I don't suppose you'll ever *like* my things very
much, but I think you'll respect them more and more because
there's a lot of queer stuff hidden away in them as a result of
all my long wanderings and peerings and gropings in the world
of art and I think they're things that will only come out gradu-
ally. I shall never make anything that will give you or anyone
else the gasp of delighted surprise at a revelation but I think I
shall tempt people to a quiet contemplative kind of pleasure—

ROGER FRY

the pleasure of recognising that one has spotted just this or that
quality which has a meaning tho' mostly one passes it by.

That is not an extravagantly high estimate; whether it is
a just one or not the art critic of the future must decide.
But that it underestimates the place that painting played
in his life is obvious. That is shown again and again by
the eager, the pathetic, delight with which he recorded
any praise of his work. If the English despised him, the
French at least, who did not suffer to the same extent
from the "snobbery of genius", took him seriously. Even
when nobody praised his work, and he was oppressed by
the conviction that art after the war must be esoteric and
hidden like science in the middle ages—"we can have no
public art, only private ones, like writing and painting,
and even painting is almost too public", he wrote (to
Virginia Woolf), he still went on painting. Even if he had
to hire a room to house his canvases, and the canvases
themselves must be rolled up, he painted. And that his
writing profited by his painting can scarcely be doubted
whatever the value of those canvases as works of art. It
was with his brush that he broke through the crust that so
often separates the critic from the creator. It was because
the painter's problems were his own that he understood
them so profoundly, followed them so adventurously, and
is first and foremost a painter's critic not a connoisseur's.

VI

The studio at Dalmeny Avenue, then, in the early
'twenties was both an ivory tower where he contemplated
reality, and an arsenal where he forged the only weapons
that are effective in the fight against the enemy. More
than ever it was necessary to oppose the emotionalism
and chaos of the herd by reason and order. If the political
man, as he told Lowes Dickinson, is a monster, then the
artist must be more than ever independent, free, individual.

But the studio was not the only room in the house; there was the dining-room, looking out over the garden, where his favourite irises nodded over the fountain presided over by the Chinese statue. On the dinner table, decorated by Duncan Grant, were the plates he had made with his own hands, and round it were the chairs that he had designed himself. Almost any guest invited to dine with him about 1920 would find him, manuscript in hand, seeking the right words with which to fill in a gap in his translation of Mallarmé.[1]

". . . One of his greatest pleasures", Charles Mauron wrote in his introduction to their joint translation, "was in poetry, and especially the poetry of Mallarmé. He made no secret of the difficulties he met with: who does not meet them? But he of all men, he who was ever on the trail of some new splendour—felt himself attracted by the mysterious *miroitement en dessous* which, imprisoned in the poet's most cryptic verses, at once exasperates and delights the mind. . . . Assured, then, of an authentic pleasure, Roger Fry's first impulse was to share it. . . ." Thus the guest before sitting down to dinner would be asked to share the dangerous delight of helping to translate Mallarmé into English:

Le vierge, le vivace et le bel aujourd'hui
Va-t-il nous déchirer avec un coup d'aile ivre
Ce lac dur oublié que hante sous le givre
Le transparent glacier des vols qui n'ont pas fui!

—how was that to be rendered? But if it was impossible to find the exact sense, let alone the exact sound, Mallarmé, intoned in Roger Fry's deep and resonant voice, filled the dining-room with magnificent reverberations. Mallarmé stood with Cézanne among his patron saints. Mallarmé, of course, led to argument. The arts of painting and writing lay close together, and Roger Fry was always making raids

[1] The manuscript was stolen, probably under some misapprehension, by a luggage thief in Paris. But it rose from its ashes at St Rémy.

across the boundaries. He was careful to explain that he
knew nothing whatever about the writers' problems, but
that did not prevent him from discussing the other art.
He enjoyed his irresponsibility. It left him free to indulge
his speculative genius unfettered. Perhaps he was not
altogether displeased to find flaws in the art of writing.
In England, at least, literature had assumed such airs of
superiority; it had done so much to turn the artist
into a mere illustrator. So he would be perverse and he
would be disparaging. How far, he would ask, could
literature be considered an art? Writers lacked con-
science; they lacked objectivity, they did not treat words
as painters treat paint. "Gerald Brenan is almost the only
writer who has the same sort of ideas about writing as
we have about painting. I mean he believes that every-
thing must come out of the matière of his prose and not
out of the ideas and emotions he describes." Most English
novels—he read very few—were on a par with Frith's
"Derby Day". Writers were moralists; they were propa-
gandists and "propaganda . . . shuts off the contemplative
penetration of life before it has found the finer shades of
significance. It simplifies too much." Defoe's simplicity
delighted him; Henry James's complexity satisfied him.
But in between, what a waste, what a confusion, what a
jumble of mixed motives and impure desires!

As a critic of literature, then, he was not what is called
a safe guide. He looked at the carpet from the wrong side;
but he made it for that very reason display unexpected
patterns. And many of his theories held good for both
arts. Design, rhythm, texture—there they were again—in
Flaubert as in Cézanne. And he would hold up a book to
the light as if it were a picture and show where in his
view—it was a painter's of course—it fell short. He greatly
admired E. M. Forster's *Passage to India*. "I think it's a
marvellous texture—really beautiful writing. But Oh lord
I wish he weren't a mystic, or that he would keep his
mysticism out of his books. . . . I'm certain that the only

meanings that are worth anything in a work of art are those that the artist himself knows nothing about. The moment he tries to explain *his* ideas and *his* emotions he misses the great thing." Then "poetisation", making things out more interesting than they really are, that imposition of the writer's personality for which there is no exact critical term, was another sin that he discovered in the work of another friend. So his light fell upon new books and upon old, upon the great and the small. It fell spasmodically; it fell erratically. "I'm sure I'm right about Gerard Hopkins" — he had been equally sure that he was right about Marguerite Audoux. Proust at first reading was a source of endless joy to him. Then he revised his views. "He comes out rather too pernickety and silly. . . . I get impatient with him. . . . Fancy a mind that could work for three years upon Ruskin!" So to Balzac . . . "what a queer creature after Proust. However, he does make a kind of texture, in fact a very solid one, out of the purely external conditions of life. He never gets inside anything or anybody but he does make the panorama move along. Also I've fallen back on a twopenny edition of the *Fleurs du Mal*— what a queer book to be distributed among 'the people'. But what a genius—only how tiresome romanticism is even when you have great genius. It becomes a duty to have such violent experiences that they tend to be faked, faute de mieux. But when he talks about cats, owls and simple things he has such tremendous style."

A theory impends, but it can be left pendant. To analyse, to explain, to theorise had for him an irresistible fascination. And yet he was almost envious of those who felt no such desire to investigate their sensations. It was so much better to create than to criticise, and perhaps, in order to create, unconsciousness was necessary. "Theories are dangerous for an artist. It is much better to know nothing about them." It was thus that many arguments would end, and he would apologise for having ventured so many sweeping, perhaps ill-founded, criticisms of an art

"about which I know nothing". And the next letter would contain, not criticism, but an experiment of his own in prose poetry. It was not very successful; his interest in technique had perhaps allowed the sensation to grow cold. The nervous tremor which distinguishes the hand-made pot from the machine-made was lacking. Yet whatever the failure of his practice, and however distracting his theory, even in his rashest raids across the boundaries he conveyed his own sense of the immeasurable importance of art. Here one had pressed a little further—here one had been baffled. But in either case there was no conclusion, only the perpetual need for fresh effort. The thing itself went on whatever happened to the artist—in books, in pictures, in buildings and pots and chairs and tables. And the less the artist gave himself the airs of genius, the humbler he was; the more detached and disinterested, the more chance he had of becoming what Roger Fry sometimes called "a swell"—a member, though it might be a very humble member, of that confraternity to whom "Cézanne and Flaubert have become in a sort the patron saints".

VII

The patron saints, in spite, perhaps because, of all the heresies of the 'twenties—its mercantilism, its mysticism, its arrivisme—remained more firmly fixed than ever in their shrines. And the old enemies were still there, the snobbery of the British public, the stupidity of the Royal Academy, the timidity of officials. Nevertheless, a change in taste was gradually coming to pass: perhaps he had done something to bring it to pass himself. He noted in 1921 the amazing fact that the National Gallery had bought a Gauguin. "Ten years ago", he wrote, "I was turned out of polite society for having a show of him. . . . Now they accept Gauguin but hate their contemporaries none the less." It was his duty, and he practised it to buy his contemporaries. "It will be a long while before the modern

pictures"—bought by selling one of his old masters to the
National Gallery—"will be let into that exclusive society.
Perhaps Pamela will live to see them there." He was still
sceptical about any genuine love of art among the English,
and indignant at the travesties palmed off by the pseudo-
artist whose "only faith is the faith in advertisement and
getting on". But though he could still be indignant, more
often than in the past his indignation was tempered by
other reflections. Officials became hidebound and reac-
tionary as a matter of course. On the other hand, there
were artists like Mark Gertler, like Matthew Smith,
like McKnight Kauffer, like Duncan Grant, whose gifts
differed but whose aims he respected immensely. There
was a group of young English painters, he thought, who
were more promising and more serious than English
painters had ever been in the past. And everywhere
he met private people—Sir Michael Sadler, Mr Hindley
Smith, Marian Richardson, to choose some names at
random—who were carrying on the fight of the indi-
vidual against the herd. There was much in all this to
encourage him. And for the rest, the scientists had shown
him that human nature is very little responsible for its
behaviour. "I am very indulgent to myself," he wrote,
"and therefore I must be indulgent to others." Over and
over again in his letters at this time he urged upon his
friends the necessity of "sagesse" and tried to acquire that
virtue himself. "To see things in their true perspective, to
cease to have any parti pris for oneself, what freedom!" As
for his own reputation, about which he used to care, he
had ceased to consider it, except as an impediment to
freedom that one must endeavour to destroy from time
to time. "He's always chucking reputations", he wrote
with admiration of Picasso. Freedom was the word that
summed up what he most desired, and perhaps, after
infinite gropings and wanderings, he was on the road to it.
 The stock phrases thus never seem to have time to settle
—he would not sit for his portrait as artist, or as critic; as

politician or as prophet. But he did, to quote his own words about Balzac, "make a kind of texture . . . out of the purely external conditions of life". In the spring he was off to Italy, or Spain, or France. In the winter, with the usual groans, he was dragged back to London. There he lectured and wrote; dined out and went to parties. At one of them Lady Astor took him for the devil "and I did my best to live up to it". At another, given to Augustine Birrell on his eightieth birthday, he rejoiced in the sight of Francis Birrell "sublime in his unconsciousness of its being 'an occasion' . . . in an old brown suit, a well-crumpled shirt, and a string of red stuff for tie . . ." and delighted in the wit of "old Augustine who was superb . . . he kept us in roars of laughter by simply saying what he felt in opposition to what people are expected to feel and finally almost forgot about the company and his speech while he mused over the engravings in the Shakespeare which we gave him". Crannies of time were filled up with Mallarmé; with chess; with the *Burlington Magazine*, and, since he was "very hard up", with doing odd jobs of expertise.

But this external framework was never allowed to cramp the other life, the personal life, which, according to his belief, must go on changing if it is to live. Detachment seems as good a word as another to define the change which these later years were bringing to pass. It was felt casually, incidentally, as such things are felt in ways that cannot be put into words. It is expressed in a letter written in 1920 to Lowes Dickinson. The old project of sharing a house together, perhaps in Pisa, perhaps in Provence, had once more come under consideration.

Seriously it's a splendid idea for one's later years—years which I mean to be fuller and richer than any before. I suppose it's a wild idea that, but I have a strange sense of liberation and ease as old age comes on. The envies and anxieties of appetite and ambition are gone or less—one's egotism is there but it's changed—it's less sharp though perhaps it's more petty.

... It's true I still like to be in touch with the younger artists ...
but I get more and more inclined for quiet and sunshine and
just to see tranquil and generous sights like the walls of
Italian buildings ... and now I know what I want to work out
I could manage a great deal of comparative isolation. And then
we should I think keep one another going—even our disagree-
ments would prevent us going to sleep intellectually.

But detachment did not mean withdrawal. His later
years, as he told Lowes Dickinson, were to be richer and
fuller, not emptier and paler than the others. And as he
approached his sixtieth year his claim that the perpetual
revision of aesthetic experiences kept one alive aesthetically
seemed to be justified in the emotional life also. New
experiences succeeded the old, and brought new orienta-
tions. No crust must be allowed to form, even if the purely
external conditions of life must have a certain solid texture.
But while every sensation was to be savoured, and none
rejected off-hand, a balance seemed to have been arrived
at—a balance between the emotions and the intellect,
between Vision and Design.

CHAPTER XI

TRANSFORMATIONS

I

Transformations was the title that Roger Fry chose for a
book of essays, and it seems a fitting title for the last ten
years of his life, the years that were to be richer and fuller
than any that had gone before. Indeed, so full were they of
change and experiment that only a rapid and fragmentary
sketch of those transformations and their results can be at-
tempted. "The great difference I find between myself and
these people", he wrote from Pontigny in 1925, "is that I
have curiosity and they haven't. I want to have *new* ex-
periences. I want to go out into this tremendous unknown
universe outside one."

The one drag upon this insatiable curiosity was, as
might have been expected, the body. The long strain of
the Omega, the hours spent potting in the cold factory at
Poole, the odd meals he cooked for himself with the smell
of paint hanging over the frying-pan, had told upon him.
He suffered from violent attacks of a mysterious internal
pain. But this also excited his curiosity. It might be in-
digestion; on the other hand it might be cancer. All
theories must be given a trial, none must be dismissed off-
hand. And so with indefatigable optimism, rather as a
scientist on the track of a new discovery than as a patient
seeking relief from pain, he went from doctor to doctor,
tried cure after cure—"One has to see lots of doctors and
draw one's own conclusions". When the orthodox failed he
had recourse to the quacks. Drops of blood were submitted
to a man with a black box and a pointer. Next a gentleman
with an instrument that "worked as a kind of wireless

receiver of telepathic vibrations" was consulted. Whatever the verdict—and it varied—he considered it with complete open-mindedness. "It's altogether too queer", he wrote when reporting one of these experiments, "and I want to find out more about it."

This temper of mind, "this ridiculous and occasionally nefast gullibility" as Clive Bell put it, "was the exaggeration of an open-mindedness that made Roger not only one of the most delightful of companions, but one of the most remarkable men of his age. Had a serious student seriously advanced an opinion (say that Giotto or that Cézanne was no good) which called in question his (Roger's) judgment and jeopardised his whole aesthetic, Roger would have listened attentively and sympathetically. And that, not out of urbanity, but because he was genuinely anxious to get at the truth. . . ." Naturally, legends arose. What limits were there to what Roger Fry would believe if given the chance? It was tempting to give him the chance. Might there not be, it was suggested, a scientific method for testing the value of works of art? The suggestion was acted upon. Next week he was found, according to gossip, "swinging a weight attached to a bit of string above a canvas by Cézanne or himself and attempting to measure by eye the extent of the oscillation". Then his son, yachting in Southampton Water, reported some vagary in the tides, or perhaps in his own watch. To his father, however, a more sinister explanation seemed possible, indeed probable. He had been reading the astronomers. "He inferred that we were in the ambit of a 'dark star' which in all probability would shortly collide with the planet and annihilate it." And so convincing was the picture that he drew of this catastrophe that doom seemed to hang over the omnibus that took his guests down the Holloway Road. As for the cures that he discovered and pressed on his friends, the patent medicines, the pills, the ointments, even the saffron-coloured vests—legend had it that he had pressed one such garment upon a lady threatened with

tuberculosis with instructions that she must wear it "if possible on a promontory above the sea, looking east at sunrise"—they were legion. Perhaps one anecdote which is told and vouched for by Clive Bell may sum up this aspect of Roger Fry's open-mindedness. A party was travelling in Italy: at Bologna one of them was struck down with illness. Roger Fry "arrived direct from Paris and found the little Italian doctor in the sick-room. Now in Paris, just outside the Gare de Lyon, Roger's eye had been taken by a gay, multi-coloured tube containing a secret remedy. He had opened it in the train, administered a dose to himself—to precisely what end I am not sure—and studied the printed matter that surrounded it. This had satisfied him that he had in his waistcoat pocket nothing less than the veritable panacea. So, when the Italian doctor had finished his examination, written out a prescription, and arranged for a consultation with the professor of the faculty, Roger stepped forward, and a little uneasily I do think, said that he had brought with him something from Paris that might be worth trying.

" 'What does it cure?'

" 'Tutto', said Roger without flinching.

" 'È troppo', said the little doctor."

II

It was not surprising, then, to find that in 1923 when other cures failed he prepared to submit himself to Dr Coué. But it was interesting. For he had a natural antipathy to that "damned thing" the unconscious; and the "huge Quaker obstinacy and independence of our race" revolted against submitting to it. On the other hand, a new experiment appealed to his curiosity, and there was also the human interest of the strange gathering that collected round the queer little man in the big shed at Nancy. Coué, he said, looked like a grocer's assistant, and yet was so simple, so gay, so sincere that soon all the dismal

invalids were laughing and believing in him as in "a kind of secular Jesus Christ". People of all nationalities and classes had come together. They told their stories in public. Miracles happened daily. A cripple walked; a deaf and dumb English lady suddenly recovered the use of faculties. At first it seemed impossible for Roger Fry to be anything but a detached and sympathetic spectator. "It's terribly difficult for people with so external and analytical a mind as I have to submit", he wrote. For six hours daily he sat on a camp-stool repeating "Ça passe" and tried to realise that his scepticism was "merely instinctive and irrational". At last the charm began to work. His pain left him, and he went on to develop a theory of the unconscious, and that theory was, of course, brought to bear upon art. The séances at Nancy had their share in developing his growing interest in the art of uncivilised races. "The development of the unconscious in art", he was to write in his last Slade lectures, "may bring about a purer and more expressive visual art and one that is complementary to the intellectual and spiritual art of the West." And with Coué in his mind he went on to the Colonial Exhibition at Marseilles and exclaimed, on seeing the negroes, "What we've lost by forgetting how to be animals!"

But these experiments in unconsciousness were interrupted in December 1923 by a call upon faculties of a very different kind. From Nancy he went to Paris to give expert evidence in the case of a disputed Leonardo. For five hours he was examined and cross-examined. A certain Mr Hyacinthe Ringrose was facetious and searching. "You found that the public thought more of your writings than of your paintings?" "Yes." "Did you ever get any prize in Paris?" "No, I never had that insult." "Did you ever read John Ruskin?" "It is a very long time since I read him, but I should say he talked a great deal of nonsense." "Have you changed your opinion sometimes?" "Yes." "And you are still liable to change your opinion?"

"I hope so." After a good deal more of such bickering, Mr Ringrose drew from him "a sort of personal confession". "When I was a young man I thought the Italian masters had got hold of what I considered the right technique. . . . At that time I really believed that there was a right way of painting and a wrong way of painting. I honestly confess that I have changed my mind. Now I no longer think that there is a right way or a wrong way of painting, but every possible way. Every artist has to create his own method of expression in his medium, and there is no one way, right or wrong. But every way is right when it is expressive throughout of the idea in the artist's mind." And he went on to deliver a very lucid and technical disquisition upon mediums; upon washes and pastes; upon the use of the thumb; upon what is meant by rhythm and what is meant by movement; and gave Mr Ringrose and the experts who crowded to hear the case a learned and brilliant lecture upon art in general and the style of Leonardo in particular. After which he returned to more séances on the camp-stool at Nancy, and could be heard muttering "Ça passe, Ça passe" as he sat abstracted and unconscious in the corner of the railway carriage which took him later that year through Spain.

III

There is another aspect of the body which has to be referred to, and if possible in his own tone of voice. That, in talking of love and its "many ways", was always perfectly simple, open and even matter-of-fact. Hence, a curious reversal of ordinary standards like that which had baffled his son in his school days. It was far more immoral to suppress the body than to give it its natural place. Its natural place had been distorted out of all proportion by the bourgeois conventions of the time. For the evasions and hypocrisies of his youth he had nothing but contempt. But if anyone imported the body into places where the

body is out of place—if a painter, for example, used his art to rouse sexual feelings—he was disgusted and had only one word for that distortion—"pornography". This honesty, like so many of his reversals of the accepted conventions, resulted in a new sense of reality. He made no attempt to hide passing affairs; they had their pleasure, perhaps their necessity, certainly their amusement; but the love that was not passing, that was transformed into a relation where mind and body mixed indistinguishably, gained in seriousness because of that honesty, and no one felt the importance of such relationships more than he did.

There was an experience about this time that affected him deeply, and of which he wrote an account. In order to introduce his own comments an outline can be given, such as remains in memory after reading a document meant only for himself and one or two friends. Among the patients at Nancy was a French woman who was neither young nor beautiful, but witty and sympathetic, and between them sprang up one of those friendships which are natural under the circumstances. The rest followed. He had reason to believe that for both of them the relationship in spite of its difficulties—she was ill, they were often separated—was of extraordinary value, when, for no reason that could be discovered, in a sudden access of insanity his friend put an end to her life. Far from having caused this tragedy, he had given her, as her family assured him, the greatest happiness she had ever known. But the shock was terrible, and in the days that followed he wrote an account of this "tragic story" in French, from which some passages may be taken:

Il se livre en moi un combat interminable entre deux principes contradictoires. Par l'amour et seulement par l'amour nous touchons ou croyons toucher à une réalité solide, à un monde peuplé de vraies substances, des âmes, des substances, indestructibles, éternelles, définitives. Dans tout le reste de notre vie règne une rélativité complète. Là il n'y a que des

relations changeantes perpétuellement, et jamais répétées. Tout effort à concilier ces deux expériences semble vain. Les deux mondes n'ont pas une perspective commune. Dans la femme le principe de la vie éternelle de l'amour prime généralement sur l'autre. Souvent elle appartient complètement à l'amour. Je crois que . . . placée comme je suis maintenant et en pleine possession de son entendement se tuerait—moi non. L'autre principe, celui de la vie relative ne se laisse pas jamais abattre complètement chez nous. Sur celui-là j'ai petit à petit formé une philosophie capable de me supporter, capable de rendre viable la vie. Est-ce qu'on connait le cas d'une seule femme qui fut vraiment sage? Tandis qu'il y a eu des hommes sages. Et la sagesse consiste dans la complète rénonciation de tout en nous qui réclame la justice. Il faut que l'on se résigne à ne pas croire même dans sa propre personnalité. L'ensemble de notre caractère est tout aussi bien le resultat pour ainsi dire fortuit de l'hérédité et du milieu que tout autre chose. . . . Il faut écarter toute idée de mérite et de blâme. Il faut traquer la vanité jusque dans ses recoins les plus intîmes, l'écraser complètement et alors la vie peut se poursuivre tranquillement. Il me semble que Lao Tzü (si c'est bien lui) est le seul philosophe qui a su annoncer cette vérité profonde.[1] Toute vanité implique une déformation de la réalité extérieure. La vie n'est qu'une longue apprentissage dans l'art de se ficher complètement de son égo. Et la folie n'est autre chose que d'être complètement emprisonné. La sagesse n'est autre chose que la suppression de toute déformation, l'acceptation complète de ce qui n'est pas nous. C'est le triomphe de l'adaptation au milieu. Ce n'est pas le bonheur mais quel Démon nous a soufflé dès notre maissance l'idée funeste que nous avons droit au bonheur?

Finally—"Je vais me guérir je le sais . . . je ne vais pas donner à la nature en plus ce spectacle ridicule de l'homme en révolte. Il y a plus de fierté dans l'acceptation, dans l'humilité complète. Je vais goûter la saveur d'être vieux, de ne plus être aimé, de n'avoir plus d'espoir ni d'ambition. . . . Il faut que la sagesse nous enseigne encore

[1] Lao Tzü said: "L'homme naturel resiste à la nature des choses, celui qui connaît le Lao coule par les interstices".

comment nous soumettre à ses conseils. C'est la dernière
et la plus dure passe de la philosophie."

<div style="text-align:center">IV</div>

He went later that summer to stay with the Maurons at
St Rémy. It was the only life that he then found tolerable.
He lodged in a little Mas, did his own housework, and
found the peasants "the most civilised, sceptical, humorous
good natured people imaginable—such people can only
happen where Christianity hasn't really taken hold—they
descend direct from the Pagan world and have its wis-
dom". The communism that had flowered from this
ancient civilisation was congenial to him. If any one
wanted a salad, he noted, he took it from the next garden,
and the neighbours did the same in their turn. Soon he was
out in the market at four in the morning, and won the
respect of the market women by guessing correctly the
price they would get for their haricots. It was very hot,
and there was the landscape to look at—the infinitely
complex chiselling of the limestone hills and the intricacy
of the squares made by the almond and the olive groves.
He forced himself to work. The light falling through the
vine leaves of the half-darkened room where Charles
Mauron, whose eyesight was threatened, was forced to sit
interested him and he began to paint his portrait. They
discussed aesthetics, played chess, and began together a
translation of E. M. Forster's *Passage to India*. "It's only by
piling new sensations on to one's memories that one can
learn to start life again", he wrote to Mrs MacColl. He
might have added, "It is only by helping other people to
overcome their troubles that one can forget one's own",
for such, as the letters abundantly prove, was one of
his main preoccupations. But for the time, "the intensi-
fication of life" had gone; the bad dreams were to the
fore.

If he could be happy, he could be very unhappy.

Often the visitor to Dalmeny Avenue would find him harassed and in pain. He had given up repeating the magic formula "Ça passe, Ça passe". Dr Coué's magic had failed. And the old obsessions returned—art was impossible in England; nobody bought his pictures; perhaps he would be forced to give up painting. London society became more and more boring: yet people pestered him with invitations; and his restlessness increased. His energy without a centre to absorb it was formidable. There was his voice on the telephone. He was just back from one of his innumerable expeditions. He had met "a delightful creature" (Spanish, French, Portuguese or from the purlieus of Manchester) who had a real gift (for poetry, painting, or nothing in particular) but was, of course— with officials what they were and the British public what it was that might be taken for granted—starving, or what was worse, living in hopelessly uncongenial surroundings. Something must be done. A lecture must be given; a hall hired; circulars sent out; the rich forced to subscribe. Something must be done—the voice was imperious; and it was heard not without dread by those whose spirit was weak or whose time was occupied. The only consolation lay in art. There were the young English painters. "Matthew Smith has made tremendous strides this winter. . . ." There were pictures, "I have bought a little Matisse for which I longed ever since I saw it years ago in the Elder Gallery". And there was always the theory: "I'm getting an idea of what is the great thing in design, namely to have the greatest possible amount of interplay between the volumes and the spaces both at their three dimensionalist. Do you understand? It means that both volumes and spaces function to the utmost against one another as it were . . . if you look at a Raphael and then at, say, a Titian, perhaps you'll see what I mean. . . ."

At last, happily, he found what he had lacked for so many years—a centre, the intimacy between two people that grows with the years. That possibility presented itself

in 1926. "Je suis incapable de me marier par suite de notre loi inique", he wrote to his friends the Maurons. The law then must be disregarded. With a simplicity that makes it unnecessary either to emphasise the fact or to conceal it, he disregarded the law. He lived with Helen Anrep from 1926 to the end of his life—"il n'y a que la formule qui manque". The reality—"jamais de ma vie ai'je recontré une sympathie aussi parfaite que nous avons"—was of such immeasurable importance that the formula could be brushed aside without hesitation. If from time to time he traced signs of outraged morality on the part of educational and other bodies, he was compelled to admit that things had improved even in England since Sir William Richmond had boycotted him from decent society, and it rejoiced him to find how successfully the young were routing the "fantastic puritanism" of the Victorians in their private lives. Certainly he was no less often asked to lecture; hostesses continued to pester him with invitations; and he was forced as time went on to admit, though it went strangely against the grain, that there were quite a number of people even in England who bought his pictures.

<div align="center">v</div>

The main external change, then, of this marriage without a formula was another change of house. He took a house opposite the tube station with a side view of the terra-cotta prominence of the Russell Hotel, in Bernard Street. "Vous voyez", he wrote to Madame Mauron, "que le bon dieu se charge de m'éviter toute monotonie dans la vie." And once more the pictures, the pots, the negro carvings, the Omega chairs and tables were rearranged. "It's great fun", he wrote, "getting things to fit and seeing the new values they take." Happiness, "this immense bien être, this extraordinary comfort and ease", as he described it, gave everything a new value. Born, it seemed, to enjoy life instinctively, he had been forced to enjoy it cour-

ageously, philosophically, in the teeth of circumstances.
Now that effort could be relaxed, and the things to be
enjoyed seemed endless. "I seem", he wrote in a letter at
this time, "to get more and more pleasure out of all the
small things." He almost ceased to analyse them. That is
why perhaps he enjoyed them so fully, and why in recording
them he came closest to being the artist that he always
longed to be. Here are some of them. "Just to walk about
Paris and come to an old door or a Louis XV balcony",
to "flâner in the Tuileries gardens and watch the fat lady
who keeps one of the kiosques . . . sitting out with her
family round a great pot of stew . . . wishing the men who
sweep up the leaves 'Bon appetit' with such an air of simple
greedy good sense and humour"; to have one's hair cut
and "notice the relations between the manicures and the
clients"; to buy toys for his grandchildren in the Printemps;
to light a fire and watch "how the flames take hold of a
great log and lick round it and eat their way into hollows
and make lovely golden caverns"; to eat "two slices of ham
shimmering in a pale reddish brown sauce of indecipher-
able subtlety and complexity"—these were among the
small things that made every day richer and fuller.
There were also the "odd contacts with people". "Why
should I provoke the confidence of the elderly clergy? . . .
But he was rather an old dear with an odd capricious
passion for pictures. . . . He said, 'I'm getting very anxious
about these Cubists and Futurists, and I mean to preach
about it one day'. So I had to offer to show him my
Cubists." Then there was the great lady, the patroness of
art, who, confronted with a blue Picasso, emitted "one of
the great sayings of the century—'Well, if you call them
Chinese, I think they're beautiful, but if you call them
French, I think they're quite stupid' ". And the perennial
and eternal earnest American lady, "who teaches art, God
help us, to 300 American girls and is seeking desperately
for the last word. She's totally incapable of seeing any-
thing, but she's longing just to hear that blessed last

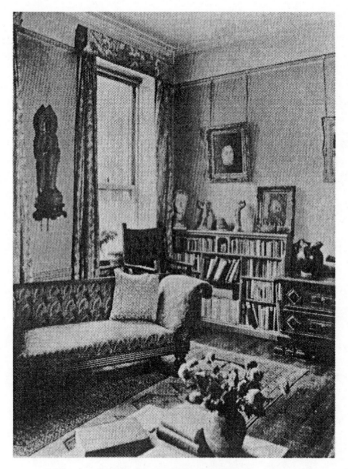

ROOM IN BERNARD STREET

PONTIGNY, A PICTURE BY ROGER FRY, ABOUT 1925

word", which word Roger Fry refused to supply. There
was the pleasure of being taught to play billiards by a
decorated French professor; and the pleasure of play-
ing roulette on a system of his own by which he earned
one franc after playing for twelve hours, and then, on the
boat coming back to England, the amusement of hearing
the French sailors squabbling: " 'Oh toi, à moins tu es
plus moche que moi!' He saw I was amused and turned
to me and said, 'N'est-ce-pas, Monsieur, il est plus
moche que moi?' I said, 'Ce sont deux types de beauté.
Dieu me garde de juger entre eux', and all the quarrel
ended in laughter." And, of course, there were the per-
petual inexhaustible pleasures of landscape, seascape and
townscape, and the simple pleasure of feeling "the extra-
ordinary sensation of pure sunlight".

So he noted down rapidly and casually the small things
that made up the common texture of daily life. Small they
were; but the enjoyment of such pleasures played a great
part in making his last years fuller and richer than any that
had gone before; and had their share too in the increasing
richness and humour of his writing.

VI

It was with many groans that he hitched his "very ex-
ternal and analytic" mind after these summer saunterings
to the task of writing. "Yes, I know I ought to write, but
you know it does need such a different focus of attention
from painting—there is really a kind of opposition in the
two attitudes." He teemed with ideas, but to sit down and
write them out meant "such intense labour and pain. . . .
How little natural aptitude I have, and how rarely I like
the turn my phrases are apt to take. How sick in fact I
get with my own style. . . . I was rather shocked at the
horrible repetition of words like 'plastic', but what is one
to do if one has to make clear one's exposition? One has to
have the exact word as much as a man of science has to use

the correct term for which no substitute is possible."[1] Such
were some of the groans with which he set to work under
friendly pressure to prepare his next book, "Transforma-
tions" (1926), for the press. "By the word 'Transforma-
tions' I wish to suggest all those various transmutations
which forms undergo in becoming parts of esthetic con-
structions", he explained. The old articles and lectures
had as usual been much "remoulded and manipulated",
and it may be that the reader will discover traces of the
intense labour and pain that the writing caused him.
Phrases repeat themselves; words, hideous words like
"pastose", "constatation" have to be coined and forced
into service to express exactly that sensation for which
there is no correct term. He never hesitated to spoil the
shape of a sentence by tagging on a "namely" or a "that
is to say" if he thought that by so doing he could lessen
obscurity and press the argument a little further. Nor
did he attempt to seduce the reader with perorations
or fine writing. But again what other writer upon art,
what other maker of aesthetic theories, has his power to
make the chase exciting and the discovery real? And again,
the ordinary reader asks, how is it done? *Some Questions in
Esthetics*—it is not an attractive title. Questions about
aesthetics are apt to fine themselves into thin air. The prob-
lem of what is meant by representation in art is remote
and obscure. But as the process of pushing the theory
further proceeds, the argument is not only so subtle and so
serpentine that it is fascinating to follow its windings, but
it grazes so many solid objects in its passage that it ac-
quires solidity; the theory becomes something that we can
see and touch. The picture is always miraculously at hand
to illustrate by the attitude of a sportsman or the shadow
on a wall, or the caricature of the old Duchess d'Uzès, the
exact point that has been reached; and from that point it
is possible to press still further. Then the views from this

[1] In 1928 he contributed an essay, "Words Wanted in Connexion with the
Arts", to *Needed Words*, by Logan Pearsall Smith. S.P.E. Tract No. XXXI.

uphill path are so new. The pattern on the carpet is seen from the other side. Much is disputable; much doubtful. Fiction is given the capacity to deal with "psychological volumes". Poetry is declared incapable of sensual appeal. New values are suggested and new vistas revealed. And at last, as if cleaned and burnished and set before us on the easel in a clearer and richer light than ever before, there is the picture itself: Rembrandt's "Schoolboy at his Lessons" lies before us. But Roger Fry's descriptions can never be detached from their context. His astonishing power of evoking, say the painting of the wood of the boy's desk, is not a purely descriptive faculty. It depends upon the friction of argument and analysis that has gone before. But if for this reason he does not provide purple passages, the glow is deeper seated; it is ingrained in the very stuff of his prose. And then, of course, there is the humour—the refreshing and perpetual play of mind— turned now upon Sir Claude Phillips and then upon the old obsessions—the Philistine, the snob, and the treatment of the artist by the State—all of which leads us on, until upon the last page we have reached the present moment, and the living artist, and ask again what comes next?

Whatever the nature of the gift that can bring before us the green of an apple, the glow of a desk, or the complicated oppositions and harmonies of abstract lines, an increasing number of people came under his spell. His fame as a critic was growing. It is difficult to check that growth; it was not marked, as is usually the case, by honours and appointments. But proofs multiplied of the extraordinary position that he had come to hold among the younger generation of artists and critics. "In so far as taste can be changed by one man," Sir Kenneth Clark wrote after his death, "it was changed by Roger Fry." The only other writer with whom he could be compared was Ruskin. "At the time of his death", Mr Howard Hannay writes, "Roger Fry's position in the art world was unique, and the only parallel to it is that of Ruskin at the height of his

reputation. . . . The scholars listened to his views on contemporary art because he knew more than they did about ancient art, and artists paid attention to his historical surveys because they illuminated contemporary painting."

It was thus as a great critic, with something of a prophet's power to excite and stimulate, that he appeared to those who were best fitted to judge among the younger generation. But Roger Fry had no reason to fear the fate he so often deplored—that he would be canonised during his lifetime. There was something about him, or his views, that still made it very difficult for those in authority to accept him. Of this he had curious proof when in 1927 the Slade Professorship, this time at Oxford, was again vacant, and the electors again rejected him. It gave him, he admitted, "a slight shock of surprise". He regretted the opportunity it would have given him to formulate some of his theories, and, though the "grand Victorian vice of saving", which he had not inherited, had given him an independence, a settled income would have been welcome. But he was more amused and interested than distressed. Could it be possible that he was still capable of inspiring fear in the minds of the elderly? "The Oxford electors", he wrote, "are afraid, Bridges says, of my unreasonableness—as though the real crime weren't that I'm so scandalously reasonable. But it's rather pleasant to feel that one's such a lurid figure . . . if they only knew what mildness, what caution, what prudent conservatism, what elderly wisdom there was behind this hob-goblin mask of mine how very shamefaced they'd be. But let's keep the mask on just for the fun of frightening them." Or was it that the authorities had a keen nose for formulas and had scented out the lack of one in his case? Whatever the reason, he was rejected, and the chief pang it caused him was that once more he had to confess his failure to his mother. The inferiority complex bred by his Victorian upbringing was not, he noted, quite dead yet; witness the fact that when he was past sixty he dreamt of a lion; and when he woke

and analysed his dream he identified the lion with Sir Edward Fry and the British public. That showed how terribly he had been suppressed by both, and he was pleased when Dr Martin confirmed him by tracing his visceral neuralgia to the effects of a puritan upbringing— "I always think we ought to show some bad effects of that early training and sure enough here it is". But though traces of Highgate and Sunninghill returned in dreams, Victorianism was evaporating. Time had changed his relation with his mother. "It's not to be believed how much she's changed", he wrote. He could discuss anything with her, and he delighted in her wit. "It shows what a portentous pressure my father exercised over her", he remarked. The old restraint had gone and it was "a real pleasure" to talk to her, even though he had to confess once more that the Oxford electors had again rejected him.

VII

But if Oxford rejected him, London accepted him. He found in these years to his amazement that he could fill the Queen's Hall when he lectured upon art. The winter exhibitions at Burlington House gave him the opportunity. He lectured on Flemish art, on French art, on Italian art; and the hall was filled. The audience, as one of them records, "was enthusiastic and rapt". It was an astonishing feat. There was the Queen's Hall, full those winter evenings of greenish mist, echoing with the sneezings and coughings of the afflicted flock. And to entertain them there was nothing but a gentleman in evening dress with a long stick in his hand in front of a cadaverous sheet. How could contact be established? How could the world of spiritual reality emerge in those uncongenial surroundings? At first by "personality"—the attraction, as Mr Hannay says, "of the whole man". "He had only to point to a passage in a picture . . . and to murmur the word 'plasticity' and a magical atmosphere was created." The voice in

which he murmured was conciliatory, urbane, humorous. It conveyed what was not so perceptible in his writing— the tolerance, the wide experience, that lay behind the hobgoblin mask of the man who had the reputation of being either a crack-brained theorist or the irresponsible champion of impossible beliefs. But as he went on it was clear that the beliefs were still there. Many listeners might have inferred that the lecturer, who looked like a "fasting friar with a rope round his waist" in spite of his evening dress, was inviting them to the practice of a new kind of religion. He was praising a new kind of saint—the artist who leads his laborious life "indifferent to the world's praise or blame"; who must be poor in spirit, humble, and doggedly true to his own convictions. And the penalty for backsliding was pronounced—if he lies "he is cut off from the chief source of his inspiration". No Fry among all the generations of Frys could have spoken with greater fervour of the claims of the spirit, or invoked doom with more severity. But then, "Slide, please", he said. And there was the picture—Rembrandt, Chardin, Poussin, Cézanne—in black and white upon the screen. And the lecturer pointed. His long wand, trembling like the antenna of some miraculously sensitive insect, settled upon some "rhythmical phrase", some sequence; some diagonal. And then he went on to make the audience see—"the gem-like notes; the aquamarines; and topazes that lie in the hollow of his satin gowns; bleaching the lights to evanescent pallors". Somehow the black-and-white slide on the screen became radiant through the mist, and took on the grain and texture of the actual canvas.

All that he had done again and again in his books. But here there was a difference. As the next slide slid over the sheet there was a pause. He gazed afresh at the picture. And then in a flash he found the word he wanted; he added on the spur of the moment what he had just seen as if for the first time. That, perhaps, was the secret of his hold over his audience. They could see the sensation

strike and form; he could lay bare the very moment of perception. So with pauses and spurts the world of spiritual reality emerged in slide after slide—in Poussin, in Chardin, in Rembrandt, in Cézanne—in its uplands and its lowlands, all connected, all somehow made whole and entire, upon the great screen in the Queen's Hall. And finally the lecturer, after looking long through his spectacles, came to a pause. He was pointing to a late work by Cézanne, and he was baffled. He shook his head; his stick rested on the floor. It went, he said, far beyond any analysis of which he was capable. And so instead of saying, "Next slide", he bowed, and the audience emptied itself into Langham Place.

For two hours they had been looking at pictures. But they had seen one of which the lecturer himself was unconscious—the outline of the man against the screen, an ascetic figure in evening dress who paused and pondered, and then raised his stick and pointed. That was a picture that would remain in memory together with the rest, a rough sketch that would serve many of the audience in years to come as the portrait of a great critic, a man of profound sensibility but of exacting honesty, who, when reason could penetrate no further, broke off; but was convinced, and convinced others, that what he saw was there.

VIII

The success of the lectures surprised him. Perhaps he had misjudged the British public. Perhaps in its queer way the public had more feeling for art than he allowed. At any rate there was the fact—"under certain conditions the English public becomes interested in 'highbrow' stuff. . . . Roger Fry had the power of making other people feel the importance of art. . . . In spite of a complete absence of purple passages or playing to the gallery he was able to keep his audience at a high pitch of interest and curiosity." People, drawn from all classes and callings,

would fill the Queen's Hall when he lectured. And not only would they fill the Queen's Hall—they threatened to fill Bernard Street into the bargain. "I am as usual", he wrote after one of these lectures, "swamped by telephone calls and people at me all the time. Miss —— wishes to know if she may come and look at my Matisse. Mr —— wants advice upon a lot of old masters. . . . A. wants to borrow my Vlaminck. B. came to consult me about his son's education as an art student." And there were the letters—the innumerable letters. One from a schoolgirl ran: "Dear Mr Fry . . . Our art mistress from school took a party to the Persian art Exhibition and we were attracted in many pictures, to people with their first fingers held to their lips. Also in some designs animals are seen biting each other. If these mean anything, or are symbolical in any way, I should be very grateful if you could tell me. Another thing is, does our common cat originate from Persia?"

He was delighted to answer schoolgirls' questions. He was delighted to give advice. He would show "hordes of school marms from the U.S.A. armed with note-books seeking information", round his rooms; and then "a very intelligent young man from Manchester" who was interested in Chinese pottery; and then go on to a committee meeting at Burlington House to arrange the Italian Exhibition; and from that to a committee meeting of the *Burlington Magazine*; and when he got home in the evening, there was somebody waiting to "ask my advice about getting up a show of Russian ikons". That was an ordinary day's work; and it was no wonder that at the end of a season of such days he would exclaim "London's impossible!"

It was an exclamation that burst forth irrepressibly every year about February or March. It was necessary to escape from London and its attractions and distractions if he was to have any peace at all. And it was equally necessary if he was to continue lecturing. He must fill his cistern

from the main source; he must see pictures again. And so he was off—to Berlin, to Tunis, to Sicily, to Rome, to Holland, to Spain and again and again to France. The old pictures must be seen once more; they must be seen afresh. "I spent the afternoon in the Louvre. I tried to forget all my ideas and theories and to look at everything as though I'd never seen it before. . . . It's only so that one can make discoveries. . . . Each work must be a new and a nameless experience."

His method was the same in his sixties as it had been in his thirties. He went to the gallery as soon as it was opened; for six hours he worked steadily round, looking at each picture in turn, and making rough notes in pencil. When lunch-time came he was always taken by surprise; and always, as in the old days, he compared his impressions with his companion's, and scribbled his theories down in letters to friends at home. "I'm getting my aesthetic feelings absolutely exhausted with the amount I've looked at. I doubt if I've ever had such hard work in my life—one's absolutely driven to it by the wealth of these museums", he wrote to Vanessa Bell from Berlin in 1928. A long list of pictures seen and noted follows. There was Menzel; there was Liebermann; there was Trübner. There were 'magnificent Cézannes'; there were Manets. There was Egyptian art; there was the art of Central Asia. Berlin had ten galleries filled with paintings and sculptures and miniatures, whereas the British Museum had only a few cases. Stimulated by all these sights, theories began to form themselves; perhaps too rapidly—perhaps they might have to be scrapped. "In fact I don't know what I'm getting at at all. All sorts of vague hints at new aesthetics seem to be simmering in my brain. . . ."

It was thus, in front of the pictures themselves, that the material for the lectures was collected. It was from these new and nameless experiences that vague hints at new aesthetics came into being. Then the vagueness had to be

expelled; the simmer had to be spun into a tough thread
of argument that held the whole together. And after the
lecture had been given the drudgery of re-writing the
spoken word would begin. The obstinate, the elusive, word
had to be found, had to be coined, had to be "curled
round" the sensation. And so at last the books came out
one after another—the books on French art, and Flemish
art and British art; the books on separate painters; the
books on whole periods of art; the essays upon Persian art
and Chinese art and Russian art; the pamphlets upon
Architecture; upon Art and Psychology—all those books
and essays and articles upon which his claim to be called
the greatest critic of his time depends.

<p style="text-align:center">IX</p>

But if, in order to write and lecture, it was necessary to
see pictures "as if for the first time", it was almost equally
necessary to see friends. Ideas must be sketched on other
people's minds. Theories must be discussed, preferably
with someone, like Charles Mauron, who could demolish
them. But even if the friend was incapable of demolishing
them, they must be shared. "He was so sociable that he
could never enjoy anything without at once feeling the
need to share it with those around him", as M. Mauron
says. It was the desire to share, to have two pairs of eyes
to see with, and somebody at hand, or at least within
reach of the pen, to argue with that made him scribble
those letters which it is impossible to quote in full, for
they have neither beginning, middle nor end, and are
often illustrated with a sketch of a landscape, or with the
profile of a sausage-maker's wife at Royat, or with a few
notes to indicate what he was "getting at" in his own
picture. But if the letters cannot be quoted in full, here is
a complete post-card: "In the train going to Edinburgh.
I wonder whether you could send me to Edinburgh 1.
my béret which is very nice for travelling. 2. Slides of

Picasso's sculptures, those queer birds. They're in the
Vitality series upstairs I think and still all together and
on the bureau. 3. A negro head [sketch] the very blank
one with no features. It's in the negro lecture which I left
on the old French chest of drawers in my sitting-room. The
carriage is scarcely warmed. Damn the English."

"Damn the English"—the words ceased to apply to the
English—was not England the only country where free
speech was allowed? But they may serve as a hint that
he was not one of those characters who have, as we are
told by their biographers, an instinctive love of their kind.
His kind often amazed him and shocked him. His eyes,
shining beneath the bushy black eyebrows, would fix them-
selves suddenly, and, looking as formidable as his father
the Judge, he would pronounce judgment. "You are
bolstering people up in their natural beastliness", his
words to Sir Charles Holmes who had given him, inno-
cently, a book on fishing recall some awkward moments
in his company. But if not gregarious he was sociable—"in-
curably sociable" he called himself. His friends meant so
much to him that he would give up the delights of wander-
ing from village to village, from gallery to gallery, in order
to be with them. Spring after spring he would exclaim, "I
feel very much inclined never to come back to England,
just to wander on into Spain and Morocco . . .", but the
sentence would end, "if you wretches will live in London,
then to London I must be dragged back".

A list of those friends would be a long one. It would
include many famous names—the names of painters,
writers, men of science, art experts, politicians. But it
would include many names that are quite unknown—
people met in trains, people met in inns, mad poets and
melancholy undergraduates. Often he had forgotten their
names; names mattered less and less to him. He went out
into society sometimes, but he came back disillusioned.
"Your old friend", he wrote (to Virginia Woolf), "went
to that charming Princess . . . and came back with another

illusion gone—he now knows that *all* aristocrats are vir-
tuous but incredibly boring and refuses to suffer them any
more . . . the said Princess having been his last desperate
throw of the net on that barren shore." After the war his
old dream of a society in which people of all kinds met
together in congenial surroundings, and talked about every-
thing under the sun, had to be given up. People were too
poor, their time was too occupied, and the English more-
over had little gift for discussing general ideas in public.
Perhaps the best substitute for this society was at Pontigny.
He went several times to the sessions there and enjoyed
them greatly. Of one he wrote:

To Helen Anrep, 7th September 1925

Pontigny broke up to-day. . . . Saturday was the day when
at last Mauron and I had our innings and brought things down
from the abstract. I elaborated a good deal on my empiricism,
said with what envious admiration I'd watched all those mar-
vellous evolutions "dans l'empyrée de la pensée" but that as
an Englishman I couldn't throw off my "empiricisme", that
however much I wanted to advance "je n'étais capable de
quitter le sol que d'un pied a la fois", and so on which amused
them a good deal. Then Mauron read an essay on literary
beauty which was by far the most creative and masterly con-
tribution (except perhaps Groethuysen's Augustine) of the
whole "décade". It was beautifully written, transparently
clear, and perfectly developed and full of the most original
ideas. . . . The enthusiasm was so great when he'd finished that
everyone applauded wh. they never do in the entretiens. So
the scientific spirit really had the last word and a great triumph
over the abstractionists and metaphysicians. We two brought
the thing out into daylight out of the mist of dialectic in-
genuity. The brilliance of these men is simply amazing. Fer-
nandez and Fayard do plays in extemporised Alexandrines or
sing songs which they make up from bouts rhythmés given
them. One night they had conferenciers who had to lecture for
2 minutes on subjects chosen out of a hat—the subjects are
always preposterous. I gave them "the Ichthyosaurus as a pre-

PORTRAIT OF F. HINDLEY SMITH BY ROGER FRY, ABOUT 1928

CASSIS, A PICTURE BY ROGER FRY (1925)

cursor of Charlie du Bos". . . . Then they did a Music Hall entertainment with acrobats who pretended to do incredible feats and of course did nothing, but the best was Martin Chauffier, a little solemn Breton with a face like a sucking nonconformist minister who had two specialities—Chateaubriand (on whom he read a very good paper) and Charlie Chaplin whom he did to perfection—the feet especially. . . . Also I liked Fabre-Luce, an exquisitely precise and formal young man— immensely rich, who has written the most brilliant and unpatriotic account of contemporary history. . . . He told me I looked like Erasmus. Je ne demande pas mieux.

But in London he was less ambitious. The attraction of London to him was that it was easy to get together little parties where old friends met new ones even if their names had slipped his memory. For if names mattered less and less, people mattered more and more. How much they mattered, how from one end of his life to the other he lived in his friendships, how in letter after letter he broke into praise of his friends—all that is not to be conveyed by lists of names. If certain friends—Lowes Dickinson, Desmond MacCarthy, Vanessa Bell, Philippa Strachey, the Maurons, his sister Margery stand out, they are surrounded by so many others from so many different worlds, talking so many different languages, that to choose from among them or to say what it was that he got from each of them is impossible. But to be with them was one of his chief pleasures. "Do you realise what delightful little parties we shall be able to have?" he wrote when he moved to Bernard Street; and one of those little parties may stand as the type of many.

His guests found him writing. He had forgotten the time; he was trying to finish a lecture. But he was delighted to stop writing and to begin to talk. The room was as untidy as ever. Ink-bottles and coffee-cups, proof sheets and paint-brushes were piled on the tables and strewn on the floor. And there were the pictures—some framed, others stood against the wall. There was the Derain picture

of a spectral dog in the snow; the blue Matisse picture of ships in harbour. And there were the negro masks and the Chinese statues, and all the plates—the rare Persian china and the cheap peasant pottery that he had picked up for a farthing at a fair. Always there was something new to look at—a new picture, or a little panel of wood perhaps with a dim face upon it—very possibly it was the portrait of Dante, painted by Giotto and carried in Dante's funeral procession. The room was crowded, and for all Roger Fry's acute sensibility, he was curiously indifferent to physical comfort. The chairs had passed their prime; the lifts in the Tube station opposite clanged incessantly; a flare of light came in from the arc-lamp in the street outside; and what he called "the hymnology of Bernard Street" brayed from a loud-speaker next door. But it did not matter. "The dinner", he wrote of one of those little parties, "was a great success. The wild ducks were a trifle tough, but our friends are not really critical. And after dinner", the letter goes on, "we settled in to a good old Cambridge Apostolic discussion about existence, whether good was absolute or not. Charles [Mauron] and I representing modern science managed to make it clear that Oliver [Strachey] and Leonard [Woolf] were mystics. They could not accept the complete relativity of everything to human nature and the impossibility of talking at all about things in themselves. It's curious how difficult it is to root out that mediaeval habit of thinking of 'substances' of things existing apart from all relations, and yet really they have no possible meanings. . . . Poor Oliver was horribly shocked to think he was in that galère. . . . It was a delightful talk. Philosophy was varied by some free criticisms of —— to begin with. He was left a good deal damaged, but with some sympathy for him as a character —when Oliver said, 'But the really wicked man is ——' And then the hunt was up and a fine run across country." That might serve for the skeleton of many such talks, and to give the skeleton flesh and blood—so far as flesh

and blood can be given without voices, without laughter, without Roger Fry himself, looking now like Erasmus, now like a fasting friar—some extracts can be taken from the letters he wrote when, after the party was over, he sat on, "thinking aloud", as he called it, over what had been said, and what there had been no time to say as the hunt galloped across philosophy, religion, science, and art, to its happy end in pure gossip. Mysticism may serve as a start.

I wish I hadn't got so hot about mysticism [he writes]. But I must go on because I've found a perfect description of mysticism—it's the attempt to get rid of mystery. To the primitive mind there is no mystery—his mysticism is so complete and is capable of such indefinite extension that he can always explain every phenomenon. Science can only begin when you accept mystery and then seek to clear it up. But the effect of science is none the less always to increase mystery for with every new avenue that's cleared up you get a fresh vista into the world beyond. To have science one has both to accept mystery and to dislike it enough to try to clear it up which is so complicated a balance that there is no wonder it's rare, and that nearly everyone is even now at heart a primitive. We still have the method of science but we are losing for the time its faith.

So to religion:

As to religion—I can't help thinking that you don't see quite enough the difficulty. If religions made no claim but what art does—of being *a* possible interpretation without any notion of objective validity all would be well—that's what the artist does —but religions all pretend to do what science tries to do— namely discover *the* one universally valid construction and hence comes all the trouble and hence it is that religions have always obstructed the effort towards more universal validity. . . . I think what I feel is that for the most part religions are so deeply dyed with wish-fulfilment that more than anything else they have stood in the way of the disinterested study (science) and vision (art) of the universe. I don't doubt they've had to be, because men couldn't straight away get the disinterested

attitude, but I think they ought to go, and that one can't by re-interpreting the word God or any other such methods make them friends of man's real happiness. . . . I don't think this is altogether the memory of my escape from a creed which really was a very gradual and painless process on the whole. I mean I had no sudden shock, no despair at losing my faith.

So to civilisation:

I'm gradually getting hold of a new idea about the real meaning of civilisation, or what it ought to mean. It's apropos of the question of the existence of individuals. It seems to me that nearly the whole Anglo-Saxon race especially of course in America have lost the power to be individuals. They have become social insects like bees and ants. They just are lost to humanity, and the great question for the future is whether that will spread or will be repulsed by the people who still exist, mostly the people round the Mediterranean. We must hope for the complete collapse of Anglo-Saxondom. The Arabs and Turks are still pure. I want to write something round this when it gets clear. It's the question of whether people are allowed a clear space round them or whether society impinges on that and squeezes them all into hexagons like a honeycomb.

Then to literature:

Why doesn't one always re-read the classics? There they are offering the most authentic, the most accessible delights, and why bother about second-rate and third-rate stuff because it's new? . . . Yes, you're quite right about the Chartreuse de Parme. I thought all the tiresome part was the beginning, but it's later on the repetition of the stabbing affrays &c. get boring. I think there's a real reason why novelists should be very sparing in violent action—it increases the element of mere chance wh. one knows the author can turn either way he likes—whereas if you remain within the ordinary course of civilised life the situation whatever it is develops with some appearance at least of logical inevitability—of course chance is always at work but its effects are minimised and one's sense of inevitable sequences is heightened. . . . I'm reading Flaubert's letters right through. What an exquisite character and

how intimately one loves him! I get furious when I think of the up-to-date young men of to-day who despise them and say he wasn't a born writer. Why, some of his letters written when he was only 18 have the most gorgeous things and written with a gush and abandonment that only a born writer could have achieved.

He had thought of a new classification for writers—into Priests, Prophets and Purveyors. Of course Flaubert actually called himself a priest of literature—it means those who regard it as a sacred calling. I'm a Priest if I'm anything. Of course there are mixed specimens. Thus Shaw is mainly prophet but tinged with Purveying. Wells is mainly purveying but with a flavour of Prophecy. Shakespeare of the early poems and sonnets was a priest but became an almost pure Purveyor, so did Dickens. No, it's a very good classification and the more you think of it the better you'll like it. . . .

He had been reading Rilke:

On the whole I don't think much of Rilke. He exaggerates too much. He's too anxious to create an effect. Things are really much more interesting than he makes them by forcing all the overtones of feeling. But I know that he's the other side of a big dividing line between our ways of taking things. You like the overtones to sound more than the main note. I want a construction made out of solid blocks first and then let the overtones modify it. . . . It's something like that isn't it?

And so to Henry James—he had been reading *Confidence*:

It hasn't the richness of texture of his late writing, but it has such a very elegant psychological pattern—you say you can almost *touch* Max's wit, well, I feel I can almost *draw* James's psychological pattern. I think I feel that aspect of things excessively—it gives me such special pleasure like the counterpoint of Poussin's designs—I wonder if there's any truth in the ordinary idea about me that I am purely "intellectual" in art —that it's a sort of excited recognition of the aptness of formal relations like a mathematician's recognition of the validity of an equation? There is something of that no doubt but then I also like some things that have very little of that quality. . . .

But anyhow there's a man [Henry James] who has a standard. He never wanders from the idea—it's all dense and close-packed. I do like conscientious art—oh you'll say that I'm a beastly moralist—but there it is—I can't help it. . . .

Also he had been reading *The Road to Xanadu,* by Livingstone Lowes, and had found it

amazingly ingenious. . . . It will be very useful if I ever do my Vision in Literature, because he's really analysed the sources of almost all Coleridge's imagery, and it's clear that he's the one really visual poet of that lot. I read some Shelley to compare and it's deplorably lacking in any sharp or decisive sensation. Even Keats was far less visual than Coleridge. He was almost an impressionist, for I find in one note how he amused himself by looking out of the window at a view towards a twilight and seeing it together with the reflection of his fire in the glass—so he evidently played with his eyes. The *Ancient Mariner* is astonishing in the colour of the images.

And so naturally to painting:

He [Simon Bussy] began about volumes, so I showed him two portraits in my Flemish art. He said that I'd chosen them on purpose and that I might have shown an Italian flat and a Fleming in relief—and that it had no importance which way it was—that I was an illuminé who imagined such things and then got excited about them. I said it wasn't a peculiarity of mine, that it was a commonplace of criticism. Then he snorted out Giotto—wasn't he a great artist by my own showing, and wasn't he perfectly flat? I brought out a photo of the Deposition. . . . Mon dieu, what a genius! I got wildly excited by just doing that. . . . At first he swore it was flat—then I showed him a Duccio which was all linear and involved one figure in another and at last he was staggered. . . .

Those are some sentences that may serve to bring back the speaking voice. But the voice would often stop. For there was music—music that so often came to his help as a critic of painting. "Plastic phrase" was coined on the analogy of musical phrase—"the big men having long-

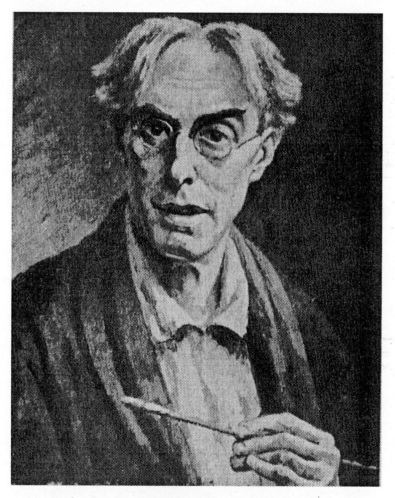

SELF-PORTRAIT, ABOUT 1926
(By permission of Mrs. F. Fry)

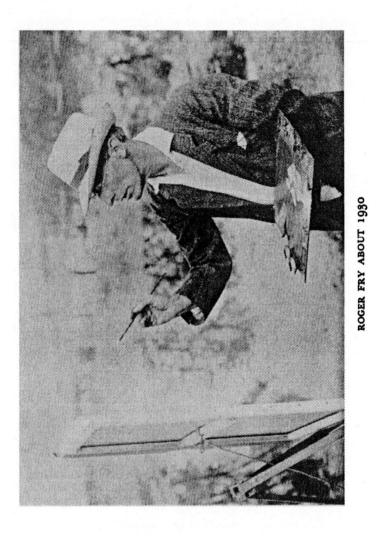

ROGER FRY ABOUT 1930

sustained phrases and the lesser only managing to hold out say for a face or one fold of drapery at a time". And Gainsborough, "never makes a statement in prose . . . it is transmuted as though music were going on somewhere". He had replaced his virginals by a gramophone, chose his records carefully and as he listened, commented.

It is scandalous the musicians don't do more for us. We ought to have perpetual concerts going regularly through all the old music so that at least we should know what it's like. . . . I was terribly moved by Monteverdi's *Orfeo*. I see that to be deeply moved I must be at a certain passing distance from the actual emotional situation—hence all the trouble with the Dostoievskis and the others. . . . I suppose Gluck isn't a very great musician, but Lord what a gift of melody, and how right in feeling he is! It's a fascinating idea—that eighteenth-century notion of the Greek. They just give it a sort of sweetness and tenderness which is all untrue, but which doesn't spoil the bigness of the contours. How I like works of art which don't break the line—that's partly because I ain't musical enough—because I see that in painting some of my greatest loves are people who do break the line—the Rembrandts, and after all Cézanne himself. . . .

He had been to the opera, *The Valkyrie*:

 . . . Well, first I thought I shall never sit this out because almost at once they rose to the last pitch of emotion without any apparent reason. . . . But gradually by not attending to the idiotic story more than just to see what he wanted to express—Lord, what an expressionist he is and what dreary Board School psychology—and then refusing to be the least interested in the emotion I managed to get a great deal of pleasure out of the interweaving of the motives and the extraordinary beauty of the orchestral colour. . . . Bizet's *Carmen*. . . . I hadn't seen [it] since I was an art student in Paris and had still left some vague Quaker scruples about the Opera. . . . It really is a most satisfactory work—so admirably planned to get everything within the operatic plane, so much drama that is rightly expressed in opera and wld. be no good on the stage. It exactly illustrates

my theory of the mixture of the arts. For it's almost perfect—
the music never so important that you want to think of it as
music and yet always adequate to the situation. . . .

Finally, after discussing mysticism, religion, science and
painting, and listening perhaps to "that remarkable
artist Mrs Woodhouse" playing Bach on the gramophone—
"Bach", he said, "almost persuades me to be a Christian"
—time must be found, before the party broke up and the
Tube station shut, for "free criticism of . . ."—that is to
say for gossip pure and simple. As a gossip he was im-
perfect. He said Smith when he meant Jones; and for all
his indignation against Smiths in general, he was curiously
tolerant of any Smith or Jones in particular. Nevertheless,
the talk aloud continues. "We spent the evening laughing
at stories, largely invented, about you. But you wouldn't
have minded." That last remark was true, so far at least
as he was concerned. He relished his friend's foibles; he
liked to hear them travestied and caricatured, to add some
fantastic theory or inaccurate anecdote of his own. But
though he laughed easily, and valued laughter more and
more—"I'm sure the 'Vale of Tears' and 'fiery ordeal'
view of life comes from people who have never learnt to
enjoy and take an envious pleasure in preventing joy
whenever they can"—still, the "only kind of fun I care
about is fun made with flickering seriousness". So, though
he laughed at his friends, he never diminished them, and
the most usual end to that fine run across country was
praise—delight in Desmond MacCarthy's wit—"I quite
agree that he has the most imaginative view about life of
almost any of us and he has the most humane humour"—
praise of his old Cambridge friend Charles Sanger:

Charlie Sanger came. . . . He really is astonishing. He's
seeing through the press the greatest book on the law of wills
that has ever been written, 2000 pages. That's the sort of thing
he does when we aren't looking—then he casually remarked
that he had nearly finished a book on mathematics for physi-

cists which contains all the mathematical machinery for doing these things about atoms and all the rest of it which hardly anyone but a few specialists dream of understanding. Then he discoursed beautifully about Orlando, then about theories of infection, then about Gibbon, and on everything he has more interesting knowledge than anyone else. I know you think I have a well-furnished mind—compared with his it's a workman's cottage to be let unfurnished. I seriously think he's the most remarkable intelligence (I don't say the most original) that I've ever met, and to think that he's utterly unknown to the public and probably always will be!

And so, standing at the door in his slippers with praise of an Apostle on his lips, the "good old Cambridge Apostolic discussion" came to an end.

<p style="text-align:center">x</p>

In the 'thirties some of the talkers began to drop out. Charlie Sanger died; MacTaggart died. It was he who on the downs above Clifton had first roused the portentously serious and solemn little boy to question everything—Canon Wilson's Sunday sermon; kingdoms; republics; Rossetti's pictures; "everything under the sun". Ironically enough they had reached very different conclusions. Roger Fry after fifty years had come to distrust all institutions, "but institutions, as such, and in the end quite apart from what they stood for, moved [McTaggart] to almost religious veneration". They evaded dangerous topics, and, when they met, talked chiefly of the past. But when McTaggart died (1935) Roger Fry went to his funeral and wrote to Helen Anrep: ". . . partly because in a way I had loved him very deeply—no, not that for we were au fond too different in temperament and his was the warmer, less critical affection—but because he had been one of the most constantly familiar beings in my life and one with whom I always found myself happily at ease, I was very much moved". They played Beethoven's

Hymn of Creation, Bach's Pastorale, and a Chorale of
Bach, and then—"was read this from Spinoza, 'The free
man thinks less of death than of anything else and all his
wisdom is the contemplation of life' or very nearly that.
So for once the right thing was said. And while the Bach
Chorale was being played the coffin moved by hidden
mechanism through the doors into?—How odd that this
up to date, hygienic, scientific machine-made and
machine-worked disposal of the body is ten times more
impressive, more really symbolic than that age-long con-
secrated business of earth-to-earth—with the ugliness of the
big hole—so unsuggestive of the infinities which surround
us. . . . Whereas this with its slow silent movement through
doors into the unknown is really dramatic and a perfect
symbol of the inevitable mechanism of things and the
futility of our protests against its irresistible force. . . . My
faith in life is utterly unreasonable and groundless," he
concluded, "it rests on nothing I can see, it seeks for no
sanction; it is the faith by which the animals live and
move, perhaps the atoms themselves. So I must hurry on
with this business of living which lasts as long as life
lasts" (to Helen Anrep, 21st January 1935).

Fortunately the younger generation, his own children
and the children of his friends, was growing up and proved
of great help in carrying on the business of living. "They
are entirely lacking in reverence", he noted. They had
greatly improved upon his own generation. When they
were small he would teach them the rudiments of chem-
istry, making a beautiful blue-green solution of copper
sulphate, or brewing coal gas in a clay pipe plugged with
plasticine on the drawing-room fire. He would appear at
a children's party glittering in chains and frying-pans
bought at Woolworth's, a fancy dress which brought out,
as fancy dress so often does, a spiritual likeness, in his case
indisputably, to Don Quixote. Later he would arrive at
their rooms in Cambridge and, remembering his own atti-
tude to his elders, exclaim in delight, "They talk about their

ROGER FRY ABOUT 1932

own interests and their pleasure in life without troubling
to recognise our presence". But there he was wrong. They
were well aware of his presence—of his humours, of his
eccentricities; of his "immense seriousness", and of his
equally immense powers of enjoyment. He would plunge
at once into his own interests and his own problems. He
would make them help to translate Mallarmé, he would
argue for hours on end with "terrific Quaker scrupulosity
and intellectual honesty"; and he would play chess, and
through playing chess bring them to understand his views
on aesthetics. "He was extraordinarily good at gaining
one's confidence," one of those undergraduates, Julian
Bell, wrote, "principally because he always took one's
ideas seriously enough to discuss them, and contradicted
them if he disagreed. . . . He made one share his pleasure
in thinking. . . . He had a power of analysing poetry, of
showing what was happening, that was extraordinarily
useful. . . . I've never known anyone so good at making
one share his enjoyments. . . . He always seemed ready to
enjoy whatever was going on, food, drink, people, love
affairs. I was never once bored in his company. He never
grew old and cursed."

And Roger Fry returned the compliment. For Julian
Bell himself he had a deep affection—"the most mag-
nificent human being I have known since Jem Stephen",
he called him. Fresh from talk with him and his friends,
he went on to reflect how much more at his ease he felt
with the young than with his own generation. They made
him realise "how curiously far I have travelled from the
standpoint of my own generation. . . . Not that I didn't
enjoy seeing [an old friend] very much, but it just showed
me how much I'd joined the younger generation."

XI

Beside Julian Bell's description of Roger Fry arguing
with undergraduates at Cambridge in 1932 may be set

another of Roger Fry filling up gaps in his knowledge that same spring in Greece. A great book, great in range at least, perpetually pushed aside to make room for lectures, for reviews and broadcasts, lay at the back of his mind; and since Greece was one of the gaps in his knowledge he went there in 1932. The conclusions he came to are to be found in the last Slade lectures. Of the journey itself scattered memories, little pictures that seem to complete the old, remain: Venice, for instance, cold in the spring evening, and Roger Fry waving his hand at the palaces and saying, "That old fraud Ruskin has chapters about all that. He was too virtuous—that's a great pity. Everything had to be squared—even those finicky palaces must be morally good, which they're not—oh no, merely slices of coloured stone." And then the voyage down the Dalmatian coast, sliding past pink grey mountains with blue shadows; and then the first sight of the Acropolis, purple that evening in a storm of rain, and his shock of surprise—his "Awfully swell— awfully swell", and his delight at the French sailors, so "educated and avertis" compared with the Germans; and then the Museum. The Museum was a disappointment. "They don't compose. That's a starfish shape. Look at the thinness of the lines, and there's no background." And so, one sunny afternoon, to a Byzantine church where an old man was reading the newspaper at three o'clock in the afternoon and the peasant women were lazily picking great yellow flowers. He had out his little conversation book and began to talk to them, and then, gazing up at the white vindictive Christ in mosaic on the ceiling of the church, exclaimed: "Better than I'd any notion of", and instantly set up his easel and began to paint. And so to Sunium, where, squatted on the turf, he dug up minute blue irises with his pocket-knife. Did he think Greek irises would grow in Suffolk? "Well, one can only try and see." And so to Delphi and the argument with the chauffeur. "We must see that monastery." The chauffeur protested; the monastery was twenty miles out of the way. "Never mind. We'll

get up at dawn." "But the road's impassable." "Never mind. We'll take the risks." "But the last car fell over the precipice." Reason convinced, at last he yielded. And so across the Peloponnese, the road winding along precipices, the road pitted with pot-holes, scarred with ruts, the passengers flung from side to side, bounced up and down. But always pitching or bouncing, back from the front seat where Roger Fry sat beside his sister came scraps of talk— about prison reform; about politics; about flowers; about Max Eastman's book; about birds; about people. "The Frys", according to a letter, "begin talking at dawn; and talk all day without stopping until . . ."—until the writer of that letter was forced to revise certain theories about Roger Fry himself.

One of the most persistent of those theories was "I've always hated families and patriarchalism of all kinds. . . . I have so little family feeling, so little feeling that it's by the family that one goes on into the future." That was the theory, and it was illustrated by so many anecdotes of the horrors of family life, and of his own attempts to escape that horror, that it was natural to suppose that he had never enjoyed a joke or shared a secret with any one of his own flesh and blood. That theory broke down with his sister. But then, he might have argued, she was not his sister; she was an individual. So the car pitched and bounced; fragments of talk and laughter were thrown back; until at a turn of the road where cypresses or poplars made a pattern and the accent was right for painting, two hands rose simultaneously, the car was halted, and brother and sister sat silent, painting. But Greece, bare of trees, angular and over-dramatic, lacked something necessary. He admired, he analysed, but he did not fall in love. That was a tribute that he reserved for France.

For years he had dreamt of a home in the South. It was to be "a rather grand place . . . where one could have big spaces and nice stones and jolly materials of all kinds". This recurring dream had had to adapt itself to his purse

—"we may have a motor car, but we shall never be rich enough to do all that". His dreams, however, had a way of coming true,—if indeed his motor car can be called a dream. It was a second-hand Citroën; it could go very fast; it stopped very suddenly. It landed him in the middle of a mustard field; it broke down on a hot Italian road and he lay on his back in the dust "tinkering the innards". But with its help he discovered the beauty of Suffolk—"It's no wonder that the only English painting or at least land-scape comes from these parts. One finds everything arrang-ing itself, the way the trees grow, the way they belong to the soil, the way they fill the spaces of the valley, and then the splendid cloud effects." The car did something to in-crease his growing respect for his native land. It could be made to hold luggage, easels, paint-boxes, earthenware pots and furniture. Not without reason the bourgeoisie of Royat were amazed when he drew up at the hotel in this battered veteran, covered with dust, having negotiated thirty hair-pin bends in the Massif Central successfully, clasping in his arms a large Provençal kitchen implement—le diable—which he was taking home to acclimatise in Suffolk. Above all the Citroën took him again and again to St Rémy. There, in 1931, he had bought a little Mas, overlooking the famous ruins, which he shared with Charles and Marie Mauron. He loved that corner of Provence with a passion that seemed to spring from some ancestral memory. He did his best to believe that there was southern blood in his veins. There was the name Mariabella and his mother's southern darkness to prove it. Even if the family annals were against him, and he was wholly English and purely Quaker, "both Margery and I always feel", he wrote, "that we were born there". It was not only the landscape that he loved; it was the pagan, classless society, where salads were held in common, where every peasant was an individual, and the old man who trimmed his olive trees was a more civilised human being than the citizens of Paris, Berlin or London. The Mas was always at the back

of his mind, a centre of sanity and civilisation, when the
telephone rang at Bernard Street, the loud-speaker brayed
next door, and the Tube opened and shut its doors upon
herds of undifferentiated cockneys. He was going to end
his days there, he said, when all the young had turned
Bolsheviks and talked nothing but politics. "Mais trêve à
la sale politique—parlons Mas"—so one political argu-
ment ended.

The Mas, of course, had to be furnished. A great stone
was hauled through the window to serve as hearth; chairs
and tables were bought at the local market; stone pillars
and jars were found in the neighbourhood; and he made
himself a bed from four sections of plane trees "just sawn
across". As for the cooking, he announced triumphantly,
"I've made a *bœuf en daube* which is a dream and will last
us about five days so all I need do is to boil peas or some-
thing", and he could read or write while he watched the
pot. "We certainly have fallen on happy places", he ex-
claimed. All night he slept on his raised couch with the
door open,—"that door which opens straight out into
nothing", and listened to the nightingales singing and the
frogs croaking, "but they always break the rhythm before
it gets quite fixed". Then he woke, and there was "the
perfect view, the view that's so full of infinitely chiselled
detail and lucky conjunctions" to look at. All day he sat
under the pine trees painting, his legs bound in copies of
the *Éclaireur de Nice*, and his head swathed in veils to pro-
tect him from the mosquitoes. The hoopoes, as he painted,
described wonderful loops in the air with their white
heraldic wings and said "Hou—hou—hou" very quickly,
answering each other. The voices of his grandchildren
reached him, chattering among the olives; now and then
they interrupted him with fantastic stories of their dolls'
adventures. At last he went indoors, to gossip with the
neighbours, to play chess, and to continue the argument
about aesthetics with Charles Mauron.

XII

Here a sentence from a letter may be quoted, for the light it throws upon the method by which the final conclusion of some of those many transformations was reached. "Charles Mauron is so terribly good at analysis that it sometimes seems impossible to make any positive construction that will resist his acids. . . . I suppose you feel like that with me, that I will go on analysing when you want to take a certain whole and look without pulling it apart. Only as I never feel clear in my mind without having analysed as far as possible, I have to applaud his destruction even of my cherished ideas." The book of all Roger Fry's books which seems to the common reader at least, to prove the value of destroying theories by acids, because the positive construction left is so very solid, is the Cézanne (1927). A masterpiece, Sir Kenneth Clark called it, and the word seems the only one to fit this profound, rich, and completely satisfying essay. It was written with great care, twice over, first in French and then in English. Here at least the theory is consumed, and the critic has become a creator. It suggests that if Roger Fry received the impulse to create from the work of art rather than from the thing itself, it was because a work of art posed an intellectual problem and thus gratified that intense intellectual curiosity, the desire "to pull apart and to analyse", which, when he came directly into contact with the thing itself, was either too active, or too separate, to let him submit, as perhaps an artist must submit, completely and unconsciously to the experience itself. At any rate, the Cézanne, whether we call it criticism or creation, seems to justify the endless work of revision and analysis that lay behind it. Much more, of course, has gone to it than purely aesthetic curiosity. Sympathy and experience have enabled the critic to place the timid little man with only a sentence or two of biography in his setting of time

and circumstance. We see him sheltering within his shell of bourgeois respectability at Aix, and then, step by step, he emerges and becomes "the great protagonist of individual prowess against the herd". It is a "thrilling drama" with its counterpart in other dramas where the hero is assailed by temptations and confronted by apparently impassable obstacles. The story, the double story, is unfolded with masterly ease and the most scrupulous care. Never was the development of a character or of a picture from the bare canvas to the infinite complexity of the finished work more closely followed or more subtly described. Every element is distinguished and shown to have its necessary part in the final composition. But though the analysis is minute, it is not a dissection. Rather it is the bringing together from chaos and disorder of the parts that are necessary to the whole. When at last the apple, the kitchen table, and the bread-knife have come together, it is felt to be a victory for the human spirit over matter. The milk-jug and the ginger-jar are transformed. These common objects are invested with the majesty of mountains and the melody of music. But in all this protracted and difficult business of revelation and reconstruction the critic's own identity has been consumed. Never does he draw attention by irrelevance or display to his own share in the work of reconstruction. The two gifts, the gift of analysis, the gift of sensibility, that so often conflict, here enhance each other —each contributes, neither dominates. "The concordance which we find in Cézanne between an intelligence rigorous, abstract and exacting to a degree, and a sensibility of extreme delicacy and quickness of response is here seen in masterly action." The words are true of Roger Fry himself. The flower has kept its colour and the microscope its clarity. And yet, though it seems as if nothing could be added, as if the art of painting had been explored to its limit, the essay ends: "But it must always be kept in mind that such analysis halts before the ultimate concrete reality of a work of art and perhaps in proportion to the greatness of

the work must leave untouched a greater part of its objective".

XIII

Like most books that appear seamless and complete, the Cézanne cost its author much drudgery and despair. "O Lord, how bored I am with it", he exclaimed; ". . . it seems to me poor formless stuff and I should like to begin it all over again." There was even more than the usual struggle with words, and their vagueness. And at moments there were doubts—could Cézanne be as great as Roger Fry believed? Was he not deluded? He went and looked at the pictures again "as if for the first time". His conviction became stronger than ever. "How much the greatest of all he is! He has that gravity and ponderation of the greatest things . . . this is the colossal thing." He had not changed his mind, in spite of the fact that all the authorities were now of his way of thinking. The authorities he noted, not without amusement, had purchased a picture by Cézanne for the National Gallery.

But if the Cézanne stands out among Roger Fry's books like Mont Sainte-Victoire, solid in structure and bathed in light, from it, as from that mountain, other tracts of country became visible. He had it at the back of his mind that one day he must find time and energy to set about a great book—a book about the National Gallery; a book that was to cover the whole history of art from the earliest ages to the present time. He hesitated. One reason for hesitation was that "I feel so infinitely less confident about anything I have to say than I used to be. It's dreadful how diffident getting a little deeper into things makes one—one sees too much to say anything." So he painted, wrote articles, gave lectures, or went once more to Italy to look again at the old pictures.

It seemed as if some drop were needed to precipitate all that he had seen and thought into written words. At last, however, in 1933, the opportunity was given him: he was

offered the Slade Professorship at Cambridge. It was a post that he had often wished for; it had often been denied him. But now at first he refused it. It had come when he did not need such recognition, and when those who would have valued it were dead. Cambridge too had lost its chief attraction for him. Lowes Dickinson had died in 1932; and there was nobody to take his place. "I knew you'd know that nothing else in my life is quite the same as that", he wrote to Vanessa Bell. "He had been all through my youth my greatest and most intimate friend. . . . I owe such an immense amount to his influence and his extraordinary sympathy. I begin to see what a tremendously big place he had in shaping all that counts in our world, bigger I think than I'd ever quite realised. . . . He seemed to have got finer, wittier, more charming with age." No one could take his place, and Cambridge without Lowes Dickinson did not altogether escape his criticism. The lack of any sense of beauty among the undergraduates was painfully proved (as he pointed out in his first lecture) by the "barbarous ugliness" of their rooms; and "Mon dieu", he exclaimed to Marie Mauron, "quelle vie que celle des universitaires, des hommes charmants et intelligents, mais si bornés et fixés dans les ornières de cette vie provinciale, et d'une conservatisme réflexe qui vraiment me choque". But the offer of the Slade was made in very flattering terms, and after some hesitation he accepted. "I think it's a good thing on the whole", he wrote; "I shall be compelled to work out some of my ideas more fully." Soon he was "head over ears in Chinese art, and hardly know how to get through in time—there's so much for me to learn. . . ." He was going to "apply his theories of esthetics to the visual art of the whole world, in roughly chronological sequence, from Egypt to the present day". He was going at last to crystallise the mass of ideas that had been accumulating in his mind ever since, as a young man he had gone to Rome and filled note-book after note-book in front of the pictures themselves. It was "the sort of

intellectual adventure which he loved", as Sir Kenneth
Clark wrote in his introduction to those last lectures; and
vast as it was, he threw himself into it with ardour. But he
was sixty-seven, and it was late in life to start upon such
an enterprise. He was beginning, he sometimes com-
plained, to feel old . . . "you begin to feel your whole body
creaking, that's what it is. . . . Don't tell people this—I'd
rather they didn't know it." It was difficult to know it;
the more work he had on hand, the greater his energy
became. It was difficult even to know that he was working,
for he carried on so many other activities simultaneously.
A specimen day is described in a letter written at that time
by Clive Bell:

Up and on the motive before breakfast; after breakfast just
slips over to Tilton to see Sam Courtauld, and arrange about
lectures, and telephone to Hindley Smith; painting in Vanessa's
studio till lunch; at lunch moans and groans about not being
allowed to eat anything; has Lottie put on to cook special in-
valid dishes but meanwhile makes a hearty meal off roast beef
and plum-tart; hurries over to Seaford to inspect Hindley
Smith's collection; back in time for an early tea so that he can
drag Vanessa and Duncan to Wilmington to paint landscape;
after dinner just runs through a few of Mallarmé's poems, which
he is translating word for word into what he is pleased to con-
sider blank verse; bedtime—"Oh just time for a game of chess,
Julian". I look out of window at half-past one and see the old
object, lying like a tomb, in bed on the terrace, reading by the
light of a candle. He had to start early this morning in order to
lunch with Lady Colefax. But, while I am dressing, I hear him
shouting to Julian through the ground-floor window—"I think
before I go we've just time to run through *L'Après-Midi d'un
faune*".

It was in the midst of such distractions, playing chess
with one hand, correcting Mallarmé with another, that
the inaugural lecture was written. Whether it was a day's
work or a day's pleasure—and it was difficult to say where
work ended and pleasure began—it was a full day at any

rate. If in his company, as Sir Kenneth Clark has said, "one felt sometimes that the proper answer to Tolstoy's 'What is art?' was the counter question 'What isn't?' " so in his company the proper answer to the question "What is life?" seemed to be "What isn't?" Everything was drawn in, assimilated, investigated. The body might creak, but the mind seemed to work with more sweep, with less friction than ever. It reached out and laid hold of every trifle—a new stitch, a zip-fastener, a shadow on the ceiling. Each must be investigated, each must be examined, as if by rescuing such trifles from mystery he could grasp life tighter and make it yield one more drop of rational and civilised enjoyment. And here fittingly, since he was no lover of vague statements, may follow his own definition "of what I mean by life . . . I mean the general and instinctive reaction to their surroundings of those men of any period whose lives rise to complete self-consciousness, their view of the universe as a whole and their conception of their relation to their kind". Could he but live five years longer, he wrote in 1933, "life will have done all for me that I can expect".

XIV

Only one subject seemed to escape his insatiable curiosity; and that was himself. Analysis seemed to stop short there. Perhaps human nature, until we have more knowledge of psychology, is inexplicable; we are only beginning, he would insist, to know anything about this very queer animal man. He was delighted, of course, to hazard theories—about the effect of a puritan upbringing, about the origin of the inferiority complex which he observed cropping up in him from time to time. And if pressed, though very little interested in the past compared with the present, he would try to set down what he could remember. "The first thing", one such fragment of autobiography begins, "is the play of light on the leaves of the elm trees

outside the nursery window at Highgate. . . ." He could remember many sights, and here and there an amusing incident or character—his father skating, for example, or Pierpont Morgan, with his strawberry nose and his little red eyes, buying pictures in Italy. But the central figure remained vague. ". . . I don't pretend to know much on the subject. It so rarely interests me", he wrote when asked to explain himself. "You say I'm wild and want to know if I'm impulsive", he went on (to Helen Anrep). "Why I should have thought, but of course I don't know, that I was impulsive (which I don't like and suspect you don't) but not wild. No, surely not wild—infinitely sane, cautious, reasonable—what makes me look wild is that I don't happen to accept any of the world's idées reçues and values but have my own and stick to them. . . . But I should have said impulsive, *i.e.* moved rather jerkily and suddenly by what appeals to me, and I think it implies something wasteful and incoherent in me which I also lament and would like you to forgive—oh, and cure, perhaps."

This lack of interest in the central figure—that central figure which was so increasingly interested in everything outside itself—had its charm. It made him unconscious, a perfect butt for the irreverent laughter, in which he delighted, of the young; unaware too of the astonishment that his appearance, clasping *le diable* in his arms, created among the respectable residents in middle-class hotels. But it had its drawbacks, for if he ignored himself, he sometimes ignored other people also. Thus it would be quite possible to collect from different sources a number of unflattering portraits of Roger Fry. They would be contradictory, of course. To some people he seemed insincere —he changed his opinions so quickly. His enthusiasm made the first sight so exciting; then his critical sense came into play and made the second sight so disappointing. The swan of yesterday would become the goose of to-day—a transformation naturally, and often volubly, resented by the bird itself. To others he seemed on the

contrary only too ruthless, too dictatorial—a Hitler, a Mussolini, a Stalin. Absorbed in some idea, set upon some cause, he ignored feelings, he overrode objections. Everybody he assumed must share his views and have the same ardour in carrying them out. Fickle and impulsive, obstinate and overbearing—the unflattering portraits would be drawn on those lines.

And he was the first to realise that there was some truth in them. He was impulsive, he knew; he was obstinate; he was, he feared, egotistical. "I suddenly see", he wrote, "the curious twisted egotism that there is somewhere in me that used to come out when I was little in my indignation against 'the twinges', as I used to call Isabel and Agnes, for wanting to play with my things." Also he was "cross, fussy, stingy, pernickety and other things". Perhaps psycho-analysis might help; or perhaps human nature in general and his own in particular was too irrational, too instinctive, either to be analysed or to be cured. And he would go on to deplore the natural imperviousness of the human mind to reason; to gird at the extraordinary morality with which human beings torture themselves, and to speculate whether in time to come they may not accept the simple gospel "that all decency and good come from peoples gradually determining to enjoy themselves a little, especially to enjoy their intellectual curiosity and their love of art". In such speculations about the race in general, Roger Fry lost sight of himself in particular. Certainly he would have refused to sit for the portrait of a finished, complete or in any way perfect human being. He detested fixed attitudes; he suspected poses; he was quick to point out the fatal effect of reverence. And yet whether he liked it or not he would have had to sit for the portrait of a man who was greatly loved by his friends. Truth seems to compel the admission that he created the warmest feeling of affection and admiration in the minds of those who knew him. It was Roger Fry, to sum up many phrases from many letters, who set me

on my feet again, and gave me a fresh start in life. It was he who was the most actively, the most imaginatively helpful of all my friends. And they go on to speak of his considerateness, of his humanity, and of his profound humility. So though he made some enemies and shed some acquaintances, he bound his friends to him all the more for the queer strains of impulsiveness and ruthlessness that lay on the surface of that very deep understanding.

But there was the other life—the artist's. He felt no need to apologise for his conduct there. A work of art was a work of art, and nothing else: personal considerations counted for nothing there. He was a difficult man, it is easy to believe, on committees. He gave his opinion uncompromisingly; he gave it wittily and pungently, or sometimes he gave it sufficiently with one deep groan. He had no respect for authority. "If you said to him, 'This must be right, all the experts say so, Hitler says so, Marx says so, Christ says so, *The Times* says so', he would reply in effect, 'Well, I wonder. Let's see.' . . . You would come away realising that an opinion may be influentially backed and yet be tripe."[1] Naturally, artists and art critics being what they are, he was bitterly attacked. He was accused of caring only for the Old Masters or only for the latest fashions. He was always changing his mind and he was obstinately prejudiced in favour of his friends' work. In spite of failings that should have made his opinion worthless, it had weight—for some reason or other Roger Fry had influence, more influence, it was agreed, than any critic since Ruskin at the height of his fame.

How, without any post to back it he came to have such influence, is a question for the painters themselves to decide. The effect of it is shown in their works, and whether it is good or bad, no one, it is safe to say, will hold that it was negligible. To the outsider at any rate, the secret of his influence seemed based, in one word, upon his disinterestedness. He was among the priests, to use his own

[1] E. M. Forster. Roger Fry: an obituary note.

definition, not among the prophets, or the purveyors. By ignoring personalities and politics, success and failure, he seemed to penetrate beyond any other critic into the picture itself. To this the outsider could also add from direct observation another characteristic—he did not indulge in flattery. Friends he had—he cannot be acquitted of liking some people better than others. But a mutual admiration society, if such things exist—and according to some observers they do—would have expelled Roger Fry at the first meeting. He was as honest with his friends' work as with his enemies'. He would look long and searchingly, and if he liked what he saw, he would praise generously, dispassionately. But if he did not like what he saw, he was silent; or his one word of condemnation was enough. But his detachment, his disinterestedness was shown most impressively by his own attitude to his own work. His painting was beyond comparison more important to him than his criticism. He never lost hope that he had "a little sensation", as he called it, or that he had at last been able to express it. He would set his own canvas on the easel and await the verdict. It was often adverse; those whose praise he would have valued most highly were often unable to give it. How keenly he minded that silence is shown again and again in his letters. But it made no difference. His own picture would be set with its face to the wall, and he would turn to the work of those who had been unable to praise his own. He would consider it with perfect single-mindedness, and if he liked it, he praised it, not because it was a friend's work, but because he admired it. "One thing I can say for myself", he wrote. "There are no pangs of jealousy or envy when I see someone else doing good work. It gives me pure delight." There perhaps lay the secret of his influence as a critic.

But his influence as a human being—his own words, "We know too little of the rhythms of man's spiritual life", remind us of the perils of trying to guess the secret that lay behind that. He did not believe with all his knowledge

that he could guess the secret of a work of art. And human beings are not works of art. They are not consciously creating a book that can be read, or a picture that can be hung upon the wall. The critic of Roger Fry as a man has a far harder task than any that was set him by the pictures of Cézanne. Yet his character was strongly marked; each transformation left something positive behind it. He stood for something rare in the general life of his time—"Roger Fry's death is a definite loss to civilisation", wrote E. M. Forster. "There is no one now living—no one, that is to say, of his calibre—who stands exactly where he stood." He changed the taste of his time by his writing, altered the current of English painting by his championship of the Post-Impressionists, and increased immeasurably the love of art by his lectures. He left too upon the minds of those who knew him a very rich, complex and definite impression.

If for a moment we attempt his own task and assume that he was an artist who began his work in 1866 and continued it with immense energy and inventiveness for sixty-eight years, we can perhaps single out a few of the qualities that gave it shape. There are certain phrases that recur, that seem to stress the pattern of the whole. His own words "It gives me pure delight" might serve for a beginning. They bring to mind the little boy who sat in his own private and particular garden at Highgate, watching for the bud to burst into flower—"I conceived that nothing could be more exciting than to see the flower suddenly burst its green case and unfold its immense cup of red". What was true of the child in the garden was true of the man all through his life. There was always some bud about to burst into flower; there was always some flower that gave him pure delight. But the critic who attempts to analyse the composition of his own work of art will have to note that his flower did not burst suddenly and completely into its immense cup of red. There were many obstacles. We recall the pond in winter; the "lack of simple humanity" in his upbringing that long cramped and fettered him.

Sunningdale and its floggings followed; from them he
learnt a hatred of brutality that lasted all through his life.
From Clifton and "its crass bourgeois respectability"
sprang his intolerance of the Philistine, of the conventional.
Cambridge, of course, meant liberation. Only there again
nature thwarted him. She gave him the capacity for pure
delight, but a mind quick to doubt, to reason, to analyse,
to dissect—perhaps to destroy pure delight. It was only
after much waste of time and temper that he set to work
with all his faculties upon the picture. The critic therefore
has to record no steady and uninterrupted progress, but
rather a series of sallies and excursions in different direc-
tions. Sensation beckons one way; training and reason
another. The Quaker, the scientist, the artist, each in turn
took a hand in the composition. And then happiness,
a medium that would have solved many difficulties, was
snatched from him. He had no centre. He had to make his
picture in the harshest conditions, out of the sternest ele-
ments. The danger that threatened him was the danger of
"imprisonment in egotism". But "life was too urgent". It
was only "by piling new sensations on to one's memories
that one can learn to start life afresh". He threw himself
into other activities, and in their pursuit found once
more that "all passions even for red poppies leave one open
to ridicule". He found, too, that to feel passion is to expose
oneself not only to ridicule but to anguish. There was no
lack of "that spiritual torment, that anxious effort which
in the lives of the greatest artists forces them always to
wrestle with new problems". Here the phrase of the Chinese
philosopher makes itself heard: "L'homme natural résiste
à la nature des choses, celui qui connait le Lao coule par
les interstices". One must master detachment. But detach-
ment did not mean withdrawal. "I want to have *new* ex-
periences. I want to go out into this tremendous unknown
universe outside one." It was thus, the critic will note, by
experiments, by revisions and perpetual reorientations that
he avoided with astonishing success the fate that attends

so many artists, both in paint and in life—repetition. Like
the frogs at St Rémy, he broke the rhythm before it got
quite fixed. As the artist grows older, therefore, the critic
becomes aware of an increasing richness and boldness in
the design. New rhythms and new themes appear. The
artist becomes less conscious and so has access to a greater
range of emotion. He draws into his theme common things,
the milk-pot, the apple and the onion, and invests them
with a peculiar quality of reality. So we can single out
some of the processes that went to the making of that
picture. But "It must always be kept in mind that such
analysis halts before the ultimate concrete reality of a
work of art, and perhaps in proportion to the greatest
of the work it must leave untouched a greater part of its
objective".

With such words of warning the critic of Roger Fry
may well drop the stick to the ground and give up point-
ing. But though the lecturer, when he came to a certain
late work by Cézanne, made his bow and said, "It goes
beyond any analysis of which I am capable", he went next
day to the gallery and tried to see the picture again as if
for the first time—"it's only so one makes discoveries".
Sometimes, though not by conscious effort, people also
are seen as if for the first time. One such occasion—it was
the last, as it happened—comes to memory. It was a
summer evening, late in July 1934, and a friend had
brought a picture upon which he wanted Roger Fry's
opinion—was it by Degas, or a copy only? The canvas
was stood on a chair in front of him, in the same room,
looking out on to the same trees where so many pictures
had been stood in front of him—pictures by Watts, and
pictures by Picasso, school children's drawings and can-
vases with the paint still wet on them. Again his eyes fixed
themselves with their very steady and penetrating gaze
upon the canvas. Again they seemed to carry on a life of
their own as they explored the world of reality. And again
as if it helped him in his voyage of discovery he turned

and laughed and talked and argued about other things. The two worlds were close together. He could pass from one to the other without impediment. He responded to the whole vibration—the still life and the laughter, the murmur of the traffic in the distance and the voices close at hand. His presence seemed to increase the sensation of everything in the room. But at the centre of that vibration was a gravity and a stillness, as in his face too there was that which made him look so often "like a saint in one of his Old Masters". But he was a saint who laughed; a saint who enjoyed life to the uttermost. "Whereas piety or holiness make goodness stink in the nostrils", he once wrote, "saintliness is the imaginative power to make goodness seem desirable." He made goodness seem desirable, as he sat laughing with his friends and looking at the picture. But how describe the pure delight "of watching a flower unfold its immense cup of red"? Those who knew him best will attempt no summing up of that sensation. They can only say that Roger Fry had a peculiar quality of reality that made him a person of infinite importance in their lives, and add his own words, "Any attempt I might make to explain this would probably land me in the depths of mysticism. On the edge of that gulf I stop."

But it was late; his mind was made up; and once more he was off.

XV

He went to St Rémy. He worked with Charles Mauron, translated Mallarmé and painted among the olive trees. "The sun shines perpetually", he wrote home, "and if only the flies didn't bite it would be an earthly paradise." Once more there was Royat, once more there were the usual groans at the romantic landscape, at the bourgeois respectability—"like a perpetual Victorian sabbath"—of the hotel. Then with Helen Anrep he drove through France seeing "an incredible number of Romanesque

churches some of astonishing beauty". One last letter to
Vanessa Bell thanked her for a last visit—"I don't think I
ever enjoyed it more"—and for a long friendship which
had grown "more and more important with the years".
He was going to settle in for a winter of hard work, he told
her; he was absorbed in his Slade lectures. He was full of
plans for the future and of hope.

He reached home in the first week of September. On the
evening of his return he was working in the room at
Bernard Street, got up to fetch something, slipped and
fell. Once before he had fallen and had written, "It's odd
that for some time before this I'd this feeling of impending
menace and my first thought after the fall was—That's it.
I'm killed. But I almost instantly recovered and began to
constater the facts." This time the fall was very serious,
the thigh was broken. For a few days he lay in great pain,
but his vitality was great, and he seemed to be recovering.
Then suddenly his heart failed and on the afternoon of
9th September he died in the Royal Free Hospital, to
which he had been taken.

On 13th September, a day as it happened of extra-
ordinary beauty, his body was cremated. When his friend
McTaggart was cremated he wrote, "This slow silent
movement through doors into the unknown is . . . a
perfect symbol of the inevitable mechanism of things and
of the futility of our protests against its irresistible force".
There was no service as Roger Fry's body passed through
the same door, but music was played, Bach's Chorale, a
Choral prelude, and Frescobaldi's Fugue in G minor. And
upon a paper that was given to his friends were printed
some lines from Comus, a passage from Transformations, and
finally the words of Spinoza which, when his friend was
cremated, he had said were the right words:

A free man thinks of death least of all things; and his wisdom
is a meditation not of death but of life.

INDEX